EDITED BY JONATHAN FINEBERG

⊞ UNIVERSITY OF CALIFORNIA PRESS Berkeley Los Angeles London

in association with The Phillips Collection Center for the Study of Modern Art

and Illinois at The Phillips, a Program of the University of Illinois at Urbana-Champaign

WHEN WE WERE YOUNG

NEW PERSPECTIVES ON THE ART OF THE CHILD

THIS PUBLICATION IS PUBLISHED IN CONJUNCTION WITH THE EXHIBITION
WHEN WE WERE YOUNG AT THE PHILLIPS COLLECTION, WASHINGTON, D.C.,
JUNE 17–SEPTEMBER 10, 2006, AND KRANNERT ART MUSEUM, UNIVERSITY
OF ILLINOIS AT URBANA-CHAMPAIGN, OCTOBER 20–DECEMBER 31, 2006.

University of California Press, one of the most distinguished
university presses in the United States, enriches lives around the
world by advancing scholarship in the humanities, social sciences,
and natural sciences. Its activities are supported by the UC Press
Foundation and by philanthropic contributions from individuals
and institutions. For more information, visit www.ucpress.edu.

University of California Press Berkeley and Los Angeles, California

University of California Press, Ltd. London, England

The Phillips Collection Center for the Study of Modern Art Washington, D.C.

Illinois at The Phillips, a Program of the
University of Illinois at Urbana-Champaign

Library of Congress Cataloging-in-Publication Data
 When we were young : new perspectives on the art
 of the child / edited by Jonathan Fineberg.
 p. cm.
 Catalog of an exhibition at the Phillips Collection,
 Washington, D.C., June 17–Sept. 10, 2006, and at the
 Krannert Art Museum, University of Illinois at
 Urbana-Champaign, Oct. 20–Dec. 31, 2006.
 Includes bibliographical references and index.
 ISBN-13: 978-0-520-25042-0 (cloth : alk. paper)
 ISBN-10: 0-520-25042-7 (cloth : alk. paper)
 ISBN-13: 978-0-520-25043-7 (pbk. : alk. paper)
 ISBN-10: 0-520-25043-5 (pbk. : alk. paper)
 1. Children's drawings. 2. Children's drawings—
 Exhibitions. I. Fineberg, Jonathan David. II. Phillips
 Collection. III. Krannert Art Museum.
 N352.W48 2006
 741.083—dc22

 2006012107

Manufactured in Canada

15 14 13 12 11 10 09 08 07 06
10 9 8 7 6 5 4 3 2 1

The paper used in this publication meets the minimum requirements
of ANSI/NISO z39.48-1992 (R 1997) (*Permanence of Paper*).

THE PUBLISHER GRATEFULLY ACKNOWLEDGES THE GENEROUS CONTRIBUTION TO THIS BOOK

PROVIDED BY THE ART ENDOWMENT FUND OF THE UNIVERSITY OF CALIFORNIA PRESS FOUNDATION,

WHICH IS SUPPORTED BY A MAJOR GIFT FROM THE AHMANSON FOUNDATION.

CONTENTS

This volume appears at an auspicious time for The Phillips Collection, as it launches its new Center for the Study of Modern Art, a place for interdisciplinary inquiry and discovery based on the Phillips's exceptional collection of modern paintings from impressionism to the New York School and beyond. The Center constitutes a new paradigm in the evolution of The Phillips Collection, from a place that began as the singular vision of its founder, Duncan Phillips, who longed to share his love of art with the public, to its maturation into a major public institution that is known as a leader in modern art scholarship and arts education.

As an important extension of its founder's vision that the study of and engagement with modern art can be a life-enriching experience for all, The Phillips is joining with the University of Illinois at Urbana-Champaign, a preeminent public research university, to make this dream a reality. This is also an important moment for the University of Illinois at Urbana-Champaign as it strides forward to even greater global prominence in research and teaching. Together, the University and The Phillips Collection will unite their areas of expertise: the university's scholarly research and teaching with the museum's record of important exhibitions, publications, and outstanding educational programs. This unique partnership brings together a large academic universe with one of the world's finest small art museums, joining to create provocative and inclusive conversations that explore topics related to a collection of singular identity. Providing a permanent structure for sustained inquiry, the Center will enable The Phillips Collection, in concert with its academic partner, the University of Illinois at Urbana-Champaign, to extend the educational mission of both as they jointly build an internationally recognized resource for the study and appreciation of modern art. This publication constitutes the first step in realizing this vision.

JAY GATES DIRECTOR, THE PHILLIPS COLLECTION

RICHARD HERMAN CHANCELLOR,
UNIVERSITY OF ILLINOIS AT URBANA-CHAMPAIGN

[FACING] Samantha Smith (female, age 7, United States), *On a Leopard's Fur: Hidden Chameleon* (detail), 2003. Tempera, oil pastel, marker, and pencil on paper, 12 × 18 inches. Collection of Jonathan Fineberg.

I have learned so much from watching my children when they were young and then talking with them as adults. I recently came across a copy of a note I wrote to Rudolf Arnheim in 1992 as we were talking about my work on *The Innocent Eye: Children's Art and the Modern Artist* for the Kunstmuseum Bern and the Kunstbau Munich: "Art and Literature decided to sleep out in the backyard in a tent last night! and Marianne and I watched them from my library running out of the tent, behind the giant blue spruce, and back with flashlights, giggling until about midnight; I'm glad to say the 're-bellious deviation' went to sleep in his own bed and was out by 9. This is certainly the right project for me with such muses!"

Everything I've written comes from an ongoing di-alogue with colleagues and friends, authors and artists. But, in particular, I owe a fundamental debt to my wife, Marianne, who has often seeded my books with some of their most fertile ideas while at the same time nur-turing me through the turmoils of writing. This ex-hibition and book have also grown out of early con-versations about children with my father, Henry H. Fineberg, M.D., who was one of the first group of child psychoanalysts to be trained at the Institute for Psychoanalysis in Chicago after World War II. That in turn prepared me for a forty-year-long friendship with Rudi Arnheim, which began in the fall of 1966 when I enrolled in his class on the psychology of art at Harvard.

I want to take this occasion for another recollection of that formative friendship with Rudi. When I last visited, he had just finished another article—he was then a youthful ninety-nine; as I write this, he is ap-proaching his one hundred and second birthday. When we moved from New York to the University of Illinois in 1984, Marianne drew a New Year's card to send to our friends, beginning a now unbroken tradition of twenty-two years. We're always late. But one year, when

[ABOVE] Rudolf Arnheim, *Postcard (Innocent Eye)*, January 1988. Sent to Jonathan Fineberg after receiving a copy of *The Innocent Eye: Children's Art and the Modern Artist*. Collection of Jonathan Fineberg.

we were even later than usual, we received a note from Rudi asking why he hadn't received his drawing from Marianne yet! I hadn't realized that he had been drawing caricatures his whole life and looked forward to these cards. Soon after that he drew and mailed us the postcard reproduced here. This book also acknowledges that friendship. I will never forget his warmth or his insight or his gentle guidance as a teacher.

Rudi wrote a great essay in 1995 for my anthology *Discovering Child Art*, but we could not afford color reproductions, and he and I agreed that somehow I would eventually find a way to reprint it with full color. This book represents that effort. Meanwhile, this book also affords me another opportunity to reflect on the dynamics of visual thinking and on child art, which have persevered as central concerns of mine for more than forty years. Along the way, a number of colleagues, including many present and former graduate students, have contributed in a variety of ways to my thinking on these subjects and to the appearance of this book. I want especially to mention Elena Basner, David Cast, Mary Coffey, Monique Cohen, Jane Cole, Lorraine Morales Menar Cox, Paul Duncam, Margaret Ewing, Alla and Angela Goldin, Josef Helfenstein, Olga Ivashkevich, Larry Jeckel, Irving Lavin, Rene Meyer-Grimberg, Megan McNitt, Marie-Cecile Meissner, Jordana Moore, John Neff, Chris Quinn, Mysoon Rizk, Richard Shiff, Harry Smith, Buzz Spector, Natasha Staller, Christine Marmé Thompson, Diane Voss, Klaus Witz, Phoebe Wolfskill, and Ted Zernich.

I also want particularly to acknowledge the generous support I received from the Dedalus Foundation for a Senior Fellowship that allowed me to free up time to work on this project. Chip Zukoski, Vice Chancellor for Research, the Research Board of the University of Illinois at Urbana-Champaign, the Center for Advanced Study, Kim and Peter Fox, and Kathleen Harleman, Director of the Krannert Art Museum, have also helped significantly along the way. Above all, I want to thank my friends Richard Herman, Chancellor of the University of Illinois at Urbana-Champaign, and Mike Ross, Director of the Krannert Center for the Performing Arts at the University, for their friendship and support over a long time and in a myriad of ways.

This book and the accompanying exhibition also announce an exciting adventure in which the University of Illinois at Urbana-Champaign and The Phillips Collection in Washington are bringing together the new and unique Center for the Study of Modern Art at The Phillips Collection with the rich research and teaching agenda of Illinois at the Phillips, a new program of the University of Illinois at Urbana-Champaign, to offer a panoply of programs and projects. Chancellor Richard Herman, Ruth Watkins in the Office of the Provost, and outgoing acting Provost Jesse Delia have made this possible from the University side; from The Phillips side, Jay Gates, Director of The Phillips Collection, Ruth Perlin, Associate Director for the Center, and Beth Turner, Senior Curator, have driven the vision behind the Center set out by Duncan Phillips and kept alive by the inspiring articulation of Loc Phillips until it finally came to be realized in this partnership. None of it would have been possible without the unstinting enthusiasm, hard work, and personal generosity of my colleagues on the Board of Trustees of The Phillips Collection: Jim Adler, Bill Christenberry, Mike Connors, Brian Dailey, Jerry Fischer, Léonard Gianadda, Rod Heller, Bonnie Himmelman, Peggy Hunter, Linda Kaplan, Cameron LaClair, Jonathan Ledecky, Caroline Macomber, Don Roth, Tom Rutherfoord, Patricia Sagon, David Steadman, Alice Swistel, George Vrandenburg, Alan Wurtzel, Jim Young, and Leo Zickler; and former board members Gifford Phillips, Liza Phillips, Loc Phillips,

Acknowledgments

and Sharon Rockefeller. Both as indispensable friends of The Phillips and of mine I want to thank Vicki and Roger Sant. I also want to thank Ann Greer, Tony Podesta, Eliza Rathbone, and Suzanne Wright for essential ideas, encouragement, and help on various fronts, and my assistant, Jessica Cash, whose hard work underlies just about everything.

Last but not least, I want to thank Deborah Kirshman of the University of California Press for long-term support and short-term production—possibly the fastest production of a major art book in the annals of UC Press! I also want to thank her staff and associates and the staff of Wilsted & Taylor Publishing Services, especially Christine Taylor, Jeff Clark, Jennifer Uhlich, and Nancy Evans, who leaped in and got this done without cutting corners on quality when we suddenly found ourselves with a year less than we thought we had in which to do it.

JONATHAN FINEBERG GUTGSELL PROFESSOR OF ART HISTORY, UNIVERSITY OF ILLINOIS AT URBANA-CHAMPAIGN

CURATOR OF THE EXHIBITION AND DIRECTOR OF ILLINOIS AT THE PHILLIPS, A PROGRAM OF THE UNIVERSITY OF ILLINOIS AT URBANA-CHAMPAIGN

The Exhibition at the Krannert Art Museum

Jonathan Fineberg has been thinking and writing about the visual richness and inventiveness of child art for many years. With the exhibition and catalogue, *When We Were Young: New Perspectives on the Art of the Child*, he provides fresh insights into children's drawings from an aesthetic point of view and explores criteria used for assessing prodigious artistic talent.

Beyond his curatorial and scholarly contributions, Jonathan is to be thanked for his energetic and visionary role in developing an ongoing collaboration between the University of Illinois at Urbana-Champaign and The Phillips Collection, Washington, D.C. At The Phillips, a newly constructed and conceived research center devoted to modern art will be directed by Jonathan, providing exciting opportunities for the art, education, and museum fields; for University of Illinois faculty and students, and for Washington, D.C., residents and visitors generally. In addition, the Krannert Art Museum and The Phillips Collection look forward to co-organizing exhibitions—*When We Were Young* being the first of our initiatives.

The Krannert Art Museum thanks Jay Gates, director of The Phillips, and his staff for being such game collaborators. Funding for the Krannert Art Museum's presentation of *When We Were Young* will benefit from the generosity of Fox Development Corporation, the Illinois Arts Council, and the Krannert Art Museum Council. Profound thanks go to the museum's staff, who once again achieved something of which to be proud.

KATHLEEN T. HARLEMAN

DIRECTOR, KRANNERT ART MUSEUM

UNIVERSITY OF ILLINOIS AT URBANA-CHAMPAIGN

Acknowledgments

JONATHAN FINEBERG

INTRODUCTION

Gifts of Seeing

I wished I had lived in the days of real journeys, when it was still possible to see the full splendor of the spectacle that had not yet been blighted, polluted and spoilt. . . . When was the best time to see India? At what period would the study of the Brazilian savages have afforded the purest satisfaction, and revealed them in their least adulterated state? Would it have been better to arrive in Rio in the eighteenth century with Bougainville, or in the sixteenth with Léry and Thevet? CLAUDE LÉVI-STRAUSS

In *Tristes tropiques* (1955), the great anthropologist Claude Lévi-Strauss reflects on the methodological failure of his own early fieldwork. He realizes that had he gone to Brazil in the sixteenth century he would have been blinded by the preconceptions of that age and failed to see what his twentieth-century eyes longed to see in retrospect. He concludes, in a melancholy note, that "a few hundred years hence, in this same place, another traveler, as despairing as myself, will mourn the disappearance of what I might have seen, but failed to see."[1]

Our subject is remarkable children's drawings. And like the young Lévi-Strauss, we too approach our subject from an altogether different era—albeit in ontogenetic, rather than historical time. We also worry, as he did, about what preconceptions we have imposed on the subject in front of us today. How have we failed

[FACING] Paul Klee, *Dwarf and Mask* (*Zwerg und Maske*), 1926 (detail, fig. 12).
[ABOVE] Paul Klee, *Woman with Parasol* (*Dame mit Sonnenschirm*), 1883–85 (detail, fig. 11).

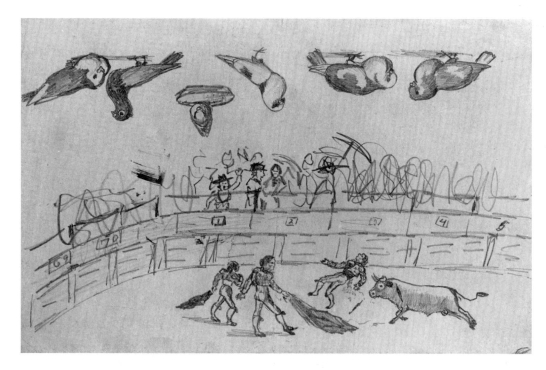

Fig. 1. Pablo Picasso (age 9), *Bullfight and Pigeons (Corrida de Toros y Seis Estudios de Palomas)*, 1890. Pencil on paper, 5⅜ × 8 inches. Museu Picasso, Barcelona. © 2006 Estate of Pablo Picasso/Artists Rights Society (ARS), New York.

to see what is remarkable in the drawing of a "gifted" child because of our adult perspective?

In his classic biography of Pablo Picasso, published in 1958, Roland Penrose writes that the artist's father obtained permission for the young Picasso to take the examination for entrance to the School of Fine Arts at La Llotja in Barcelona at the age of just fourteen. "The results were startling," Penrose reports. "The test, for which one month was prescribed, was completed by him in exactly one day, and so successfully that in his finished drawings from life he proved to be in advance of mature students." The jury, Penrose goes on, "were at once convinced that they were faced . . . with a prodigy."[2]

In 1992, when John Richardson published the first volume of his biography of Picasso, he revealed that the young Picasso was, in fact, given a simplified exam at La Llotja, in consideration of his age. "Any halfway gifted student could have completed [it] . . . in a day," Richardson writes.[3] Picasso's daughter Paloma, after reading Richardson's book, told me how surprised she was to learn that the earlier account of Picasso's breathtaking performance at the entrance examinations had been fabricated, because she had often heard her father recount the story himself![4] Picasso's "*legend*," Richardson argues, "obliged him to have been a genius from earliest days," but "virtuosity is conspicuously absent . . . [from] Picasso's juvenilia." The artist's early drawings, he observes, are "what one would expect from a reasonably gifted child."[5]

The earliest extant drawings by Picasso date from 1890, when he was nine years old. A number of histo-

rians have wondered why earlier drawings did not survive if he was recognized to be brilliantly gifted from an early age—as Picasso himself and all of his biographers have reported—especially since he grew up in an artist's family where such things would have been appreciated. If Picasso, like many great artists, was as concerned with his own "legend" as Richardson tells us he was, the artist may well have destroyed earlier works that showed less "prodigious" skills than those found in, for example, the rendering of the pigeons in his *Bullfight and Pigeons* of 1890 (fig. 1), one of the rare early drawings that survive. However, Picasso's drawing of a plaster statuette of Hercules, done in the same year (fig. 2), bears out Richardson's view: it is good for a nine-year-old, but not breathtaking.

Picasso's very *unremarkable* performance in the Hercules drawing is reason enough to look again at our criteria for judging giftedness, knowing what became of this child draughtsman. We have to wonder if we are overlooking the markers that matter most. Richardson's account of Picasso's childhood drawing as no more than "what one would expect" points to the commonly held notion that we can identify prodigious artistic talent in children by a child's skill at rendering three-dimensional forms and mastering central perspective. Works like Picasso's highly accomplished study after a plaster cast, done at the age of fourteen (fig. 3), J.A.D. Ingres's *Head of a Niobid*, inscribed by the artist as "Mon 1er Dessin" ("my first drawing") and dated to 1789, when the artist was nine years old (fig. 4), and Albrecht Dürer's famous *Self-Portrait as a Thirteen-Year-Old* (1484, fig. 5) all confirm the widely held assumption that an artistically brilliant child is a precocious master of verisimilitude. This belief is implied in Penrose's apocryphal story and in Picasso's own self-mythologizing.

In his discussion of Picasso's *Bullfight and Pigeons*,

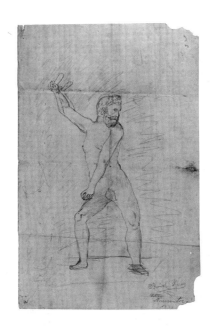

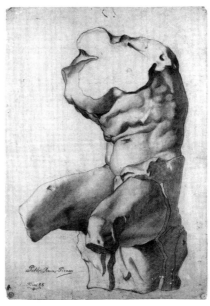

Figs. 2–3. [*top*] Pablo Picasso (age 9), *Hercules (Hércules)*, 1890. Pencil on paper, 19½ × 12⅝ inches. [*bottom*] Pablo Picasso (age 14), *Study of a Torso, after a Plaster Cast*, 1894–95. Charcoal and Conté crayon, 20⅝ × 14½ inches. [*both*] Museu Picasso, Barcelona. © 2006 Estate of Pablo Picasso/Artists Rights Society (ars), New York.

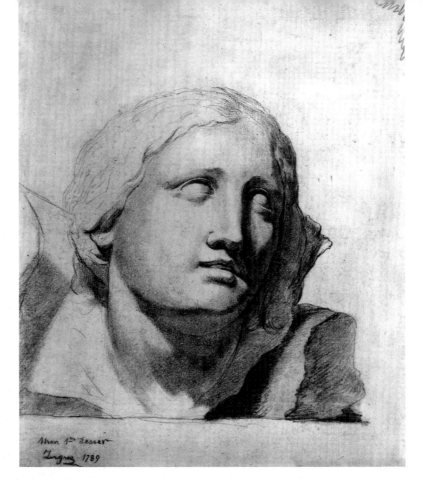

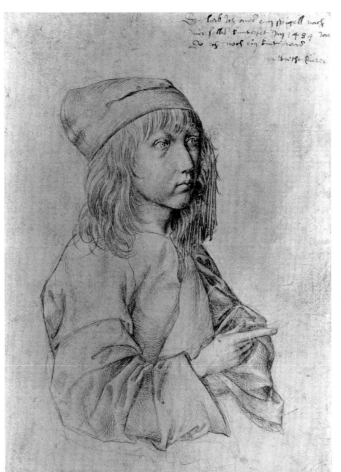

Fig. 4 [*top*]. J. A. D. Ingres (age 9), *Head of a Niobid*,
1789. Black chalk, 12³/₁₆ × 9¹³/₁₆ inches, inscribed
by the artist: "Mon ɪer Dessin." Private collection.
Courtesy of Galerie Arnoldi Livie, Munich.

Fig. 5 [*left*]. Albrecht Dürer, *Self-Portrait as a
Thirteen-Year-Old (Selbstbildnis als Dreizehnjähriger)*,
1484. Silverpoint on sized paper, 10⅞ × 7¾ inches.
Albertina, Vienna, ʟ448 (996).

Richardson calls attention to the distinction in style between the two parts of the page, oriented upside down from each other. He accepts the bullfight scene as the work of the juvenile Picasso, but he finds the fully modeled rendering of the pigeons implausibly skillful for the young artist and concludes that they are "either copies after, or wholly or partly the work of, don José," the artist's father.[6] Indeed, don José was a professional academic artist and a "specialist" at painting pigeons (see fig. 6). I want to suggest, however, that both parts of the drawing were indeed made by the young Picasso, as has always been understood, and that the stylistic discrepancy results from training. We know from all accounts of Picasso's youth that his father began training him to draw pigeons from an early age. Moreover, the rendering of the pigeons seems rather loose and expressive for don José. But more to the point, the style of the other surviving pigeon drawing by Picasso—*Pigeons*, signed and dated to 1890 in the artist's juvenile hand (fig. 7)—demonstrates an equivalent finesse.

The interesting aspect of Picasso's childhood works (and where I see the real gifts) is not in his dazzling academic skill at rendering, but rather in the unique character of his way of seeing. The quickness and vivacity with which Picasso caught the movement of the birds in *Pigeons* (especially the interaction of the little chicks at the bottom) and the expressiveness of the line in both *Pigeons* and *Bullfight and Pigeons* are what really demonstrate Picasso's early gift. The seemingly "childlike" looseness and the playful liveliness of the scribbled crowd in the background of *Bullfight and Pigeons* display a stunning sense of self-assurance in drawing for a nine-year-old. That free, gestural line is by no means haphazard or lacking in control, as it might at first appear. It brilliantly conveys the enthusiastic spectators. If we look at the section directly above

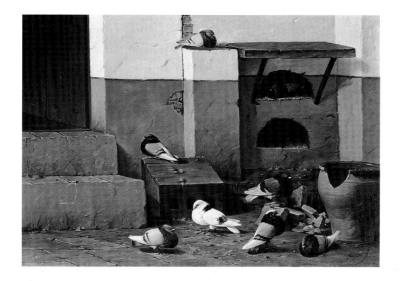

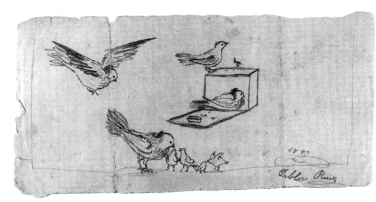

Fig. 6 [*top*]. José Ruiz Blasco, *Pigeon-Loft (Palomar)*. Oil on canvas, 40³⁄₁₆ × 57⅞ inches. Ayuntamiento de Málaga, acquired 1878.

Fig. 7 [*bottom*]. Pablo Picasso (age 9), *Pigeons (Palomas)*, 1890. Pencil on paper, 8¾ × 4¼ inches. Museu Picasso, Barcelona. © 2006 Estate of Pablo Picasso/Artists Rights Society (ARS), New York.

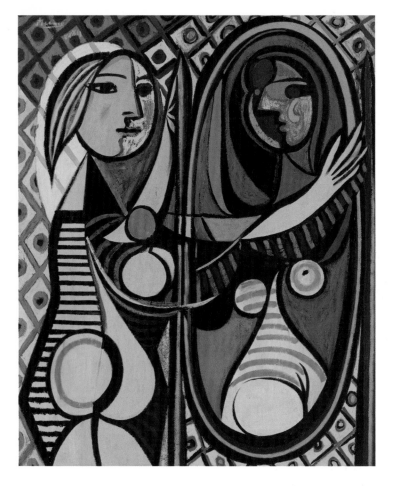

the fallen matador, we also see a virtuosic transformation of the line from an exciting expression of the energy and movement of the crowd into descriptive contour.

That sleight of hand in *Bullfight and Pigeons* is precisely what also animates Picasso's famous *Girl Before a Mirror* of 1932 (fig. 8), where a single line at one moment shows us the face in profile and in the next doubles as the contour of a three-quarter view. In his 1951 sculpture *The Crane* (fig. 9), Picasso's ability to see a fork and a stopcock as the foot and crown feathers of a bird and *still* to see them as a fork and a stopcock involves the same radical multivalency of lines and forms and images. Here, Picasso even persuades us to overlook what we know about the components (the fork, the broken scissor blade that he uses for a beak, the stopcock) in favor of an entirely different totality.

The fantasy that directs a child's play allows her or him to transform everything at hand into the necessary elements of the fantasy: the family dog can become a stalking lion, a garbage-can lid may serve as King Arthur's shield. Yet a child *knows* that the broomstick is not a horse. One of the things we appreciate in Picasso's work is precisely this childlike ability to overcome the fixity of meaning, known through experience and reason. Indeed, his contravention of experiential knowledge—the fork as a foot and so on—revitalizes

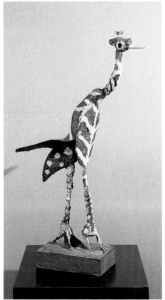

Fig. 8 [*above left*]. Pablo Picasso, *Girl Before a Mirror*, 1932. Oil on canvas, 64 × 51¼ inches. The Museum of Modern Art, New York, Gift of Mrs. Simon Guggenheim, 2.1938. © 2006 Estate of Pablo Picasso/Artists Rights Society (ARS), New York. Digital image © The Museum of Modern Art/Licensed by SCALA/Art Resource, New York.

Fig. 9 [*left*]. Pablo Picasso, *The Crane*, 1951. Painted bronze after found objects, 29½ inches high. The Neumann Family Collection. © 2006 Estate of Pablo Picasso/Artists Rights Society (ARS), New York.

Introduction

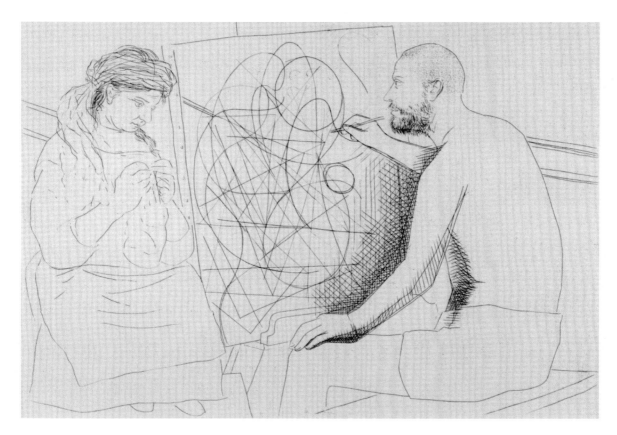

Fig. 10. Pablo Picasso, *Painter and Knitting Model*, 1927. Plate iv from Honoré de Balzac, *Le Chef d'oeuvre inconnu*
(Paris: Ambrose Vollard, 1931), etching on paper, 7⅞ × 10⅞ inches, ed. 83/99. Tweed Museum of Art,
University of Minnesota Duluth, Purchased with Funds Gifted by Alice B. O'Connor and
John Brickson. © 2006 Estate of Pablo Picasso/Artists Rights Society (ARS), New York.

our emotional connection to objects by destabilizing their identity and thereby making them available for other meanings.

In this description of the physically impossible in works like *The Crane*, Picasso achieves a kind of realism —and this realism underlies his entire oeuvre. He assigns a powerful content, which defies verbal description, to the otherwise banal elements of a composition, and he makes them cohere more persuasively than what we know about the objects from our experience of them in the world. He has a remarkable ability to see in a way that redefines what is in front of him. This is the brilliant trait that we see prefigured in the multi-

valence of the "scribble" in the background of *Bullfight and Pigeons.*

Picasso's famous *Painter and Knitting Model* of 1927 (fig. 10)—part of a suite of illustrations for Honoré de Balzac's *Le Chef d'oeuvre inconnu* (*The Unknown Masterpiece*, 1931)—is one of several works of the late 1920s and early 1930s in which the artist consciously contemplates his own visual virtuosity in being able to redefine things by the way he sees and describes them. He shows us the artist at an easel, carefully studying his neoclassically drawn model, while paradoxically drawing free gestural lines on the canvas to express what he "observes." The "scribble" on the canvas is yet another

Gifts of Seeing

Fig. 11 [top]. Paul Klee (c. age 4–6), *Woman with Parasol* (*Dame mit Sonnenschirm*), 1883–85. Pencil on paper, 4½ × 3¼ inches. Paul-Klee-Stiftung, Kunstmuseum Bern. © 2006 Artists Rights Society (ARS), New York / VG Bild-Kunst, Bonn.

Fig. 12 [bottom]. Paul Klee, *Dwarf and Mask* (*Zwerg und Maske*), 1926, 100 (A 0). Pen and black ink on German Ingres white paper, laid down on board by the artist, 6½ × 6½ inches, dated and numbered on the mount, signed lower center. Private collection, Urbana, Illinois. © 2006 Artists Rights Society (ARS), New York / VG Bild-Kunst, Bonn.

of the many permutations of Picasso's line; here, he recalls the expressive gesturing of works such as *Bullfight and Pigeons* while at the same time self-consciously parsing its grammar with an epistemological rigor.

Painter and Knitting Model contrasts the freedom of the expressive line on the canvas with the sparse neoclassical draughtsmanship that describes the artist and his model. Like a tongue twister, Picasso then purposely contradicts himself in that part of the drawing (which is otherwise so controlled in style) by giving us little glimpses—in the hair and head scarf of the sitter and in the artist's beard—of a wilder, less controlled "nature." Then in yet another turn, he redefines "nature" (the figures in the room) using the tight control of the contour drawing, while the wilder pen strokes of the hair on the figures in the "real" room highlight by contrast an underlying control in the otherwise seemingly "free" line on the canvas, making the realm of "art" seem consciously designed (which of course it is).

In the childhood drawings of Paul Klee, we see early gifts of an altogether different sort. His *Woman with Parasol* (1883–85, fig. 11), made sometime between the ages of four and six, demonstrates no particular technical skill. Look at the rendering of the hand, for example, or the complete absence of any articulation of the space. Yet the drawing shows a delightfully imaginative eccentricity in describing the character of this humorous lady with her bent umbrella (presumably a spontaneous invention in response not only to the subject, but also to the shape of the paper and to the space left for the umbrella by the time the child artist got there). This humorous eccentricity in observing human nature, while at the same time playing with the form and materials in dialogue with the subject, is at the heart of Klee's mature genius as an artist. In his 1926 drawing *Dwarf and Mask* (fig. 12), for example, we

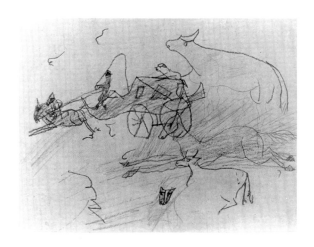

are never entirely certain whether the line is describing the odd subject or making expressive pirouettes on its own, as in the stripe down the figure's legs or in the play of mirroring geometric patterns on the neck and the mask.

So it is the individuality and inventiveness of vision, perhaps, not skill, that serve as a marker of giftedness. In the drawings of the four- to six-year-old Henri de Toulouse-Lautrec, such as *Carriage, Cows, and Horses* (c. 1870, fig. 13), the looseness, movement, and action of the line show an early confidence in drawing that resembles Picasso's. This quality would grow into one of the defining features of his greatest works: the certainty with which he defines a complex form and movement with a flowing contour line in the lithograph *Miss Loïe Fuller* (1893, fig. 14), for example, is prefigured in his self-assured and energetic childhood drawings. A depiction of two animals made by Keith Haring when he was four years old (fig. 15) has much of the character of his later images of babies, people, and animals, with their flat patterns and contours (see fig. 16). Winslow Homer's 1846 pencil sketch *Adolescence* (fig. 17), done at the age of ten, similarly anticipates the subject matter and mood of later well-known works, such as *The Nooning* (c. 1872, fig. 18). A brilliantly imaginative crayon drawing made by the three-and-a-half-year-old Alison Saar in 1959 (fig. 19) indicates how an early predisposition for certain formal structures may unconsciously inspire later subjects—even one as deeply laden with intellectual content as the Afro-Caribbean iconography of the bottle tree, a form she invokes in her sculpture *Compton Nocturne* of 1998 (fig. 20).

So what are we to conclude about what it means to have early talent in art? Nothing in the work of such great artists as Paul Cézanne, Klee, or Jackson Pollock—perhaps not even in their mature work—ever approximates the academic skill level of the teenage

Fig. 13 [*top*]. Henri de Toulouse-Lautrec (age 6), *Carriage, Cows, and Horses*, c. 1870. Pencil, 5¼ × 8½ inches. Château du Bosc, Naucelle, France. Photograph courtesy of the Musée Toulouse-Lautrec, Albi, with the authorization of Mme Tapié de Céleyran.

Fig. 14 [*bottom*]. Henri de Toulouse-Lautrec, *Miss Loïe Fuller*, 1893. Lithograph printed in color with gold on cream wove paper, 14¹⁵⁄₁₆ × 10¼ inches. Smith College Museum of Art, Northampton, Massachusetts, Gift of Selma Erving, Class of 1927, Sc 1978:1-45.

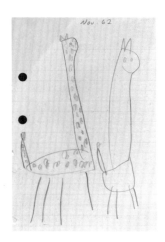

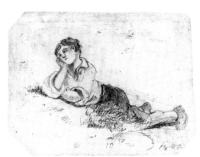

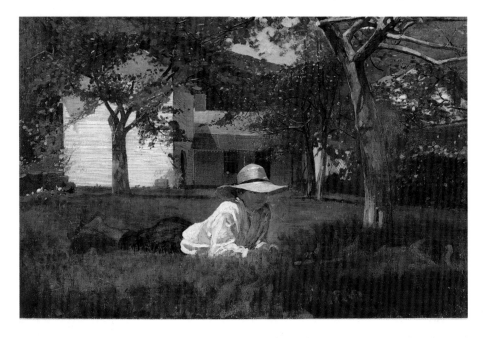

Fig. 15 [*top left*]. Keith Haring (age 4), *Childhood Drawing of Two Animals*, 1962. Pencil on notebook paper, 11 × 8½ inches. Collection of the Estate of Keith Haring. Keith Haring artwork © Estate of Keith Haring.

Fig. 16 [*top right*]. Keith Haring, *Untitled*, 1980. Acrylic on paper, 25 × 69 inches. Private collection. Keith Haring artwork © Estate of Keith Haring.

Fig. 17 [*bottom left*]. Winslow Homer (age 10), *Adolescence*, 1846. Pencil, 3⅝ × 4¾ inches. Bowdoin College Museum of Art, Brunswick, Maine, Gift of the Homer Family, 1964.69.8.

Fig. 18 [*bottom right*]. Winslow Homer, *The Nooning*, c. 1872. Oil on canvas, 13¹⁵⁄₁₆ × 19¾ inches. Wadsworth Atheneum Museum of Art, Hartford, Connecticut, The Ella Gallup Sumner and Mary Catlin Sumner Collection Fund, 1947.1.

Picasso. There's nothing like it in the early work of Wassily Kandinsky, Piet Mondrian, or even the great draughtsman Henri Matisse. But Sir Edwin Henry Landseer, at about the age of seven, drew *Sketch of a Seated Cow* (c. 1809, fig. 21), which is even more impressive with respect to the skills of perspective and rendering than Picasso's work at nine. Landseer went on to make a career of works such as *Dignity and Impudence* (fig. 22), painted for the Royal Academy exhibition of 1839 and seriously intended as a moral allegory (accompanying catalogue notes explained its allegorical references, in case you missed the point).

So if the child most gifted in rendering, proportion, and perspective at an early age turns out to be a maudlin academic painter, and if so many of the greatest artists of the modern period turned out not to need such precise technical abilities to achieve what they did, we have further cause for our skepticism about using mastery over the conventions of representation to measure prodigious talent. The more significant traits appear to be a unique way of seeing and exceptional powers of visualization (as in the examples of Klee and Picasso).

Another recurrent characteristic of visually gifted children seems to be an obsessive need to draw. Ellen Winner, in her book *Gifted Children*, singles out this tendency.[7] Richardson (among others) reports of Picasso's childhood that "he used to 'draw for hours on end, provided people let him be and . . . his cousins didn't distract him from his favorite pastime.'"[8] There are countless other reports of important artists draw-

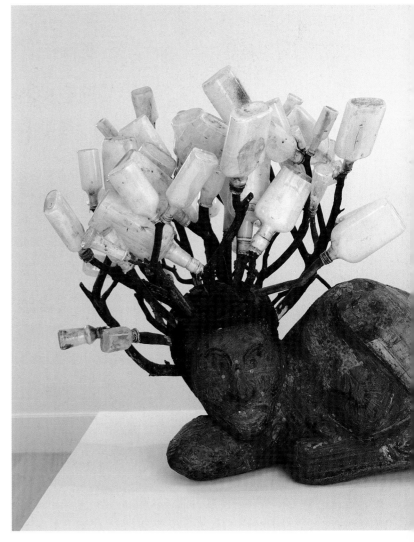

Fig. 19 [*top*]. Alison Saar (age 3½), *Untitled*, 1959. Crayon on paper, 12 × 8⅞ inches. Collection of the artist. Courtesy of Michael Rosenfeld Gallery, LLC, New York.

Fig. 20 [*bottom*]. Alison Saar, *Compton Nocturne* (detail), 1998. Wood, tin, bottles, paint, and tar, 33 × 80 × 28 inches. Weatherspoon Art Museum, University of North Carolina at Greensboro, Museum purchase with funds from the Benefactors Fund, 1999.

Gifts of Seeing

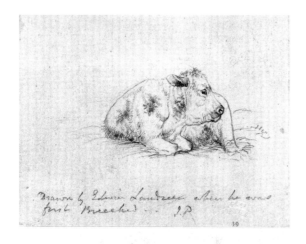

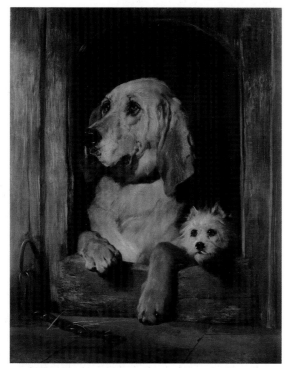

Fig. 21 [*top*]. Sir Edwin Henry Landseer (c. age 7), *Sketch of a Seated Cow*, c. 1809. Pencil on paper, 3⁷⁄₁₆ × 4⁹⁄₁₆ inches. Victoria and Albert Museum, London, FA49. © The Board of Trustees of the Victoria and Albert Museum.

Fig. 22 [*bottom*]. Sir Edwin Henry Landseer, *Dignity and Impudence*, 1839. Oil on canvas, 39 × 27³⁄₁₆ inches. Tate Gallery, London. Photograph: Tate Gallery, London/Art Resource, New York.

ing obsessively, preoccupied with visualizing form from an early age; indeed, it is so common as to be a cliché of artists' biographies. In "The Painter of Modern Life," Charles Baudelaire speaks about a friend— now a great artist, he says—who remembers studying the muscles and colors of the skin on his father's arms: "He was already being obsessed and possessed by form."[9]

That early compulsion to draw and a predisposition to visualizing things as a way of comprehending them (both, evidently, common to great artists) point to a powerful mode of reasoning that is not verbal. In a world increasingly dominated by images, it is more and more evident that a strictly logocentric approach to problem solving and to learning is only one of many viable tools. Over the past decade, the writings of Howard Gardner on the different styles of learning have begun to make educators more conscious of our failure to address visual thinking and visual literacy in our schools.[10] Winner has noted that gifted children are "inveterate non-conformists," wanting to work things out for themselves, and she points out that our standardized system of measuring high achievement in everything from the civil service to admission to Harvard weeds out our most creative thinkers.[11] "Perhaps [the high testers] would reveal weaknesses in mathematics if the tests were not multiple-choice and required them to discover rules never taught to them," she writes.[12] Visual thinking is especially hard to test and creativity nearly impossible.

The objective of this book is to encourage a reexamination of gifted visual thinking in children, prompted by the deep interest of such artists as Klee and Alexander Calder in the relationship of drawing, in particular, to creative thinking. The first essay in this volume is by Rudolf Arnheim, a pioneer in the field of the psychology of art. He explains how, for children,

Introduction

drawing helps to clarify the structure of what they see in the world. He also cautions us against the reductive approach to child art, found in much of the literature, which looks at it as if every child were the same. Many researchers in the first half of the twentieth century, for example, sought norms, using children's drawings to identify and classify common modalities in children's thought. Psychologists such as Viktor Lowenfeld did this to find developmental markers and also to understand more fully the thinking patterns of "the child's mind," at some cost to seeing the individuality in children. As an example of this indexical enterprise, Lowenfeld captions a drawing in one of his important books of the period, *The Nature of Creative Activity* (1939), as follows: "'D Sneezes, Blows his Nose, and puts the Handkerchief in his Pocket.' Different movements represented in a single figure," and he places it in a section entitled "Representation of Time and Space" (fig. 23). Lowenfeld's *Creative and Mental Growth* (1947) was one of the most influential art-education textbooks of the twentieth century.

The psychoanalytic literature does quite the reverse, giving all the attention to individual variation. Here, drawings have from time to time played a role in the interpretation of specimen cases, as in the famous drawing by "The Wolfman" (fig. 24) in Sigmund Freud's essay "From the History of an Infantile Neurosis," written in 1914, or the drawings by "Richard" (figs. 25–27) in Melanie Klein's *Narrative of a Child Analysis* of 1961.[13] The Wolfman's drawing is a rendering of a dream, and the interpretation of dreams, Freud says, opens a "royal road to a knowledge of the unconscious activities of the mind."[14]

Rudolf Arnheim, one of the first researchers to take a genuine interest in the aesthetic of children's drawings, claims not only that the art of children is the expression of inner tendencies and thoughts, but also

Fig. 23 [*top*]. D.H., *D Sneezes, Blows his Nose, and puts the Handkerchief in his Pocket*. Courtesy Viktor Lowenfeld Papers, Pennsylvania State University Archives, Pennsylvania State University Libraries.

Fig. 24 [*bottom*]. "The Wolfman," *Drawing of a Dream*. In Sigmund Freud, "From the History of an Infantile Neurosis" (1918/1914). Sigmund Freud © Copyrights, The Institute of Psycho-Analysis and The Hogarth Press for illustration from vol. 17 of *The Standard Edition of the Complete Psychological Works of Sigmund Freud*, trans. and ed. James Strachey. Reprinted by permission of The Random House Group Ltd. and Basic Books, a member of Perseus Books, LLC.

13

Fig. 25 [*left*]. "Richard" (age 10), *Untitled Drawing*, summer 1941. Made during
a psychoanalytic session with Melanie Klein, crayon on paper, c. 7 × 4½ inches.
In Melanie Klein, *Narrative of a Child Analysis* (New York: Basic Books, 1961),
fig. 26. By permission of the Trustees of the Melanie Klein Trust.

Fig. 26 [*middle*]. "Richard" (age 10), *Untitled Drawing*, summer 1941. Made during
a psychoanalytic session with Melanie Klein, crayon and pencil on paper,
c. 7 × 4½ inches. In Melanie Klein, *Narrative of a Child Analysis* (New York: Basic
Books, 1961), fig. 19. By permission of the Trustees of the Melanie Klein Trust.

Fig. 27 [*right*]. "Richard" (age 10), *Untitled Drawing*, summer 1941. Made during
a psychoanalytic session with Melanie Klein, pencil on paper, 7 × 4½ inches.
In Melanie Klein, *Narrative of a Child Analysis* (New York: Basic Books, 1961),
fig. 51. By permission of the Trustees of the Melanie Klein Trust.

that it enters into dialogue with people and things in the world. He shows, in his essay here, that there are as many individual styles among the solutions that children invent to convey meaning as there are among professional artists.

Christine Marmé Thompson's essay, "The 'Ket Aesthetic,'" and Olga Ivashkevich's essay, "Drawing in Children's Lives," also address the ways in which children use their art to explore their experience in meaningful ways. Thompson looks at the influence of popular culture on children's drawings, and Ivashkevich focuses her attention on the process and social interaction of drawing. As in Lévi-Strauss's *Tristes tropiques*, the newer research on child art recognizes the inevitable influence of the researcher's own perspective on the data. But instead of rejecting such research altogether on the grounds of impurity, much of the literature is now focusing on what we can understand about the cultural and social influences on children by acknowledging and analyzing our biases, rather than looking at the aesthetic development of children as a closed system of instinct and cognitive growth.

Nevertheless, it is rare to have a full account of a child's interactions with the world through their drawings even today, when we recognize its importance more clearly. Miraculously, we have a daily journal, transcribed into a publication of more than three thousand pages, that scientifically details the life of Louis XIII from his birth in 1601 into his adolescence, accompanied by drawings made by the young prince from the ages of four to nine and commentary on the circumstances surrounding them. Louis had all the hallmarks of a visually gifted child, and in other circumstances those gifts might have developed more fully in adulthood (though he did continue to draw as an adult; see fig. 28). Jean Héroard, the royal physician, shows us how Louis worked out his anxieties in form

Fig. 28. Louis XIII, *Drawing of a Courtier*, after 1628. Pastel. Bibliothèque Nationale de France, Paris.

and tells us that doing so calmed him. He comes to re-gard Louis's compulsion to draw, so characteristic of gifted children, as both powerful and innate. He re-ports on November 6, 1608, for example, that Louis "is so attentive to his painting that they could not get him to stop. He put all of his mind to it." At times, Héro-ard tells us, Louis swore at people who distracted him when he was drawing and occasionally they had to threaten the boy to get him to stop drawing and attend to other things. In one instance, Louis became so in-volved that the queen was asked to send a man to or-der him on her behalf to stop for lunch.[15] Misty Hous-ton, a scholar of French literature, provides a context for understanding Héroard's journal as a unique and important document of premodern childhood in her essay, "The Early Drawings of Louis XIII in the *Jour-nal de Jean Héroard*."

This book accompanies an exhibition at the Phillips Collection on Paul Klee and follows a recent exhibition there on Alexander Calder's friendship with Joan Miró. All three artists were deeply interested in child art. Klee's profound investigation of (primarily his own) child art surfaced repeatedly throughout his career as an opening to understanding what was essen-tial to the mind and creativity of the artist. Calder, too, was captivated by the relationship between drawing and creativity. Elizabeth Hutton Turner, Senior Cura-tor at the Phillips Collection and an expert on early-twentieth-century modern art, has contributed an es-say that looks at Calder's thoughts on how children should be taught to draw.

In the final essay of this volume, I will return to speculate on the psychodynamics of visual thinking. In play, children test responses and examine their fears about the scenarios of real life. I will look at child art en route to art in general. Art, as a kind of creative play, literally gives form to what is new on the horizon of

our consciousness and essential for us to "see" as indi-viduals and as a society. We find the forces of the un-known in the unconsciousness of childhood and in the perpetual unfolding of an unpredictable future, and art allows us the first glimpse of the new forces that will be shaping our lives.

The essays in this book are followed by a collection of children's drawings, ordered roughly by age and se-lected for traits that struck me as visually inventive. I make no pretense of scientific comprehensiveness or objectivity in any way with this selection. The draw-ings come from all over the world, and they generally center on earlier childhood (ages four to nine). A num-ber of childhood drawings by great artists and histor-ical figures are included without hierarchy, for the op-portunity to ask ourselves if and how they stand out among the others. (Can we already find in these draw-ings the incipient gifts that would later emerge so clearly in the lives of these extraordinary people?) But I also assembled this collection of images for the sheer pleasure of looking at them. The control of form and design in *The Lion's Toothpaste* (gallery no. 3), for example, takes our breath away when we learn that it was made by a three-year-old! We are startled by the directness and power of emotion in an eleven-year-old Norwe-gian boy's drawing, *When My Father Gets Angry* (gallery no. 83), but we also enjoy, as he does, the mastery over the experience through representation. Some of the childhood drawings of those who became great artists seem surprisingly serious in their concentration on the skills of capturing a likeness from the real world, and we wonder why the expansive creativity we find in their later work is so conspicuously absent. I have also in-cluded a few adolescent drawings going all the way to the age of seventeen to underscore the gradual na-ture of the transition out of childhood; these draw-ings combine adult mastery with persevering traits of

childhood thinking and prompt us to wonder what role such ongoing tendencies may play in the adult artistic genius.

The last part of the book consists of a thoroughly annotated chronology of the literature concerning child art, exhibitions on the subject, and the rare documentation of premodern children's drawings, from the earliest examples I could find in the thirteenth century to the present. The chronology also contains considerable discussion of the existing literature so as to provide a reasonably comprehensive historiography of this subject up to and including the methods and perspectives of the literature today. This should be useful to anyone interested in pursuing this subject seriously, but also in a more casual reading to anyone wondering how we came to where we are today in looking at the creativity of children as we do.

Insofar as it is appropriate to have a conclusion to an essay that intends to open a new conversation on this subject, I would say that the ability to *see* meaning in form or to manipulate form to create meaning is an important gift in children's drawing, and it is also at the heart of what makes a great work of art. It seems clear to me that artists like Klee and Picasso were artistic prodigies from an early age. But what singled them out was not their ability to render well or to master perspective, though Picasso's father taught him to do that quite early on. Rather, it was their unique way of using visual form to express their encounter with the world that marked them apart and that, consciously cultivated, would become the nucleus of their mature careers.

NOTES

1. See Claude Lévi-Strauss, *Tristes tropiques*, trans. John and Doreen Weightman (1955; New York: Penguin Books, 1992), 41–44.

2. Roland Penrose, *Picasso: His Life and Work* (London: Victor Gollancz, 1958), 42, 47.

3. John Richardson, *A Life of Picasso, Volume I: 1881–1906* (New York: Random House, 1991), 62–64.

4. Paloma Picasso, conversation with the author, New York, September 30, 1992.

5. Richardson, *A Life of Picasso, Volume I*, 29.

6. Ibid.

7. Ellen Winner, *Gifted Children* (New York: Basic Books, 1996), 3.

8. Richardson, *A Life of Picasso, Volume I*, 31.

9. Charles Baudelaire, "The Painter of Modern Life," in Baudelaire, *The Painter of Modern Life and Other Essays*, trans. and ed. Jonathan Mayne (London: Phaidon Press, 1964), 8.

10. See the discussion of Gardner's work in the annotated chronology in the present volume.

11. Winner, *Gifted Children*, 73.

12. Ibid., 49.

13. Sigmund Freud, "From the History of an Infantile Neurosis" (1918/1914), in *The Standard Edition of the Complete Psychological Works of Sigmund Freud*, vol. 17, trans. and ed. James Strachey (London: Hogarth Press and the Institute of Psycho-Analysis, 1955), 30; and Melanie Klein, *Narrative of a Child Analysis* (New York: Basic Books, 1961), figs. 26, 19, and 51, respectively.

14. Sigmund Freud, *The Interpretation of Dreams* (1900), in *The Standard Edition of the Complete Psychological Works of Sigmund Freud*, vol. 5, trans. and ed. James Strachey (London: Hogarth Press and the Institute of Psycho-Analysis, 1955), 608.

15. Jean Héroard, *Journal de Jean Héroard: Médecin de Louis XIII*, 2 vols., ed. Madeleine Foisil (Paris: Fayard, 1989), 1533, 1364, 1514.

RUDOLF ARNHEIM

BEGINNING WITH THE CHILD

More than once in the history of Western art, there has been a return to fundamentals. This happened when—and perhaps because—so high a level of refinement had been reached that there was no way of proceeding further in the same direction. Certainly this was the case toward the end of the nineteenth century, when the subtlety of color nuances in the watercolors of Paul Cézanne or, under the influence of photography, the complexity of shape relations in works by Edgar Degas had come to strain the mind's power of visual discrimination and organization to the limit. As a matter of survival, it became necessary to go back to where it all had started and where it all starts every time a human being sets out to engage in the business of life.

The foundation had to be regained in two respects. In an almost biological sense, the human organism had to recapture the elements of the physical environment,

19

[FACING] Fig. 29. Artist unknown (female, age 3, United States), *Tadpole Figure*. Marker on paper, 10 × 8½ inches. Collection of Rudolf Arnheim.

the basic objects made by nature and man, which must be known by their invariant and independent appearance. Directly related to this reacquisition of physical reality was the need to go back to the basic shapes and colors by which things are visually understood, the geometrical primaries and the straight blacks and whites, the reds and blues and yellows, from which the world composes itself.

To break with a tradition that has run its course and to reinvent the world of imagery, artists tend to look around for models. The guidance and inspiration they derive from remote sources demonstrate that productive help can be obtained from communication that is at best partial. Just as European artists received a needed impulse from African carvings, about whose meaning and function they knew next to nothing, so they received a strong influence from children's drawings that relied on precepts, interpretations, and connotations that had little to do with the states of mind producing those unassuming pictures. All that was needed were some of the formal properties for which artists were searching to resolve problems of their own.

It is only natural that when critics or historians discuss the influence of children's art on modern art, they are quite specific about the effects to be observed in this or that painter or sculptor. Less attention has been given to the particular models. "Children's drawings" are referred to as though they were a standardized product. If, however, one has had some experience in the field of child art, one knows that its output is almost as varied as that of adults. Although there are basic traits shared by most of them, no two children have quite the same style. Differences are due partly to the stage of development reached by the child, but also to differences of temperament, to influences from the environment, and to levels of talent. Correspondingly, the particular stylistic features impressing a particular

artist have not always been the same. I therefore propose to sketch some of the characteristics of children's drawings and then to relate them to a few of their reflections in the work of artists.

The child meets the world mainly through the senses of touch and sight, and typically he soon responds by making images of what he perceives. The tie between stimulus and response is deeply rooted in all organic behavior, but the particular response of answering the percept of a thing or happening with an act of portrayal is a privilege of the human species. Its main psychological function is evident. The picture, far from being a mere imitation of the model, helps to clarify the structure of what is seen. It is an efficient means of orientation in a confusingly organized world. To this end, certain principles of strategy impose themselves. One begins by examining the components of the world's inventory item by item, and indeed by identifying each part of every object separately. The definition of each element, however, takes place in the context of the larger whole. Definition and organization begin with the very simplest of shape and relation and proceed step by step to the conception of more complex structures.

Figure 29 is an early human figure, done by a three-year-old girl.[1] It shows, first of all, a difference between intention and execution. Intended is the symmetry of the body. This symmetry is discovered as one of the most relevant features of the human figure. It also governs the child's sense of visual form: shapes are spontaneously symmetrical as long as they are not modified by other functions. The frontality of the round head serves as the roof of a T-shaped structure. Its horizontality is stressed by the two lateral arms, and it reposes symmetrically on the central axis of body and legs. This revealing symmetry, however, is only hinted at in the drawing. Roundness and straightness are kept

Rudolf Arnheim

from perfection by two factors: the motor activity of the child's hand and arm is not yet fully controlled, and the visual judgment of the shapes to be obtained has not yet been sharpened.

It is essential for our purpose to realize that this imperfection in the execution of the drawing is not a negative quality; rather, we cherish it as a lively illustration of the relation between abstract perfection and human endeavor, between rigid geometry and the spontaneity of muscular freedom—an attractively human charm that has not been lost on our artists. The slight deviations from the visibly implied shapes and relations greatly animate, in the judgment of the adult, the dynamics of the intended figure. In a six-year-old's drawing of a man carrying a basket of Easter eggs (fig. 30), there is a loosening of relation between the head and the trunk and between the eggs and their container, which relieves the schematic conception of the figure and lets us sense an active child at work.

Depending on the temperament of the particular child, but also on the mood of the moment and the nature of the subject matter represented, the ratio between the control of formal precision and the spontaneity of motor behavior varies greatly. The two personages of figure 31, drawn by a five-year-old girl, are stirred by a hurricane of motion—a quality more congenial to a painter like Jean Dubuffet than to, say, Paul Klee. The wildness of such a performance does not interfere with the child's access to the scene she is depicting; and the child is equally remote from the romantic sensibility of the adult, who savors all this motion as an image of creative energy in action.

The child, whatever the particular style of his work, is involved in the struggle for conquering the puzzles of a disorderly world. With increasing skill, the intended dominance of the guiding elementary shapes imposes itself. In figure 32, showing Little Red Riding

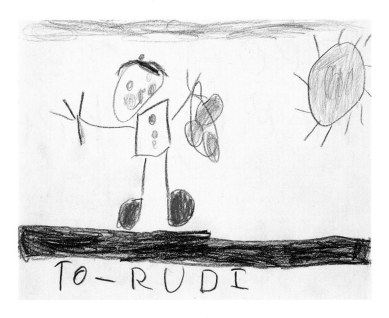

Fig. 30. Margaret (female, age 6), *Man Carrying a Basket of Easter Eggs—"To Rudi,"* 1953. Crayon on paper, c. 6 × 10 inches. Collection of Rudolf Arnheim.

Beginning with the Child

Fig. 31 [*top*]. Barbara (female, age 5, United States),
Two Figures, 1942. Pencil on paper, 8½ × 12 inches.
Collection of Rudolf Arnheim.

Fig. 32 [*bottom*]. Barbara (female, age 6, United States),
Little Red Riding Hood and the Wolf, March 1943. Pencil
and colored pencil on paper, 7½ × 8⅝ inches.
Collection of Rudolf Arnheim.

Hood and the wolf, each detail, from the anatomy of the nose to the earrings and the toes, is sharply defined. Remarkable here is the sense of form, the enviable freedom from dependence on the shapes of nature, and the visual power of the rectangles and ovals that characterize the relation between animal and human figure. Far from merely indicating a lack of skill, an inability to represent models more faithfully, the casting of live bodies into fundamental shapes represents a truly creative achievement. Equally significant is the capability of the young mind to accept without question a meaningful equation between the shapes of nature and their thoroughly different representation on paper. The child, although fully capable of seeing the difference between model and picture, operates on the basis of a relation between representation and reality that we are tempted to find much more sophisticated than our own notion of the one simply imitating the other. The child spontaneously accepts the image as an enlightening equivalent of the model, created within the conditions of a particular medium. The child understands the nature of the translation and has no trouble practicing it.

The endless variety of aspects which the objects of the world present to our eyes is obediently rendered by painters of the naturalistic tradition. The child, in a search for clarity, ignores the confusion of accidental appearances and reduces them to the alternatives of frontality and profile. The turtle in figure 33 is shown from what we would call "on top," while the lady appears in profile. This reduction provides the most informative sight available for each object. It guarantees a finality of presence even to more complex scenes. The approach of the three magi in figure 34 is made compelling by their uncompromising profiles, while mother and child, the stable target of the happening, repose in frontal symmetry.

Rudolf Arnheim

22

This biblical story, drawn by a five-year-old girl, relies on spatial placement to articulate the relation between the actors. The empty ground on which the figures are drawn has now become a shared setting, in which the encounter is, one might say, choreographed. The drawing has a pentimento showing that at first there was no interval between the crib and the closest visitor. The compositional correction greatly clarifies the distinction between the two groups.

The transformation of the empty ground into a shared breathing space, an "ether" enveloping the narrative, is a first step in the separation of the represented scene from the medium of representation. The drawing of the magi still adheres to the plane of the flat piece of drawing paper, but in other works this limitation is transgressed when the subject matter demands it. Figure 35, drawn by a six-year-old Japanese boy, tells a story of mutual assistance: the rabbit helps the lion to free himself from the trap; in return, the lion rescues the rabbit from the hunters. Three of the scenes are arranged in frontal symmetry, allowing for the beautiful composition of the third episode, where the central axis of the two friends is opposed by the enemies in profile. In the first scene, however, the approach of the rabbit from a distance introduces a distinction between foreground and background—a momentous detachment from the base of the pictorial medium.

Fig. 33 [*top*]. Artist unknown, *Lady and Turtle*.
Pencil and colored pencil on paper, 5¾ × 7 inches.
Collection of Rudolf Arnheim.

Fig. 34 [*middle*]. Artist unknown (age 5), *The Three Magi*.
Pencil and colored pencil on paper, 7⅝ × 10¼ inches.
Collection of Rudolf Arnheim.

Fig. 35 [*bottom*]. Hiragi Tanaka (male, age 6, Japan),
The Rabbit Helps the Lion Free Himself, The Lion Rescues the Rabbit,
1959. Pencil and crayon on paper, 10⅝ × 13 inches.
Collection of Rudolf Arnheim.

Beginning with the Child

Once the first step into depth has been taken, the road is open for the complete conquest of space. In the metropolitan scene of figure 36, also drawn by a young Japanese child, a spatial continuum leads from the pedestrians in the foreground all the way through the distant crowd held in the side street by the traffic policeman. This invasion of depth, never undertaken by many early cultures, abandons the elementary adherence to the rules of two-dimensionality, which attracted the painters of the twentieth century to the work of young children.

There are other ways in which children go beyond the characteristics of early representation. The drawings of the youngest look very similar under any cultural condition. What degrees of freedom are accessible later depends on the style dominant in the environment. The portrayal of individuality, for example, is all but absent at first and will never be encouraged in some settings. The two dashing figures drawn by an American boy in figure 37 presuppose the child's acquaintance with the heroes and villains of cartoon illustrations. The copying of such materials is quite common among our children and encouraged by some educators, but fortunately the child's particular drawing style often prevails over the commercial slickness of the model. The military policeman in figure 38 still profits from the geometrical precision typical of the boy's age level.

Fig. 36 [*top*]. Artist unknown (Japan), *Metropolitan Scene*, 1959. Pencil on paper, 7½ × 10⅝ inches. Collection of Rudolf Arnheim.

Fig. 37 [*above*]. Artist unknown (United States), *Two Dashing Figures*. Pencil on paper, 10½ × 8 inches. Collection of Rudolf Arnheim.

Fig. 38 [*right*]. Artist unknown, *Military Policeman*. Pencil on paper, 6⅛ × 4¾ inches. Collection of Rudolf Arnheim.

24

Yet another elaboration of the basic style comes from the seductiveness of shape and color. In the artistic process, the visual patterns emerging in the medium itself are directly given to the maker's eyes and handled by him. They are therefore closer to his attention than the subject matter of the outer world. In figure 39, a five-year-old girl has taken the likeness of a fountain pen from this outer world, but the pen's shapes and colors, once on paper, acquire an abstract life of their own, amplified by further shapes and arousing new expressive connotations: the aggressive pointedness of the pen inspires a picture of what the girl calls "an evil animal." Carried to its extreme, the eloquence of pure form displaces the subject matter almost entirely and leads to abstract ornaments, as in figure 40, done by an eight-year-old Japanese girl.

Our particular Western tradition of realistic style and standardized subject matter can promote a beautiful refinement of a child's precision of form and tidy representation. The young American preteen who drew *Venus and Mars* (fig. 41) has seen art books and museums; she knows what paintings are supposed to be about. She endows the mythological theme with her own restrained sexuality, but the integrity of her formal control is unimpaired. A picture of this quality will arouse the respect of the adult artist, who will acknowledge her as a young colleague, but her work is less likely to offer him much of the kindred spirit for which artists of our time went to look at the products of kindergarten and early grades. This last example, however, serves to epitomize what I have implied in this brief survey of children's drawings—namely, that they can speak to the adult artist not simply because they differ so thoroughly from the artist's own professional tradition, but because basically they derive from the same occupation: they, too, are ways of coping with the human condition by means of significant form.

Fig. 39 [*top*]. Artist unknown (female, age 5), *Fountain Pen*. India ink and colored pencil on paper, 5½ × 6¾ inches. Collection of Rudolf Arnheim.

Fig. 40 [*middle*]. Artist unknown (female, age 8, Japan), *Abstract Ornament*, c. 1959–60. Pencil on paper, 6⅜ × 7¾ inches. Collection of Rudolf Arnheim.

Fig. 41 [*bottom*]. Rita Weill (female, age 12, United States), *Venus and Mars*, c. 1951. Pencil and watercolor pencil on paper, 7⅛ × 9⅜ inches. Collection of Rudolf Arnheim.

Beginning with the Child

Fig. 42. Joan Miró, illustration for Paul Eluard's
A toute épreuve (Geneva: Gérald Cramer, 1958).
Color woodcut, 11³⁄₁₆ × 5½ inches. Museum of Fine
Arts, Boston. © 2006 Successio Miró/Artists
Rights Society (ARS), New York/ADAGP, Paris.

Even so, the difference between the intentions of the artist and those of the child is most evident where the similarity is greatest. Joan Miró's woodcut of a female figure (fig. 42) could hardly have been conceived by someone who had never seen a child's drawing. Both reduce the human form to its simplest frontal symmetry, but the similarity ends there. The difference between naïveté and sophistication begins with the use of the empty ground, which in the young child's drawing would simply be the emptiness of uncultivated space, not yet included in the conception, which is limited to the exploration of single objects. Miró uses this same emptiness to express solitude. His woodcut is one of those he created to illustrate Paul Eluard's book of poems *A toute épreuve* (1958). Our figure appears next to a poem complaining about loneliness:

> Tous les refus du monde
> Ont dit leur dernier mot
> Ils ne se rencontrent plus ils s'ignorent
> Je suis seul, je suis seul, tout seul
> Je n'ai jamais changé.[2]

Accordingly, the empty ground is not disregarded by the figure but interacts with it in a counterpoint between nonbeing and being. The head, controlled in its position by the sensitive hand of the adult artist, stops just short of taking its place on the neck. The hollows between the arms reach into the body like breasts, and the torso is squeezed into slimness with the help of the fireball, the embodiment of fullest expanse. The frontality of the figure stands for the lack of change of which the poet speaks, but its rigidity is relieved by the placement of three colors: the pairing of eyes and feet is offset by color difference, and the color red unites the ball, the left eye, and the right foot in a paradoxical triangle.

Miró's reference in this example is to the particular

Rudolf Arnheim

style of child art in which the elements of geometry are used explicitly to define the shapes of objects. Paul Klee is attracted by the same quality when, with a kind of playful cubism, he submerges the things of nature in abstract networks of form. Whereas the child uses the formal elements to comprehend the objects to which it is unequivocally devoted, Klee develops these elements into ornaments to estrange his subjects from their physical reality. In *The Saint* (1921, fig. 43), for example, strands of hair and the folds of garments are transformed into calligraphic scrolls—a stylistic mode that is often a symptom of mental withdrawal observed in the artwork of schizophrenic patients.

But such alienating stylization is offset in Klee's work by other features, equally related to the drawings of children. One of them is humor. We smile at the excessively large head of his figure, especially when we notice that she is called *The Saint*. At play is an ambiguity in the way of perceiving deviations from naturalistic correctness. To the child's mind, disproportions are entirely in keeping with representing the world faithfully, and the same is true for the rules of form valid in Klee's pictorial universe. At the same time, however, the adult views such deviations as weaknesses of the child, a lack of skill, a discrepancy between aspiration and achievement or as the deficiencies of the subject portrayed in the picture. And it is precisely such a contrast that, as Henri Bergson has taught us, constitutes the psychological base of humor. This amusement, although mostly absent from a child's mind, is clearly present in Klee and his grown-up audience.

Another aspect enlivens these childlike creatures—namely, the lack of civilized accoutrements. Early figures keep to the essentials; they are assemblies of limbs, devoid of clothing. The adult reads the parsimony of this style as nakedness, a return to the uninhibited

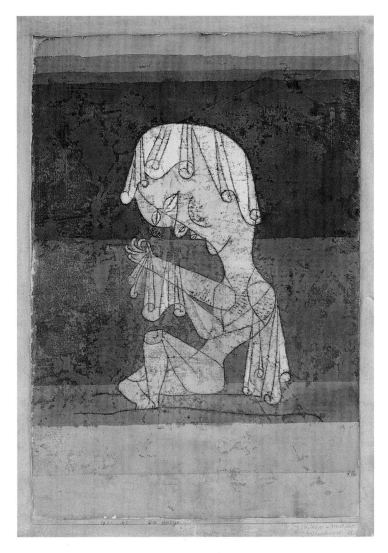

Fig. 43. Paul Klee, *The Saint (Die Heilige)*, 1921. Watercolor and oil transfer drawing on laid paper, mounted on thin cardboard, 17¾ × 12¼ inches. Norton Simon Museum, Pasadena, California, The Blue Four Galka Scheyer Collection. © 2006 Artists Rights Society (ARS), New York / VG Bild-Kunst, Bonn.

Beginning with the Child

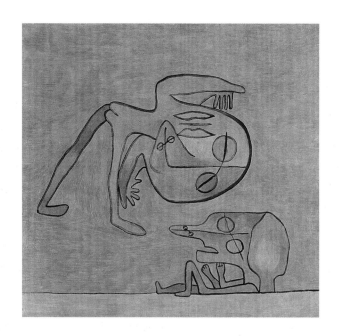

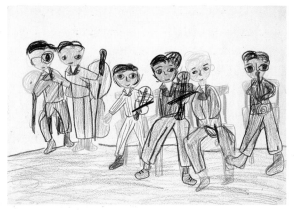

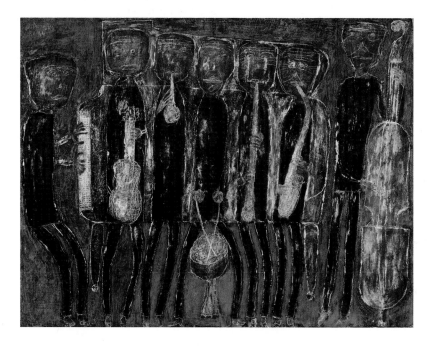

innocence of paradise, whose inhabitants are enviably free of the taboos shackling us. The two licentious playmates of Klee's *Let It Happen* (1932, fig. 44) tumble into each other's arms like carefree animals. A similar reduction of civilized society to a state of primordial barbarism is evident in works by Jean Dubuffet when he replaces the elegance of the traditional portraits of ladies with his shockingly carnal displays of naked women.

I shall conclude this brief survey with a comparison between a child and an artist depicting the same subject of an orchestra at play (figs. 45 and 46). The child, a Japanese first grader, is clearly closer to the cheerful noise of reality. The musicians crowd the stage, overlapping one another, and differ in stance and attire. The violins and the trumpet have been imposed on the completed figures, creating an unintended but enlivening transparency, and the chairs, done last, add blue afterthoughts to the foreground action. The small accidents of the child's coping with the problems of depicting the scene she experienced in her own setting help to enrich the visual variety of the picture.

In comparison, Dubuffet's *Grand Jazz Band (New Orleans)* (1944) looks austere. The reduction to geometric elements is more radical because it is more conscious. The figures are stereotyped, and their parallelism ties them together like a striped piece of fabric. The artist refrains deliberately from expressing the turmoil of the jazz band. The composition is symmetrically arranged around the drummer as the central axis, with the pianist and the bass player as lateral wings. A rich texture of pigments and scratchings helps to characterize the painting as a visual delicacy rather than an investigation of folkways. There is much gourmandise in this primitivism. Thus the artist echoes the child across the wide gap between nature eagerly scanned by a young explorer from close by and tasted as a treat of the senses by the detached, aging mind of an artist of our time.

NOTES

This essay is reprinted, with slight revisions, from Jonathan Fineberg, ed., *Discovering Child Art: Essays on Childhood, Primitivism and Modernism* (Princeton, N.J.: Princeton University Press, 1997).

1. The children's drawings illustrating this essay are from my collection. The Japanese examples were obtained during a Fulbright year in 1959–60.

2. All of the rejects of the world
 Had said their last words.
 They no longer recognized each other, they didn't know each other.
 I am alone, I am alone, all alone
 I have never changed.

Fig. 44 [*facing top*]. Paul Klee, *Let It Happen (Mag kommen)*, 1932. Oil on canvas, 23¼ × 24¼ inches. Billedgalleri, Bergen, Norway, 1932.278 (x18). © 2006 Artists Rights Society (ARS), New York / VG Bild-Kunst, Bonn.

Fig. 45 [*facing middle*]. Artist unknown (female, age 5–6, Japan), *Orchestra*, c. 1959–60. Crayon on paper, c. 7 × 10 inches. Collection of Rudolf Arnheim.

Fig. 46 [*facing bottom*]. Jean Dubuffet, *Grand Jazz Band (New Orleans)*, December 1944. Oil and tempera on canvas, 45⅛ × 57¾ inches. The Museum of Modern Art, New York, Gift of Nina and Gordon Bunshaft, 1515.1968. © 2006 Artists Rights Society (ARS), New York / ADAGP, Paris. Digital image © The Museum of Modern Art / Licensed by SCALA / Art Resource, New York.

CHRISTINE MARMÉ THOMPSON

THE "KET AESTHETIC"

Visual Culture in Childhood

In his essay "Barney in Paris" (2000), Adam Gopnik describes the dismay of a conscientious parent confronted with the prospect of his child's enchantment with one particular element of American commercial culture:

> When people ask why Martha and I, not long after the birth of our first child, left New York for Paris, we can usually think of a lot of plausible-sounding reasons. . . . The real reason was Barney. We had seen one after another of our friends' children . . . sunk dumbly in front of a television set watching a man in a cheap purple dinosaur suit sing doggerel in an adenoidal voice with a chorus of overregimented eight-year-old ham actors. Just a glimpse was enough to scare a prospective parent to death: the garish Jeff Koons colors, the frantic prancing, the cynically appropriated public domain melodies.

[FACING] Oliver Hobson (male, age 7), *Drawing after a Donald Duck Pillowcase* (detail). Crayon on paper, 12 × 17⅞ inches. Collection of Jonathan Fineberg.

And, finally, that anthem of coercive affection—"I love you / you love me / we're a happy family"—sung, so incongruously, to the tune of "This Old Man."[1]

If the parents' solution to the dilemma of Barney was idiosyncratic, the problem itself was not: What parent has never experienced such intense aversion to an icon their child dearly loves? It was not "American kiddie video culture" in general that was at issue, but Barney specifically, Gopnik avers.[2] He and his wife were eager to introduce Luke to both the enduring icons of their own childhoods and newer, but equally engaging characters such as Bert and Ernie. But the parents' shared dislike of Barney was deep. And so, opting for a radical solution, the family moved to Paris, where young Luke's experiences in the months to follow were direct and unmediated, the stuff of which the idyllic childhoods harbored in adult imagination are made: visiting the circus, playing in parks, riding the carousel, developing a fondness for Charlie Chaplin. This satisfactory state of affairs continued until the family returned to New York for a few days' visit, and a jet-lagged Luke, installed in front of a VCR with a stash of tapes, encountered one lumbering purple dinosaur. Luke was, immediately and irrevocably, hooked on Barney.

The Barney tapes somehow followed Luke on his return to Paris to become the cause of considerable tension in the months ahead, as parents and child argued about their respective rights to the control of the VCR and the pleasures made available there. Gopnik observed his own warring parental impulses rising up in response to Luke's affection for Barney:

Not wanting to be a bad or unduly coercive parent, I thought, Well, he has a right to his pleasures, but I too have a right—indeed a duty—to tell him what

I think of them. We began to have a regular daily exchange. . . . Naturally it occurred to us that the pro-Barney campaign was a resourceful and in many ways admirable show of independence on the part of a two-and-a-half-year-old who might otherwise have been smothered by his parents' overbearing enthusiasms. . . . What puzzled me of course was why. Loving Barney in Paris was partly a way of teasing his parents, but it was not *simply* a way of teasing his parents; it was too deep, too emotional for that. Nor had Barney yet crossed the ocean, so it wasn't any kind of peer pressure from the French kids he played with in class and in the courtyard every day. In Paris, in fact, almost all the childhood icons are those that have been in place for forty years: stuffy, bourgeois Babar; witty Astérix and Obélix; and imperturbable Lucky Luke, the Franco-American cowboy in perpetual battle with the four Dalton brothers. Although these characters from time to time appear in cartoons, they remain locked in their little worlds of satire and storytelling. There is no Barney in France, and there is no French Barney. Whatever spell was working on my son, it was entirely, residually American.[3]

In this vividly recounted story of generations at odds, with an element of popular culture plopped defiantly between them, we encounter a classic instance of the "ket aesthetic" at work. Allison James explains that the term "ket" was originally used by adults to denote rubbish or "an assortment of useless articles" (or, in its more archaic use, the carcasses of animals dead of natural causes).[4] More recently, British children have adopted the term to describe the candies they purchase for themselves with their weekly allowances. James proposes children's appropriation and transformation of the term as a metaphor for the relationship

Christine Marmé Thompson

between the world of children and adults, one in which children construct and maintain a culture of their own, separate from but dependent upon adult culture, through the creative reinterpretation of adult practices. Adults also consume sweets, of course, but they seldom, if ever, choose for themselves the kinds of graphically named, luridly colored, deliberately transgressive, oddly performative candies that are favored by children—Warheads, Nerds, Gummy Worms, NikL-Nips, Sour Patch Kids, and so on. James suggests that it is through situations such as this, in which children's tastes and preferences run counter to those of the "cultured" adult world, that children define themselves as individuals and as members of a culture of their own:

> By confusing the adult order children create for themselves considerable room for movement within the limits imposed upon them by adult society. This deflection of adult perception is crucial for both the maintenance and continuation of the child's culture and for the growth of the concept of self for the individual child. The process of becoming social is often described in terms of "socialization," a model which stresses the passive mimicry of others. I would suggest, however, that this process is better seen in terms of an active experience of contradiction, often with the adult world. It is thus of great significance that something that is despised and regarded as diseased and inedible by the adult world should be given great prestige as a particularly desirable form of food by the child.[5]

Within this "disorderly and inverted world of children," different standards prevail.[6] As James points out, "kets" are the most social form of children's food, apt to be pulled from the mouth, examined, and shared, in the hours between the adult-controlled rituals of mealtimes, as "the normal eating conventions, instilled by parents during early childhood are flagrantly disregarded."[7] Claudia Mitchell and Jacqueline Reid-Walsh recognize children's devotion to "kets," emblematic of their fascination with other forms of literal and metaphoric "junk food," as, at the very least, an assertion of agency and control, if not active resistance to the restrictive nature of adult culture. When children's preferences manifest themselves—in the choice of characters to admire, television programs to watch, toys to campaign for, and so on—many adults become uneasy. Much of this discomfort emerges from our desire to see our children (and to have our children *be seen*) doing something serious and worthwhile. "The tensions . . . have as much to do with what we think we ought to be doing as parents or teachers, than necessarily anything indigenous to the artifacts themselves."[8] And yet, in the art room as elsewhere, the "ket aesthetic" prevails whenever a slackening of adult control occurs.

Even among very young children, in the early years of preschool, the impulse to apply developing graphic skills in the service of popular culture emerges. Not long after they create the first forms that attentive adults recognize as representations, children begin to cluster figures in groups, forming alliances that may be ambiguous in nature but clear in their solidarity of purpose. For many young children, the temptation to dress these figures up as favorite characters derived from popular culture surfaces almost instantaneously. It is as if the depiction of such characters were intrinsic to young children's fascination with their capacity to produce images and objects, their motivation to enter and explore the realm of image making.

For many years, I have studied the choices that preschool and kindergarten children make when they are encouraged to create images and objects in classroom settings but without the direct intervention or control

33

of teachers and parents. I have been interested in the choices children make when their work is "voluntary," in the sense defined by art educators Betty Lark-Horovitz, Hilda Lewis, and Marc Luca—made within occasions and structures arranged by adults, but with the significant decisions of medium, scale, elaboration, and subject matter left entirely to the individual child.[9] It is important to realize that, even when none of the usual parameters of school art lessons are imposed, the work children produce can hardly be considered spontaneous, for even very young children quickly realize that there are limits to adult tolerance for manifestations of the "ket aesthetic."[10] And yet the social and personal identities of contemporary children are deeply implicated in their participation in the common culture of their generation and social group. There is undeniable social value in the highly visible display of the symbols of children's culture, the public demonstration that one is "in the know" regarding the latest and most prestigious cultural icons. Children moving between cultures, as many contemporary children do, may find their efforts to establish friendships facilitated by the global marketing strategies of Disney, Mattel, and Nintendo. The abilities to enact appropriate story lines and to create convincing likenesses, to incorporate in visual representations the telling details, are potent sources of cultural capital, eagerly accumulated by children striving to establish their own identities and memberships within the group.

Not long ago, I had the opportunity to visit my seven-year-old nephew Matthew, currently a first grader at a Catholic elementary school in Chicago. Several months earlier, in an effort to show his aunt and uncle some of his favorite neighborhood haunts, Matthew had escorted us to a shop specializing in collectibles—cards, games, action figures, and other para-phernalia—associated with characters from popular video games, television series, and films. Knowing of his interest in collectors' cards, I asked Matthew which series among the many available he was most interested in collecting. He answered without hesitation—Pokémon, the ubiquitous "pocket monsters" imported from Japan, characters that seem to have remarkable global appeal and staying power. Knowing that the ability to draw Pokémon characters is a skill with a great deal of cachet in the early elementary years, I asked Matthew who, among his classmates, was most accomplished in drawing Pokémon characters. He sighed and shrugged, deeply resigned, and told me, "I don't know. Pokémon is bannded [sic] in our school."

While it is easy to sympathize with the teachers who decided that Pokémon should be "bannded" at Matthew's school, it is important to consider the effects of such efforts to prescribe appropriate and inappropriate educational content.[11] This enforced division of children's interests into official and unofficial spheres reflects the status of popular imagery as "a recurring site of struggle and negotiation" between adults and children.[12] The "cultural pedagogy" made available to children outside school, through a pervasive visual and mediated culture, educates powerfully, from infancy onward.[13] And, in ways subtle and overt, teachers may resist the incursion of that unofficial world into their classrooms. Ellen Seiter notes, "As early as the age of four, children can appreciate that *The Flintstones* is not normally a part of the school's curriculum—not the sort of video title (like a nature documentary or a *Sesame Street* episode) that would be approved for classroom viewing."[14] Preschool children learn quickly, through lessons directly and indirectly offered, that the experiences valued in their schools are of a different order than those they might choose for themselves,

Christine Marmé Thompson

that they are not supposed to talk about TV in this school, where books are valued, where tapes are rarely shown, where show-and-tell objects are censored. TV takes its place in the repertoire of forbidden references, like those to smelly feet or body parts or diapers. In fact, TV songs or jingles are often sung moments before or after crude language or jokes are voiced. No wonder many teachers hate popular children's TV, when it is associated with bedlam, rule-breaking, forbidden activities.[15]

The carnivalesque erupts all too quickly in classrooms where children's unofficial interests are allowed to prevail.[16]

In part, adult resistance to the allure of popular culture for young children reflects visions of childhood innocence that persist despite much evidence to the contrary. Children allowed to write or draw or construct the images and stories that are most intriguing to them may well, as Anne Dyson suggests,

take refuge in stories that strike adult educators as not only constraining (i.e., unimaginative, derivative) but downright dangerous (i.e., filled with the complexities of power and identity, of gender and race). "Innocent" children, adults may feel, should be free from such complexities, free to play on playground and paper. But children's imaginative play is all about freedom from their status as powerless children. Tales about good guys and bad ones, rescuers and victims, boyfriends and girlfriends allow children to fashion worlds in which *they* make decisions about characters and plots, actors and actions. Thus, for children as for adults, freedom is a verb, a becoming; it is experienced as an expanded sense of agency, of possibility for choice and action.[17]

As Brent and Marjorie Wilson emphasized in explaining why children draw, it is just this capacity to engage in world making, to document the present, explore the past, and anticipate the future, to invent scenarios and control events, that makes the creation of images and objects, visual and verbal narratives, so compelling to children.[18] In other historical moments—those captured by the developmental theories that undergirded art-education practice during most of our lifetimes—the content of children's drawings emerged largely from direct personal experience, supplemented, frequently, by more fantastic speculations that came from books or films or stories shared by those known to the child.[19] These sources retain their presence in the drawings of contemporary children, their potency increased many times over by the wholesale immersion of this culture in a "hypertextuality" that has, in many significant respects, altered the relationship between adult and child as both consumers and creators of culture.[20]

An examination of children's drawings reveals the range of mediated sources upon which young children rely as they create drawings reflecting the interests they bring from the "unofficial" spheres of childhood to a relatively open classroom activity, drawing in sketchbooks. Images with sources in visual culture constitute a category of young children's drawings that bears an unusually close relationship to the world of objects and suggests the particularly irresistible appeal for children of characters and stories presented intertextually—or, more crassly, through "total marketing" strategies that tie together animated programs, books, films, and toys in a sort of blitzkrieg mode of product placement.[21] While many of the figures drawn by children in preschool and early elementary years tend to be highly conceptual, simplified, and almost generic in nature, operating on what Brent and Marjorie Wilson describe

The "Ket Aesthetic"

as a "simplicity principle,"[22] even the most rudimentary representations of characters drawn from media sources attest to the artist's attempt to specify the unique attributes of that particular subject, to capture the distinguishing physical traits and accoutrements of dress, cuisine, and weaponry that set the Ninja Turtle Donatello apart from his companion Michelangelo, for example. Homages of this sort betray an unexpected competence in the observation and depiction of relevant details, even as they follow an expected evolutionary sequence from early depictions of figures standing alone against an undifferentiated ground toward an increasing interest in portraying action and interactions within settings that are more fully described.

These early appropriations of media-inspired imagery appear to be accomplished best in drawn images —or so it seems when children's worlds are observed only from the margins of the classroom. Children typically have fewer opportunities to work with materials that lend themselves to construction or collage, and perhaps because such materials are more resistant and more exotic, children tend to create more abstract images when such opportunities arise. It may also be the case that teachers provide more explicit direction and establish constraints when children work with these materials, thus precluding the incursion of these interests. Children's direct use of these toys as props and premises for dramatic and constructive play—in everyday activities that could be considered the genetic precursors of performance and installation—is largely relegated to play at home and in the neighborhood.

In some respects, this division between the official and unofficial worlds of children's culture is necessary and appropriate. As Joe Kincheloe observes,

the new childhood seems to distinguish itself from adulthood on the basis of an affective oppositional

stance toward it. . . . Children . . . seek to distinguish themselves from those with whom they are most frequently in contact—adults. . . . In this context, it is interesting to observe how children—particularly those from middle-class and above backgrounds— are drawn to cultural productions and even food (e.g., McDonald's) that transgress parental boundaries of propriety, good taste, and healthfulness.[23]

North American children have become adept practitioners of "consumption as self-creation," notes Dominic Scott.[24] Through consumption, Dan Fleming suggests, they "actively [create] their own identities that are beyond the reach of adults."[25] There is, in this, a mixture of resistance to adult standards of quality and propriety, assertion of control, and affirmation of children's own power to construct an autonomous culture in which they are the experts and guides. While Kincheloe seems to position children as, at best, ambivalent toward adults and, at worst, actively antagonistic toward them, the majority of children seem to coexist more or less peacefully and profitably with adults. As William Corsaro suggests, children's culture is neither autonomous nor isolated from the adult world, as "children are always participating in and part of two cultures—children's and adults'—and these cultures are intricately interwoven."[26] Adults may well be the primary source of the constraints children confront and the puzzles they attempt to unravel through drawings and other forms of symbolic play, but adult culture often provides both the impetus and the resources through which children struggle to make sense of the world.

Significantly, there is choice exercised both in the selection of objects of play and in the further selection of which of the array of such objects children choose to memorialize in drawings or elaborate in the scenar-

Christine Marmé Thompson

ios of solitary or social play. As Fleming points out, fully three-fourths of the toys purchased in the United States are "licensed"—that is, associated with some media character that exists in another form. The Shirley Temple doll of the 1920s was the first such media tie-in; today, Fleming observes, "it seems impossible to conceive of the toy industry as being anything other than dependent on a popular culture which shapes and structures the meanings carried by toys."[27] The proliferation of toys spawned by popular culture renders many traditional observations about the ways play functions for children obsolete. For example, visual realism, or faithfulness to the original, matters greatly in contemporary objects of play; handcrafted approximations are decidedly inferior substitutes for exact replicas incorporating all the features relevant to the smooth operation of the original. Plastic action heroes virtually demand to be cast in reenactments that hew to the scripts as given, incorporating the child's knowledge of the "real" situations in which such characters might find themselves. These scenarios can only be reenacted robustly and authentically if all the relevant parts, props, and players are at hand. This responsibility for truth to form can be a heavy one. Arguably, play is constrained as energetically as it is promoted by a plastic tub brimming with X-Men and all that they survey, although children frequently subvert or ignore canonical texts in favor of variations better suited to their own fantasies.

It is possible to interpret the visual culture of childhood as a culture manufactured for children by adults who understand them poorly. This is a notion worth considering, even in regard to those items, classic children's toys and books, of which most adults would heartily approve. However, as Fleming points out, "it is worth reminding ourselves of the sheer imaginative energy which children invest in the playthings of their mass culture; and it is very much *their* culture," reliant upon their choices.[28] Fleming asks if the success of a particular product line is ever

> fully comprehensible as simply the accumulation, the adding on top of each other, of a young organism's developmental urge to play, the promotional effect of a TV series, and the inherent tactile or visual attractiveness of the toy as an object? That stacking up of pressures and appeals certainly says something about what is going on. Examining things just a bit more closely, however, soon reveals, as an entirely distinctive feature of children, toys and popular culture in their fascinating interrelationships, a certain unmistakable "synchronization" across those areas. When it all comes together around the Ninja Turtles or the Transformers, this powerful "synchronisation" is clearly more than the sum of the parts—clear if for no other reason than that other similar parts do not stack up to the same effect.[29]

In a column in the *New York Times Magazine*, Rob Walker chronicled the success of a collection of slightly misshapen stuffed creatures known as Uglydolls, which have, so far, been most popular with young adults. Walker discussed with the dolls' designers their plans to expand into the children's market, and the likelihood that the dolls would appeal to this newly targeted group:

> Each character comes with a tag explaining the character's back story and how they all "know" one another and what each one is like. Wage works diligently at Super Mart, although, poignantly, no one at the store knows he works there; Jeero, meanwhile, wishes Wage and Babo wouldn't ask him so many questions, since he "just wants to sit on the couch with you and eat some snacks." Hits with kids like

the American Girl dolls have a similar narrative glue. To Tracy Edwards, the Barneys vice president who oversees the chain's home and kids businesses, the Uglydoll characterizations are important: "The stories, in the end, sell the dolls."[30]

And yet more than narrative possibilities are at work in children's selections among the multiple choices made available by the culture. Evidence of this selective appropriation may be seen in the highly discriminating process through which images and objects are chosen as subjects for children's voluntary drawings. Many equally beloved images, which seem to function in very similar ways in children's imaginative lives, seldom or never find their way into children's drawings. The paradigmatic fashion doll, Barbie herself, is rarely drawn, though fashion models and lavishly attired women appear frequently among young girls' voluntary drawings. The most cherished texts of children's literature, such as *Where the Wild Things Are* or *Winnie the Pooh*, are seldom spontaneously adapted as subjects for dramatic, constructive, or symbolic play, while Mighty Morphin' Power Rangers seem ideally suited to this purpose. This mysterious process of selection provides a continual demonstration of children's agency, their identity as "social actors shaping as well as shaped by their circumstances,"[31] and their involvement in the construction of their own distinctive visual culture.

Undeniably, the way that adults envision *childhood* affects the clarity with which we are able to "see" *children*. As William Ayers poses the problem, "When we look out over our classrooms, what do we see?"[32] What we make of the "ket aesthetic" and the children who subscribe to it is largely a matter of perception. Typically, as Andrew Stremmel notes, "We regard childhood as provisional, preparatory, and subordinate to adulthood as opposed to a unique and distinct time and place in the development of a person. We often disregard children's problems, squelch their creativity, deny their emotions, and generally ignore or diminish the significance of their daily experiences."[33] So accustomed are we to considering the limitations of children, Stremmel observes, that university students enrolled in teacher-education programs frequently register more surprise at children's competence and kindness than they do at instances of misbehavior.

This systematic underestimation of children's competence and integrity reflects a widespread but depleted "image of the child,"[34] a perspective that is decisive in determining our orientations and actions toward children. Patricia Tarr recognizes that competing images of the child prevail in contemporary North American society. Adults may envision the child as a cute object, a "wiseass," a consumer, an innocent, or a *tabula rasa*; in each case, whether they relate to the child as parents, researchers, teachers, or merely bystanders, they will act toward the child in a manner consistent with the image of children that they hold.[35] As Loris Malaguzzi notes, it is difficult "to act contrary to this internal image."[36] Daniel Walsh suggests that adults tend to orient themselves toward an "eternal" child —timeless, universal, essentially unchanging—rather than recognizing the situated, specific, "historical child" that stands before them.[37] This tendency is apparent when children exceed expectations or defy normative assumptions in the classroom, in moments when teachers may deny children's ability to do what they are clearly doing at that very moment—to participate in a prolonged discussion of a work of art, for example, or to draw from observation, or to collaborate in an undertaking.

Christine Marmé Thompson

A more abundant image of the child permeates the educational philosophy and practice in the preschools of Reggio Emilia in northern Italy, widely considered to be exemplary pedagogical sites. Malaguzzi explains:

> It's necessary that we believe that the child is very intelligent, that the child is strong and beautiful and has very ambitious desires and requests. This is the image of the child we need to hold. Those who have the image of the child as fragile, incomplete, weak, made of glass, gain something from this belief only for themselves. We don't need that as an image of children. Instead of always giving children protection, we need to give them the recognition of their rights and of their strengths.[38]

As Allison James, Chris Jenks, and Alan Prout acknowledge, we live in "an era marked by both a sustained assault on childhood and a concern for children."[39] A widespread cultural ambivalence toward children influences the provisions made for parenting and teaching, and shapes the basic understandings of children on which we operate. There is a movement evident in sociology and other fields to recognize children as "social actors" rather than "a defective form of adult"[40]—though this shift of academic focus occurs at the same time that "children are arguably ... more hemmed in by surveillance and social regulation than ever before."[41] In an age in which parents fear for the physical and psychological safety of their children, the limited forms of autonomy once available to children have been further reduced.

Writing more than two decades ago, Brent and Marjorie Wilson acknowledged the role that the arts play in allowing each of us, children and adults alike, to imaginatively explore worlds beyond those we directly experience. They suggested that children may be particularly dependent upon the interventions of artists, writers, and scientists who facilitate the process of "coming to know." They posed the question:

> What of the special plight of children, who have the most learning to do and the fewest means of attaining it? Firsthand exploration is the furthest from their grasp—imagine going to India when you aren't allowed to cross the street alone—and symbolic exploration of realities through the arts and other media is still out of reach because children have not yet attained the skill of "reading" books, maps, formulae, and diagrams as adults easily do. There is, however, one notable exception, in media that are primarily visual and correspond in at least some ways to children's firsthand experience of the world—television, films, drawings, and paintings. ... These visual symbols—pictures—provide children with their primary symbolic means of understanding reality.[42]

This fundamental insight into the primacy of graphic languages in young children's coming to know the world has been enacted to great advantage in the preschools of Reggio Emilia, where graphic representations serve as a primary means through which children represent, expand, and communicate their understandings. As the work created by children in Reggio Emilia and in other supportive contexts attests, children's facility as interpreters and producers of visual imagery is far more sophisticated than we may suspect, when demonstrated in contexts in which children themselves are seen as "rich, strong, and powerful."

As Brent and Marjorie Wilson pointed out, children both select and create images in order to frame the puzzling and amorphous questions that they confront in the process of coming into the world, to render

The "Ket Aesthetic"

them manageable and available for continued scrutiny. These questions focus on matters of life and death, identity, conflict, and values challenged and confirmed. Children's intrinsic determination to make meaning of the world propels them to make use of the resources at their disposal in the particular historical moment in which they find themselves, the "tools and symbol systems" of their culture.[43] Children accomplish the construction of meaning in various ways, through play and work, in dialogue with peers and adults, in their active engagement with the world, and in piecing together bits of conversation overheard and, perhaps, only partially understood.

The artifacts and activities that comprise children's culture can facilitate this process of making meaning, for individual children as well as the peers who endorse and enjoy similar pleasures. Fleming, for example, recognizes contemporary toys as suited to contemporary times. He describes them as "harmonizing objects," which serve children's attempts to make sense of an increasingly confusing world, one in which the horrors of war, the effects of poverty, the banality of evil occur in plain sight:

> The bad things out there, as perceived by children, are now so numerous that toys are increasingly impelled to take on forms capable of drawing those things into childhood play, in order to satisfy the child's determination to deal with them (such "determination" being a structural feature of play rather than a conscious aim). In other words, childhood requires objects that are flexible enough to bring into some kind of balance a variety of feelings and meanings which might otherwise have remained disturbingly at odds with one another.[44]

There are at least two ways to conceptualize the culture of childhood. The first perspective, characteristic of what is known as "the new social studies of childhood," sees children's culture as an inevitable and largely benign result of children's collective lives, their existence in groups. Corsaro, for example, suggests that traditional theories of socialization imply an individualistic and directional process in which the child is cast as the passive recipient of adult culture. He offers, in place of the concept of socialization, the notion of "interpretive reproduction," to recognize "the innovative and creative aspects of children's participation in society" and their simultaneous reliance on the adult world and its "cultural routines."[45] He explains:

> Children create and participate in their own unique peer cultures by creatively taking or appropriating information from the adult world to address their own peer concerns. The term *reproduction* captures the idea that children are not simply internalizing society and culture, but are *actively contributing to cultural production and change*. The term also implies that children are, by their very participation in society, *constrained by the existing social structure and by societal reproduction*.[46]

Within local cultures of childhood, rituals and artifacts that bind children within classrooms and cliques are created with ideas borrowed freely from the adult world. "Peer culture is public, collective, and performative," Corsaro notes.[47] As James puts it, the culture of childhood is "a context within which children socialise one another as well as socialise with each other."[48] Even local peer cultures may entail a certain oppositional stance toward adults and the control they exert; at the very least, adults may be excluded from its operations.

A second, more ominous perspective emphasizes the role of distant adults in the creation of culture for children, the conviction that "traditional notions of

Christine Marmé Thompson

childhood as a time of innocence and adult-dependency have been challenged by children's access to corporate-produced popular culture."[49] Changes in the cultural experience of children have created a more mediated, more vicarious, and more globalized and commercial culture, with significant implications for the formation of children's cultural and personal identities,[50] and for their relationships to adults. Kincheloe summarizes his interviews with children about the role of media in their lives:

> In the new information environment and the new childhood that accompanies it, attention to television, Internet, video games, music CDs, videos, and other productions is the *vocation* of children. They are the experts in this domain and their knowledge surpasses almost every adult. . . . Through their new access to information children know that there exists an esoteric knowledge of adulthood and that adults are hiding information from them.[51]

Gaile Cannella points out that this process has long been in motion: "Originating with adults, child-rearing manuals, bedtime stories, literature, and mass-media impose on children a particular knowledge that dictates need. Very little evidence exists for the presence of child discourse and knowledge in society. Younger human beings are not heard without the filter of those who are older."[52]

Within this perspective, children can be seen as hapless victims of commercial culture or as relatively powerful and well-informed agents. Joseph Tobin writes:

> In the first scenario, [popular culture] is seen as an Althusserian apparatus, sinister, powerful, and systematic in achieving its seduction and interpellation of child consumers, who are seen as lacking agency and the capacity to resist commercial appeals and industry-launched fads. . . . In the second scenario it is the children who . . . hold the cards. . . . The second scenario is reflective of the much more upbeat American school of cultural studies that emphasizes the pleasure, agency, and resistance of consumers (even when they are children).[53]

It is the playful and subversive nature of kinderculture, the deliberately transgressive choices that children make among the options made available to them, that testifies most clearly to children's capacity to contribute to cultural life. Seiter suggests that this more "'forgiving' theory of media effects" is common among teachers who have ample opportunity to observe children, to witness what they do with the found materials of children's culture.[54] Nicholas Paley notes that children operate within the culture as it is provided to them as *bricoleurs*, ready to improvise with materials at hand, to transform what is given in order to make it newly meaningful to them.[55]

Jo Alice Leeds and Diana Korzenik are among those who have pondered the relationship between adult aesthetic judgments and the valuation of child art that prevails at a particular historical moment.[56] As Leeds pointed out, attitudes toward children and childhood are equally decisive. An examination of the role of commercial culture in children's art making raises innumerable questions about art making—its origins and sources—and about "why children draw."

What are the implications of this discussion for teaching and understanding child art? Where *does* the "ket aesthetic" fit in our understanding of graphic activity in childhood and in the curriculum? One of the basic tenets of the "creative self-expression" movement, early in the last century, stipulated that art edu-

The "Ket Aesthetic"

cation should draw its content from children's life experiences. This dictum may have been more readily endorsed in theory than it was embodied in practice; adults are notoriously inept judges of what is of interest to children, though children are remarkably willing to play along much of the time. But, as Tarr insists, "Curricula need to take up children's questions rather than ignoring or glossing over their issues."[57] That is, we need to find ways to understand more clearly how children's life experiences, including those derived from a commercial culture that we view with skepticism, can enter and inform the pedagogical spaces we inhabit with them. We need to turn a clear and critical eye to the images of the child and the constructions of childhood that underlie our teaching and research, in order to better understand the world of contemporary childhood and the accommodations we might make to the experience of being a twenty-first-century kid. Dyson suggests that the exclusion of these interests from the classroom may well undermine children's creative and critical capacities and the democratic mission of schooling:

> Curriculum must be undergirded by a belief that meaning is found, not in artifacts themselves, but in the social events through which those artifacts are produced and used. Children have agency in the construction of their own imaginations—not unlimited, unstructured agency, but, nonetheless, agency: They appropriate cultural materials to participate in and explore their worlds, especially through narrative play and story. Their attraction to particular media programs and films suggests that they find in that material powerful and compelling images. If official curricula make no space for this agency, then the schools risk reinforcing societal divisions in children's orientations to each other, to cultural art forms, and to school itself.[58]

NOTES

An early version of this essay appeared in the *International Journal of Arts Education* 3, no. 1 (2001): 68–88; another version was presented at the symposium "The Visual Culture of Childhood: Child Art after Modernism," Pennsylvania State University, November 2005. The term "ket aesthetic" is borrowed from Allison James's essay "Confections, Concoctions, and Conceptions," in Henry Jenkins, ed., *The Children's Culture Reader* (New York: New York University Press, 1998), 394–405.

1. Adam Gopnik, "Barney in Paris," in Gopnik, *Paris to the Moon* (New York: Random House, 2000), 166–67.

2. Ibid., 167.

3. Ibid., 170–71.

4. James, "Confections, Concoctions, and Conceptions," 394.

5. Ibid., 395.

6. Ibid., 404.

7. Ibid., 400.

8. Claudia Mitchell and Jacqueline Reid-Walsh, *Researching Children's Popular Culture: The Cultural Spaces of Childhood* (New York: Routledge, 2002), 25.

9. See Betty Lark-Horovitz, Hilda P. Lewis, and Marc Luca, *Understanding Children's Art for Better Teaching*, 2nd ed. (Columbus, Ohio: Charles E. Merrill, 1973).

10. See Gaile S. Cannella, *Deconstructing Early Childhood Education: Social Justice and Revolution* (New York: Peter Lang, 1997); and Joseph Tobin, "The Irony of Self-Expression," *American Journal of Education* 103 (1995): 233–58.

11. See Joseph Tobin, ed., *Pikachu's Global Adventure: The Rise and Fall of Pokémon* (Durham, N.C.: Duke University Press, 2004).

12. Ellen Seiter, *Television and New Media Audiences* (Oxford: Clarendon Press, 1999), 5. See also Anne H. Dyson, *Writing Superheroes: Contemporary Childhood, Popular Culture, and Classroom Literacy* (New York: Teachers College Press, 1997); Anne H. Dyson, *The Brothers and the Sisters Learn to Write: Popular Literacies in Childhood and School Cultures* (New York: Teachers College Press, 2003); and Karen A. Hamblen, "Children's Contextual Art Knowledge: Local Art and School Art Context Comparisons," in Liora Bresler and Christine Marmé Thompson, eds., *The Arts in Children's Lives: Context, Culture and Curriculum* (Boston: Kluwer Academic Press, 2002), 15–27.

13. See Joe L. Kincheloe, "The Complex Politics of McDonald's and the New Childhood: Colonizing Kidworld," in Gaile S. Cannella and Joe L. Kincheloe, eds., *Kidworld: Childhood*

Christine Marmé Thompson

Studies, Global Perspectives, and Education (New York: Peter Lang, 2002), 84.

14. Seiter, *Television and New Media Audiences*, 4.

15. Ibid., 4–5.

16. See Mikhail Bakhtin, *Rabelais and His World*, trans. H. Iswolsky (Bloomington: Indiana University Press, 1984); and Donna J. Grace and Joseph Tobin, "Pleasure, Creativity, and the Carnivalesque in Children's Video Production," in Bresler and Thompson, eds., *The Arts in Children's Lives*, 195–214.

17. Dyson, *Writing Superheroes*, 166.

18. See Brent Wilson and Marjorie Wilson, *Teaching Children to Draw: A Guide for Parents and Teachers* (Englewood Cliffs, N.J.: Prentice Hall, 1982).

19. Christine Marmé Thompson, "Drawing Together: Peer Influence in Preschool-Kindergarten Art Classes," in Bresler and Thompson, eds., *The Arts in Children's Lives*, 129–38.

20. See Kincheloe, "The Complex Politics of McDonald's."

21. Dan Fleming, *Powerplay: Toys as Popular Culture* (New York: Manchester University Press, 1996), 117.

22. Wilson and Wilson, *Teaching Children to Draw*.

23. Kincheloe, "The Complex Politics of McDonald's," 80.

24. Dominic Scott, "What Are Beanie Babies Teaching Our Children?" in Cannella and Kincheloe, eds., *Kidworld*, 64.

25. Fleming, *Powerplay*, 117.

26. William A. Corsaro, *The Sociology of Childhood* (Thousand Oaks, Calif.: Pine Forge Press. 1997), 26.

27. Fleming, *Powerplay*, 40.

28. Ibid., 37.

29. Ibid., 15–16.

30. Rob Walker, "Consumed," *New York Times Magazine*, February 15, 2004, 28.

31. Allison James, Chris Jenks, and Alan Prout, *Theorizing Childhood* (New York: Teachers College Press, 1998), 6.

32. William Ayers, *To Teach: The Journey of a Teacher* (New York: Teachers College Press, 1993), 28.

33. Andrew J. Stremmel, "The Cultural Construction of Childhood: United States and Reggio Perspectives," in Victoria R. Fu, Andrew J. Stremmel, and Lynn T. Hill, eds., *Teaching and Learning: Collaborative Exploration of the Reggio Emilia Approach* (Upper Saddle River, N.J.: Pearson Education, 2002), 37–50.

34. Loris Malaguzzi, "For an Education Based on Relationships" (trans. Lella Gandini), *Young Children* (November 1993): 9–12.

35. Patricia Tarr, "Reflections on the Image of the Child: Re-
producer or Creator of Culture," *Art Education* 56, no. 4 (2003): 6–11.

36. Malaguzzi, "For an Education Based on Relationships," 11.

37. Daniel J. Walsh, "Constructing an Artistic Self: A Cultural Perspective," in Bresler and Thompson, eds., *The Arts in Children's Lives*, 101–12.

38. Loris Malaguzzi, "Your Image of the Child: Where Teaching Begins," *Child Care Information Exchange* 96 (1995): 52–61; quote on page 53.

39. James, Jenks, and Prout, *Theorizing Childhood*, 3.

40. Ibid., 96; see also Alan Prout, *The Future of Childhood: Towards the Interdisciplinary Study of Children* (New York: RoutledgeFalmer, 2000).

41. James, Jenks, and Prout, *Theorizing Childhood*, 7.

42. Wilson and Wilson, *Teaching Children to Draw*, 22–23.

43. Lev S. Vygotsky, *Mind in Society: The Development of Higher Psychological Processes* (Cambridge, Mass.: Harvard University Press, 1978).

44. Fleming, *Powerplay*, 62.

45. Corsaro, *The Sociology of Childhood*, 18, 19.

46. Ibid., 18.

47. Ibid., 95.

48. Allison James, *Childhood Identities: Self and Social Relationships in the Experience of the Child* (Edinburgh: Edinburgh University Press, 1993), 94.

49. Kincheloe, "The Complex Politics of McDonald's," 83.

50. See ibid.; and Pia Christensen and Allison James, eds., *Research with Children: Perspectives and Practices* (New York: Falmer, 2000).

51. Kincheloe, "The Complex Politics of McDonald's," 96.

52. Cannella, *Deconstructing Early Childhood Education*, 35.

53. Tobin, ed., *Pikachu's Global Adventure*, 8.

54. Seiter, *Television and New Media Audiences*, 59.

55. See Nicholas Paley, *Finding Art's Place: Experiments in Contemporary Education and Culture* (New York: Routledge, 1995).

56. See Jo Alice Leeds, "The History of Attitudes Toward Child Art," *Studies in Art Education* 30, no. 2 (1989): 93–103; and Diana Korzenik, "Is Children's Work Art? Some Historical Views," *Art Education* 34, no. 3 (September 1981): 20–24.

57. Tarr, "Reflections on the Image of the Child," 7.

58. Dyson, *Writing Superheroes*, 181.

OLGA IVASHKEVICH

DRAWING IN CHILDREN'S LIVES

Children in Western cultures have been making self-initiated drawings for centuries. These creations did not become a subject for serious consideration, however, until 1848, when the Swiss educator and illustrator of children's books Rodolphe Töpfer published his *Réflexions et menus-propos d'un peintre génevois* with two chapters devoted to child art.[1] Töpfer believed that art is not imitation but the spontaneous expression of ideas, and viewed the child's unprompted graphic expression as more akin to the drawings of great artists than to the art of the "merely skilled" academic artist.[2] Töpfer's fascination with children's self-initiated drawings reflected an emerging romantic paradigm within modernism, whereby childhood was perceived as an innocent and innately creative state of being, free from the conventions of culture. Drawings spontaneously produced by children were believed to reflect original and

[FACING] "Jessie" (female, age 7, United States), *Dive*, June/July 2003 (detail, fig. 54).

natural laws of creativity that deserved appreciation and close study. From the postmodern perspective, the weaknesses of this argument are obvious, as we begin to acknowledge the role of the cultural ideas and graphic models that inform drawings by children. Influences include books, media images, and drawings produced by peers. In fact, contemporary research has proven that children's drawings possess a set of powerful conventions that are preserved and recycled within different children's groups and subcultures, and that children are more likely to make use of available graphic symbols than to invent them on their own.[3]

The focus of the majority of studies of children's drawings has been on the qualities of drawing per se—graphic principles, developmental patterns, subject matter, or expressive elements such as color, line, and composition. In these examinations, drawing has been purposefully removed from the circumstances of its production and analyzed without consideration of the child's intentions in making it. The question as to why a child makes drawings if they are not solicited by adults—what ideas, feelings, and desires inspire the child's self-initiated picture making—remains open. To my view, the answers to this question can be found only in the particular context of the process of a specific drawing, when we can use the child's direct comments and behavior to shed light on the form and purposes of a picture. If the relationship between the child and the investigator is sufficiently trusting, interviewing the child about his or her pictures may also prove fruitful, although new motives may enter into the child's retrospective retelling even if the interview follows immediately after the making of the work.

STUDIES OF CHILDREN'S DRAWINGS

The early research on children's drawings was dominated by generalizations and universal assumptions, based on large collections of drawings from schools and individual children within families. Often the drawings were not initiated by children themselves but made upon teachers' requests or other adult direction. In 1887, the first systematic study of children's self-initiated drawings was published by the Italian poet and philosopher Corrado Ricci.[4] Interestingly, Ricci's pioneer collection started with approximately one hundred unsolicited drawings produced by a friend's daughter. He later expanded the collection with an additional 1,250 drawings from various elementary schools. Ricci's dissatisfaction with working from a single child's drawings derived from his wish to identify the general principles of children's graphic representations rather than to look at the intentions behind specific pictures. Following Ricci, other researchers undertook studies based on large samples of children's works, among which they did not differentiate solicited drawings from self-initiated drawings (Louise Maitland in 1895, Herman T. Lukens in 1896, James Sully in 1896, Georg Kerschensteiner in 1905, Siegfried Levinstein in 1905, Karl Lamprecht in 1906, Philip B. Ballard in 1912 and 1913, and Stella Agnes McCarty in 1924).[5]

The earliest account that seems to consider a child's intentions for self-initiated drawing can be found in the revolutionary work of Georges Luquet, who studied over 1,500 drawings produced by his daughter, some of which he observed in process. His first work, *Les Dessins d'un enfant* (*The Drawings of a Child*), published in 1913, led to another study, *Le Dessin enfantin* (*Children's Drawings*) of 1927.[6] Luquet's close observation of his daughter's drawing process provided insights that influenced the work of many subsequent scholars, including Jean Piaget and Viktor Lowenfeld. Unlike the researchers of his own time who believed that small children drew from memory rather than from obser-

Olga Ivashkevich

vation, Luquet noted that the child generally aimed at realism. He states that "children are realists first in all their motifs, in the subjects they draw,"[7] expanding the notion of realism to include anything "that is real at the time it is created to whosoever creates it."[8] According to Luquet, children's intellectual realism, in contrast to adults' visual realism, is based on the "internal model" that is created when the child depicts an object for the first time.[9]

Another important study was undertaken by the German psychologist William Stern. Chapter 20 of his book *Psychology of Early Childhood Up to the Sixth Year of Age*, published in 1914, contains a case study of a six-year-old boy's self-initiated drawing.[10] Stern stresses the playful character of early picture making and defines it as an intellectual activity, claiming that the lines drawn by the child are essentially the "markings of thought."[11] In describing one instance of a particular boy's drawing, he emphasizes the role of associations that caused sudden "jumps" from one idea (butterfly) to another (camel) while the boy was making the drawing.[12] According to Stern, these changes in thinking can occur when the child switches from one graphic characteristic of an object to another.[13]

Among early attempts to understand the process of children's spontaneous picture making, there is also a remarkable study by Walter Krötzsch, a German teacher who was engaged in researching children's scribbling.[14] Krötzsch stressed the importance of observing children "in the act of creating" in addition to analyzing the results of their creations.[15] While observing children during the process of scribbling, he noticed the primacy of rhythm and movement in the development of a drawing. He also discovered that graphic form, writing, and ornament develop out of the child's first rhythmic and automatic scribbling.[16]

During the last decades of the twentieth century,

some practicing psychologists and art educators conducted studies emphasizing the observation of children's unsolicited drawing activity, with a major focus on the child's purposes in picture making. Claire Golomb, who studied young children's drawing and sculpture making in the early 1970s, paid close attention to children's comments while they worked.[17] She points out that the extensive narratives that often accompany drawing and modeling reveal that children are generally not interested in a complete depiction of what they know about a particular subject. Rather, "much is left out because it is difficult to represent, superfluous to the basic structure . . . and can be accomplished by verbal description."[18] Golomb's definition of spontaneous children's drawing as a form of symbolic play radically differs from the traditional concept of drawing as an imitation of the mental image, as it was described by Piaget. She writes: "Unlike imitation, which in Piaget's system is synonymous with the tendency to accommodate to the object, symbolic play tends to transform the object in line with the child's emotional needs."[19] According to Golomb, the child does not copy, but rather plays with reality by creating symbolic attributes of objects and their functions.[20]

Brent Wilson delved into the reasons for the child's self-initiated picture making in an article of 1974, investigating the prolific drawing of superheroes and comic strips by a ten-year-old boy named J. C. Holz.[21] Wilson did not observe the boy during the process of drawing, but he interviewed the boy and his mother about the drawings later. J.C. reported that he had "a whole bunch of superheroes" in his head and was trying "to get them out" of his mind. "Sometimes I pretend I have the powers of the heroes," he told Wilson. "This summer I pretended [to be] the Adventurer and rode my bike around with a black jacket."[22] Wilson concludes that J.C.'s spontaneous picture making is a

Drawing in Children's Lives

form of "arousal-seeking behavior" that is based on a strong drive to avoid boredom.[23] This hypothesis was influenced by a homeostatic model of motivation popular in the 1970s, which assumes that all individuals tend to establish an emotional balance "between the overly boring and the overly stimulating."[24] Although Wilson's theoretical beliefs overshadowed some of the real reasons for J.C.'s unsolicited drawing, this study was among the first determined attempts to understand the child's drive to draw.

In Brent and Marjorie Wilson's *Teaching Children to Draw* (1982), the authors contrast spontaneous drawings made by children "at home or in spare and stolen time at school, on the edges of notebooks or on any available paper," with school art, which is encouraged by the teacher, a parent, or another adult.[25] The Wilsons argue that spontaneous drawings are often dismissed by adults as mere play or as less colorful and visually compelling work than drawings done at school. They stress the importance of spontaneous drawings as disclosing "a set of symbols through which the child might present and experiment with personal and developing ideas about himself and about his world."[26] According to the Wilsons, children's spontaneous drawings represent four major realities: common, archeological, normative, and prophetic. The common reality derives from familiar and everyday perceptions. The child's aspiration to draw familiar objects is explained by the desire to construct and reinvent them for better understanding. The archeological reality is "the reality of the self." The human mind is composed, the authors argue, of layers of "memories, feelings, thoughts, impressions, and desires," and drawing helps children to try out images of themselves "in order to reveal the essential self."[27] The normative reality involves the concepts of good and bad, right and wrong, just and unjust. Drawing that represents this reality is essentially a reinvention of the standards of right and wrong.[28] The prophetic reality symbolizes the future and provides children with an opportunity to develop models for their own future selves, actions, and worlds.[29] Although these categories may be overly schematic, they do suggest the variety of often overlapping orientations in the subject matter of children's self-initiated drawings. The factors that may lead to spontaneous picture making range from aesthetic or kinesthetic pleasure to the need for peer recognition, for communicating thoughts and ideas, or for creating "working models" of the world. As the Wilsons acknowledge, it is important to ask children about their drawings before making any assumptions about a particular drawing. They stress that "often even marks and configurations that appear to be minimal and insignificant have been found to contain tremendously important ideas."[30]

A case study conducted by Paul Duncum in the early 1980s also aimed to investigate individual children's reasons for drawing, focusing in this instance on depictions of horses by two eight-year-old girls.[31] Duncum proposed to interpret children's drawings in the context of their lives rather than as an isolated "artlike phenomenon"—to perceive the drawing as merely the "tip of an iceberg of fantasy" that is not obvious in the drawing itself and needs to be uncovered by talking to the child about his or her picture.[32] In his doctoral dissertation of 1986, Duncum describes three case studies of prolific middle-childhood drawers, illuminating not just major graphic themes, but also the functions of drawing in the whole context of the children's lives.[33] Duncum interviewed the children as well as family members to capture the complexity of the contexts in which the drawing occurred.

Matthew, one of the three drawers studied by Duncum, was a thirteen-year-old boy whose major drawing

Olga Ivashkevich

themes reflected a conflict between "goodies and baddies," fairness, action, friendly social relations, and rule making. Duncum conjectures that Matthew engaged in drawing in part due to a speech impairment that isolated him from his peers. As his mother pointed out, "His drawing was a form of self-expression because he couldn't speak very well, because he felt remote from this world."[34] According to Duncum, Matthew was "unable or unwilling to compete with his peers and his older brother" and had found "various activities that have allowed him to explore the world in ways that many other children do more directly"; one such activity was drawing.[35]

Sophie, who was studied between the ages of eight and nine, mainly drew horses, horse riders, and a variety of other animals. These drawings emphasized themes of nurturance, a love of animals, and the power, virility, and mastery associated with horse riding. Duncum asserts that Sophie's social environment was supportive but very competitive. Being surrounded by slightly older peers at school and two big sisters at home, she felt insecure, and drawing provided her with a degree of safety. She usually declined to play with the neighborhood children, instead preferring to stay at home alone, playing with animals or drawing. Drawing also served as a strategy for social approval, an assertion of competence and superiority. Sophie strove to make highly realistic drawings and enjoyed being praised for that. As her father noted, "There is nothing Sophie likes to hear more than her drawings are those of a child twice her age."[36] She also had a keen desire to be "famous," which Duncum suggests was provoked by "adulation, competitiveness, lack of power and isolation."[37]

A third research participant, Eugene, age ten, had been a prolific cartoon drawer from the age of four. (Duncum interviewed him again at age fifteen.) His drawing narratives were full of conflict, mainly between good and evil, where goodness was associated with "decisive action, circumspection, loyalty to friends, and intelligence."[38] Due to his family's frequent relocation from place to place and his lack of physical coordination, Eugene had difficulties in communicating with peers and was often physically and psychologically harassed. Unwilling to express himself through regular social relations and perceiving the world in threatening terms, Eugene drew as "an escape from the demands of personal interaction, particularly the solicitousness of others," Duncum writes.[39] His drawing also "allowed the opportunity to materialize fantasies of power and to exercise the real power he acquired over graphic conventions."[40] Furthermore, drawing served as a means to attract attention, to create a bridge to other people: Eugene deposited his cartoon drawings in the school library and sought to have his work published and his name recognized.[41] Through graphic activity, he received attention from a small group of peers and enjoyed seeing his brother imitating his drawings.

In the 1980s, Angela Robertson conducted another in-depth examination of the meaning and purpose of a particular child's self-initiated drawing activity by focusing on the teenage drawings by her son Bruce.[42] Besides collecting and observing the making of Bruce's drawings, Robertson also conducted short interviews to reveal the influences and major themes in his prolific picture making. Robertson schematized Bruce's drawing methods in six categories: drawing from pictures, from memory, from observation, by finding correlations between the images he invented and feelings, by doodling, and by spontaneously mixing and mismatching parts of representations into hybrids, like "a shark-plane swooping down in an air battle."[43] Yet the majority of his drawings at puberty were characterized

by "playful humor, divergent 'what if' flights of fancy, and a love of incongruity and the bizarre."[44] According to Robertson, the state of "the mind at play" was "an essential part of Bruce," and served as an expression of his "perceptual, sensorial, and emotional feelings and kinesthetic sensations," especially the boy's awareness of "muscular body movement derived from his agility in sports and interest in physique."[45] A central theme of his drawings was adolescent identity, "subsuming other themes of sex, power, violence, family life, cultural influences, and the teenage subculture."[46] Bruce seemed to draw mainly in a cartoon style. When asked by Robertson about the reasons for cartooning, he responded: "I don't like serious drawings ... because they are not real. I can express emotions that I certainly can't express in the house, like lunatic, extreme joy, glee, boredom, confusion, or idiocy. It's also weird [that] when I'm supposed to be drawing it's hard. When I'm not supposed to be drawing, like in class, I can, easily, and wham—it works."[47] While Bruce borrowed a lot from popular media imagery, Robertson asserts that it was his interest and need for graphic expression that motivated his search for techniques.[48]

Phil Pearson's case study of a thirteen-year-old Samoan boy named Rei, published in 1993, looks at the reasons for self-initiated picture making in the context of peer and family culture.[49] Pearson's interest is less in the boy's drawings themselves than in "illuminating the complex pattern of social relations within which Rei, and his image making, are embedded."[50] He states that by looking "at the person rather than drawings," one can come to understand the purpose of self-initiated image making in children's lives.[51] The study is based on interviews conducted with Rei, his older brother, and his parents. Each of the contexts in which Rei was involved—school, church, and home—pro-

vided a special opportunity for drawing. Drawing in church was tolerated by the authority of both the church and his parents, and the presence of his older brother, also a prolific drawer, stimulated him in his picture making. Pearson writes: "For Rei, Iati [Rei's brother] represented both the model and the reason for his involvement in the enterprise."[52] The boredom of sermons was another important reason for engaging in drawing activity at church. At home, Rei drew with his brother, who influenced both his graphic expression and his choice of subject matter, which was based primarily on popular TV programs. One of the central topics of Rei's drawings was muscle men. Rei often accompanied Iati to the gym and was himself involved in a rugby league, though he was not particularly successful in sports. His brother seemed to surpass him in both sports and academics, so drawing was the only enterprise in which Rei appeared to exceed Iati in skill. Elementary school played a particularly important role in Rei's image making. Due to his involvement with a highly competitive group of classmates immersed in graphic activity, he became a prolific drawer. As Pearson points out, Rei never made pictures "for himself" at school; his drawing "has derived both source and audience from the interests of the social group he has been involved with."[53]

Among recent studies of children's unsolicited drawing, the work of John Matthews stands out. He studied spontaneous graphic representation during infancy in his own two children and concluded that scribbling as a pure kinesthetic activity does not exist; rather, he argues, scribbling has organization and meaning from the very beginning.[54] Early representations by infants, such as horizontal arcs, vertical arcs, and push-pull gestures, are discovered from normal body movements and defined by Matthews as "drawing actions."[55] According to him, "the earliest drawing

Olga Ivashkevich

actions are based upon early gesticulation of the body already articulated into emotional and expressive phrases and passages."[56] Therefore, it is meaningless "to seek the precise moment when 'real' drawing begins," for it is embedded in the development of children's intelligence.[57]

During the last decade, much research has been devoted to cultural influences on children's drawings, such as picture books, media images, and peer influences. Researchers are increasingly interested in the particulars of graphic representation as signifiers of children's responses to specific images in their immediate cultural environment, rather than as universals of drawing development. Within the cultural paradigm, interesting research has been conducted in the classroom by means of direct observation, further illuminating the context of children's culture and the functions of image making within a peer-influenced environment.

A study by Chris Boyatzis and Gretchen Albertini that focuses on fifth graders' voluntary drawing at school uncovers pronounced gender differences in girls' and boys' drawings as well as same-sex peer influences on the choice of graphic themes and style.[58] The authors argue that children's drawings are affected by the norms of socialization accepted in a given society and are "in accord with societal gender stereotypes."[59] According to Boyatzis and Albertini, "conformity and adherence to the peer group's behavioral norms" reaches its peak during the middle-childhood years, a period that is also marked by high gender segregation, and both factors affect the drawing process. After the teacher in the classroom studied by the authors announced voluntary drawing time, children grouped themselves "quickly and rigidly along gender lines . . . with no instances of gender integration."[60]

All the boys' groups studied by Boyatzis and Alber-

tini seemed to choose similar subjects for drawing: violent or competitive scenes in sports or high-tech scenarios. Two boys sitting together worked collaboratively on Robo-Cop figures. A drawing by Jon, a drawer distinguished among the boys for his highly realistic style, served "as a model and inspiration" for his peer Martin, who tried to copy a part of Jon's drawing. Two other boys, Max and Alex, were engaged in drawing fighter planes. Both of them chose the same composition and graphic narrative, exchanging ideas while drawing. Boyatzis and Albertini assert that, in general, the "boys' drawing session revealed strong conformity to each other's styles in subject matter, technical form, and meaning," while "the verbal exchanges entailed ample self-criticisms, ongoing commentary about the drawing process, and both solicited and unsolicited evaluations from peers."[61]

Girls' drawings revealed similar peer influences, both graphic and verbal, according to Boyatzis and Albertini. However, the girls' drawings exhibited themes that were strikingly different from those of the boys', with nature, animals, and people predominating. One of the girls, Erin, started to draw a picture of a "female fat cat" in a natural setting with sun, clouds, and grass, and her drawing partner, Deirdre, followed her with her own drawing of a cat resting.[62] According to Duncum, there is a direct relation between the children's preferred drawing subjects and gender-based standards and stereotypes. He claims that "usually without being consciously aware, children select their subjects in accord with what they conceive to be the appropriate subjects for their gender, and consequently they find these rewarding."[63]

Christine Thompson, in "Action, Autobiography and Aesthetics in Young Children's Self-Initiated Drawing" (1999), provides a sensitive account of preschool children who draw together during voluntary

sketchbook time in the classroom.[64] She describes three broad strategies used by children in their self-initiated drawings: imaginative play, autobiographical praxis, and copying.[65] Whereas fictive drawing expands beyond real experiences to fantasy worlds and often includes images seen on TV, in picture books, or in computer games, autobiographical drawing records everyday experiences and objects. Direct copying involves borrowing not only from picture books and media, but also from peers' drawings.

Another paper by Thompson provides evidence that autobiographical drawings are quite rare among contemporary children, as children are now so engaged in the images of contemporary popular culture.[66] She describes the case of a four-year-old girl, Emma, who usually depicted everyday events and objects, but was in the minority within her group by doing so; the other preschool children showed a preponderant interest in reproducing images from popular culture. Emma's drawings, based upon her experience of constructing a snowman while visiting her friend's house or a recent discussion with her mother on their garden reconstruction, "stood out among the rainbows and hearts and homages to Pokémon" that absorbed the attention of her slightly older classmates.[67] Thompson remarks that today's childhood is radically transformed by the complexity of social relations and children's participation in an enveloping visual culture. She notes: "Consumer culture provides children with a shared repository of images, characters, plots, and themes; it provides the basis for small talk and play."[68]

DRAWING TOGETHER: A CONTEMPORARY CASE OF UNSOLICITED PICTURE MAKING

Expanding the topic of collaborative picture making within children's culture, I would like to describe a curious case that I observed in the loosely structured environment of a day camp. The children in the camp—ages six through nine—spent the whole day there, and even with bus trips, daily art lessons, and walks outside, children had a lot of free time, which they were encouraged to use productively. For the most part, they would trade cards, play board games, make crafts, and draw. A stack of sketchbooks and a pile of pencils were always accessible, but children were never told to use them. During the first week, I noticed that a few girls would turn to the sketchbooks more often than other campers would. Soon, two of the girls, Maria and Jessie,[69] both seven years old, appeared to be inseparable during their drawing time. I joined them every time they got together and recorded all the conversations that occurred as they drew.

Like other researchers, I found that for my subjects drawing was essentially a form of graphic play that they invented together. It had certain rules that both of them generally followed. The key rule was drawing with a partner. When another girl wanted to join Maria and Jessie, they suggested finding someone else to draw with. I asked if it was really necessary to do this if you wanted to draw, and Maria responded with assurance: "Yes, you need a partner." The girls always started with a theme to draw—a jungle, a house, or a horse. While drawing, they exchanged ideas and discussed different meanings that emerged during the process. As Thompson has discovered in her research, children often negotiate the content of their drawings, assigning and exchanging roles "in order to prolong collaboration and move it forward," as they would "assign, accept, and exchange roles in other forms of imaginative play."[70]

I found that this negotiation of meaning was fundamental to the joint drawing adventure. Although both of the girls worked on the same topic and often influenced each other's graphic solutions, each of them had quite distinct ideas about the content of their picture, and these ideas sometimes did not fit with the

Olga Ivashkevich

other's drawing. While collaborating, they developed an appreciation for each other's ideas, and even if conflicting directions arose, both girls accepted their differences. In the beginning of their work on the jungle drawings (figs. 47 and 48), I asked them how they managed to draw together:

> MARIA: What I do is . . . I think of an idea and Jessie asks me at a certain time what I think my idea is and I tell her . . . Well, I imagine what thing should we draw . . . I think about it and I tell it to Jessie and she imagines how it would be different from mine. When I start off with one tree, she does one tree, but then when I do vines, she draws vines with leaves on them. When I draw a lion, she draws a tiger . . .
>
> JESSIE [interrupting, indicating her own drawing]: A lion with a mane! [Pause.] We decide to draw a jungle and then draw a jungle . . . My vines on my deck have leaves on them.
>
> MARIA: Mine don't. I want to make him a little fat, like all in one . . . I'm gonna make this all in one.

The process of exchanging ideas and negotiating meanings was especially evident during the process of drawing a fancy house (figs. 49 and 50). Jessie and Maria talked for forty minutes while making this drawing, and their ongoing comments shed light on how the drawing together actually happened. Before they began drawing, the girls came up with the topic of the fancy house by exchanging different thoughts, eventually developing an idea that seemed interesting to both of them:

> JESSIE: Maria, what should we draw next?
>
> MARIA: How about we dra-a-aw . . . buildings! [Excited.] Let's draw buildings!
>
> JESSIE: I can draw a fancy, fancy house.
>
> MARIA: Oh, yeah [with great interest]. Fancy, fancy.

Fig. 47 [top]. "Jessie" (female, age 7, United States), *A Jungul* [sic], June/July 2003. Charcoal pencil on sketchbook paper, 8½ × 11 inches. Collection of Olga Ivashkevich.

Fig. 48 [bottom]. "Maria" (female, age 7, United States), *The Forest*, June/July 2003. Charcoal pencil on sketchbook paper, 8½ × 11 inches. Collection of Olga Ivashkevich.

Drawing in Children's Lives

Fig. 49 [*top*]. "Jessie" (female, age 7, United States), *A Fancy House*, June/July 2003. Charcoal pencil on sketchbook paper, 11 × 8½ inches. Collection of Olga Ivashkevich.

Fig. 50 [*bottom*]. "Maria" (female, age 7, United States), *A Fancy House*, June/July 2003. Charcoal pencil on sketchbook paper, 8½ × 11 inches. Collection of Olga Ivashkevich.

Oh [with enthusiasm], how about a fancy, fancy penthouse?

JESSIE: Hotel.

MARIA: Yeah. What does it look like now?

JESSIE: Bi-i-g building, like a bi-i-g, bi-i-g rectangle.

Later on, Jessie and Maria had to negotiate the meaning of "fancy," and they ran into a conflict of interpretation. While Maria was definitely thinking of something rich and expensive, Jessie was thinking of it more in terms of decorative details.

MARIA [about Jessie's drawing]: This is like a hotel that costs a lot of money to stay at.

JESSIE: Yeah, like two hundred dollars. A regular hotel would be a hundred.

MARIA: No, it is eight hundred to stay here.

JESSIE: No, no one would want to stay here. Too much! [Draws flower decorations on the top of her house. Their thinking shifts in the conversation, which began with the intention to draw a fancy house; they then imagine that it is a hotel (Jessie offers this first), and then they come back to thinking of it as a house once again, moving back and forth in their thinking in a playful negotiation.]

Shortly thereafter, Maria was captured by Jessie's ideas about the aesthetic appearance of the house and suggested another decoration, but met resistance:

MARIA: Oh [with enthusiasm], I know how we can make it more figurative. It is when it's snowing out. Christmas!

JESSIE: My flowers would die, though . . .

MARIA [confused]: No . . .

[Jessie laughs.]

MARIA [trying to find a solution]: When you say one's like . . .

Olga Ivashkevich

JESSIE: Wallpaper!

MARIA: Yeah, wallpaper!

JESSIE [unsatisfied]: Wallpaper will melt in water . . .

Jessie accepted the idea of a snowy Christmas only after her friend suggested putting Christmas lights on the house. She was equally enthusiastic about including a Christmas tree and a fancy limousine in the picture. She added snow when the drawing was almost complete, after Maria insistently reminded her. This final touch seemed to be really important to complete the image.

Maria wanted to make very clear to me that even if they used the same ideas and often drew the same objects, their drawings were dissimilar. When I saw Jessie drawing a car behind her house, I asked her if she had decided to make the same car that Maria just had. Maria spoke up rapidly, before Jessie had a chance to respond:

MARIA: I'd let you sort of copy that from me, but not really. Because this time I sort of copied that from her. But it's okay to copy because we are not really copying; we do not do the same thing. Like, I made this one way with a fa-a-ncy door lock, and she—look!—she made a royal house!

Jessie was much less concerned with the issue of copying and never tried to justify it. She always seemed to be inspired by Maria's ideas and easily agreed on drawing certain topics. However, she rarely looked at her friend's drawing and seemed to be more engaged with her own pictures, always humming to herself as she worked. Her sudden comments during the drawing process revealed that intimate narratives were a part of her pictures. At some point, while adding the windows to the fancy house, Jessie revealed a personal story behind her drawing:

JESSIE: I drew a house with four windows on top. Because four people live here: a brother, a sister, a mom, and a dad.

MARIA: Brother, sister, mom, dad . . . But do you really have a sister?

JESSIE: No, it's more fun to have a brother.

MARIA: Why do you think that?

JESSIE: Because they get along better . . . But . . . I don't think me and Devin [her real sister] get along better.

MARIA: But why don't you guys get along?

JESSIE: We are very different.

At times, the drawings that the girls made lost their uniformity as the chosen topic elicited strong personal reactions and led in different directions. Rather than causing conflict, this aroused a keen mutual curiosity about the other's point of view. During the course of drawing, Maria and Jessie would often turn to the topic of sports, for example. Contesting and competing are ingrained in U.S. culture, and the girls explored them eagerly. In one instance, they decided to draw a boxing match, and Maria insisted that they had to draw two cats as the main characters (fig. 51). Jessie, however, announced that her characters would be a girl and a boy (fig. 52). This did not change Maria's intent to draw boxing cats, but it captured her interest so deeply that she barely paid attention to her own drawing, becoming unusually inattentive to the details as she focused on Jessie's drawing. A short dialogue that occurred in the process revealed Jessie's profound impact on Maria's understanding of the boxing theme, redefining it as gender wrestling:

JESSIE: I draw a boy and a girl boxing, and a girl is going to win!

MARIA: Why do you need that?

Drawing in Children's Lives

Fig. 51 [*top*]. "Maria" (female, age 7, United States), *Boxing Cats*, June/July 2003. Charcoal pencil on sketchbook paper, 8½ × 11 inches. Collection of Olga Ivashkevich.

Fig. 52 [*bottom*]. "Jessie" (female, age 7, United States), *You Go Girl*, June/July 2003. Charcoal pencil on sketchbook paper, 8½ × 11 inches. Collection of Olga Ivashkevich.

JESSIE: Maybe because I want to? [Pause.] The girl is boxing in a skirt.

MARIA: Oh, that's not allowed. You can't wear a skirt in boxing.

JESSIE: But these are not like real boxers . . .

MARIA: She's going to trip and fall!

JESSIE: No, she's not. The boy is already about to fall over. That shows girl power!

Sometimes Jessie and Maria had a hard time coming up with a theme to draw. It seemed as though all the possibilities had already been exhausted or nothing was interesting enough to them. One day, after a long argument over what to draw, the girls decided to work on a diving scene based on their experience at the swimming pool (figs. 53 and 54). But instead of their usual discussion of the topic, Maria initiated a verbal competition, claiming her authorship of the theme of diving in a teasing manner and developing a "repeat after me" game:

MARIA: It was my idea. I guess you like my ideas. . . . If you like my ideas, then I should start doing the ideas and you just listen . . .

JESSIE: No. [Laughs.]

MARIA: Repeat after me, repeat after me, okay?

JESSIE: Okay.

Jessie repeated everything that Maria said, word for word, then they switched, and Maria repeated words after Jessie. During this game, they completed their drawings.

This case of collaborative drawing among peers provides interesting insights into picture making as a part of children's culture. It testifies to the fact that borrowing graphic ideas from others is not simply imitation; rather, it is just a starting point for a very complex process of acquiring, negotiating, and playing with different meanings. With the help of their

Olga Ivashkevich

playmates, children clarify, question, and reinvent the experiences, cultural concepts, and values that impact their lives. Without intending to make broad generalizations, this account offers a different approach to children's drawings by taking a closer look at the drawing process and at the purposes of children's self-initiated picture making. Whether a drawing is made at home or at school, created alone or together with friends, it always bears the distinct mark of the particular child's intentions and ideas in negotiation with others. It is an artifact of lived experience.

NOTES

1. Rodolphe Töpfer, *Réflexions et menus-propos d'un peintre génevois* (Paris: J.-J. Dubochet, Lechevalier, 1848).

2. Meyer Schapiro, *Modern Art: Nineteenth and Twentieth Centuries* (New York: G. Braziller, 1978).

3. These ideas can be found as early as 1932, in G. W. Paget, "Some Drawings of Men and Women Made by Children of Certain Non-European Races," *The Journal of the Royal Anthropological Institute of Great Britain and Ireland* 62, no. 35 (1932): 127–44. In the 1980s, a body of research was done by the Wilsons: see Marjorie Wilson and Brent Wilson, "The Case of the Disappearing Two-Eye Profile: Or How Little Children Influence the Drawings of Little Children," *Review of Research in Visual Arts Education* 15 (Winter 1982): 19–32; and Brent Wilson, "The Artistic Tower of Babel: Inextricable Links Between Culture and Graphic Development," *Visual Arts Research* 1, no. 21 (1985): 45–60. See also Sven B. Andersson, "Local Conventions in Children's Drawings: A Comparative Study in Three Cultures," *Journal of Multicultural and Cross-cultural Research in Art Education* 13 (Fall 1995): 101–12.

4. Corrado Ricci, *L'Arte dei bambini* (Bologna: Nicola Zanichelli, 1887); translated into German as *Die Kinderkunst* (Leipzig: Voigtlaender, 1906); abridged version translated into English by Louise Maitland as "The Art of Little Children," *The Pedagogical Seminary* 3 (October 1895): 302–7.

5. See Louise Maitland, "What Children Draw to Please Themselves," *The Inland Educator* 1 (September 1, 1895): 77–81; Herman T. Lukens, "A Study of Children's Drawings in the Early Years," *The Pedagogical Seminary* 4 (1896): 79–110; James Sully,

Fig. 53 [*top*]. "Maria" (female, age 7, United States), *Diveing*, June/July 2003. Charcoal pencil on sketchbook paper, 8½ × 11 inches. Collection of Olga Ivashkevich.

Fig. 54 [*bottom*]. "Jessie" (female, age 7, United States), *Dive*, June/July 2003. Charcoal pencil on sketchbook paper, 8½ × 11 inches. Collection of Olga Ivashkevich.

Drawing in Children's Lives

Studies of Childhood (New York: D. Appleton, 1896), in Daniel N. Robinson, ed., *Significant Contributions to the History of Psychology, 1750–1920* (Washington, D.C.: University Publications of America, 1977); Georg Kerschensteiner, *Die Entwicklung der Zeichnerischen Begabung* (Munich: Carl Gerber, 1905); Siegfried Levinstein, *Kinderzeichnungen bis zum 14. Lebensjahr* (Leipzig: R. Voigtländer, 1905); Karl Lamprecht, "Les Dessins d'enfants comme source historique," *Bulletin de l'Académie Royale de Belgique* 9–10 (1906): 457–69; Philip B. Ballard, "What London Children Like to Draw," *Journal of Experimental Pedagogy* 1 (1912): 127–29; Philip B. Ballard, "What Children Like to Draw," *Journal of Experimental Pedagogy* 2 (1913): 127–29; and Stella Agnes McCarty, *Children's Drawings* (Baltimore: Williams and Wilkins, 1924).

6. Georges Luquet, *Les Dessins d'un enfant* (Paris: Alcan, 1913); and Georges Luquet, *Le Dessin enfantin*, translated as *Children's Drawings* by Alan Costall (1927; London: Free Association Books, 2001).

7. Luquet, *Le Dessin enfantin*, 77.

8. John A. Michael and Jerry W. Morris, "European Influences on the Theory and Philosophy of Viktor Lowenfeld," *Studies in Art Education* 26 (1984): 108.

9. Luquet, *Le Dessin enfantin*, 47, 51.

10. William Stern, *Psychologie der frühen Kindheit bis zum sechsten Lebensjahre* (Leipzig: Quelle und Meyer, 1914), published in English as *Psychology of Early Childhood Up to the Sixth Year of Age*, trans. Anna Barwell (New York: H. Holt, 1924).

11. Ibid., 237.

12. Ibid., 198.

13. Ibid., 240.

14. Walter Krötzsch, *Rhythmus und Form in der freien Kinderzeichnung* (Leipzig: Haase, 1917).

15. Brunhilde A. Kraus, "History of German Art Education and Contemporary Trends" (Ph.D. diss., Pennsylvania State University, 1968), 47.

16. Helga Eng, *The Psychology of Children's Art* (London: Kegan Paul, Trench, Trubner, 1931), 142.

17. Claire Golomb, *Young Children's Sculpture and Drawing* (Cambridge, Mass.: Harvard University Press, 1974).

18. Ibid., 60.

19. Ibid., 185.

20. Ibid.

21. Brent Wilson, "The Superheroes of J. C. Holz: Plus an Outline of a Theory of Child Art," *Art Education* 27, no. 8 (1974): 2–7.

22. Ibid., 3.

23. Ibid.

24. Ibid.

25. Brent Wilson and Marjorie Wilson, *Teaching Children to Draw: A Guide for Parents and Teachers* (Englewood Cliffs, N.J.: Prentice Hall, 1982), xv.

26. Ibid.

27. Ibid., 24, 28.

28. Ibid., 29, 31.

29. Ibid., 35.

30. Ibid., 37.

31. Paul Duncum, "The Fantasy Embeddedness of Girls' Horse Drawings," *Art Education* (November 1985): 42–46.

32. Ibid., 44.

33. Paul Duncum, "Middle Childhood Spontaneous Drawing from a Cultural Perspective" (Ph.D. diss., Flinders University of South Australia, 1986).

34. Ibid., 406.

35. Ibid., 408.

36. Ibid., 446.

37. Ibid.

38. Ibid., 470.

39. Ibid., 490.

40. Ibid.

41. Ibid., 491.

42. Angela Robertson, "Development of Bruce's Spontaneous Drawings from Six to Sixteen," *Studies in Art Education* 29, no. 1 (1987): 37–51.

43. Ibid., 43.

44. Ibid., 40.

45. Ibid.

46. Ibid., 39.

47. Ibid., 42.

48. Ibid., 44.

49. Phil Pearson, "Who Cares About Ninja Turtles?: Image Making in the Life of Iati," *Australian Art Education* 17, no. 1 (1993): 14–22.

50. Ibid., 14.

51. Ibid., 22.

52. Ibid., 15.

Olga Ivashkevich

53. Ibid., 20.

54. John Matthews, *Drawing and Painting: Children and Visual Representation*, 2nd ed. (London: Paul Chapman, 2003), 13.

55. Ibid., 42.

56. Ibid.

57. Ibid., 50.

58. Chris J. Boyatzis and Gretchen Albertini, "A Naturalistic Observation of Children Drawing: Peer Collaboration Process and Influences in Children's Art," *New Directions for Child and Adolescent Development* 90, no. 1 (2000): 31–48.

59. Ibid., 32.

60. Ibid., 35.

61. Ibid., 39.

62. Ibid., 42.

63. Paul Duncum, "Children's Unsolicited Drawing and Gender Socialization," in Anna M. Kindler, ed., *Child Development in Art* (Reston, Va.: National Art Education Association, 1997), 109.

64. Christine M. Thompson, "Action, Autobiography and Aesthetics in Young Children's Self-Initiated Drawing," *Journal of Art and Design* 18, no. 2 (1999): 155–61.

65. Ibid., 159.

66. Christine M. Thompson, "Kinderculture in the Art Classroom: Early Childhood Art and the Mediation of Culture," *Studies in Art Education* 44, no. 2 (2003): 135–46.

67. Ibid., 136.

68. Ibid., 142.

69. The children's names have been changed.

70. Thompson, "Kinderculture in the Art Classroom," 140.

Drawing in Children's Lives

Jordndon.

Le nombril

vela ce que
je ne veux pas
dire... et te me
a rire

MISTY S. HOUSTON

THE EARLY DRAWINGS OF LOUIS XIII IN THE JOURNAL DE JEAN HÉROARD

The *Journal de Jean Héroard* is a six-volume manuscript written by the physician assigned to watch over the growth of Louis XIII, the young heir to the French throne, from the prince's birth in 1601 until the death of the physician in 1628. The journal begins with Héroard's stated intention of "acquitting himself worthily in the care of the prince's nourishment."[1] But the journal is far more than a set of notes for monitoring Louis's diet: Héroard deems it necessary to record what he observes about Louis's growth in general from day to day, from hour to hour, in order "to establish a solid judgment as to the future alterations and changes to which, upon his birth, nature subjects all men."[2] Thus, a journal kept for monitoring the health of the prince comes to contain records of everything from the child's tantrums to the way he passes his leisure hours. Interleaved among the pages of the orig-

[FACING] Louis XIII (age 6), *Torso (Doundoun), Bird, etc.,* August 10, 1607 (detail, fig. 65).

inal journal are twenty-five of Louis's childhood drawings, done in the doctor's presence (see figs. 55–73). Héroard notes the child's intentions in each, the subject matter, what training the prince received, and other observations that reveal a great deal about them.

As a medical log, Héroard's journal takes an objective tone. To stress this objectivity, Héroard steps outside his own project, avoiding the first-person voice. He does not claim ownership of the journal and hardly mentions himself at all; when he does, he refers to himself as "the author" of the project, "the faithful servant" of the prince, or simply "H." This marks his insistence upon making Louis the journal's sole subject. Yet despite this claim to objectivity, the journal is shaped by Héroard's singular perspective; the information he chooses to report betrays his own interests and concerns. There are two lenses through which Héroard observes Louis: that of the doctor who is in charge of the future king, a child living in a period when a lack of self-mastery and self-restraint is almost all that distinguishes childhood from adulthood; and that of the grandfatherly old man in his fifties, himself childless, who delights in the endless string of adorable gestures and comments by the child and who guides him and gently advises him as a grandfather might do.

Héroard's "observation of [Louis's] inclinations," and his observation of Louis's drawing and painting in particular, offers us insights that a record of Louis's daily life by itself would not.[3] While his portrait of Louis as a child-artist leaves us with little analysis of the significance of this treasury of drawings to Louis's experience, it nevertheless reflects changes in the way that children and their creations were perceived. During the medieval period, Philippe Ariès argues in his history of childhood, children were not considered to be especially significant until they reached an age at which their health and future were not in jeopardy,

around seven years old.[4] After this, children were considered to be reasonable, if less developed, adults and were initiated into the adult world. These beliefs are evident in Louis's education: he is raised in the nursery at St. Germaine-en-Laye by his governess and nurse until he is seven, at which point he is moved to the adult world at the Louvre and begins regular instruction with his governor and his father, Henri IV. From this point on, he is expected to behave more responsibly.

Notions of childhood were starting to change during this period, however, largely owing, according to Ariès, to "the growing influence of Christianity on life and manners."[5] Likely in proportion to their increased life expectancy, the status of children gradually changed. Children were beginning to be perceived as innocent and unique, and this stimulated new ideas about educating and interacting with them. As adults began to recognize children's individuality, they came to derive pleasure and amusement from their children's foibles and successes.[6] The influence of this developing perspective on children—the precursor to modern beliefs about the innocence and vulnerability of children and their place as the hope and future of society—is apparent in Héroard's journal.[7] His intention of documenting Louis's inclinations, his ongoing analysis of Louis's personality, and the care and patience he uses in approaching the boy all point to a more enlightened viewpoint on children.

Medieval beliefs continued to inform much religious and scientific knowledge in the early 1600s, however. Although Héroard is a doctor, for instance, he does little more than observe his patient and control his diet. In his pedagogical treatise *L'Institution du prince* (1609), he subscribes to medieval notions of royalty when he writes that "the king is the image of God governing all things, even a human God."[8] For this rea-

62

Misty S. Houston

son, anything coming from Louis (physical or intellectual) merits examination: his feces, his expressions, his flashes of temper or tenderness are all documented in detail in Héroard's journal. Again evincing a medieval perception of royalty, Héroard makes comments about Louis's abilities that surpass his capabilities, particularly when he is quite young.[9] When Louis is only three months old, for instance, Héroard makes the implausible claim that he has pronounced Héroard's name.[10] As Louis matures, Héroard continues to note his physical and mental abilities, apparently gauging his progress toward becoming the man and king he is to be. Héroard is particularly interested in Louis's reasoning and physical mastery. There is a consistent emphasis upon Louis's manual dexterity, which Héroard sees as making him apt for mechanical arts (in which category he places drawing and painting).

Héroard's treatment of Louis's drawings is an index to the doctor's overall apprehension of childhood; at the same time, his ideas about childhood bear on the way that he treats Louis's drawings. Most of Héroard's descriptions of the drawings involve a very limited interest in Louis's mechanical abilities. On numerous drawings, as well as in journal entries, Héroard notes Louis's dexterous execution, commenting "very recognizable." The historian Madeleine Foisil, editor of the first full-length publication of the *Journal de Jean Héroard*, indicates that drawing was a pastime of Héroard himself and that he stimulated Louis's interest in painting.[11] But Héroard's comments speak of his scientific interests. He was known to have made skilled and detailed drawings of the bone structure of horses for his book *Hippostéologie, ou discours des os du cheval* (1599).[12] This was not a creative project, but one that involved accuracy and truth to nature, a manner of drawing that differed in intent from the drawing Louis would do for pleasure. Héroard does not evaluate

Louis's paintings on the basis of their ideas or of their expression of Louis's imagination or creativity; instead, he assesses their accuracy, or conformity to nature. On August 21, 1605, Héroard writes that Louis "enjoys drawing, making birds. He has the judgment to put the eyes, legs, feet, and other parts in the places they should be."[13] Héroard's attention is not on Louis's pleasure at drawing, the rapture of his passion, or even the fact that he has an aviary that he tends to religiously, but rather on the precision of the work. His comments suggest his concern with the child's ability to see objectively—to perceive the world, recognize its natural laws, and comply with them, rather than producing fanciful creatures ungrounded in reality. On the following day, Louis again takes to drawing birds, and Héroard again notes their accuracy, writing that the drawings are "quite recognizable" as birds.[14]

Gradually, Héroard's references to Louis's paintings and drawings shorten, until they note only what is depicted and whether it is good, well done, or recognizable. At a key moment when the seven-year-old Louis seems to be expressing his imagination, Héroard rejects his creation: Louis shows Héroard a picture he has made of a bird, like one on a cabinet. Louis tells him, "You see, Monsieur Eroua [Héroard], I made it without seeing the original. I had it in my mind." Héroard tells him that it is quite nice, "but that it still needed the crest." Louis looks at the cabinet and says, "Yes, but I did not have it in my mind yet. I want to put it there [in my mind], then I'll paint it" (January 26, 1608).[15] Although Louis has painted from memory, which is remarkable, Héroard does not applaud his work because it is inaccurate. He sends him back to the model to observe the crest that is missing in his depiction.

Héroard's documentation of Louis's artwork often focuses on fine motor skills and Louis's visual perception, where emotional or contextual notes would offer

The Early Drawings of Louis XIII

Fig. 55 [*above*]. Louis XIII (age 4), *Bird and Bird Head on a
Long Neck*, 1605. Bound in as a page of the journal of
Jean Héroard. Bibliothèque Nationale de France, Paris.

Fig. 56 [*right*]. Louis XIII (age 4), *Figure*, August 22, 1605.
Bound in as page 118 of the journal of Jean Héroard.
Bibliothèque Nationale de France, Paris.

much to their interpretation. On August 10, 1607, for instance, Héroard comments on one of the most conspicuous drawings by the six-year-old Louis, a nude (fig. 65). He comes closer than ever to providing a reading of Louis's emotional state as he draws, but his concerns nevertheless remain quite scientific:

> Then he set to making the bird, marked A; after [that,] to make [D]oundoun, his nurse; as he was making the belly button, he traced that which is lower, and having made it [said]: "And that is what I didn't want to say." [He] started the face with the two eyes, then the nose, the mouth, and afterward made the round of the head, and then followed it by tracing below.[16]

Labels and arrows added by Héroard indicate the navel and the part of Doundoun's anatomy that Louis "didn't want to say." Héroard also remarks that Louis begins to laugh when he says this.[17] Although this is a remarkable drawing—made all the more so by Héroard's notes—the doctor fails to remark on Louis's use of drawing to communicate something he is bashful about saying aloud, nor does he comment on the sexual nature of the drawing. Instead, Louis's process of drawing dominates Héroard's description.

Héroard commonly notes in the journal that Louis draws "dexterously and with attention" (December 14, 1606), or "attentively, dexterously, and with power and affection for learning" (February 7, 1607).[18] He also comments on Louis's tastes and how his personal preferences influence his concentration and even his performance. Louis has a strong desire to draw well; when he is with instructors, he asks questions and listens to their advice. Frequently, he returns to drawings from another day and amends them. Whereas Louis resists his academic lessons and occasionally

Fig. 57 [*top*]. Louis XIII (age 4), *Scribbles*, 1605. Bound in as reverse of page 118 of the journal of Jean Héroard. Bibliothèque Nationale de France, Paris.

Fig. 58 [*bottom*]. Louis XIII (age 5), *Red Gouache Figure and Gestural Smearings*, August 20, 1606. Bound in on the back of page 302 of the journal of Jean Héroard. Bibliothèque Nationale de France, Paris.

The Early Drawings of Louis XIII

Fig. 59 [*top*]. Louis XIII (age 5), *Segmented Rectangle and Serrated Free Form*, August 20, 1606. Bound in the journal of Jean Héroard. Bibliothèque Nationale de France, Paris.

Fig. 60 [*bottom*]. Louis XIII (age 5), *Birds and Scribbles*, September 21, 1606. Bound in as page 320 of the journal of Jean Héroard. Bibliothèque Nationale de France, Paris.

refuses to participate in religious mass, dancing, or other activities, he seeks out time to draw and instruction in drawing, willingly submitting to guidance in this area. Héroard's interest in Louis's drawing is peculiar, since it is hardly important to the prince's education, which will increasingly focus on military skills, horsemanship, religious instruction, and manners. If Louis is allowed to pursue the arts and have lessons, it is mainly because it is viewed as an "innocuous" pastime.[19]

But Héroard does not seem to share the more accepted opinion that art is too childish for Louis. He is interested not only in the formation of the king, but also in the interests and pleasures of the child. He nurtures Louis's interests and notes the effect they have upon his character and personality. He gratefully accepts the drawings Louis gives him for his register, and he speaks to Louis about their contents, noting down what Louis describes. On the one hand, Héroard treats the drawings objectively, without attempting to probe the thoughts and emotions of the prince through his drawings. This is consistent with his role as the doctor to the future king. But on the other hand, Héroard seems to cherish the drawings for their input into Louis's personality. Like Louis's speech, which Héroard records using phonetic spelling in order to capture the prince's unique lisping pronunciation, the drawings preserve the unique and charming character of the child. Most of the drawings that Héroard collects in the folios are produced by Louis between the ages of five and eight, and Héroard makes his most extensive notes on the drawings of this period. These drawings do not prove Louis's artistic genius; rather, they show that he is very much like other children, even like children of today. They do not reveal a miraculous, divinely granted proficiency, as medieval notions of royalty would predict. The drawings are, instead, faulted

Misty S. Houston

and imperfect, just like the child himself. Their chief interest for Héroard lies in their expression of the child's perceptions and interests.

Héroard's *Institution du prince* marks the doctor's departure from medieval conceptions of childhood. A treatise on education, the text is composed of a dialogue between himself and M. de Souvré, Louis's governor from the age of seven, in which Héroard enlightens Souvré on how to raise the prince. He outlines the prince's schedule, leaving large gaps for leisure activities of the prince's own selection:

> He should be up and dressed by seven o'clock and study till nine. Then to church, and after mass be free till eleven, at which hour he should dine. Lessons should begin again at one and end at three. He should then be free till six o'clock supper and he should go to bed at nine.... In their playtime, children should be free to enjoy themselves, walking and dancing, running and jumping, playing at tennis and pall-mall, riding, hawking, and coursing.[20]

Héroard's encouragement of Louis's drawing, then, arises from a philosophy that play is essential to a healthy mind and body.

The prince begins drawing at the same time he begins to learn to write, as a boy of four, sitting beside Héroard. Some of his earliest drawings appear on pages covered with letters from the alphabet and rough, unsteady attempts at spelling—"Loys" for "Louis," for example. The journal indicates that Louis has a strong affinity for drawing. Héroard, in fact, marvels: "Where does this inclination to painting come from?"[21] (With these words, Héroard may well be wondering about the origins of his own inclination as much as Louis's.) Some in the court frown upon the practice; M. de Souvré, for example, regards drawing as a fruitless practice that is too effeminate for a prince

Fig. 61 [*top*]. Louis XIII (age 6), *Practice Alphabet*, June 1607. Bound in as page 426 of the journal of Jean Héroard. Bibliothèque Nationale de France, Paris.

Fig. 62 [*bottom*]. Louis XIII (age 6), *Detailed Head and Practice Writing*, 1607. Bound in on the back of page 441 of the journal of Jean Héroard. Bibliothèque Nationale de France, Paris.

The Early Drawings of Louis XIII

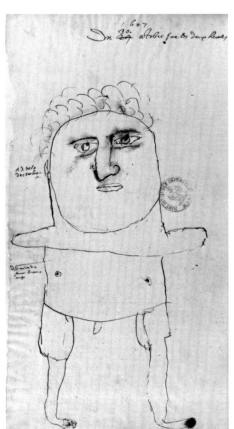

Fig. 63 [*above*]. Louis XIII (age 6), *Bird, Cow, Person, Circle / Face, and Practice Letters*, 1607. Bound in on the back of page 439 of the journal of Jean Héroard. Bibliothèque Nationale de France, Paris.

Fig. 64 [*left*]. Louis XIII (age 6), *Full-Length Male Figure*, 1607. Bound in the journal of Jean Héroard. Bibliothèque Nationale de France, Paris.

Fig. 65 [*below*]. Louis XIII (age 6), *Torso (Doundoun), Bird, etc.*, August 10, 1607. Bound in as page 462 of the journal of Jean Héroard. Bibliothèque Nationale de France, Paris.

Fig. 66 [*left*]. Louis XIII (age 6?), *Practice Writing ("Luys Dauphin sera bien sage") and Cut Out with Scissors (to indicate the instruction to cut out)*, 1607?. Bound in as page 481 of the journal of Jean Héroard. Bibliothèque Nationale de France, Paris.

Fig. 67 [*right*]. Louis XIII (age 6?), *A a H, Bird (cut out from front of page)*, 1607?. Bound in as reverse of page 481 of the journal of Jean Héroard. Bibliothèque Nationale de France, Paris.

who will someday lead armies.[22] Others see it as inconsequential; whenever the court historian takes over the journal during Héroard's various absences, there is never more than a word indicating that Louis draws. Nevertheless, Héroard's emphasis on Louis's picture making indicates a belief that drawing, even if not in the service of science, is suitable to the breeding of an enlightened king.

Whereas Louis is reported to have frequent temper tantrums about the things he is forced to do, drawing and painting, along with looking in books and playing with animals and toys (until M. de Souvré insists that he give them up), seem to be favorite pastimes. The comparative freedom and self-direction in these activities suit his apparently creative temperament.

In the controlled environment where he is surveyed —and physically and socially manipulated, by everything from diuretics and suppositories to opportunistic courtiers—drawing is something of his own that suffers little outside intervention. He also uses his drawings as a sort of currency, presenting them as peace offerings to get out of punishment from his detested governess, Mme Montglat. On December 14, 1606, he makes numerous pleas to Montglat to avoid the whipping that will come at the end of the day. In addition to promising to be coifed and to study, he promises to paint: "I will make a handsome little cherub," he bargains.[23] This implies that Louis regards his paintings as personal property, as items that are private and that he alone owns. In one telling incident, he has paintings,

Fig. 68 [*top*]. Louis XIII (age 6), *Face with Continuous Line*, 1607. Bound in as page 483 of the journal of Jean Héroard. Bibliothèque Nationale de France, Paris.

Fig. 69 [*bottom*]. Louis XIII (age 6), *Birds, Horseback Riders*, 1607. Bound in as reverse of page 483 of the journal of Jean Héroard. Bibliothèque Nationale de France, Paris.

which are pinned up on his tapestries, removed for the visit of an ambassador, insisting that they are only for his papa to see.[24] His pride in his artwork is apparent in the journal's reports of his requests to have his artwork framed.[25]

The journal shows that Louis is at peace and content when he is drawing and painting, spending long hours at his work without tiring of it and sometimes returning to a drawing over the course of several days. On November 6, 1608, Héroard writes that Louis "is so attentive to his painting that they could not get him to stop. He put all of his mind to it."[26] At other times, he swears at people who distract him.[27] On several occasions, he becomes so involved that he has to be threatened to desist; his mother is even asked to send a man to order him on her behalf to stop for lunch.[28] A combative, haughty, often malicious child, he is shown to concentrate for hours on end at both drawing and receiving instruction in drawing. Héroard writes lengthy passages about the time Louis spends with instructors and master painters. Not one who likes being told what to do, Louis is deeply intrigued by the art of court painters and humbled before them, and he submits himself to their authority. In December of 1606, Héroard writes that Louis "sends for two young painters, said he wanted to learn to paint.... [Louis] asked: 'What should I do, do I need white, red?' and worked dexterously and with attention."[29] When Martin Fréminet, the king's painter, gives him instruction, he behaves as though he is intimidated but nonetheless wants to continue. Louis sheds his competitive nature before other painters, even accepting the advice of the son of a gardener, who is closer to him in age.

When he has his portrait painted, or sometimes simply for pleasure, Louis sits in the gallery to watch the painters work. Héroard describes at length how Louis imitates their gestures and stances. On April 30,

Misty S. Houston

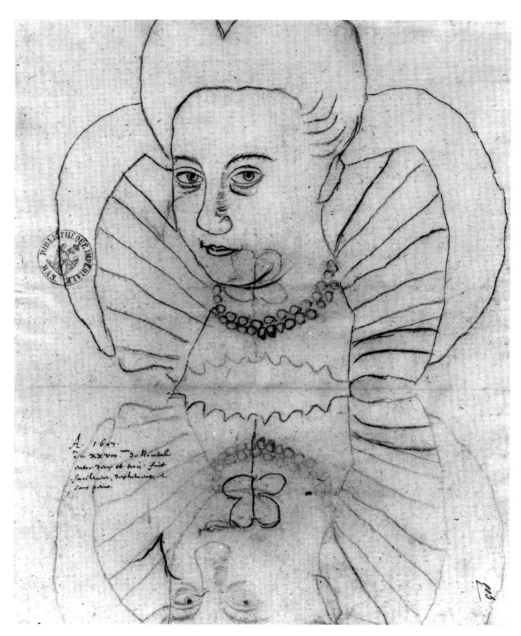

Fig. 70. Louis XIII (age 6), *Assisted Copy after a Master Painter's Portrait*, 1607. Bound in
as page 503 of the journal of Jean Héroard. Bibliothèque Nationale de France, Paris.

1605, he writes that Louis "sat and amused himself by drawing on paper. He imitated the painters, positioning his right hand, in which he held the plume like a paintbrush, over above the left arm, like the painters do on the maulstick, and moved his hand and the plume as artistically as the painter had done his paintbrush."[30] A couple of months later, Héroard again describes Louis's commitment to learning to draw: "he follows [his instructor] with his brush coldly, attentively, dexterously, and with will and affection for learning; this desire made him rise earlier than usual" (February 7, 1607).[31] Héroard is impressed by Louis's ability to imitate the painters he sees and even more by his desire to imitate them so closely. Moreover, Louis takes his lessons seriously, as if he were preparing to be not a king, but a painter. When he is being painted by Charles Martin, painter and valet to the king, Louis "has him give him colors and a brush, [and he] imitates the painter, mixing the colors."[32] When asked what he is doing, Louis answers, "I am painting Monsieur the Dauphin. ... See, see, I am looking at myself"(May 10, 1606).[33]

Louis happily participates in all of the activities of a painter, even the less noble ones. Héroard shows us an industrious and content Louis: "He crushes his colors himself on the slate, which he holds at his thumb while working with the same actions of a painter; sings while painting" (November 1, 1608).[34] On October 2, 1610, he

> made all of his colors on the spoon himself; painted on the canvas of Avarice and Prudence, clothed,

Fig. 71 [*top*]. Louis XIII (c. age 7), *Face and Smear in Corner*, undated. Bound in as page 141 of the journal of Jean Héroard. Bibliothèque Nationale de France, Paris.

Fig. 72 [*bottom*]. Louis XIII (age 8), *Coach and Six with Horse and Rider in Foreground*, 1609. Bound in as page 176 of the journal of Jean Héroard. Bibliothèque Nationale de France, Paris.

Misty S. Houston

Fig. 73. Louis XIII (age 8), *Coach and Six*, 1609. Bound in as page 179 of
the journal of Jean Héroard. Bibliothèque Nationale de France, Paris.

[they were] rather good. Is attentive to this; made all of the actions that he knew a painter to make. At the end, packed up his colors and his brushes himself.[35]

Perhaps Louis's dedication is, in part, an index of the great pleasure he derives from his instructors' encouragement and praise, in contrast to the remonstrances associated with his poor performance in writing and other studies. He learns the techniques, the procedures, and the use of different mediums, truly becoming a painter. Although drawing takes Louis away from preparation for his future role as king, Héroard nevertheless encourages these inclinations; indeed, Héroard uses Louis's passion for art to control him. Constantly

at arms with someone, it seems, Louis spends whole days in fear of the punishment he will receive for his misdeeds. In allowing Louis to spend his free time drawing quietly and absorbing himself into it, Héroard makes life easier on the young prince.

Héroard's way of dealing with Louis is unique: instead of threatening him when he misbehaves, as Louis's governess does, Héroard patiently talks to him. As he writes in his *Institution du prince*, he believes that it is more effective "to stammer with the little children, that is to say to accommodate oneself to the delicacy of their age and to teach them more so by way of gentleness, and of patience, than by that of severity and haste."[36] Much of the journal records Héroard's

The Early Drawings of Louis XIII

Socratic conversations with Louis, in which he gently directs him to a moral lesson or a modification of his behavior. Héroard uses the same strategy in regard to Louis's drawings: he talks to Louis about what he has drawn, often asking him to explain himself, and then makes notes in the journal. Without this record of Louis's comments on the subjects of his drawings, we might never have understood, for example, his intention to illustrate what he "did not want to say" out loud when he depicted Doundoun's female genitals, nor learned that Louis started laughing after he said this. We might well have taken this drawing for a copy of a painting or statue in the palace; instead, we are given a deeper insight into Louis's love for Doundoun, which sometimes bordered on romantic infatuation.

As we look at the drawings by Louis in Foisil's edition of Héroard's journal, we can trace the development of the child along with Héroard. Louis makes remarkable improvements in his drawings from the time he begins to seek out instruction, around the age of six, and Héroard's references to them become less and less detailed as they become more and more recognizable. Perhaps there is a decrease in attention to this aspect of Louis's leisure time in deference to Louis's attachment to painting as a private pastime, or perhaps because Héroard has already firmly established Louis's practice of exercising his inclination to drawing and painting. Louis would continue to have a deep appreciation for the arts throughout his lifetime, and would regularly take time to draw. (His pastel drawing of a courtier, in the collection of the Bibliothèque Nationale de France, Paris, attests to this; see fig. 28 on page 15.) From 1613 to 1627, there are thirty-five references to Louis spending part of his day painting (there are no references in 1628, the last year of the journal); though Héroard notes little more than "Louis paints," this nevertheless tells us that painting had become a regular part of his daily life. Moreover, it shows that Louis uses painting as Héroard prescribes in his *Institution du prince*: as a way to relax, to escape from other worries, and to be in control.

As we saw at the beginning of this essay, Héroard proposes, in the course of his journal, to "establish a solid judgment as to the future alterations and changes to which, upon his birth, nature subjects all men." Héroard's attention to Louis's character, more than to specific tasks of training, causes the child to take Héroard into his confidence, a place from which the doctor can better advise and attend to him. Unlike M. de Souvré, whom Louis occasionally insults and in whose lessons he frequently meets with displeasure, Héroard deals with Louis as a child rather than a proto-adult. Although Héroard is not completely free of medieval notions of childhood—particularly with respect to his perception of Louis as a child-sized, but otherwise complete, divinely instituted being who is to be observed during its physical maturation, rather than as a distinct, weak, and dependent child—neither is he as entrenched in these notions as is M. de Souvré. Héroard sees himself as progressive, standing opposed to the conventional methods of the time in encouraging Louis's personality to develop rather than attempting to mold him. So with his drawings as with everything else, Héroard seeks to observe and nurture Louis's nature, rather than seeing him as the neutral clay from which a king must be fashioned.

NOTES

1. Jean Héroard, *Journal de Jean Héroard: Médecin de Louis XIII*, 2 vols., ed. Madeleine Foisil (Paris: Fayard, 1989), 369. Translations from the French are my own.
2. Ibid.
3. Ibid.
4. Philippe Ariès, *Centuries of Childhood: A Social History of Family Life* (New York: Alfred A. Knopf, 1962), 38.

Misty S. Houston

5. Ibid., 43.

6. Ibid.

7. Louis's poor health, together with the need for an heir to the throne, makes his survival a matter of great concern, and perhaps contributes to the emotional, and often physical, distance between Louis and the king and queen, which is typical of the period. Héroard is unique in his approach and attachment to the child; he points in the direction that ideas were moving, though in fact, not all of Héroard's contemporaries were moving in this direction yet (for example, M. de Souvré, discussed below, differed with Héroard in his treatment of the prince).

8. Quoted in Madeleine Foisil, Introduction, in Héroard, *Journal*, 356.

9. Lloyd deMause discusses Héroard's contradictory perspectives on Louis, whom he depicts at times as an adult and at times as a child. See his "The Evolution of Childhood," in deMause, ed., *The History of Childhood* (New York: Psychohistory Press, 1974), 22–23.

10. Héroard, *Journal*, 382.

11. Foisil, Introduction, in Héroard, *Journal*, 161.

12. Madeleine Foisil, *L'Enfant Louis XIII: L'éducation d'un roi 1601–1617* (Paris: Perrin, 1996), 23.

13. Héroard, *Journal*, 742.

14. Ibid., 744.

15. Ibid., 1364.

16. Ibid., 1278.

17. Ibid.; see marginal notes on page 1278 or notes on drawing.

18. Ibid., 1130, 1170.

19. Elizabeth Wirth Marvick, *Louis XIII: The Making of a King* (New Haven, Conn.: Yale University Press, 1986), 73.

20. Quoted in Lucy Crump, *Nursery Life Three Hundred Years Ago: The Story of a Dauphin of France, 1601–10* (London: George Routledge and Sons, 1929), 139.

21. Héroard, *Journal*, 741.

22. Crump, *Nursery Life Three Hundred Years Ago*, 106.

23. Héroard, *Journal*, 1129.

24. Ibid., 1316.

25. Ibid., 1170, 1362.

26. Ibid., 1533.

27. Ibid., 1364.

28. Ibid., 1514.

29. Ibid., 1130.

30. Ibid., 654.

31. Ibid., 1170.

32. Ibid., 944.

33. Ibid.

34. Ibid., 1530.

35. Ibid., 1830.

36. Quoted in Foisil, Introduction, in Héroard, *Journal*, 353.

The Early Drawings of Louis XIII

ELIZABETH HUTTON TURNER

"ANIMAL SKETCHING"

Aspects of Drawing and Play in Early Calder

To keep one's art young one must imitate young animals.
What do they do? They play. CONSTANTIN BRANCUSI

Among the stories associated with Alexander Calder (1898–1976) is one that takes place in his parents' New York City apartment during the 1920s when Calder was in his twenties. The young Calder spends the evening wrestling on the floor with a yellow tabby named Soufflé, whom he has adorned with a paper hat with fringe that makes him out to be a lion. As Calder will later write, the scene provokes his father to exclaim, "Go get a book and improve your mind."[1]

In those early days, in addition to reading studies of art, such as Élie Faure's *History of Art*, Calder also consulted a psychology text, James Sully's *Studies of Childhood* (1896), which espouses, among other things, the fundamental connection between drawing and play.[2] The association of art and childhood was of direct personal relevance to Calder as he inaugurated his career: not only was it the means by which he asserted his

[FACING] Brassaï, *Alexander Calder's Circus*, 1931 (detail, fig. 78, © Estate Brassaï–RMN).

Fig. 74. Alexander Calder, illustration in *Animal Sketching* (Pelham, N.Y.: Bridgeman Publishers, 1926), 12. © 2006 Estate of Alexander Calder/ Artists Rights Society (ARS), New York.

independence from the weight of tradition within his own family of artists (both his father and grandfather were well-established sculptors and his mother was an accomplished painter), but it also connected his activities to the most radical artistic inventors of his day.

Among Calder's first authoritative statements as an artist were his instructions to young students in a book entitled *Animal Sketching*, published in 1926.[3] Generously illustrated with his informal gesture drawings of animals made with India ink and a Japanese brush (indicative of his days of study at the Central Park and the Bronx Zoos), the book reveals Calder's initial preoccupations as an artist in New York between 1923 and 1926 (see figs. 74–76). Despite being a relative novice at the Art Students League, Calder found that fluency in drawing came naturally to him. Working from the model in Boardman Robinson's classes, Calder later recalled, "I had the knack of drawing with a single line."[4] Even so, the traditional pedagogical approach to drawing that Calder would have encountered at the League does not seem to have been the point of inspiration for his first book.

Animal Sketching differs from conventional drawing manuals in two very important respects. First, Calder assumes a scientific posture—and rightly so. Though a newcomer in the art world, Calder was a college-educated engineer and thus empirically and mathematically trained to apprehend the phenomenological world. Accordingly, he defined drawing as a sensori-motor process, a reflex arc linking mind and body. He writes:

First the eye and the brain, or the brain alone, must act and determine what it is desired to place on canvas or paper. This is a mental process. The second process is physical, for the hand must so control

Elizabeth Hutton Turner

Fig. 75 [*left*]. Alexander Calder, illustration in *Animal Sketching*
 (Pelham, N.Y.: Bridgeman Publishers, 1926), 22. © 2006 Estate
 of Alexander Calder/Artists Rights Society (ARS), New York.
Fig. 76 [*right*]. Alexander Calder, illustration in *Animal Sketching*
 (Pelham, N.Y.: Bridgeman Publishers, 1926), 52. © 2006 Estate
 of Alexander Calder/Artists Rights Society (ARS), New York.

pencil or brush that the desired effect may be obtained, that the image the eye has carried to the brain may be correctly transmitted to canvas or paper. An artist may do great things after he has mastered one or the other of these processes, but he cannot achieve real heights with only one of them at his command.[5]

Second, unlike most drawing manuals, *Animal Sketching* does not propose to teach techniques, methods of composition, or modes of mature adult expressions; rather, it aims for a certain fluency in capturing the first impulses of art. In this regard, Calder seems intent on developing the vantage point of the child. As he notes, "He [the student] must see and conceive things and also be able to execute them as he wishes."[6]

Animal Sketching quite simply and clearly encourages children to follow a natural impulse for making pictures. Calder introduces this notion to his young readers by saying, "The desire to draw something is the best incentive to make a drawing. But the mere thought, 'I must make a drawing' is no more an incentive than the thought 'I must write a book.' The desire to draw something is engendered by a condition or fact that of itself interests one, whether he can draw or not, or whether or not the thing to be drawn is difficult of execution."[7] *Animal Sketching* functions less as a pedagogical treatise than as a motivational text with the intent of kindling the novice's natural desire to draw by looking at animals. Calder finds a precedent for the fundamental impulses underlying child art—as well as proof positive of the first principles of art—by reaching back in time: "The earliest men of which we have any record, thousands of centuries ago, expressed their sense of beauty by leaving pictures drawn on their cave dwellings. These pictures are for the most part of animals—of deer, mastodons and wild horses."[8]

Calder's ensuing illustrations and commentary initially read as an endeavor to journey back in time as a sketch hunter, observing animals and their characteristic ways. He begins with a simple statement: "ANIMALS—ACTION. These two words go hand in hand in art." His subsequent descriptions of animals in action sound, at times, like those of a naturalist: "A deer sometimes will move each ear in a different direction, catching two warning sounds. So there is always a feeling of perpetual motion about animals and to draw them successfully this must be borne in mind."[9] In his discussion of birds, he counsels that capturing the line of movement comes through trial and error—almost as if by natural selection (see fig. 75): "As a rule it will take many rapid sketches of a bird in motion to get one that correctly records the action, but one such drawing is worth the trouble."[10]

The following chapters, whether referencing horses or monkeys, continue to stress the basic theme that the more a young artist watches and learns how animals behave and move, the greater his aptitude for an equivalent fluency of expression in drawing. Calder notes, "All actions of every animal tell us what they are like in the native state. If we can suggest some of these things in a drawing we feel elated because we have really 'got' the beast."[11] What is captured and transmitted by drawing is not simply a descriptive illusion of the animal, but an energetic line of movement. Calder advises, "Caricature the action as well as the animal."[12] Under the heading "Animal Instinct," Calder stresses the primacy of a preternatural disposition to draw— one for which no teacher or coach can take credit and that can only be gained through experience and empathy with animals: "Animals think with their bodies to a greater extent than man does. In anger or fight, ears flatten against the head, the hair along the spine rises. The dog at sight of food drools at the mouth, male

Elizabeth Hutton Turner

birds courting display their feathers. . . . There is no self-consciousness: animals are always intent upon the thing they are doing, and we must feel that they are as we sketch them."[13] Thus *Animal Sketching* arrives at its final destination (or, rather, back at its point of origin) —a moment in the evolution of consciousness before language claims its patterns upon mind and impulse, a moment when visual stimulus invokes an uninhibited response. As the illustrations of a hopping kangaroo and a squirrel burying a nut accompanying this text would suggest, Calder clearly believed that he himself had returned to such a moment—that he felt such a primal impulse in the execution of his rapid-fire strokes of India ink (see fig. 76).

Calder would have found support for his convictions in the scientific research of James Sully, whose *Studies of Childhood* was the first serious text on the subject in Great Britain.[14] Though by the time of his death, in 1923, doubts had been cast on Sully's reliance upon naturalistic observation, his precepts concerning the child artist remained relevant.[15] Composed of observations solicited from teachers, mothers, artists, and others, together with his own commentary, loosely framed by evolutionary theory, *Studies of Childhood* in many respects provided a precedent for Calder's own collection of observations in *Animal Sketching*. Like Calder, Sully asserts that early childhood drawing is by its very nature instinctive and not a product of education.[16] Further, he asserts that children's interest in animals "lead[s] them to draw at an early stage."[17] Prior to publishing *Animal Sketching*, Calder had corresponded with his sister, Peggy, concerning *Studies of Childhood*, debating the merits of Sully's idea that uncorrupted children would progress naturally from crude representation to modeling.[18] Sully observes that children often lose the sense perception for artistic purposes early on due to mental and muscular habituation, much like the

Fig. 77. Alexander Calder, *Acrobat*, c. 1927. Steel wire, cloth, painted wood, 6 × 4¾ × ¾ inches. University of California, Berkeley Art Museum, Gift of Margaret Calder Hayes, Class of 1917. © 2006 Estate of Alexander Calder/ Artists Rights Society (ARS), New York.

"Animal Sketching"

Fig. 78. Brassaï, *Alexander Calder's Circus*, 1931. Gelatin silver print. © Estate Brassaï–RMN.

acquisition of symbolic language.[19] Certainly, *Animal Sketching* represents an attempt to reassert the primacy of sense perception. Sully remains inconclusive on the question of how long the movements of the draughtsman's hands are guided strictly by a visual image of the form, however, before practice inevitably introduces the conscious element of the image on the paper into the process[20]—hence Calder's focus on movement in *Animal Sketching*.

Sully most likely would have welcomed Calder as a lay observer of children and accepted his impressions. Calder was, after all, an artist himself and had once been a child prodigy with his own workshop; as such, Sully would have presumed him to have sensory memories of his childhood firmly in place.[21] Perhaps more important is the degree to which Calder seems to have accepted Sully's precepts. Especially striking is how closely Sully's definition of play matches Calder's definition of drawing: both are defined, in Sully's words, as "the bodying forth of a mental image into the semblance of outward life"; and in Calder's notion of drawing as a conceptual activity when he said, "First the eye and the brain, or the brain alone. . . . This is a mental process. The second process is physical."[22] Indeed, Sully was convinced that the play impulse becomes the art impulse: "May we not say, then, that the impulse of the artist has its roots in the happy semi-conscious activity of the child at play, the all-engrossing effort to 'utter,' that is, give outer form and life to an inner idea, and that play-impulse becomes the art-impulse (supposing it is strong enough to survive the play-years) when it is illuminated by a growing participation in the social consciousness."[23]

The most convincing evidence of Calder's adoption of Sully's precepts of art and play is the near-coincident publication of *Animal Sketching* and Calder's purchase of a toy circus, which he began to embellish with his own figures (figs. 77–78), such as a velvet cow whose

Figs. 79a [*top*] and b [*bottom*]. Children's drawings illustrated in James Sully, *Studies of Childhood* (New York: Longman's, Green, 1903), 369.

"Animal Sketching"

Fig. 80. Calder making a wire portrait of Kiki de Montparnasse,
May 1929. Film still, Pathé Cinema. Private collection, New York.
Courtesy of the Calder Foundation, New York, © 2006 Estate
of Alexander Calder/Artists Rights Society (ARS), New York.

head turned around when its udder was pulled. What initially began as an object for private play and personal experiment with simple machines and studies in motion—Calder later explained, "I started the circus for myself"[24]—became completely transformed as it was enhanced and later performed by Calder for the intelligentsia in Paris and New York. Its artfulness was "illuminated," as Sully writes, "by the growing participation in the social consciousness."[25] In making the circus figures, Calder departed from the artfulness of the Japanese brush, instinctively pursuing the most direct means of expression: made from everyday materials that discard superficial aspects of resemblance, Calder's hand-sewn assemblages of bits of cloth and wire describe the action of the performer with an immediacy much akin to that found in the children's drawings Sully reproduced in *Studies of Childhood* (see fig. 79).[26]

Calder's early study of childhood and drawing emboldened him to play out new conceptions about Art. As a result, he invented a unique medium and method, one in which every movement was translated or simplified without any loss of vitality and each observation of nature was translated into its material potential through drawing with wire (fig. 80). The mental and physical sensation of drawing would continue to guide him as a mature artist. As James Johnson Sweeney observed some thirty years after Calder's circus experiments began, "The spirit of play underlies all the vital work that Calder has done. . . . Calder's genius, in other words, is his ability to feel himself into his expression physically, and to compose his work in response to this experience."[27]

NOTES

The epigraph is from James Johnson Sweeney, "Alexander Calder: Work and Play," *Art in America* 44 (Winter 1956–57): 9.

1. Alexander Calder, *Calder: An Autobiography with Pictures* (New York: Pantheon Books, 1966), 70. See also Margaret Calder Hayes, *Three Alexander Calders* (New York: Universe Books, 1987), 69.

2. Hayes, *Three Alexander Calders*, 83. See also James Sully, *Studies of Childhood* (1903; London: Free Association Books, 2000), 330.

3. Alexander Calder, *Animal Sketching* (Pelham, N.Y.: Bridgeman, 1926; Mineola, N.Y.: Dover, 1973).

4. Calder, *Calder: An Autobiography*, 67.

5. Calder, *Animal Sketching*, 7; see also Sully, *Studies of Childhood*, 386.

6. Calder, *Animal Sketching*, 7.

7. Ibid.

8. Ibid.

9. Ibid., 9.

10. Ibid., 23.

11. Ibid., 29.

12. Ibid., 43.

13. Ibid., 53.

14. Elizabeth Valentine and James Sully, "Biographical Introduction," in Sully, *Studies of Childhood*, xliv.

15. Ibid., xi.

16. Sully, *Studies of Childhood*, 330.

17. Ibid., 372.

18. Hayes, *Three Alexander Calders*, 83.

19. Sully, *Studies of Childhood*, 39, 369.

20. Ibid., 386–87.

21. Ibid., 21, 489.

22. Ibid., 322; Calder, *Animal Sketching*, 7.

23. Sully, *Studies of Childhood*, 327.

24. Cleve Gray, "Calder's Circus," *Art in America* 52, no. 5 (1964): 27. Calder mentions embellishing the circus in *Calder: An Autobiography*, 80. See also Joy Sperling, "The Popular Source of *Calder's Circus: The Humpty Dumpty Circus*, Ringling Brothers and Barnum and Bailey, and the Circque Medrano," *Journal of American Culture* 17, no. 4 (Winter 1994): 1–14.

25. Sully, *Studies of Childhood*, 32.

26. Ibid., 369. In an early typescript, Calder states that he made wire animals and a few animated dolls as early as spring 1926; unpublished typescript, January–February 1929, Calder Foundation archives, New York, 1.

27. Sweeney, "Alexander Calder: Work and Play," 12.

"Animal Sketching"

JONATHAN FINEBERG

CHILD'S PLAY AND THE ORIGINS OF ART

There was a child went forth every day,
And the first object he looked upon and received with
wonder or pity or love or dread, that object he became.
WALT WHITMAN

In a photograph taken in July of 1957, Pablo Picasso watches his daughter Paloma draw at the kitchen table; he is completely absorbed (fig. 81). Paul Klee was so fascinated with a watercolor made by his twelve-year-old son Felix in 1919 that he painstakingly copied the upper half of it in an oil painting of 1920, just as a student might copy the work of an Old Master in the Louvre to learn every nuance of its construction (figs. 82 and 83). For the great modern artists who took inspiration from children's drawings, immersion in the creativity of the child added vibrancy to their explorations of whatever was most fundamental to their aesthetic projects, whether it was the radical multivalency of images in Picasso's cubism or the relentless exploration of authenticity that dominated Klee's career.[1] The way children think and express themselves often

[FACING] Paul Klee, *Untitled (Tent City in the Mountains)*, 1920 (detail, fig. 83).

Fig. 81. Pablo Picasso watching his daughter Paloma drawing at the kitchen table at La
California, Cannes, France, July 1957. Photographed by David Douglas Duncan, in Duncan,
The Private World of Pablo Picasso (New York: Ridge Press, 1958), 164. Photography collection,
Harry Ransom Humanities Research Center, The University of Texas at Austin.

has a revelatory quality that seems to go right to the heart of things.

Some years ago, my wife, Marianne, was in the room with my two-and-a-half-year-old son Henry when a fire truck drove by with the siren going. Henry stood up on his bed, looking around, and said excitedly, "It's in my room!" His mother stopped short of saying, "No, it's outside," when she realized that, of course, it *was* in his room. He was talking about the sound, which she had already displaced in her mind to the fire truck outside. In the same way, the drawings of children can reopen the categories into which we normally organize and shelve the common experiences of daily life.[2]

Simple things take on a vividness in child art that often catches us by surprise. The exhilarating freshness we feel—which we are apt to call "innocence"—has to do with the way in which children's drawings reveal and reorganize our emotions. As Rudolf Arnheim puts it, children are "coping with the human condition by means of significant form."[3] In art, children find ways to embody their experience in symbols that they can manipulate in order to explore the relations between themselves and the things they find in the world—just as adult artists do. This work of creating significant form is driven by the necessity of bringing coherence to our experience. Artists are therefore attracted precisely to what they find unfamiliar, out of control, even uncomfortable to see, to that which undermines our categorical habits of seeing, because that is where the most unsettling challenges lie.

René Magritte's *The Rape* of 1934 (fig. 84) demonstrates the way in which an image can communicate a range of emotions that no manner of words can fully portray. Try describing this work verbally to someone

Jonathan Fineberg

who has never seen a reproduction of it, and then show the picture. Images as well as abstract forms embody experience with a directness that destabilizes our usual way of thinking. Moreover, the peculiar sensation of physical unease that a work like this Magritte painting gives us suggests that it communicates on the most primitive psychological level—that of body memory and sensation.

Most of us recognize from our own experience that a variety of physical sensations defying verbalization are commonly evoked by a deep encounter with a work of art. In describing his response to the *Apollo Belvedere*, the eighteenth-century art historian Johann Joachim Winckelmann writes: "My chest seems to expand with veneration and to rise and heave."[4] In a 1964 article for *The Nation*, exactly two hundred years later, Max Kozloff writes: "Ultimately, Pollock . . . gave visual *flesh* to a whole era of consciousness in mid-century."[5] Bodily associations are also common in rebukes to works of art, as when Charles Baudelaire, in his review of the Salon of 1846, calls the pictures of Horace Vernet "a kind of brisk and frequent masturbation in paint, a kind of itching on the French skin."[6]

The fact that something visual can elicit such strong visceral associations hints that works of art articulate bodily experience. In his 1923 book *The Ego and the Id*, Sigmund Freud defines the ego as the psychic mechanism that mediates between primal instincts in the unconscious and the demands of the outside world.[7] The earliest form of the ego, Freud points out, is the body ego, derived from the memory of early bodily sensations.[8] Our visceral response to works of art and the inaccessibility of art to verbal account lead me to surmise that this somatic experience may be a response to the revelation of primary process, the term Freud gave to the preverbal world of primal memory and repressed instinct in the unconscious.

Fig. 82 [*top*]. Felix Klee, *Tent City with Blue River and Black Zig-Zag Clouds*, February 1919. Watercolor on paper, 9⅓ × 6⅝ inches. Private collection, Switzerland.

Fig. 83 [*bottom*]. Paul Klee, *Untitled (Tent City in the Mountains)*, 1920. Oil on cardboard, 7½ × 10⁷⁄₁₆ inches. Private collection, Switzerland. © 2006 Artists Rights Society (ARS), New York / VG Bild-Kunst, Bonn.

Child's Play and the Origins of Art

Fig. 84. René Magritte, *The Rape* (*Le Viol*), 1934. Oil on canvas, 28½ × 21 inches. The Menil Collection, Houston, 76-06 DJ. Photograph by Hickey-Robertson, Houston. © 2006 C. Herscovici, Brussels/Artists Rights Society (ARS), New York.

Visual thinking, then, serves to reconnect us with the content of the primitive unconscious. As Freud notes, in his *Introductory Lectures on Psycho-Analysis* (1917), art opens an exceptionally traversable "path that leads back from phantasy to reality."[9] Kleinian psychoanalysis emphasizes the fluidity of the ongoing dialogue between this bodily atavism and the conscious mind throughout life. But the French psychoanalyst Jacques Lacan goes even further, proposing that what he calls the "I" is a representation, founded in a dialectic with life experience. It is a constructed image, which reenters the world of the unconscious and serves to organize the motile energies of primary process.[10] I am suggesting that art also relies on this kind of introjection, but augmented with a high degree of deliberate intervention in a conscious mode of organizing and contemplating symbolic form. The sculptor Jacques Lipchitz told Paul Dermé in 1920: "The work of art should go from the unconscious to the conscious, and then finally to the unconscious again, like a natural, even though unexplainable, phenomenon."[11]

In 1863, Baudelaire famously wrote that "genius is nothing more nor less than *childhood regained* at will."[12] Underlying this formulation is the perception that the recovery of childhood offers a passage to fundamental knowledge about the present state of existence, and nowhere is this perception more powerful than in the realm of the visual. Thus Baudelaire's "childhood regained" might, in psychoanalytic terms, be better understood as "childhood reintegrated," because the kind of genius that pertains to the creativity of the artist involves, first, a radical exposure—a general lowering of the artist's psychic defenses so as to have liberal access to this material—and, second, a newly coherent reorganizing of unconscious content, as represented in visual forms.

Jonathan Fineberg

In this way, the experience of art involves an integration of unconscious memory and energies with current events; artists simultaneously reveal otherwise inaccessible unconscious material in this unique arena of conscious thought and introject the formal structures they devise back into the unconscious (in the same manner described by Lacan in reference to his concept of representations constructed in experience). It is important to remember the fluidity of this interchange and the way it continually modifies the individual's unconscious organization. In adults, visual thinking continues to have privileged access to the reservoirs of unconscious memory and thought. The act of genius that puts us in awe—in Picasso's *Large Nude in a Red Armchair* of 1929 (fig. 85), for example—is the artist's ability to open this material so profoundly and extensively, and to bring it into rapport with the artist's current state of being. We are in awe because we all recognize ourselves in this exposure and in this reintegration.[13]

The exposure of repressed material is, however, incompatible with the ego, and *that clash* produces anxiety. All artists recognize this anxiety as part of the creative process, and their desire and ability to tolerate it in order to make a work of art mark them apart from most other people.[14] Meanwhile, the public also responds with revulsion to the exposure of unconscious content in a work of art; only a small number of viewers are willing to tolerate, as the artists do, that uneasy encounter that is, however, at the essence of art.

In *Against Architecture,* a book centered on the writings of Georges Bataille, Denis Hollier points out that "the nameless is excluded from reproduction, which is above all the transmission of a name." He then describes Bataille as "relentlessly" attempting to achieve "the perverse linguistic desire to make what is unnameable appear within language itself."[15] Hollier's

Fig. 85. Pablo Picasso, *Large Nude in a Red Armchair*, May 5, 1929. Oil on canvas, 76¾ × 50¹³⁄₁₆ inches. Musée Picasso, Paris. Photograph by J. G. Berizzi, Réunion des Musées Nationaux/Art Resource, New York. © 2006 Estate of Pablo Picasso/Artists Rights Society (ARS), New York.

Child's Play and the Origins of Art

point is that Bataille introduces a powerful, disintegrating force into a text—a force that is intuitively recognizable and undeniable, yet cannot be described explicitly in language. Bataille introduces this into the very ordering and naming—that is, into the reproductive structure of language itself—thus thrusting language into a perpetual state of dynamic instability from within.

The vivid repulsion we feel in response to some of Bataille's best writing resembles our discomfort before Magritte's painting *The Rape*. Both contain a radical exposure of emotional connections that our civilized selves reject; like dreams, they do not follow the rules of conscious logic (in itself a form of repression), but instead they show us a more primal kind of reasoning. What we call "innocent" in the expressive directness of children involves the same destabilizing exposure of the unruly unconscious. Like the ancient Greeks who named the Furies "Eumenides" ("the kindly ones") in order to appease them, we use the term "innocence" to help us distance our adult selves from the perseverance of thoughts too primitive to acknowledge. Yet there is something in the mechanisms of artistic expression that allows the artist to overcome some of the barriers established by the ego between conscious thought and the repressed, and the accessibility of the experience to the viewer implies that the viewer can also breach this wall in her- or himself.

In "Creative Writers and Day-Dreaming" (1908), Freud theorizes that "the essential *ars poetica* lies in the technique of overcoming the feeling of repulsion in us which is undoubtedly connected with the barriers that rise between each single ego and the others."[16] But an even more critical barrier (which Freud does not fully examine) is within the artist's ego itself. When Wassily Kandinsky says, of the artist, that "his joyful vision is the measure of his inner sorrow," he is addressing that transgression of the ego by the revelation of the unconscious and its subsequent mastery through form. The creative process inherently produces anxiety when it releases repressed material, letting it out of the ego's control. This revelation also creates a sense of alienation that the artist experiences as even a sympathetic public steps back from the disorganizing exposure of the unconscious in art. "Even those who are nearest to him in sympathy," Kandinsky says, "do not understand. Angrily they abuse him as a charlatan or madman."[17] But, the greater proximity of visual expression to unconscious material is precisely what gives the best works of art (whether by adults or children) their privileged sense of authenticity.

In art, the barrier between consciousness and the unconscious may be more permeable than Freud believed. Ernst Kris, in his landmark work on creativity, describes the creative process as "a combination of the most daring intellectual activity with the experience of passive receptiveness," citing the poet A. E. Housman's explanation that "poetry is less an active than a passive and involuntary process."[18] Housman reported that he had a drink in the afternoon, the "least intellectual" part of his day, and with his mind essentially elsewhere, poems came to him from "the pit of the stomach."[19] Our sense that creative inspiration "just comes" to us, particularly with somatic associations, suggests that we are experiencing the reemergence of the repressed, rooted in early body memory. The revealing clue is precisely that we feel that we don't know where it comes from. We can't even quite identify it, though we feel that we know it intimately. As Elizabeth Murray has said of the forms in her work: "I sort of know what they are, but don't completely know what they are either."[20]

We could talk at length about the experience described by my then seven-and-a-half-year-old daugh-

Jonathan Fineberg

Fig. 86. Maya Fineberg (female, age 7½, United States), *Resting*, 1989.
Pencil on paper, 8½ × 11 inches. Collection of Jonathan Fineberg.

ter Maya in her simple line drawing of herself taking a rest (fig. 86), for example, without ever coming close to communicating in words what she captured and communicated so vividly in visual form. We understand it completely, and yet we cannot quite describe it. The physicality of her form borders on an uncomfortable directness, transformed by a satisfying mastery. There is, of course, an important distinction between the adult master and even the most talented child in the depth of their intellectual grasp of their subject. It matters fundamentally that Picasso could draw a perfectly rendered female form and chose not

to in his 1929 *Large Nude in a Red Armchair*, whereas the seven-year-old, whose drawing shares some formal similarities with the Picasso, could not: in electing not to use such skills, Picasso consciously raised a series of questions about what forms were most appropriate to his content and made decisions about how to deviate from conventional representation, and this ultimately gives his work a deeper meaning with respect to a wider range of intellectual issues than a child is able to engage.

However, common to both the Picasso and Maya's drawing is the need to give form to bodily experience.

Child's Play and the Origins of Art

Fig. 87 [*above*]. Fred Tomaselli, *Land's End 1*, 1997.
Paper and glue, 15½ × 19⅛ inches. Private collection.
Photograph by John Berens, courtesy of James Cohan
Gallery, New York.

Fig. 88 [*facing*]. Fred Tomaselli, *Land's End 1* (detail),
1997. Paper and glue, 15½ × 19⅛ inches. Private collection.
Photograph by John Berens, courtesy of James Cohan
Gallery, New York.

The child expresses this need more directly; in the work of Picasso, its expression is nuanced, shaped by complex considerations in relation to the adult's experience and intellectual concerns. But this fundamental need is powerful, because it derives from the necessity of ordering and mastering the perpetually shifting relations of perception and emotion at the interface of the psyche and the world. For this reason, great artists often talk about the sense that they became artists because "they couldn't do anything else" or because they "had to paint." The same sensation seems to drive the gifted child: Ellen Winner, in her book *Gifted Children* (1996), describes "a rage to master" as a persistent trait of the gifted child.[21] In adult artists, too, we see a driving need to keep creating, no matter how anxiety-producing the exposure may be and regardless of how arduous the process of giving form to powerful content and then working that content into a new coherence in the symbolic language of art. As Georgia O'Keeffe explained to an interviewer late in life: "I'm frightened all the time. Scared to death. But I've never let it stop me. Never!"[22]

That perpetual drive to continue reflects a need to understand and bring coherence to the ever-changing facts of existence in the world. In creating, the artist not only comes to understand things him- or herself, but he or she also performs a critical service to society in giving form to what is so new in our experience that we do not even have a vocabulary with which to examine it. For example, in Fred Tomaselli's 1997 collage *Land's End 1* (fig. 87), we see what looks like the pages of a bird-watcher's guide. But as we get closer, we begin to notice zippers and Velcro, and all at once it comes to us that he has constructed these birds out of collaged fragments from a Lands' End clothing catalogue (see fig. 88). What is interesting to me in this experience is that neither reading closes out the other;

Jonathan Fineberg

rather, they are overlaid, creating a more complex reality than we first expected to see. This kind of multivalency—whether in complexity theory in physics or in the appropriationist mixing of tracks in hip-hop music—is at the heart of postmodern experience; by necessity, we see in a more unstable, dynamic, and multivalent way today, and this work articulates something about the way we now reconfigure our encounter with daily life on the plane of images. This is something fundamental and new about the world, and although it is a vastly complex epistemology with an open-ended array of continuous possibility, this work gives us a language of forms with which to examine it.

What seems to me so important about Tomaselli's collage is that it literally gives form to an experience of the world that we all share and yet find difficult to articulate in words—all the more so in 1997, when the work was made. More recently, Tomaselli remarked, "Well, you know, I have a funny relationship to nature. The very first nature experience I had was at Disneyland. The first authentic experience I had with nature,

the first waterfall I saw after hiking with my friends, I had this problem where I couldn't quite believe that the waterfall wasn't running by the aid of electricity, pumps, and conduits. But I couldn't quite, and still can't quite, get over the fact that it's actually *real*, or exists outside of culture."[23]

If we understand genius in the mature artist as having to do with the ability to articulate perceptions that we cannot yet put into words and may not even bring into consciousness until we see them in a work of art, then perhaps we need to look for early visual giftedness in the child's ability to grasp complex reality on the level of form, rather than looking for technical achievement such as rendering or the mastery of spatial representation. To paraphrase Paul Valéry, the trouble with the future is that it isn't what it used to be; the artist, like the gifted child, perceives and is impelled to come to terms with an ever-changing reality. As humans, we need art for this, and for both the child and the adult artist, making art is an affirmation of existence in an often bewildering world.

Child's Play and the Origins of Art

NOTES

The epigraph is from Walt Whitman, *Leaves of Grass*, in Whitman, *Complete Poetry and Collected Prose*, ed. Justin Kaplan (New York: Library of America, 1982), 138.

1. I discuss this subject in detail in Jonathan Fineberg, *The Innocent Eye: Children's Art and the Modern Artist* (Princeton, N.J.: Princeton University Press, 1997).

2. Ultimately, this is what great works of art do, too, but in a more sophisticated way and with an affect of greater depth.

3. Rudolf Arnheim, "Beginning with the Child," in Jonathan Fineberg, ed., *Discovering Child Art* (Princeton, N.J.: Princeton University Press, 1998), 22. Reprinted, with slight revisions by the author, in this volume.

4. Johann Joachim Winckelmann, *Geschichte der Kunst des Altertums* (Dresden, 1764), 393; cited in Alex Potts, *Flesh and the Ideal: Winckelmann and the Origins of Art History* (New Haven, Conn.: Yale University Press, 1994), 127.

5. Max Kozloff, "Art," *The Nation* 148, no. 7 (February 10, 1964): 151 (italics added).

6. Charles Baudelaire, "The Salon of 1846," in Baudelaire, *Art in Paris: 1845–1862, Salons and Other Exhibitions*, trans. and ed. Jonathan Mayne (London: Phaidon Press, 1965), 94.

7. Sigmund Freud, *The Ego and the Id* (1923), in *The Standard Edition of the Complete Psychological Works of Sigmund Freud*, vol. 19, ed. and trans. James Strachey (London: Hogarth Press and the Institute of Psycho-Analysis, 1961), 3–66. Freud defines the ego as an integrating mechanism between inner drives and the demands of the outer world; it modifies, redirects, represses, and disguises aspects of the unconscious in order to navigate external reality successfully and at the same time quiet or satisfy inner urges to a tolerable level.

8. Ibid., 26–27.

9. Sigmund Freud, *Introductory Lectures on Psycho-Analysis (Part III)* (1917), in *The Standard Edition of the Complete Psychological Works of Sigmund Freud*, vol. 19, 375.

10. See, for example, Jacques Lacan, *Les Complexes familiaux dans la formation de l'individu: Essai d'analyse d'une fonction en psychologie* (1938; Paris: Navarin, 1984); Jacques Lacan, "The Mirror Stage as Formative of the Function of the I as Revealed in Psychoanalytic Experience," in *Ecrits: A Selection*, trans. Alan Sheridan (New York: W. W. Norton, 1977), 1–7.

11. Jacques Lipchitz with H. H. Arnason, *My Life in Sculpture* (New York: Viking Press, 1972), 195.

12. Charles Baudelaire, "The Painter of Modern Life" (1863), in Baudelaire, *The Painter of Modern Life and Other Essays*, trans. and ed. Jonathan Mayne (London: Phaidon Press, 1964), 8; Charles Baudelaire, *Oeuvres complètes* (Bruges: Gallimard, 1961), 1159.

13. For an interesting discussion of this issue, see Jonathan Lear, *Love and Its Place in Nature* (New Haven, Conn.: Yale University Press, 1990).

14. Samuel Weiss sums up the literature on this subject well in his review of Gudmund J. W. Smith and Ingegerd M. Carlsson's *The Creative Process: A Functional Model Based on Empirical Studies from Early Childhood to Middle Age* (Madison, Conn.: International Universities Press, 1990), in *Psychoanalytic Quarterly* 63 (1994): 599. He also notes that Smith and Carlsson "even suggest that the sensitivity, coming close to projection, allows internal threats to be experienced as outside."

15. Denis Hollier, *Against Architecture* (Cambridge, Mass.: MIT Press, 1989), 31.

16. Sigmund Freud, "Creative Writers and Day-Dreaming" (1908), in *The Standard Edition of the Complete Psychological Works of Sigmund Freud*, vol. 9, 153.

17. Wassily Kandinsky, *Concerning the Spiritual in Art*, trans. Francis Golffing, Michael Harrison, and Ferdinand Ostertag, after Michael Sadleir (New York: George Wittenborn, 1947), 27.

18. Ernst Kris, *Psychoanalytic Explorations in Art* (New York: International Universities Press, 1952), 318, 295.

19. Ibid., 295.

20. Elizabeth Murray, in *Fourteen Americans: Directions of the 1970s* (Michael Blackwood Films, 1980).

21. Ellen Winner, *Gifted Children* (New York: Basic Books, 1996), 3.

22. Georgia O'Keeffe, in Mary Lynn Kotz, "A Day with Georgia O'Keeffe," *Art News* (December 1977); cited in Laurie Lisle, *Portrait of an Artist: A Biography of Georgia O'Keeffe* (Albuquerque: University of New Mexico Press, 1986), 217.

23. Fred Tomaselli, in a documentary film created by John Carlin and Jonathan Fineberg, *Imagining America: Icons of Twentieth-Century Art* (Muse Film and Television, 2005).

Jonathan Fineberg

GALLERY

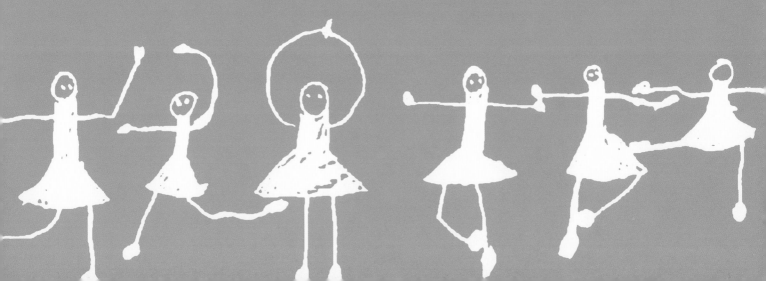

INFORMATION ABOUT ARTISTS, MEDIA, AND DIMENSIONS HAS BEEN PROVIDED WHEN AVAILABLE. NATIONALITIES OF WELL-KNOWN ARTISTS HAVE BEEN OMITTED. UNLESS OTHERWISE INDICATED FOR DATES ON CHILDREN'S DRAWINGS, WORKS IN THE RUDOLF ARNHEIM COLLECTION DATE FROM THE 1940S–50S, WORKS LISTED IN THE JONATHAN FINEBERG COLLECTION DATE FROM THE 1980S–90S, AND WORKS FROM THE INTERNATIONAL MUSEUM OF CHILDREN'S ART, OSLO, DATE FROM THE 1980S–90S.

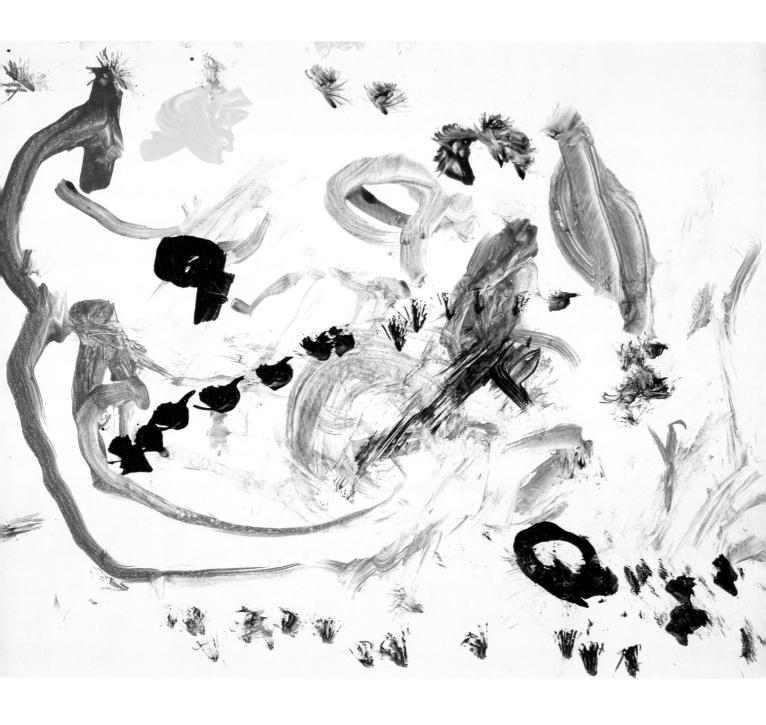

1. **HANNAH SCATES** (female, age 3, United States), *Untitled*.
Tempera on paper, 11 × 14 inches. Collection of Jonathan Fineberg.

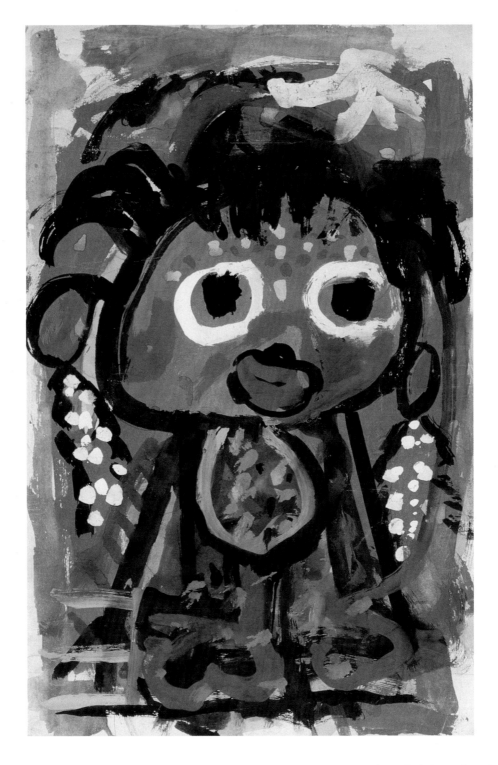

2. **M. DAVANA** (age 3, India), *Myself.* 20⅞ × 14⅛ inches.
The International Museum of Children's Art, Oslo.

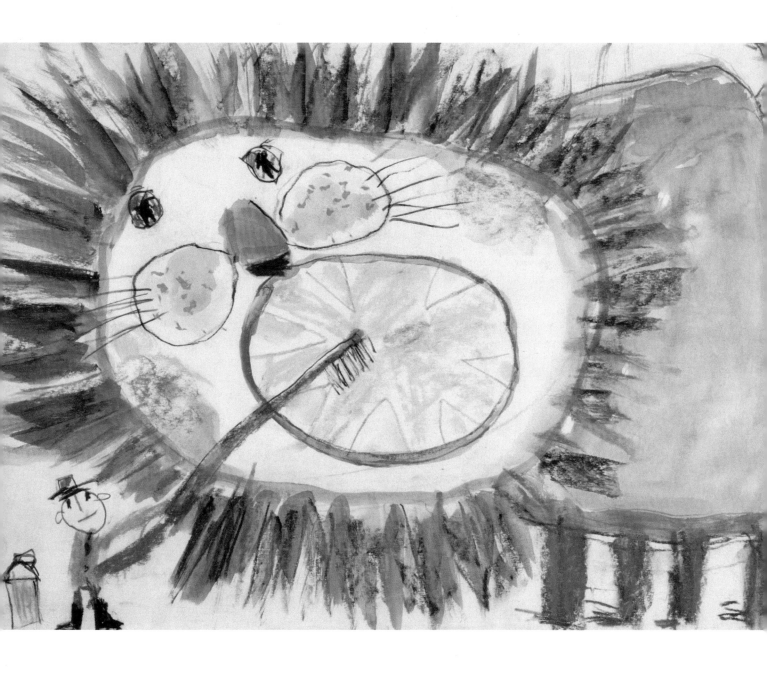

3. **ERIKA TAMANO** (female, age 3, Japan), *The Lion's Toothpaste*. Watercolor and oil pastels on paper, 14¾ × 20⅞ inches. The International Museum of Children's Art, Oslo.

4. **SWAPNIL SANJAY SHAH** (male, age 3, India), *Grandpa and I.*
14½ × 22 inches. The International Museum of Children's Art, Oslo.

5. *TOMAZ GLOBOVNIK* (male, age 3, Slovenia), *The Boy Pedenjed Does His Hair*. Gouache and
oil pastels on paper, 11⅜ × 8 inches. The International Museum of Children's Art, Oslo.

6. **MICHIRU SHIOJI** (male, age 3, Japan), *My Father Is Angry*. Gouache on paper, 20⅞ × 14½ inches. The International Museum of Children's Art, Oslo.

7. **ERNST LUDWIG KIRCHNER** (age 3), *Railroad Train*, January 21, 1884.
Pencil on paper, 6½ × 9 inches. Collection of Dr. E. W. Kornfeld.
© by Ingeborg & Dr. Wolfgang Henze-Ketterer, Wichtrach/Bern.

8. *MAYA FINEBERG* (female, age 4, United States), *Untitled Tadpole Figure.*
Marker on paper, 11 × 8½ inches. Collection of Jonathan Fineberg.

9. **PAUL KLEE** (c. age 4–5), *Untitled (Frau und Kind mit Aufgespannten Schirmen, und eine Erwachsene mit Kind [Woman and Child with Open Umbrella, and an Adult with a Child]),* 1883–85. Pencil on red-lined paper, 6⅓ × 7⅓ inches. Private collection, Switzerland.
© 2006 Artists Rights Society (ARS), New York / VG Bild-Kunst, Bonn.

10. **TAKAKO TOMITA** (female, age 4, Japan), *A Train Running in the Sunset*.
15⅛ × 21¼ inches. The International Museum of Children's Art, Oslo.

11. ***FELIPE BARRICO*** (male, age 4, Brazil), *The Family Stroll*. 11¹³⁄₁₆ × 16⅛ inches.
The International Museum of Children's Art, Oslo.

12. **ASAMI KANESHIGE** (female, age 4, Japan), *A Hen*. Charcoal and tempera on blue paper, 15¾ × 21⁷⁄₁₆ inches. Collection of Rudolf Arnheim.

13. **DOLORES ROCHA-SANCHEZ** (female, age 4, Mexico), *Portrait.*
13⅜ × 9 inches. The International Museum of Children's Art, Oslo.

14. **LUAI TABAZA** (male, age 4, Jordan), *Untitled*. Watercolor and ink on paper, 13 × 9¹³⁄₁₆ inches. The International Museum of Children's Art, Oslo.

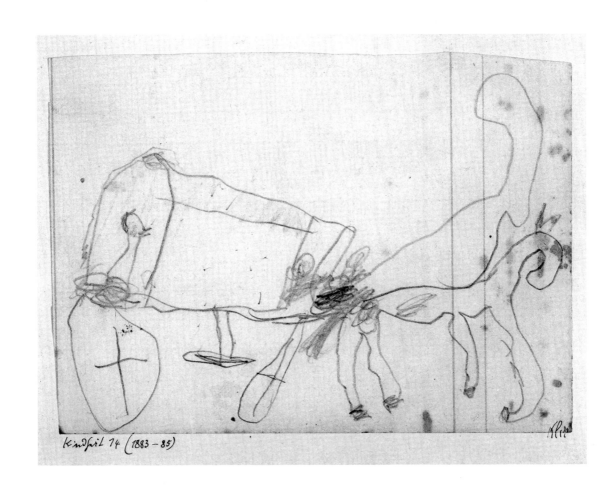

Kindheit 14 (1883–85)

Klee

15. **PAUL KLEE** (c. age 4–5), *Horsedrawn Wagon (Droschkengespann)*,
1883–85. Pencil on paper, 4⅙ × 5¾ inches. Kunstmuseum Bern.
© 2006 Artists Rights Society (ARS), New York / VG Bild-Kunst, Bonn.

16. **MUHAMMED MUHAMMED EL HUSSEINI** (male, age 5, Egypt), *Family Seen Through Children's Eyes*. 12⁹⁄₁₆ × 9 inches. The International Museum of Children's Art, Oslo.

17. **YUMIKO ISHIKAWA** (female, age 5, Japan), *Full of Blossoms*. Watercolor on pink paper, 15¼ × 21¼ inches. Collection of Rudolf Arnheim.

18. **DAVID ARTHUR** (male, age 5, United States), *Untitled*. Marker and crayon on paper, 12 × 18 inches. Collection of Jonathan Fineberg.

19. **COSTI YANNELIS** (male, age 5½, United States), *Untitled (War Scene)*.
Marker on paper, 8½ × 11 inches. Collection of Jonathan Fineberg.

20. **BETYE SAAR** (c. age 5), *Baby*, c. 1931. Crayon and ink stamp on paper, 9 × 12 inches. Collection of the artist. Photograph courtesy of Michael Rosenfeld Gallery, LLC, New York.

21. **MAYA FINEBERG** (female, age 5½, United States), *Duck with Falling Blueberries*.
Tempera on paper, 8¾ × 11⅞ inches. Collection of Jonathan Fineberg.

22. **NAOMI FINEBERG** (female, age 5, United States), *Dalmatian*.
Pencil on paper, 16 × 23 inches. Collection of Jonathan Fineberg.

aged 5. —

23. **SIR EDWIN LANDSEER** (age 5), *Sketch of a Dog*, c. 1807. Pencil on paper,
4³⁄₁₆ × 4⅓ inches. Victoria and Albert Museum, London, FA48.
© The Board of Trustees of the Victoria and Albert Museum.

121

24. **TAKESHI VEDA** (male, age 5, Japan), *A Postman*. 20½ × 15 inches.
The International Museum of Children's Art, Oslo.

25. *HE SI NUO* (age 5, China), *Going to School*. Gouache on paper,
19⅞ × 20¼ inches. The International Museum of Children's Art, Oslo.

26. **ARTIST UNKNOWN** (c. age 5), *Untitled (Face)*. Pencil and crayon on paper, 11⅞ × 7⅞ inches. Viktor Lowenfeld Papers, Pennsylvania State University Archives, Pennsylvania State University Libraries.

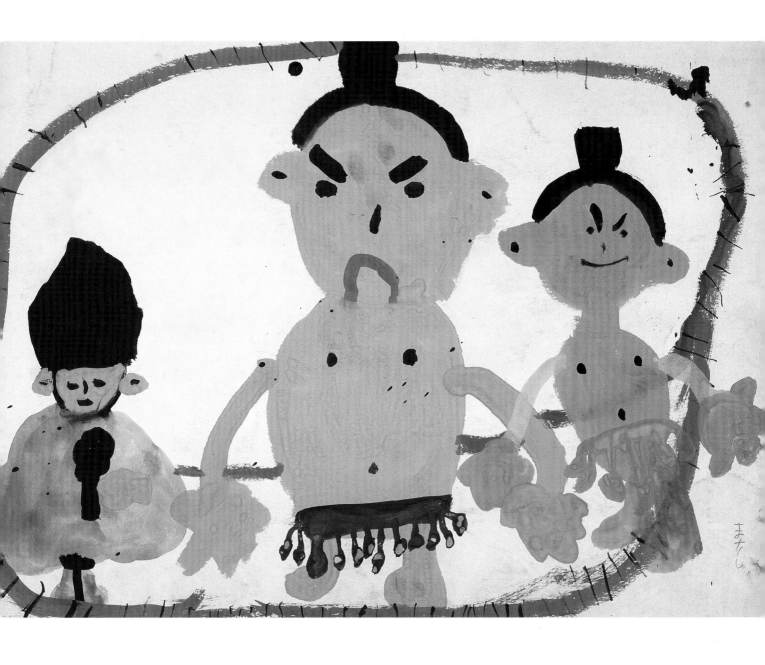

27. **MASASHI YAMADA** (male, age 5, Japan), *Sumo Wrestling*. Tempera on paper, 15 × 21¼ inches. Collection of Rudolf Arnheim.

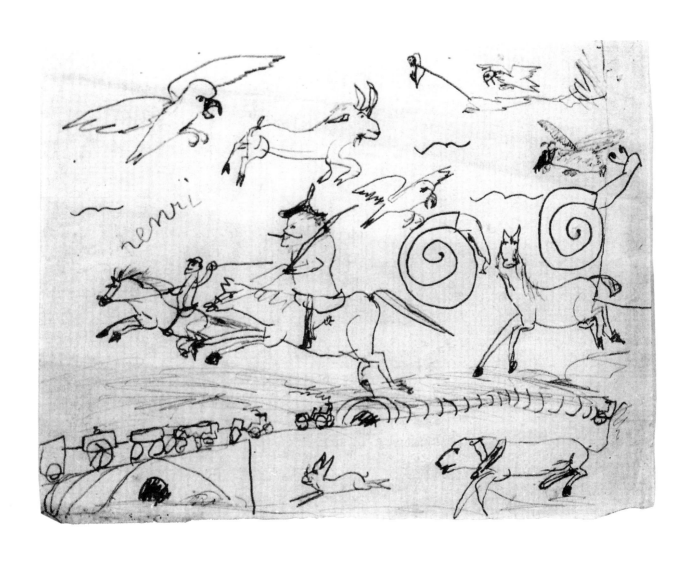

28. **HENRI DE TOULOUSE-LAUTREC** (c. age 6), *Untitled (Horsemen, Trains, Birds and Animals)*, c. 1870. Pencil, 6¾ × 9⅛ inches. Château de Bosc, Naucelle, France. Photograph courtesy of the Musée Toulouse-Lautrec, Albi, with the authorization of Mme Tapié de Céleyran.

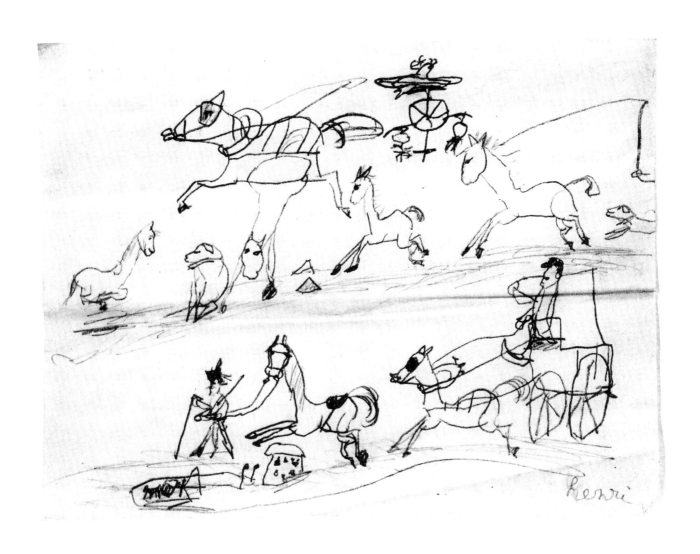

29. *HENRI DE TOULOUSE-LAUTREC* (c. age 6), *Horsedrawn Wagon, Man Leading a Horse and a House by a River on the lower tier; upper tier: Horses and Dogs,* c. 1870. Pencil, 6¾ × 9⅛ inches. Château de Bosc, Naucelle, France. Photograph courtesy of the Musée Toulouse-Lautrec, Albi, with the authorization of Mme Tapié de Céleyran.

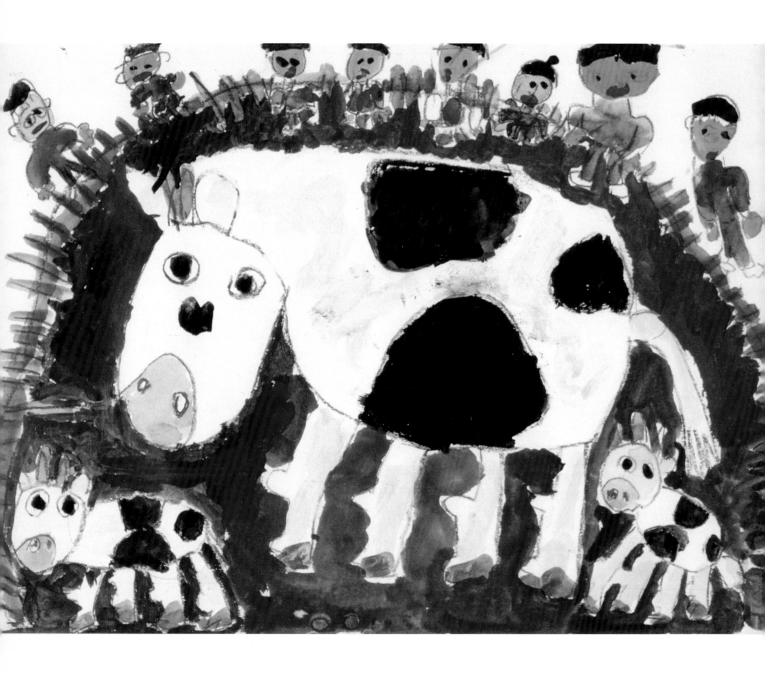

30. **TAKANORI SHIOI** (male, age 5, Japan), *Pretty Cow*. 14¾ × 20⅞ inches. The International Museum of Children's Art, Oslo.

31. **DEBASHIS MAZUMDER** (male, age 6¾, United States), *Ninja Turtle*.
Tempera on paper, 18 × 12 inches. Collection of Jonathan Fineberg.

32. **MICHELLE VEIDENBAUM** (female, age 6, United States), *Untitled Figure*. Marker on paper, 11 × 8½ inches. Collection of Jonathan Fineberg.

33. ***JOHANNES*** (male, c. age 7, the Netherlands), *Ensign with Two Dogs*,
c. 1520–25. Pen and ink, in a schoolbook from the old Latin school of Edam:
Horatius, *Epistolae* (Paris, 1503?). The Hague, Koninklijke Bibliotheek.

34. *"JOHANNES"* (male, c. age 7, the Netherlands), *Ensign on a Ship*, c. 1520–25.
Pen and ink, in a schoolbook from the old Latin school of Edam: Aesopus,
Fabulae (Louvain, 1513). The Hague, Koninklijke Bibliotheek, Edam 8:1.

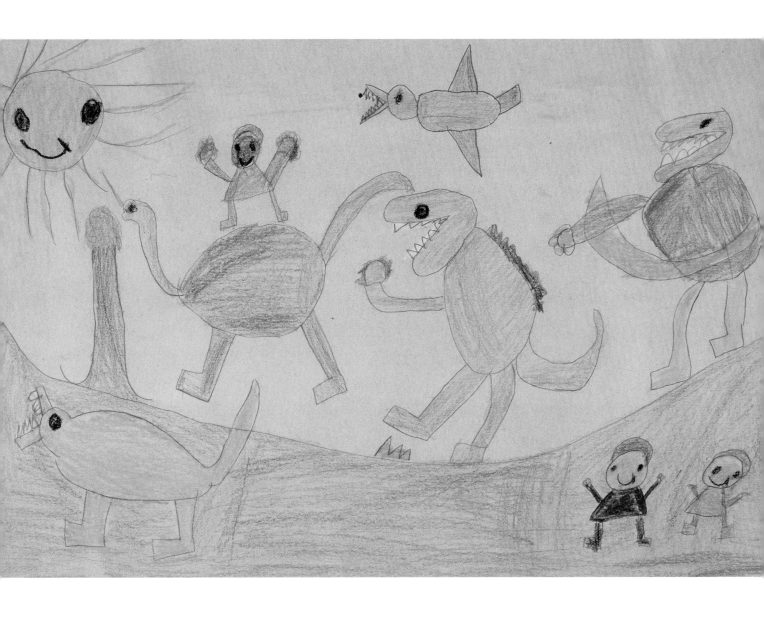

35. **NOAH FIELDER** (male, age 7, United States), *Dinosaur and Soldiers*.
Crayon on paper, 10¾ × 17 inches. Collection of Jonathan Fineberg.

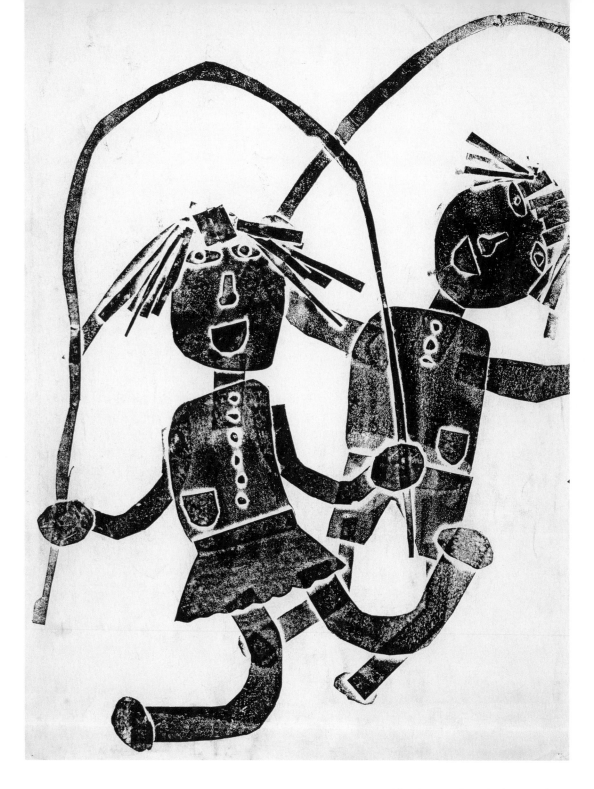

36. **MAKIKO SUGAI** (female, age 7, Japan), *Skipping*. Ink monoprint on paper, 21½ × 15½ inches. Collection of Rudolf Arnheim.

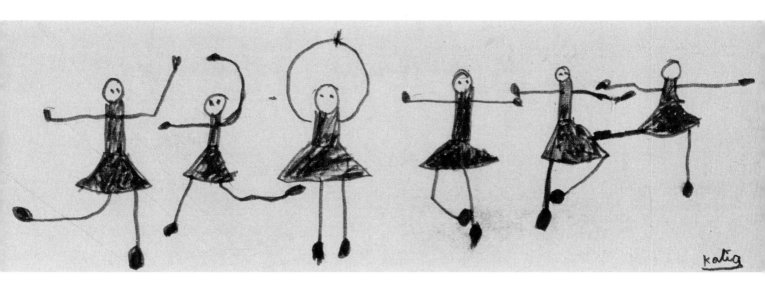

37. **KATIA JOHANDY** (female, age 7, France), *Classic Dance*. Ink on paper, 3⅛ × 10⅝ inches. The International Museum of Children's Art, Oslo.

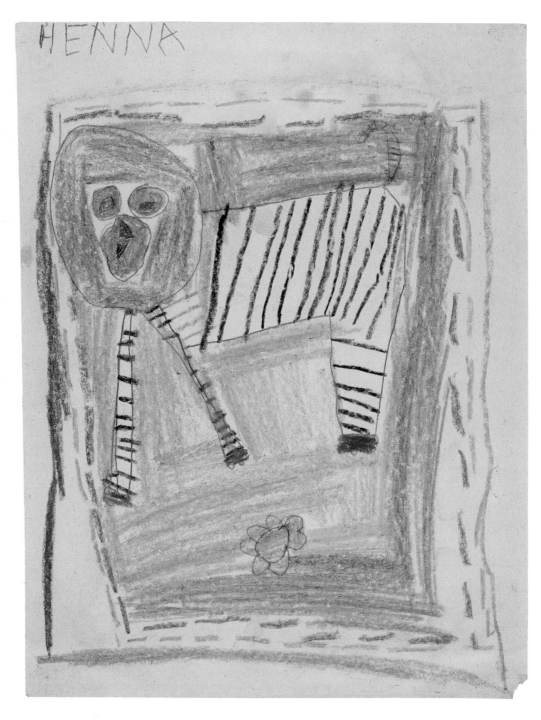

38. **HENNA KHALIQUE** (female, age 7, United States), *Lion*.
Crayon on paper, 12 × 10 inches. Collection of Jonathan Fineberg.

39. **G. V. DAMITH** (age 7, Sri Lanka), *Gentle Giants*. 14¾ × 18⅞ inches.
The International Museum of Children's Art, Oslo.

40. **WILL WARDEN** (male, age 7, United States), *Zeus, His Wife, and a Guy Who Got Struck by Lightning*. Colored marker on paper, 9 × 12 inches. Collection of the artist.

41. **WILL WARDEN** (male, age 7, United States), *Ninjas Fighting,
Teeth Knocked Out, Sword Knocked Out of One's Hand.* Colored
marker on paper, 9 × 12 inches. Collection of the artist.

42. *ARTIST UNKNOWN* (age 7, Japan), *Bull.* 15 × 21¼ inches.
The International Museum of Children's Art, Oslo.

43. **BRANDY BERRY** (female, age 7, United States), *Cat*. Crayons and glitter on paper, 17⅞ × 12 inches. Collection of Jonathan Fineberg.

44. **HENRY FINEBERG** (male, age 7¾, United States), *Halloween Spooks*.
Crayon on paper, 13 × 19⅝ inches. Collection of Jonathan Fineberg.

45. **REMY TIPEI** (male, age 7, United States), *War*. Marker on paper, 11 × 17 inches. Collection of Jonathan Fineberg.

46. **PIERRE ALECHINSKY** (age 8), "*Notre visite au jardin zoologique,*" October 19, 1935. Pencil drawing on schoolbook. Collection of the artist. © 2006 Artists Rights Society (ARS), New York / ADAGP, Paris.

47. **MARLINA STRÉCHOVA** (female, age 8, Czech Republic),
A Stroll. The International Museum of Children's Art, Oslo.

48. *TAKAFUMI KABAYASHI* (male, age 8, Japan), *Weighing*. Ink and gouache on tan cardboard, 21¼ × 14⁷⁄₁₆ inches. Collection of Rudolf Arnheim.

49. **FRANK PRATT** (male, age 8, United States), *War*. Crayon
on paper, 8⅞ × 15¾ inches. Collection of Jonathan Fineberg.

50. *JINICHI OZAWA* (male, age 8, Japan), *A Snow Plow*. Gouache and ink, 15½ × 21⅜ inches. Collection of Rudolf Arnheim.

51. **HENRY FINEBERG** (male, age 8, United States), *Electric Solar-Powered Pocket Knife*
(including headset, toothpick, recorder, magnifying glass, mini dishwasher, squirt gun,
clear bug-box, address book, toenail clippers, tweezers, nail file, dictionary, mini spoon,
radio, pencil, mini fork, mini TV, clock, solar panel, mini telephone, and star-shaped
cookie cutter). Pencil on paper, 5¼ × 4½ inches. Collection of Jonathan Fineberg.

52. **SHINICHI ARAI** (male, age 8, Japan), *An Old Story*. Gouache and ink, 15¹³/₁₆ × 21¹/₁₆ inches. Collection of Rudolf Arnheim.

53. **JOAN MIRÓ** (age 8), *Pedicure*, 1901. Colored pencil, watercolor, and ink on paper, 4⅝ × 6¹¹⁄₁₆ inches. Fúndació Joan Miró, Barcelona, F.J.M. 22. © 2006 Successio Miró / Artists Rights Society (ARS), New York / ADAGP, Paris.

54. **JOAN MIRÓ** (age 8), *Umbrella*, 1901. Pencil on paper, 7¼ × 4 inches. Fúndació Joan Miró, Barcelona, F.J.M. 19. © 2006 Successio Miró / Artists Rights Society (ARS), New York / ADAGP, Paris.

55. **VINCENT VAN GOGH** (age 8¾), *Sketches of a Dog Head,*
Cow Head, and Three Men's Heads, January 3, 1862. Black chalk
on paper, 8¾ × 7 inches. Van Gogh Museum, Amsterdam.

56. ***FRANKLIN DELANO ROOSEVELT*** (c. age 9), *House and Tree*, c. 1890–92. Ink on paper, 4 × 6⅛ inches. Franklin D. Roosevelt Library, Hyde Park, New York, MO 82-8:1.

57. *FRANKLIN DELANO ROOSEVELT* (c. age 9), *Horse and Buggy*, c. 1890–92. Ink on paper, 4 × 5⅝ inches. Franklin D. Roosevelt Library, Hyde Park, New York, MO 82-8:2.

58. *SIR JOHN EVERETT MILLAIS* (c. age 9), *A Dog in Profile*, late 1830s.
Pencil, 3½ × 5 inches. Royal Academy of Arts, London.

59. **TENAYA ARNESON** (female, age 9¼, United States), *My Brother Kerk as Santa Claus*. Ink, pencil, and watercolor on paper, 14³⁄₁₆ × 10³⁄₁₆ inches. Collection of Jonathan Fineberg.

60. *GERARD TER BORCH* (age 9), *Figure Study*, April 24, 1626.
Black chalk, 5⅛ × 5⅛ inches. Rijksmuseum, Amsterdam, A 783.

61. **REGINALD MARSH** (c. age 9), *Childhood Drawing of a Policeman*,
c. 1907, Sketchbook no. 26. Pencil on paper, c. 4 × 3 inches.
Reginald Marsh Papers, Archives of American Art. Photograph by
Geoffrey Clements, © 2006 Estate of Reginald Marsh / Art Students
League, New York / Artists Rights Society (ARS), New York.

62. **PABLO PICASSO** (age 9), *Picador*, 1889–90. Oil on panel, 9½ × 7½ inches. Private collection, Paris. © 2006 Estate of Pablo Picasso / Artists Rights Society (ARS), New York.

63. **CAI MENG** (age 10, China), *Lion Drawing*. 16¹⁵⁄₁₆ × 26¾ inches.
The International Museum of Children's Art, Oslo.

64. **THÉODORE CHASSÉRIAU** (age 10), *Turk Holding a Giraffe by a Rope with Another Turk Behind*, 1829. Watercolor and brown ink in a sketchbook, 3⁹⁄₁₆ × 4¼ inches. Musée du Louvre, Paris, inventaire: vol. 25, p. 378.

65. **OLYA BOBROVA** (female, age 10, Russia), *Affected*. Gouache on paper,
15¾ × 13⁹⁄₁₆ inches. The International Museum of Children's Art, Oslo.

66. **YUKA SAITO** (female, age 10, Japan), *Aoi Festival*. Pastel and gouache on paper, 14⅜ × 21⅛ inches. Collection of Rudolf Arnheim.

67. **PAUL KLEE** (age 10), *Das Storchennest auf dem Haus* (*The Stork's Nest on the House*), 1889. Pencil on paper, 7½ × 8⅞ inches. Estate of Felix Klee, inv. no. 1230. Photo © Bildarchiv Felix Klee. © 2006 Artists Rights Society (ARS), New York / VG Bild-Kunst, Bonn.

68. *EDWARD HOPPER* (c. age 10), *Untitled (Civil War Battle Scene)*, c. 1892. Graphite on paper, 8 × 10 inches. Whitney Museum of American Art, New York, bequest of Josephine N. Hopper, 70.1553.45. Photograph by Geoffrey Clements.

Battle Bunker's Hill.

69. *TIMOTHY TILESTON* (male, age 10), *Battle of Bunker's Hill*,
c. 1797. Watercolor on laid paper, 5¹¹⁄₁₆ × 7⁹⁄₃₂ inches. Courtesy
Winterthur Museum, bequest of Henry Francis du Pont.

Oct. 18, 1904.

Spring

70. **E. E. CUMMINGS** (age 10), *Spring*, October 18, 1904. Black ink,
10⅞ × 8⅓ inches. By permission of the Houghton Library,
Harvard University, Cambridge, Massachusetts, BMS AM 1823.7 (5).

71. **E. E. CUMMINGS** (c. age 10), *Untitled ("Edward Estlin Cummings the animal ruler and his matchless group of 32 elephants little and big")*, c. 1904. Black ink, 9 × 5½ inches. By permission of the Houghton Library, Harvard University, Cambridge, Massachusetts, BMS AM 1823.7 (5).

72. **MERET OPPENHEIM** (age 10), *Child-Devouring Devil*, c. 1923.
Pencil and watercolor, 6⁵⁄₁₆ × 4⅛ inches. Private collection, Switzerland.
© 2006 Artists Rights Society (ARS), New York / ProLitteris, Zürich.

73. **JONAS LINDBORG** (male, age 10, Sweden), *Dad*. Gouache and India ink on paper, 7¾ × 11¼ inches. The International Museum of Children's Art, Oslo.

74. ***VEZA BEZBARDOVA*** (age 10, Belorussia), *A Poor Child.* 16¹⁵⁄₁₆ × 11¹³⁄₁₆ inches. The International Museum of Children's Art, Oslo.

75. **DAVID** (male, age 11), *Abschied, Eisenbahnwagon* (captioned *D.H., D bids
Farewell to His Father* by Viktor Lowenfeld), December 3, 1936. Pencil on
paper, 6⅝ × 9 inches. Viktor Lowenfeld Papers, Pennsylvania State
University Archives, Pennsylvania State University Libraries.

76. *SIR JOHN EVERETT MILLAIS* (c. age 11), *Study of a Sleeping Lion and Pacing Tiger*, late 1830s or early 1840s. Watercolor over pencil, 11 × 14⁹⁄₁₆ inches. Royal Academy of Arts, London.

77. ***EDWARD HOPPER*** (age 11), *Untitled (Sketch of a Dog)*, June 12, 1893. Charcoal on paper, 15 × 11 inches. Whitney Museum of American Art, New York, bequest of Josephine N. Hopper, 70.1560.174. Photograph by Geoffrey Clements.

78. **NARIYOSHI MINAMI** (male, age 11, Japan), *Taima Temple.*
Ink and gouache, 21⁷/16 × 14 inches. Collection of Rudolf Arnheim.

79. **ROBERT ARNESON** (age 11), *Untitled*, c. 1941. Pencil on paper mounted on board, 8½ × 11 inches. Collection of the Estate of Robert Arneson, Art © Estate of Robert Arneson / Licensed by VAGA, New York.

80. **ARTIST UNKNOWN** (age 11), *Mother Visiting Me (Nine Women and Girls)*.
Colored pencil or crayon(?) on paper, 17¼ × 22⅝ inches. Viktor Lowenfeld Papers,
Pennsylvania State University Archives, Pennsylvania State University Libraries.

81. **ARTIST UNKNOWN** (c. age 11), *Untitled (Seven Figures)*. Crayon on paper, 12 × 18⅛ inches. Viktor Lowenfeld Papers, Pennsylvania State University Archives, Pennsylvania State University Libraries.

82. **GREGORY STAFFORD** (male, age 11, United States), *A Visit to the DIA*.
Pen and pencil on paper, 10⅞ × 14 inches. Collection of Jonathan Fineberg.

83. *JAN ERIK SØRENSEN* (male, age 11, Norway), *When My Father Gets Angry*.
12³⁄₁₆ × 16½ inches. The International Museum of Children's Art, Oslo.

84. *CLAES OLDENBURG* (age 11), *A Part of Neubern's Army, from "Neubern and Its Modern Ways of Living,"* February 1939. Pencil and collage in staple-bound book, 11 × 8½ inches. Collection of the artist. Photograph by Ellen Page Wilson, New York.

85. **CLAES OLDENBURG** (age 11), *Landscape with Air War*, c. 1940.
Pencil and colored pencil, 11 × 8½ inches. Collection of
the artist. Photograph by Ellen Page Wilson, New York.

86. **MARK LEE** (male, age 11, United States), *My Teacher Made Me Draw Myself*.
Pencil on paper, 12 × 9 inches. Collection of Jonathan Fineberg.

87. **_LARRY WALKER_** (male, age 12, United States), _Untitled (Portrait)_.
Pastel, 17⅞ × 11⅞ inches. Collection of Jonathan Fineberg.

88. *KATIE MONAGHAN* (female, age 12, United States), *Untitled.*
Pencil on paper, 5⅛ × 8 inches. Collection of Jonathan Fineberg.

89. *LINA KRISTIN WELLE* (female, age 13, Norway), *Untitled*.
12⅝ × 11¹³⁄₁₆ inches. The International Museum of Children's Art, Oslo.

90 [*top*]. **RIGIL WOODS** (male, age 12, United States), *Cartoon.*
Pencil on paper, 7⅜ × 10⅜ inches. Collection of Jonathan Fineberg.

91. **WINSLOW HOMER** (age 13), *Rocket Ships*, 1849–50. Graphite
pencil on cream wove paper, 3¾ × 15⅛ inches. Museum of
Fine Arts, Boston, gift of Edwin A. Wyeth, 1913.13.4499.

92. *MICAH OGLESBY* (male, age 13, United States), *Untitled Portrait of a Man with a Moustache.* Pencil on paper, 10½ × 6½ inches. Collection of Jonathan Fineberg.

93. **_KERRY JAMES MARSHALL_** (age 15), _Untitled (Skull)_, c. 1970–71. Graphite on paper,
17 × 19 inches. Collection of the artist. Photograph courtesy of Koplin del Rio Gallery,
West Hollywood, permission courtesy of Jack Shainman Gallery, New York.

94. **TAKUKO SHIJO** (female, age 15, Japan), *Self-Portrait*. Pencil and gouache, 14¹⁵⁄₁₆ × 21¼ inches. Collection of Rudolf Arnheim.

95. **WALT DISNEY** (age 16), *Untitled (Head of a Woman)*, c. 1917.
Pencil on cardboard, 6 × 3⅞ inches. Walt Disney Archives,
Burbank, California, © Disney—All rights reserved.

96. **WALT DISNEY** (age 16), *Untitled (Sheet of Cartoon Heads)*, c. 1917.
Black ink on gray paper, 8⅜ × 5⅞ inches. Walt Disney Archives,
Burbank, California, © Disney—All rights reserved.

97. *DWIGHT DAVID EISENHOWER* (c. age 15–19), *Untitled drawing from inside back cover of his brother's copy of* Silas Marner *by George Eliot,* c. 1905–9. Pencil on paper, open pages 6⁷⁄₁₆ × 8½ inches. Dwight D. Eisenhower Library, Abilene, Kansas.

98. **TED TURNER** (age 17), *Untitled Shipwreck*, 1955.
Watercolor on paper. Collection of the artist.

99. *GEORG BASELITZ* (age 17), *Untitled*, 1955. Watercolor, 16½ × 11¾ inches.
Kunstmuseum Basel, Kupferstichkabinett, Basel. © Georg Baselitz.

100. **LAURA HERZBERG** (female, age 17, United States). *Self-Portrait.*
Pencil and colored pencil on paper, 28 × 22 inches. Collection of the artist.

1224-38 Around 1980, archaeological excavations in Novgorod, Russia, reveal seven birch-bark fragments with drawings, dating from between 1224 and 1238 A.D. Scratched into the bark by a six- or seven-year-old boy named "Onfim," these appear to be both writing lessons for the boy and expressive drawings. By the mid-1980s, these excavations have produced 632 fragments "written by local townsfolk, among them women and children."[1]

1348-53 Giovanni Boccaccio (1313–1375), *Decameron*. In this fictional work, a plague has stricken Florence, prompting twelve young men and women to head for the country, where they travel together from villa to villa and entertain one another with stories every day for twelve days. On the sixth day, the storyteller relies on his audience's knowledge of how children draw to persuade them that there is no older and more noble family than the Baronci, whose physiognomy is the ironic proof: "whereas other men have well-formed, and properly proportioned faces, a number of the Baronci have a very long

and narrow face, while others have faces wide beyond all measure; still others have very long noses, some of them short ones, and some have chins that stick out and turn up with jaws like that of an ass; and there are even some who have one eye bigger than the other, and there are even a few who have one eye lower than the other, which all gives them faces like the ones children usually make when they are first learning how to draw.... It seems quite obvious that the Good Lord was still learning to paint when he created them; therefore, since they are older than anyone else, they are the most noble."[2]

C. 1520-25 In the margins of his schoolbooks from the Latin school of Edam in the Netherlands, a child draws two pictures, among the earliest known examples of children's art (see gallery nos. 33–34). (The books are now housed in the Royal Library, The Hague.) One of the drawings depicts an ensign standing on a ship, holding a flag that waves behind him. The other shows what may be the same ensign and flag, but no ship is shown; instead, the ensign holds a small dog on a leash while another small dog stands beside him. On the basis of the style, we might speculate that the drawings were done by a six- or seven-year-old child.

1528 Conte Baldessare Castiglione (1478–1529), *Il Cortegiano (Book of the Courtier)*.[3] Castiglione advocates the importance of drawing in a young courtier's education; he also advocates the education of young (gentle)women.

1550 Giorgio Vasari (1511–1574), *Le Vite de' più eccellenti architetti, pittori, et scultori italiani (The Lives of the Most Eminent Italian Architects, Painters, and Sculptors)*. "In our own times it has been seen ... that simple children roughly reared in the woods, with their only model in the beautiful pictures

[ABOVE] Onfim (male, age 6–7, Russia), *Untitled*, c. 1224–38. Scratches on birch bark.

and sculptures of nature, and by the vivacity of their wit, have begun by themselves to make designs."[4]

1601–28 Jean Héroard (1551–1628), a physician, comes into the service of the future Louis XIII of France at the time of the prince's birth in 1601 and subsequently documents the prince's rearing, behavior, and health in detail in a journal.[5] Interleaved into the six handwritten volumes of the journal are twenty-five original drawings made by Louis between 1606 and 1609 with commentary by the doctor and occasional transcriptions of remarks about them by Louis (see page 60 and figs. 55–73). More than a diversion, art is a natural gift for Louis, one he will continue to cultivate throughout his life (see fig. 28). As a child, he does not like to read or write, but he likes looking at pictures, which the queen encourages by giving him books of engravings. Héroard cleverly uses this passion in the young prince to teach him in other ways as well. He does not teach Louis writing or reading or religion—this is left to special instructors—but rather, Héroard teaches and guides the prince according to his tastes and inclinations. Nevertheless, Héroard seems to regard the drawings as little more than an indulgence and a means to enhance Louis's intellectual discipline. At the age of seven, Louis leaves the world of childhood at Fontainebleau and St. Germaine-en-Laye and moves to the Louvre, where his education is transferred to his father, the king, and his governor, M. de Souvré. Héroard's role is now to supervise only the health of the prince; he is no longer Louis's instructor, and at this point the text in the journal thins out. When Henri IV is assassinated in 1610, Héroard is nominated first physician, owing to the influence of Marie de Médici, and he holds this position for the rest of his life. At Héroard's death in 1628, Louis says, "I still really need him." Héroard's journal is one of the only extant sources of premodern childhood drawings.

1693 John Locke (1632–1704), *Some Thoughts Concerning Education*. Locke considers the ability to draw an important facet of the young gentleman's education because it enables him to communicate more thoroughly than with "a whole sheet of paper in writing."[6] Influenced by Locke,

Benjamin Franklin will further propose, in 1749, that "Drawing is no less useful to a Mechanic than to a Gentleman."[7] Locke's emphasis on learning from the experience of the senses (rather than from books) and on the importance of adapting education to the nature of the child will influence Jean-Jacques Rousseau's ideas of drawing as a means of learning to see.[8]

1762 Jean-Jacques Rousseau (1712–1778), *Emile*. One of the most widely read philosophical treatises on education and child rearing, written in the form of a didactic novel, *Emile* is banned by the authorities upon its publication, subsequently causing its author, under threat of arrest, to go into self-imposed exile from both France and his native Switzerland for five years. Condemned for its religious and political precepts and deplored for advocating the deferral of intellectual and religious instruction until at least the age of fifteen, *Emile* advances the notions that the child emerges with innate goodness, that childhood is a unique age distinct from adulthood, and that children, with the guidance of a tutor, should be allowed to follow their natural inclinations for as long as possible rather than be treated as adults born fully developed with the capacity to reason already intact. The novel's narrator, Emile's tutor, allows his charge to develop independent will and self-sufficiency, relying on Emile's natural "vivacity" and "gaiety" without relinquishing control over his desires.[9] That is, as Allan Bloom puts it, "while the child must always do what he wants to do, he should want to do only what the tutor wants him to do."[10] Toward this end, Rousseau has Emile spend his childhood in the countryside, where he can both exercise his strength and cultivate his senses—"swimming, running, jumping, spinning a top, throwing stones" as well as learning to "measure, count, weigh, compare."[11] To develop his sense of sight, Emile learns to draw: "Children, who are great imitators, all try to draw. I would want my child to cultivate this art, not precisely for the art itself but for making his eye exact and his hand flexible."[12] Rather than provide "imitations to imitate" and drawings to copy, Emile's tutor wants his student "to have no other master than nature and no other model than objects."[13] He is

certain that Emile "will dabble for a long time without making anything recognizable," but is equally certain that Emile will "develop a more accurate glance, a surer hand, the knowledge of the true relations of size and shape which exist among animals, plants, and natural bodies, and a quicker capacity for experiencing the play of perspective."[14] He warns against interpreting the child's zeal for drawing as evidence of artistic genius: "We need sharper observations than is thought to get assurances of the true genius and the true taste of a child who shows his desires far more than his disposition, and who is judged by the former for want of knowing how to study the latter."[15] To this end, Rousseau prophetically calls for "a treatise on the art of observing children."[16]

1767 Johann Friedrich Oberlin, an Alsatian Lutheran pastor in Waldersbach, founded the first *salle d'asile* (hall of refuge), or infant school for the care and instruction of very small children while their parents worked in the fields. He taught about nature by having children learn to draw insects, plants, and stones. Such object-based learning—learning from an object by exploring the object itself and its context—prefigures a strategy that perseveres to the present, most frequently in museum educational programs.

1773–74 Johann Heinrich Pestalozzi (1746–1827), a Swiss educational and social reformer heavily influenced by the writings of Jean-Jacques Rousseau, begins to formulate his own pedagogical principles while keeping a diary on the early education of his son, Jean-Jacques (named after Rousseau).[17] The first pedagogue to give drawing instruction a fundamental role in the education and development of a child, Pestalozzi is also criticized for introducing dry, repetitious, sequential drawing exercises, which would come to typify nineteenth-century art education throughout Europe and the United States. At the age of three, Jean-Jacques has to "draw straight lines and an upright perpendicular line" until he satisfies the aims of "order, accuracy, completeness, and perfection"; after doing so, he is allowed to move on to the next stage of practice.[18] One of the benefits of this practice, according to Pestalozzi, is the cultivation of patience and discipline:

"Let the natural instinct for imitation guide you here. You have a stove in your room. Make a drawing of it; if your child in the course of a whole year should not succeed in drawing a proper stove, he will at least have grown accustomed to sitting still and working."[19]

1787 Dieterich Tiedemann (1748–1803) writes a biography on the behavior of his infant son, entitled *Beobachtungen über die Entwickelung der Seelenfähigkeiten bei Kindern* (*Observations about the Development of the Inner Strengths of Children*) (Altenburg, Germany: Bonde, 1787).

1801 Johann Heinrich Pestalozzi, *Wie Gertrud ihre Kinder lehrt* (*How Gertrude Teaches Her Children*).[20] This collection of letters, in which Pestalozzi presents his ideas about the teaching of drawing and its central role in developing children's skills of observation and measurement, breaks new pedagogical ground, according to Kate Silber, by emphasizing "self-activity in acquiring and using knowledge in its first stages."[21] Clive Ashwin explains that, for Pestalozzi, drawing is an exemplary form of self-activity that serves as the vehicle by which children "rise from the level of vague sense impressions to the formation of clear ideas."[22] For Pestalozzi, drawing forges the crucial link between knowledge and sensory experience by providing children with three modes of analysis, which Ashwin summarizes in question form: "How many, and what kinds of objects," what is "their appearance, form or outline," and how may they be represented "by sound or word"?[23] Ashwin argues that these analytic modes, embodied by number, form, and language, become the "pillars of [Pestalozzi's] pedagogical theory."[24]

1803 Johann Heinrich Pestalozzi, *ABC der Anschauung* (*ABCs of Sense-Impression*).[25] Two years after publishing his theories on education in *How Gertrude Teaches Her Children*, Pestalozzi, with the help of assistant Christoph Buss, publishes a teacher's manual for an elementary drawing course, complete with a syllabus, exercises, and a description of the method. The object of the course is to bring children to an understanding of formal relations by acquainting them with simple figures based on straight lines and elemental shapes, while also increasing their ability to gauge proportions (without drawing instruments) and

Chronology

skillfully render each form. As Pestalozzi outlines, teachers first demonstrate and describe the figure to be learned while students recite the description and copy the figure, before locating objects in the room of the same form. The course exercises increase in complexity but always rely on "horizontal," "vertical," and "sloping lines" as well as "varieties of angles," the only forms children are allowed to use—although, if they want to, they may combine or invent new forms by using the learned forms.[26] This approach, Pestalozzi believes, will instill "at the earliest age simplicity, order and taste."[27] Its regimented style might be excused given Pestalozzi's concern with finding a way for teachers with little training to instruct "large groups of children effectively" (in contrast to Jean-Jacques Rousseau's model of a single tutor and single pupil).[28] As Clive Ashwin explains, many of the children for whom Pestalozzi has developed his program of instruction are "not only poor, . . . verminous, starving and diseased," but also suffering from "the devastation of war."[29]

1809 Joseph Schmid (1787–1851), *Die Elemente des Zeichnens nach Pestalozzischen Grundsätzen* (*The Elements of Drawing According to Pestalozzian Principles*). Schmid, who teaches math and drawing, is a former student of and later assistant to Johann Heinrich Pestalozzi. As a guide to development through aesthetic growth, his drawing manual extends and deepens Pestalozzi's ideas by addressing children's creative urges as well as the importance of line quality, modeling, and color. In order "to develop the hand, the eye, and the aesthetic taste," his approach is geared toward exercising "the hand, the eye and the inner mind."[30] Schmid believes that, despite the strength of its art collections and academies, the Europe of his day lacks "artistic impulse," in contrast to the era of "the Ancients," who supported a "national education for art."[31] He argues that such an education would cultivate artistic genius by fostering and nurturing children's natural impulse toward creativity. Like Jean-Jacques Rousseau and the Romantics, Schmid believes that aesthetic principles should be derived from nature rather than from artistic achievements of the past. Although based on "simple combinations of dots and linear shapes," Schmid's exercises also place emphasis on "the Creation and Invention of Beautiful Forms."[32] He argues that "what children do themselves expresses itself very vividly here and should be noted."[33]

1826 Friedrich Froebel (1782–1852), *Die Menschenerziehung* (*The Education of Man*).[34] Froebel, an educator in Berlin, makes several visits to Johann Heinrich Pestalozzi's school in Yverdon, Switzerland, between 1805 and 1810 and opens his first school in 1816. *The Education of Man* is considered his most important work.[35] In 1837, he opens another school, the Child Nurture and Activity Institute, in Blankenburg (a village near Keilhau in the Thuringian Forest of Germany). Three years later (in 1840) he renames the school a "*Kindergarten*"—a term still commonly used. The Kindergarten provides young children with an environment that fosters self-direction, spontaneous play, and a close relationship with nature. Froebel's goal is an environment where children are not directly instructed but allowed to learn through play and imitation. His most substantial contribution to educational theory is his conviction that self-activity and play are necessary elements in a child's education.

Froebel believes in a comprehensive education that includes religion, reading, writing, drawing, German, singing, mathematics, life science, geography, Greek, piano, and physical exercise.[36] According to Patricia Tarr, Froebel combines "Pestalozzi's respect for children, use of objects, stress on nature . . . with his own experiences in agriculture, architecture, geometry, mapping, and his religious views."[37] Froebel believes that every child, having come "out of God's creative mind," has innate creative drives that develop according to the child's nature.[38] Having borrowed much of his approach toward drawing from Pestalozzi and his assistants, Froebel additionally advocates the use of color and develops exercises in painting.[39]

In addition, Froebel's kindergarten is packed with objects designed for play, including a set of twenty "gifts" and "occupations"—such as blocks, balls, and sticks—of his own invention.[40] Froebel creates these gifts to assist children in noticing and appreciating familiar forms and patterns found in nature. Froebel develops his blocks in the 1830s for children to learn the principles of geometric form and function, as well as to foster creativity.

Chronology

He starts with a wooden cube and adds other blocks. The complete set is contained in a wooden box and intended for children aged three through eight. "Froebel blocks" are the first known building-block construction sets for children, and they are spread throughout the world and continue to inspire the creativity of children today.

1828–32 Peter Schmid (1769–1853), *Das Naturzeichnen für den Schul- und Selbstunterricht* (*Nature-Drawing for School and Self-Instruction*).[41] A self-educated artist and drawing teacher, Schmid first comes to public attention in 1809 with the publication of his autodidactic drawing manual, after which he settles in Berlin and establishes himself as an instructor. After several years, he is asked to reorganize the local system for training drawing teachers, and by 1833 he is appointed Royal Professor of Drawing. *Das Naturzeichnen*, a four-volume manual, advocates a system "of drawing from solid objects with only the minimum of introductory exercises"[42] and concentrates on four topics: "straight-sided bodies," "bodies composed of curved and mixed lines," "perspective," and "shading."[43] Schmid has the student draw directly from objects in nature (rather than copy from drawings) in order to exercise the eye and mind while enabling an empirical grasp of perspective. Although Schmid's system, which requires the purchase of a set of geometrical blocks in addition to the manual, proves "well beyond the [financial] reach of normal class use,"[44] it nevertheless remains influential. In 1839, it captures the attention of the American educator Horace Mann, who visits Prussia to review the educational system and is "particularly impressed" by the high quality of students' graphic work.[45]

1844 Horace Mann (1796–1859), a Boston educator and editor of the *Common School Journal*, promotes Peter Schmid's system of drawing in the journal, reproducing plates from his *Das Naturzeichnen* for the benefit of American teachers.[46]

1848 Rodolphe Töpfer (1799–1846), *Réflexions et menus-propos d'un peintre génevois* (*Reflections and Comments of a Genevan Painter*).[47] In this posthumous collection of essays on aesthetics by the Swiss artist and educator Töpfer, published in 1848, two chapters are devoted to revelations about children's natural creativity. Töpfer asserts that "art exists already complete" in children's drawings.[48] In a discussion of Töpfer's book, Meyer Schapiro explains that Töpfer believes that "art [is] not imitation but the [spontaneous] expression of 'ideas.'"[49] For Töpfer, aesthetic expression is found not only in "art of the highest perfection," but also in the works of children and "savages" and is "all the more evident because of the graphic ignorance of the designer."[50] Indeed, writes Schapiro, Töpfer asserts that formal academic training, with its focus on imitation, would only destroy children's natural "vivacity and artistic intention."[51] It is Töpfer's conviction that "savages" and children "draw the natural object not as a representation of itself envisaged as beautiful, but as a sign of intention, . . . of an elemental beauty that may be rough and crude indeed but which issues at last absolutely and exclusively from the power of thought" and "prevails far above servitude to imitation."[52]

1856 Margarethe Schurz (1833–1876) settles in Watertown, Wisconsin, from Germany and starts a German kindergarten based on Froebel's model.[53]

1857 John Ruskin (1819–1900), *The Elements of Drawing*. An English critic, social theorist, and professor of art, Ruskin prefaces his manual on drawing by remarking that it is "not calculated for the use of children under the age of twelve or fourteen."[54] A child of this age, Ruskin advises, should be engaged in only "the most voluntary practice of art . . . and should be allowed to scrawl at its own free will, due praise being given for every appearance of care, or truth, in its efforts."[55] He encourages the use of "cheap colours" or paints as long as children have acquired "sense enough to use them": if a child is only producing "senseless stains, the colour may be taken away . . . but as soon as [the child] begins painting red coats on soldiers, striped flags to ships, etc., it should have colours at [its] command and, without restraining its choice of subject . . . , it should be gently led by the parents to draw, in such childish fashion as may be, the things it can see and likes—birds or butterflies, or flowers or fruit."[56]

1859 Charles Darwin (1809–1882), *The Origin of Species*. Darwin's notion that "ontogeny recapitulates phylogeny" is a critical stimulus to the concern with child art.

1859 Elizabeth Palmer Peabody (1804–1894) meets Margarethe Schurz and becomes a convert to Friedrich Froebel's ideas. In 1860, she opens "the first English-speaking kindergarten in Boston."[57] According to Patricia Tarr, Peabody believes that Froebel's approach encourages "children's inner expression," "contribute[s] to the child's harmony or an integrated personality," and cultivates "habits of 'docility, industry, and order.'"[58] For thirty years, she promotes kindergartens throughout the United States, giving lectures, organizing exhibits, and publishing articles.[59]

1860 Seven states (Maryland, Vermont, Rhode Island, Connecticut, New Hampshire, Maine, and Pennsylvania) enact compulsory school attendance.

1861 Herbert Spencer (1820–1903), *Education*.[60] Stuart MacDonald notes that Spencer is "the first educationist to make general use of the principle of evolution," particularly the work of the French naturalist Jean Lamarck.[61] In this collection of essays, written between 1854 and 1859,[62] Spencer views children's artistic activity as integral to their full development and argues that the "question is not whether the child is producing good drawings. The question is, whether it is developing its faculties."[63] Spencer welcomes "the spreading recognition of drawing as an element of education"[64] but laments the forms it has taken, especially "the dreary discipline of copying lines."[65] He directs attention instead toward what "the child first tries to represent" and insists on the importance of color: "Things that are large, things that are attractive in colour, things round which pleasurable associations most cluster, human beings from whom it has received so many emotions; cows and dogs which interest by the many phenomena they present; houses that are hourly visible and strike by their size and contrast of parts. And which of the processes of representation gives it most delight? Colouring. Paper and pencil are good in default of something better; but a box of paints and a brush—these are the treasures. . . . The priority of colour to form, which, as already pointed out has a psychological basis, should be recognized from the beginning, and from the beginning also, the things imitated should be real."[66] Ultimately concerned with children's development toward "greater accuracy and completeness in observation," Spencer seems not to attribute any importance to self-expression.[67]

1876 Philadelphia Centennial Exposition. As in many national and international expositions held at this time, exhibit space is provided for drawings produced in schools by students of all ages as a means of evaluating the strength of the various systems of instruction in place. The kind of work represented typically involves "picture-making from copies" or examples of geometrical and ornamental forms.[68]

1877 Charles Darwin publishes "A Biographical Sketch of an Infant," an account, written in 1840, about his son's early childhood.[69] While Darwin's focus is primarily on language development, subsequent child study researchers will compare artistic development to language development, especially in coming up with developmental stages.[70]

1879 Wilhelm Max Wundt (1832–1920) establishes the first psychology laboratory in Leipzig, Germany. G. Stanley Hall is one of his students.[71]

1881 Wilhelm Preyer (1841–97), *Die Seele des Kindes (The Mind of the Child, Part 1: The Senses and the Will)*.[72] In this volume, Preyer writes about the mental development of the child during the first years of life. In the chapter on sight, he makes a remark on children's drawings: "Not till after the third year is the ability to represent known objects, even by lines on paper or by cutting, manifested." Before this, Preyer writes, the child wants to draw (Preyer uses the verb "write" to mean a kind of drawing that intends to represent but without verisimilitude). The child, he says, "thinks that by all sorts of marks he is representing a locomotive, a horse, a spoon, a plate, a bottle; but does not succeed without help."[73] He also mentions his own son's interest in drawing: "The surprisingly persistent desire of my boy (in his thirtieth month), repeated daily (often several times a day), to 'write' locomotives . . . sprang from his seeing locomotives frequently."[74] Preyer concludes that this interest is due to the locomotive being "the largest moving mass perceived" by the child's eye

and "the great number of optical nerve-fibers excited by the change of light and dark."[75]

1882 Under the name of the "Incoherents," a young Parisian writer named Jules Lévy organizes a show of "drawings by people who don't know how to draw."[76] The show reflects a larger climate of interest in art that is outside the academic formulas, including self-taught artists and the art of children.

1885–86 Ebenezer Cooke (1838–1913) writes "Our Art Teaching and Child Nature." Cooke, led by John Ruskin's remarks about children and art "to reconsider the principles of art-teaching in the schools," publishes his first call for reforms. He asserts that "the teacher's knowledge of the pupil's nature is not less important than the system on which he teaches" and that "it is possible to use the apparatus and neglect the spirit." He advocates a method whose goal is "to evolve expression, to exercise imagination, [and] to stimulate voluntary mental activity" rather than "teach mechanically … with little aim beyond exactness [and] cramming order in." Like "steam and electricity," which are now "our servants," the child's nature may be harnessed only by studying, sympathizing, and "obeying it," Cooke claims.[77]

1886 Alfred Lichtwark (1852–1914), an elementary school teacher and cultural critic, is appointed director of the Hamburg Kunsthalle and begins writing tracts on the reform of art instruction in schools as well as the importance of cultivating a national aesthetic spirit. He argues that Germans suffer from an "obsession with knowledge" and hopes "to redress the balance away from the intellect and towards the senses."[78] Convinced that the entire German population is in need of aesthetic cultivation, he revives the term "dilettante" as a positive concept and founds amateur societies for the pursuit of the arts.[79] As Kunsthalle director, Lichtwark asserts that the process of art contemplation needs an "awakening of sensitivity" by "prolonged observation" and less emphasis on "the communication or acquisition of knowledge."[80] Moreover, he believes that the everyday object is just as capable of inspiring aesthetic appreciation as the work of fine art.[81]

1887 Corrado Ricci (1858–1934), *L'Arte dei bambini* (*The Art of Little Children*).[82] Setting out to study the drawings of a friend's daughter but discovering after five months that he had collected only a hundred of these "artistic documents," Ricci turned instead to elementary schools, where he was able to collect an additional 1,250 drawings in the space of a month.[83] This publication of his findings is considered "the first systematic study of children's art."[84] Much subsequent research will bear out his conclusion that children's art is dominated by "laws of integrity": "the child describes the [objects being drawn] instead of rendering them artistically. [Children] try to reproduce [the man] in his literal completeness, and not according to the visual impression. They make, in short, just such a description in drawing as they would make in words."[85] Ricci discovers that children up to age three do not generally try to represent anything, but when they first come to do so they almost invariably "give expression to a man" whose first "primitive form" takes several stages to arrive at "complete physical integrity," at which point the "man no longer submits to the suppression of any part of himself."[86] That is, he presents both eyes even when in profile, both legs if astride a horse, and his whole body if within a boat. Jo Alice Leeds calls attention to Ricci's apparent empathy with children's logic as well as his unusually neutral approach in judging the value of their work. Leeds distinguishes him from later researchers, like James Sully and Bernard Perez, whose emphases on children's representational "mistakes" reflect a strong bias toward "visual realism."[87]

1887 Alfred Lichtwark, *Die Kunst in der Schule* (*Art in School*). In this work, Lichtwark emphasizes the ahistorical nature of the child's manner of simplifying form and argues that "we have recognized the relation between the first attempts of the child and those of primitive man."[88]

1887 Georg Hirth (1841–1916), *Ideen über Zeichenunterricht* (*Ideas about the Teaching of Drawing*).[89] Art theorist, publisher, and founder of the Art Nouveau periodical *Jugend*, Hirth defends the innate talent of children and pushes for reform of artistic instruction. According to Clive Ashwin, "Hirth is concerned not with "seriousness, application,

diligence and finish," but rather argues that "the child should be encouraged to sketch, to practice rapid drawing . . . and to use its powers of invention."[90] Hirth also advocates greater understanding of children's developmental stages and recognizes that "in the first years, . . . it does not matter at all how the child draws, but that it draws gladly and a great deal."[91] He further insists that children's sensitivity to color naturally precedes their understanding of formal or spatial relations, thereby rejecting, in Ashwin's words, "the whole history of the teaching of drawing."[92]

1887–1930 Child labor reform.

1888 Bernard Perez (1836–1903), *L'Art et la poésie chez l'enfant* (*The First Three Years of Childhood*).[93] A child psychologist, Perez studies children's initial art activity as a vital part of their development and is especially interested in the development of children's feelings for nature, beauty, and the arts.[94] In this work, Stuart MacDonald explains, Perez hopes to expose "the workings" of children's minds by analyzing their "expression or language" based on the anecdotal information of friends and family as well as his own observations.[95] According to Jo Alice Leeds, Perez is too blindly guided by the aesthetic standards of "civilized adulthood"[96] to view children's early drawings as anything other than examples of mistaken representational logic: "The child's progress seems spontaneous and does not follow any straight line of development. Improvements occur here and there in the use of detail as if by chance, and this general condition may be explained by the technical ignorance of the child, his short observation span, his capricious memory and attentiveness, and the often mistaken demands of his logic."[97] James Sully would be very influenced by this work.[98]

1889 Francis Paulhan (1856–1931), "L'Art chez l'enfant."[99] Paulhan comments on his observations about the artistic imagination of children.

1890 Two years after its establishment by T. R. Ablett, the Royal Drawing Society, London, presents the "first exhibition of children's art ever shown in Britain," according to Stuart MacDonald.[100] Princess Louise, Queen Victoria's daughter and the society's president until 1939,

awards prizes and even purchases a few of the works. Reviews appear in the *Times, Morning Post,* and *Daily Telegraph.* Because of the success of the exhibit, the society makes it an annual event. Princess Louise's husband, the Duke of Argyll, dubs it "The Children's Royal Academy."[101]

1890 Alfred Binet (1857–1911), "Perceptions d'enfants: Interprétation des dessins" ("Childrens' Perceptions: Interpretation of Drawings").[102] Intelligence, according to Binet, consists of 1) being able to perceive the external world, and 2) accessing these perceptions through memory and ruminating on them. Based on this belief that perception is the foundation of both parts of intelligence, Binet conducts research on two young girls, from the ages of two to five, in order to determine what they, specifically, can perceive and conceptualize.[103] He finds that children's perceptions are essentially practical and utilitarian in nature. He combines these results with work from two preceding studies of children's perception, regarding the perception of quantity and of distance. In these, Binet finds that the child is able to establish only the distance that she needs to know in order to interact with the world—that is, to avoid harm—and that her perception of quantity does not generally go beyond six.

Binet uses Preyer's naming method to explore color perception. Introducing the child to balls of various colors and the names of those colors, he then asked the child to perform two tasks: 1) to name the color of a ball presented to her, and 2) to fetch a ball of a particular color.[104] Binet finds that the results do not explain whether a child's confusion during these tasks are due to her sense of color, her distinction between colors, or her sense of words. Therefore he experiments with a new method, which he calls the method of recognition,[105] in which the child is asked to find a ball of the same color as one that is presented to her. This method is much more successful. He concludes that the child's confusion during the first exercise is due to perception "of words, not of colors."[106]

In perceiving drawings, Binet finds, the child only recognizes what is familiar to her. She cannot recognize parts of objects, for example, but requires the whole:

Chronology

"The work of disintegration" is not easy for the child whose analytic talent is lacking, he notes; the child most often requires "the impression of the whole" to be replaced to recognize objects.[107] Similarly, with regard to the perception of emotions in pictures, the child recognizes only those with which she is familiar, specifically laughter and tears.[108]

In terms of the distinction between dream and reality, Binet notes that it is difficult to ascertain but that it seems verifiable at approximately four and a half years of age. Giving the example of a child who tells Binet she saw her father kill a boy but cannot show him where it happened because the place, she acknowledges, is inaccessible, Binet concludes that children often feel that something actually took place while also being aware that it did not happen in reality.[109]

Testing how a child perceives objects that are familiar to her, Binet asks the children to describe certain objects. Both sisters reply by giving uses for the objects, reinforcing Binet's proposition that the child has a utilitarian perception of the world. Moreover, the answers are reflexive, given without rumination, and are formulaic, satisfying a taste for repetition or rhythm.[110] In terms of the children's perception of internal needs, Binet concludes that children do not focus on the need itself, but on the means to satisfy it, suggesting that this may arise from a difficulty in perceiving internal psychological phenomena.[111]

1890–1900 Children's drawings by American Indians in the Southwest are published by the government.

1891 G. Stanley Hall (1844–1924), "The Content of Children's Minds."[112] This scientific study by Hall, a psychologist and educator, has implications for pedagogy. In 1888, when he becomes president of Clark University in Worcester, Massachusetts, Hall makes it a center for child study, essentially launching the child study movement in the United States.[113] In 1891, he founds the journal *The Pedagogical Seminary*[114] and in 1909 brings Sigmund Freud to Clark University to receive an honorary degree (Freud's only such honor). Arlene Richards writes that Hall is "the first to talk of and list the development of the human figure in drawings," summarizing Hall's system of "six stages between ages 3 and 8," one per year: "mere marks"; "circle head with longitudinal lines for legs"; "facial features are added"; "arms are extended from the head"; "the body is represented"; and "diaphanous clothes are added."[115]

1891 Jacques Passy (1864–1898), "Note sur les dessins d'enfants."[116]

1892 Earl Barnes (1861–1935), "A Study of Children's Drawings."[117] A professor of education at Stanford University and later the editor of the journal *Studies in Education*, Barnes concludes that children make drawings "not to exactly imitate something, nor to produce an aesthetic feeling, but to convey an idea" through visual language.[118] He bases his conclusions on a study involving 6,393 classroom children, ages six to sixteen,[119] in which, in order to establish "some common element" that would make comparison possible and allow for "large generalizations," Barnes selected a poem to be read out loud twice and then to be illustrated by one or more drawings.[120] These drawings were collated according to how many and which scenes were illustrated at each age, and to establish whether "girls followed the same lines of interest and development as the boys, and whether there was any law governing the drawing of full-faces and profiles."[121]

Barnes reports that he found "very little difference" between boys and girls and discovered that "a child will draw those scenes which most interest him"—in this case, the part of the drama that "leads up to the [catastrophic] climax." Between thirteen and sixteen, he notes, children draw fewer scenes or are "less daring in expressing themselves . . . than before." At nine or ten, children switch from full-face figures to those in profile, which, for Barnes, is an indication of "the point in the child's development where he begins to represent things as they really are" and thus a time when "the grammar of drawing might be introduced."[122] For younger children, Barnes recommends that drawing be used "freely as a means of expression," even if that means encouraging a "period of the grotesque": "If we believe that this is a sane and well-ordered universe, tending ever toward higher forms . . .

then in dealing with the drawing in our schools, we should follow the child's lead."[123] Allowing children to pass through the "period of the grotesque," Barnes claims, ensures that they will be ready for and will move on to the next phase in their development—for, as Arlene Richards puts it, Barnes believes that "each child must go through the developmental stages."[124] Even when children are ready for the grammar of drawing, however, Barnes insists that instructors continue to foster spontaneity and encourage drawing as a form of expression, a way for children to come "out to meet the world," as well as to reveal their thoughts and feelings for the benefit of further research.[125]

1893 Chicago World's Fair. Many schools exhibit their students' work, the nature of which elicits this response from educator J. Liberty Tadd: "Could any sane person walk around the ten acres of school exhibits last year at Chicago and be satisfied with the work going on under the name of art, of drawing, of manual training? Could any one for a moment think that it represented the work of individual child life, of growing organisms—each one alive? Did it not all seem fashioned from the same mean lack of thought, exhibited by some plan or system-maker? Did it not show, in its very similarity and endless repetition of the same things, the hand of trade? Did it not show from its very constant and feeble ringing of the changes in cubes, blocks, cones, prisms, definitions, the reiteration of terms, construction, representation and decoration, the shallow minds, wading in a morass of second-hand thoughts, words, and phrases?"[126]

1893 Konrad Lange (1855–1921), *Die künstlerische Erziehung der deutschen Jugend* (*The Artistic Education of German Youth*).[127] This work is regarded by Clive Ashwin as the first real articulation of a burgeoning reform movement in Germany.[128] Lange, a professor at Königsberg, demands the cultivation of visual sensitivity in Germany's students and pushes for reforms of the educational system, which he claims only corrupts, as Ashwin puts it, the "child's perception of beauty and taste for art."[129] An attack on most of the "fundamental principles" in traditional drawing instruction, Lange's book is described by Ashwin as "perhaps the most influential . . . of its kind."[130]

Heavily influenced by Friedrich Froebel's ideas on children's drawing development, Lange claims that children can start learning how to draw at the age of three or four and that drawing instruction should not be postponed until the age of twelve, as it usually is in German schools at that time. He describes the basic technique that can be used for training young children (which he calls "grid drawing"): students are provided with gridded paper, which helps them practice moving the pencil in various directions.[131] According to Lange, freehand drawing is problematic at an early age; he stresses that "drawing is harder than writing since the hand of the child is not able to force the pencil into the longer, continuous line" and he concludes, therefore, that freehand drawing should be avoided before school age.[132] Lange also points out that good muscles and clear concepts "will help to force the pencil into a certain direction."[133] He argues that, in general, the practice of freehand drawing is bad for the young child since it deprives him of the possibility to learn "a truly artistic drawing of an outline."[134] Lange will later team up with other reform-minded educators, including Alfred Lichtwark and Carl Götze, to organize the 1901 Dresden conference.[135]

1893 Carl Götze (1865–1947) founds the Teachers' Association for the Cultivation of Artistic Education in Hamburg, Germany. According to Clive Ashwin, the association will "set the pace and [establish] the climate of the reform movement in Hamburg and subsequently in Germany."[136]

1895 Louise Maitland, "What Children Draw to Please Themselves."[137] Based at Stanford University, Maitland conducts this quantitative study of 1,570 drawings by children from ages five to seventeen in order to determine what they choose to draw voluntarily, given the assumption that their drawings "represent only a passing mood at a given moment."[138] Maitland compares work done in class with work done out of class, dividing the drawings into four age groups, then further dividing and subdividing the work by content (such as indefinite pictures, pictures of separate objects, picture-stories, and landscapes, as well as humans, plant life, houses, and other objects, including still lifes). Having done so, she arrives at the

Chronology

following conclusions: younger children draw more freely and willingly than older children (in this, she agrees with Earl Barnes); children draw to describe rather than to represent naturalistically (Corrado Ricci's premise); drawings by children between the ages of five and thirteen become increasingly comprehensive, with more of a setting, while after the age of thirteen, children become increasingly particular in their drawings, focusing on one object; human figures are the most popular thing to draw, while ornament is the least favorite (about the latter, Maitland speculates that young children "do not recognize the beautiful as existing" and older children "do not care for it" or "find their means of expression inadequate" to render it[139]); and finally, the conventional category of "design" drawings, including geometrical models, architectural plans, and drawing exercises, increase in popularity with older children but the overall quality of the work is poor ("inaccuracy and slovenliness are the conspicuous elements. The lines are often ruled, they are too long or too short, the angles are not true, the squares, the circles, triangles and sections are consequently untrue, and the dots meant to help and guide the children are more often than not in the wrong place"[140]), leading Maitland to suggest a return to formal drawing instruction, at least for the older children.

1895 James Mark Baldwin (1861–1934), *Mental Development in the Child and the Race: Methods and Processes.*[141] An infant psychologist, Baldwin is primarily interested in the imitative nature of children's mental processes and studies infants' drawings for the light they may shed on the origins of handwriting. Rather than observing the spontaneous process of drawing, Baldwin shows children "copies"— rough outline drawings of people, animals, and so on— and observes the child's actions. He argues that until the age of about twenty-six or twenty-seven months infants' drawings are simply "the vaguest and most general imitation of the teacher's movements, not the tracing of a mental picture";[142] the mental image of an object is disconnected from the kinesthetic movements of the hand. However, at a certain moment the child captures an idea of "tracery imitation" and obtains "the sense of connection between what was visually in her own consciousness

and the movement of her own hand or pencil."[143] At this point, the child begins to imitate her own mental picture. For instance, she tends "to neglect the new object or copy and substitute for it in whole or part some drawing which she had already learned to make."[144] Baldwin stresses that tracery imitation forms a basis of handwriting.[145]

1896 Herman T. Lukens (1865–1949), "A Study of Children's Drawings in the Early Years."[146] Having studied more than 3,400 children's drawings, Lukens advances the premise that children choose to draw "out of their own heads" rather than "from the object," even when the object is in front of them and they are specifically told to "draw what they see."[147] Although he asserts that "far greater individuality and freedom, both in subjects and in methods, must be allowed,"[148] Lukens warns against the retrogressive nature of scribbling (with its "unmeaning lines"[149]) and against conventionalization (the reliance on predetermined symbolic forms to convey diverse information) and recommends the cultivation of "a few, bold, well-chosen, significant lines used with telling effect to suggest action and indicate expression."[150] According to Arlene Richards, Lukens is the first researcher to directly compare children's language development with their artistic development.[151]

1896 James Sully (1842–1923), *Studies of Childhood.*[152] Of all the early research on childhood, according to Herbert Read, Sully presents the first "coherent theoretical explanation" based on evolutionary theory and is the first to systematically relate children's artistic development to that of a "primitive" race or culture. Sully approaches children's artworks as bodies of information to be organized and described by the characteristics of their stages of development, so that a child's transition from single-line to double-line treatment or from full face (frontal view) to profile (side view) in drawing the human figure become important milestones for evaluating his or her progress. Sully's proposal, an organic evolution of forms toward greater complexity and naturalism, is extremely influential, and his classification of the stages of development in children's art will form "the basis of all subsequent classifications."[153] Viktor Lowenfeld, for example, will later credit Sully for his belief that art activ-

ity fosters children's development and considers Sully's attempts to understand children's scribbling an important contribution to child study and art education. (He will, however, disagree with Sully's conclusion that children who name their scribbles project meanings arbitrarily, arguing instead that children actually connect mental images to the kinds of motions they make, such as round movements for a round head.)[154] Like Bernard Perez, Sully relies on anecdotal evidence and the criteria of adult aesthetic standards in order to analyze children's work: "We find in the drawings of untrained children ... a curious mode of dealing with the most familiar forms. At no stage in this child-art can we find what we should regard as elements of artistic value; yet it has its quaint and suggestive side."[155]

1896 John Dewey (1859–1952) establishes the University of Chicago Laboratory School. Together with Anna Bryan, Patty Smith Hill, and G. Stanley Hall, Dewey is one of the leaders of a new progressive movement in the protocols of teaching in kindergarten and its integration into public schools.

1897 Franz Cizek (1865–1946) opens his Juvenile Art Class in Vienna. An artist, teacher, and member of the Viennese Secession, Cizek not only appreciates children's art as art (as have others, like Rodolphe Töpfer, before him), but is further intrigued with the new idea that "Child Art is an art which only the child can produce."[156] Cizek is perhaps the first to offer an art class with the express purpose of providing children with creative liberty and the chance to work from their imagination. Influenced by Friedrich Froebel's precepts and opposed to the dry objectives of formal drawing instruction, Cizek encourages children to discover their own aesthetic practices and not try to paint "as grownups do." If "the work accomplished accords with the child's age and is altogether uniform in quality and ... in every single detail," Cizek considers it "honest" and "direct" and believes it to contain "in itself the eternal laws of form."[157] Thus, he is opposed to the practice of correcting children's mistakes in proportion, perspective, or color, since such mistakes, he believes, are at the heart of children's creative expression and account for individual style: "The most beautiful things in the creating of the child are his 'mistakes.' The more a child's work is full of these individual mistakes the more wonderful it is. And the more the teacher removes them from the child's work the duller, more desolate and impersonal it becomes."[158] As Cizek tells one visitor, "the child speaks, then he learns the grammar, not the other way around."[159]

In 1903, on the recommendation of Carl Götze,[160] Cizek will receive official government approval for his class. Open to children of any age (though most are between the ages of seven and fourteen), the classes will continue, with forty to sixty students per class, until 1938. During this time, the works of Cizek's students are exhibited widely, and "thousands of visitors" come to Vienna to observe Cizek in action. A few, such as Francesca Wilson (a teacher in Birmingham, England) and Wilhelm Viola, devote their efforts to publicizing Cizek's accomplishments.[161] Stuart MacDonald speculates that Wilson and Viola are "so carried away by Cizek's philosophy of self-activity and free expression that they [blind] themselves to the firm methods he [uses] with his pupils."[162] Not only does Cizek "carefully" choose and restrict the colors his pupils use, MacDonald claims, but he also gives very clear directions, insisting "that the paper should be filled, that strong rhythmic outlines should be drawn, ... that figures should be full of character and movement, that colours should not be painted over other colours, ... that decorative patterns should be included where appropriate," and that children should "not get ahead of [their] age."[163] Richard Carline, who characterizes the work of Cizek's students as "singularly dated" and "reflecting the [Art Nouveau] taste and fashion of the period,"[164] also casts doubt on whether Cizek actually achieves his ideal of the teacher who hovers "like an invisible spirit over his pupil, always ready to encourage, but never to press or force,"[165] but nevertheless credits Cizek with establishing a new atmosphere in the art class by emphasizing that students' enjoyment of their work "was essential if the work was to prove of value."[166]

1897 Elmer E. Brown (1861–1934), ed., "Notes on Children's Drawings."[167] Here, Brown publishes the results of a study involving four different children, whose artistic activity was monitored by adult relatives in close contact

with the children for a number of years. The results are based on the responses of the adults to questions such as when, how, and why the child began drawing; whether the child's intention was to represent objects or make beautiful forms; whether the child copied another person's drawing or drew an object he or she was looking at; what signs of discouragement there were if the drawing did not conform to the child's mental picture; and what signs there were that the drawing was a symbol rather than an actual representation. Brown concludes that children work conceptually rather than naturalistically and that it is "clearly a mistake to regard a child's drawing as a fair representation of his mental image of the thing."[168] Indeed, Brown speculates, children are flighty and susceptible to whim, which makes them "very indulgent toward their own representations, however unrecognizable to other people." He accepts, however, that children grasp at least "the spirit of things" or "their essential forms," even citing an example in which a child indicates the footprints of the movement in a dance in the scribble on her page.[169] Brown finally notes that conceptual drawing, as a method for improvement, is not thought to work well.[170]

1897 Ebenezer Cooke (c. 1837–1913), "The ABC of Drawing." In this article, Cooke synthesizes Johann Heinrich Pestalozzi's grammar of drawing with provisions for children's free, spontaneous expression "of life and feeling within" and promotes this new approach as the foundation of elementary instruction.[171] Cooke also proposes a new element in the visual alphabet of forms: the "j," or quarter-outline of an ellipse, which he describes as "the line of life, development, and movement." This element, he argues, is not only the essence of all natural forms ("bud, leaf, flower, seed, embryo," fish, birds, mammals, ocean waves, planetary orbits, and so on), but also at the heart of children's drawings and clearly evident in their scribbling.[172] Cooke characterizes drawing as a skill that can be learned, like carpentry or surgery, and a process that will "nurture and develop the creative instinct" present in all children, as well as reveal "the state of [the child's] mind and its knowledge."[173]

1897 Carl Götze, "Was offenbart das Kind durch eine Zeichnung?" ("What Does a Child Disclose in a Draw-

ing?").[174] According to Clive Ashwin, Götze argues in this article that pedagogy, "if it is to claim to be scientific," must begin with the idea "that the child's view of the world is essentially different from that of the adult."[175] Having acquainted himself with research being done in the United States on children's drawings, Götze accepts the preliminary conclusion "that small children perceive everything as a whole, and do not bother themselves with details. They look first for the use of the object, and then only gradually reproduce characteristic features."[176] He nevertheless calls for a thorough investigation of the spontaneous and voluntary art of children in order to "establish a psychological foundation for a natural . . . drawing method."[177]

1897 Carl Götze, *Zur Reform des Zeichenunterrichts* (*Toward the Reform of the Teaching of Drawing*).[178] Clive Ashwin reports that, on behalf of the Teachers' Association for the Cultivation of Artistic Education in Hamburg, Götze reviews the findings of recent studies of children's art and presents the position of the Hamburg association in relation to "traditional methods of teaching drawing." He asserts the need for a pedagogy resting on intuition and feeling rather than "the strictly rational and cognitive basis of conventional drawing methods."[179]

1897 James Sully, *Children's Ways*.[180] In this revision of his earlier research, Sully points to the discrepancy between his influential belief that children are naturally disposed toward imitating nature and the results of his subsequent research. He notes that it has become "pretty evident" to him that children do not draw likenesses "of what they see when they look at an object," but rather present all the features of the object without troubling "about so small a matter as our capability of seeing them all at the same moment." He concludes that what he once treated as a "later and decidedly 'knowing' stage" is no "nearer the point of view of our pictorial art" than when the child "was in the earlier stage of bald symbolism."[181] He also concedes that while children's drawings are "so far away from those reproductions of the look of a thing which we call pictures, they are after all a kind of rude art. Even the amusing errors which they contain, though a shock to our notions of pictorial semblance, have at least this

Chronology

point of analogy to art, that they aim at selecting and presenting what is characteristic and valuable." His discussion ends with the optimistic hope that when children begin to develop their "aesthetic perception" by focusing attention on "the prettiness of things," then "a more serious effort to reproduce [the] look" of these things will follow.[182]

1898 *Das Kind als Künstler (The Child as Artist)*, Kunsthalle, Hamburg. This children's art exhibition, organized by Carl Götze and held in Alfred Lichtwark's Kunsthalle, is accompanied by a catalogue, *Das Kind als Künstler: Ausstellung von freien Kinderzeichnungen in der Künsthalle zu Hamburg*,[183] described by Clive Ashwin as "one of the most important documents" of the German educational reform movement.[184] Götze draws heavily upon the recent child-study research from both Europe and the United States and advances the following opinion about the child's visual logic: "One used to believe that when a child observed objects it examined them closely and then portrayed them exactly. This assumption can no longer be defended. Although children show a sharp and sure gift for observation when excited by a powerful interest, they direct their observation only toward what is striking, and remain blind to everything else."[185] Having determined that children typically employ schematic or symbolic rather than naturalistic modes of drawing and are generally not concerned with capturing likenesses, Götze questions the rationale for having children copy existing objects. He proposes that traditional methods of drawing instruction neither cater to children's needs nor develop their creative impulses. Insisting that children be allowed to draw from their imagination, Götze advocates "artistic permissiveness" in the classroom, placing "little emphasis on technical achievement."[186]

The exhibit features the work of children from Hamburg, Brussels, the United States, Japan, and Britain, as well as work by Native American children and work from ethnological collections (from Madagascar, Peru, Greenland, Siberia, Brazil, and New Guinea).[187] To obtain such a wide range of children's work, Götze and his colleagues invited researchers from different countries to submit examples.[188] A review of the exhibition in a conservative educational magazine objects to its implication that every child is an artist and that children can develop aesthetic taste on their own without being exposed to "fine masterpieces." Despite this somewhat hostile reception, Götze, Lichtwark, Konrad Lange, and other reformists push ahead; in 1901, they organize a series of conferences that contribute to the evolution of the concept of art education, culminating in the 1901 Dresden conference.[189]

1899 John Dewey, *The Child and the Curriculum*.[190] An innovative and highly influential treatise on the American education system, *The Child and the Curriculum* establishes a totally new approach to education that eliminates the existing contradictions between the personal, "wholehearted," and emotional child's life and the impersonal, highly specialized, and abstract principles of the curriculum. Dewey argues that there is, in fact, no gap "between the child's experience and the various forms of subject-matter" themselves, but that "from the side of the child it is a question of seeing how his experience already contains within itself elements ... of just the same sort as those entering into the formulated study." He calls for abandoning "the notion of subject-matter as something fixed and ready-made in itself, outside the child's experience,"[191] noting that the various fields of study are "themselves experience," or the outcome of someone's efforts and strivings.[192] The teacher's concern, therefore, should be the ways in which the subject may become part of the student's experience.[193]

1901 At a meeting held in Dresden on September 28–29, a group of Germany's top art educators discuss what pictures should be hung in schools.

1902 John Dewey, *The School and Society*. In this book, Dewey stresses that the impulse to draw is one of the child's basic instincts. He recommends letting the child express his impulse freely, and then, "through criticism, question, and suggestion bring[ing] him to consciousness of what he has done."[194] For Dewey, the art impulse is mainly connected with the "social instinct"—the desire to tell and represent.[195] Making an important point that contributes to the better understanding of children's nature and their way of thinking, Dewey states: "Imagination is the medium in which the child lives. To him there is every-

where and in everything which occupies his mind and activity at all a surplusage of value and significance."[196]

1902 Earl Barnes (1861–1935), "Studies on Children's Drawings, VII: The Beginning of Synthesis."[197] In a clarification of what children would gain by being granted more artistic freedom, Barnes explains that those who object to having children draw freely because they "cannot draw" miss the point entirely: "[The child] cannot draw, but he does not know that he cannot. . . . Children under eight, if not already spoiled by bad teaching, can be depended upon to draw of their own volition, or on request, anything on earth, or under the earth, or in the heavens above." Barnes further argues that allowing children to draw what they want will neither "confuse the child's mind" nor "perpetuate imperfect imagery," but will instead reveal "the fragmentary contents of the child's mind" and make the child "conscious of his insufficient knowledge," thereby stimulating further observation as well as "organization of thought."[198]

1902 Earl Barnes, "The Present and Future of Child Study in America."[199] After announcing the goals of his research to be the same as those of fields like astronomy, chemistry, physics, and biology (which, he writes, "have examined, labeled and grouped everything in the world"), Barnes declares that child study should be seen as "an inevitable part of the scientific movement of modern times" and recommends that researchers employ the same methods to establish truth as in other scientific endeavors, even if the object of study is "the subjective world."[200] He further recommends that since most of the research thus far has dealt with material gathered from a group of children "examined only once," it is time for "scientific observers" to keep "careful records" based on "the same child, and the same groups of children, from birth to maturity."[201]

1902 Lena Partridge, "Children's Drawings of Men and Women."[202] Here, Partridge reports on her study of drawings by schoolchildren between the ages four and thirteen, who were given paper and asked to draw a man on one side and a woman on the other. After collecting more than two thousand drawings, Partridge selected two hundred for closer scrutiny, looking for the absence or presence of certain body parts, the use of single or double strokes for limbs, the direction in which the figure or its parts were turned, the attention given to clothes or distinction of gender, and the use of full-face or profile views. Having quantified and tabulated her results, Partridge concludes that "the treatment of the human figure . . . shows a regular and ordered development and the stages are clear and well marked"; further, she proposes, such drawings could serve "as a rough test of the place the child [has] reached in his development."[203] She suggests that children's fragmentary thought, slight powers of concentration, absorbing interest in detail, and weak sense of proportion make them exaggerate those parts that interest them, resulting in "incorrect and misleading" observations.[204] Like James Sully, she optimistically suggests that if children are allowed to draw as they want, then "powers of observation" and "aesthetic feelings" will inevitably and eventually develop toward naturalistic representation.[205]

1902 Mme. Albert Besnard, "Dessins d'enfants."[206] Asked to comment on the state of dreams and the quality of vision in children of the era, Mme. Besnard gives a general account of her observations on drawings and sculpture made by children between the ages of five and twelve. Finding that drawings by children between five and eight years of age are more expressive than those of children between the ages of eight and twelve, she concludes that drawing is the true medium of the simple. Children over eight whose art is still expressive, she is convinced, are either young for their age or gifted artists whose inner vision has withstood the extraneous influences that tend to impede spontaneity, expression, and observation in most children.[207] She suggests that drawings representing subjects of pure imagination, not reproduced from the memory of a model, prove her hypothesis that "the gift of imagination is nothing more than the exaltation of the gift of vision."[208] The child draws as though in a dream, she comments, and his drawings reveal to us his true interior nature and his aspirations. She is impressed by the ability of some of the children whose drawings she observes to express their subject's energy and by the attention of others to details of perspective. Her impression

of the children's sculptures is less promising. She observes that young children produce simple objects that resemble one another, while older (or more advanced) children produce sculptures that testify to the memories they have developed from copying models in school. Children are not often given the proper materials to work with because they tend to be messy, she notes, and so the young artists before her are without experience, knowing only the techniques they learn in school.

Mme. Besnard takes issue with the examples of art surrounding children, suggesting that most of what is presented to the child's eye, from décor to billboards, poisons his sense of taste. The unattractive, uninteresting, and mechanical drawings in children's textbooks further serve to thwart children's observational skills. She calls for tasteless images to be removed from children's sight, at least in their hours of study and recreation, and replaced with reproductions of masterpieces in architecture, sculpture, painting, and so on, in order to preserve them from perverted tastes.[209]

1905 Georg Kerschensteiner (1854–1932), *Die Entwicklung der Zeichnerischen Begabung* (*The Development of Drawing Ability*).[210] This monumental work is the result of research conducted by Kerschensteiner, the superintendent of the Munich public schools, using some 300,000 to 500,000 drawings produced by 58,000 schoolchildren. In it, Kerschensteiner proposes to uncover, among other things, the connection between intellect and graphic expression, the artistic differences between boys and girls, and the nature of children's relationship to ornament. After classifying the drawings by age, sex, technique, and subject matter, he establishes four increasingly complex levels of graphic expression. Determining that boys improve more from one level to the next, he also concludes that many children never achieve the third and fourth levels, which involve naturalistic representation. According to O. K. Werckmeister, Kerschensteiner's four-level scheme describes a natural and regular development "toward the representation of visible reality in space,"[211] with an intermediate phase of "schematism" in which children resort to "transcription of the conceptual characteristics"

of their subject.[212] For Kerschensteiner, improvement in drawing is only possible through good instruction and the diligent imitation of visual impressions. He also advocates the use of memory drawing in which, Peter Smith notes, "objects would be shown, discussed, and then hidden while the student drew what he recalled of the object."[213] According to Diane Simons, Kerschensteiner is not of the view "that in every child there [is] a dormant artistic genius" or "that artistic work [will] lead to moral ennoblement"; although he accepts the importance of children deriving "pleasure from drawing and painting," he places more emphasis on training children "to observe closely and attentively" as well as inclining them toward "productive self-activity."[214] As Brunhilde Kraus notes, Kerschensteiner hopes to establish a system that will help students develop "a maximum of technique, clarity of judgment, and the ability to think logically."[215] His curricular plans, explains Simons, include postponing "systematic" drawing instruction until the fifth year of school as well as avoiding "all the geometric drawing" by relying on "drawing from memory," copying models, and studying perspective.[216] Kerschensteiner is best known for developing the concept of the vocational school in Munich and establishing ties between schoolwork and industry needs.[217]

1905 Siegfried Levinstein (1876–?), *Kinderzeichnungen bis zum 14. Lebensjahr*.[218] A German historian and anthropologist, Levinstein studies about five thousand children's drawings in order to understand the process of children's graphic development. From his observations, he proposes three stages of development: fragmentary, narrative, and expressive. He also notes that some children develop an interest in their "environmental impressions," whereas others prefer to express their "personal feelings," a distinction that anticipates the haptic-visual dichotomy put forward by Viktor Lowenfeld in the 1930s.[219] John Michael and Jerry Morris note that Lowenfeld will credit Levinstein with his willingness to move away from traditional aesthetic criteria in evaluating children's drawings, toward "qualities of self-expression, mood projection, and personal interpretation," as well as to give importance

to the "use of subject matter, the depiction of the human figure, the use of space, and the use of color."[220]

1905 *Kinderkunst*, Kunstsalon Richter, Dresden. Consisting of both children's drawings and drawings from "primitive" cultures, the exhibition is intended to demonstrate similarities in the observation and representation of nature between the two groups.

1905 In Breslau, Germany, researchers under the direction of William Stern (1871–1938) organize a study of the free drawings of children, resulting in an important collection of children's drawings.

1906 Karl Lamprecht (1856–1915), "Les Dessins d'enfants comme source historique."[221] According to Florence Goodenough, Lamprecht aims to collect and study children's drawings from throughout the world. Among the thousands of drawings sent to him, via a central office in Leipzig, "almost every nation in the world [is] represented."[222] Lamprecht's primary interest, Goodenough notes, is in studying racial similarities and differences among the drawings. Lamprecht also collaborates with Siegfried Levinstein.

1906 Edouard Claparède (1873–1940), "Plan d'expériences collectives sur le dessin des enfants."[223] Claparède, an influential psychologist, proposes a plan for studying children's drawings that is similar in scale to the one by Karl Lamprecht.[224] Claparède's aim is different from Lamprecht's however, according to Florence Goodenough: Claparède intends to study the developmental stages in children's drawings, "with the idea of ascertaining what relationship, if any, exists between aptitude in drawing and general intellectual ability."[225]

1906 "Exposition des dessins d'enfants, obtenus par la méthode intuitive et directe des dessins d'après nature," is noted in the Parisian *Chronique des arts* for February 3, 1906.

1907 Marcel Réja (pseudonym of Paul Meunier, 1873–1957), *L'Art chez les fous: le dessin, la prose, la poésie* (*The Art of the Insane: Drawing, Prose, Poetry*).[226] Published by the *Mercure de France*, Réja's study asserts a parallel between "Negro art," psychotic art, and children's art. In children's art, he argues, feeling and thinking are integrated as they never are in art produced in later stages of life.

1907 A conference on children's art is held in conjunction with the Salon of the Musée du Peuple, Angers, on June 8. The conference is organized by Gérôme-Maësse [Alexis Mérodack-Jeaneau], founder of the Parisian journal *Les Tendances nouvelles*.[227]

1908 The first volume of the Leipzig journal *Zeitschrift für Angewandte Psychologie*, edited by William Stern and Otto Lipmann, publishes several articles on children's art and surveys some major collections of "free children's drawings." The major collections of children's art are cited.

1908 Mecislas Goldberg (1868–1907), *La Morale des lignes*. Goldberg claims that "primitive" art is a mature state of child art.

1908 E.-T. Hamy (1842–1908), "La Figure humaine chez les sauvages et chez l'enfant" ("The Human Figure as Rendered by Savages and Children").[228]

1908 *Novoe obshchestvo khudozhnikov* [Fifth exhibition of paintings of the St. Petersburg New Society of Artists], St. Petersburg. Held in the home of Count Stroganov, the exhibition includes an "exhibition of children's drawings," taken principally from the collections of K. A. Syunnenberg and S. Chekhonin.

1908 *Iskusstvo v zhizni rebenka* (*Art in the Life of the Child*), St. Petersburg, November 15, 1908–January 8, 1909. Organized by F. G. Berenshtam and A. F. Gaush and held in "The Passage," the exhibition includes various objects, including children's toys, books, and even "paper architecture," as well as children's drawings. It is widely reviewed in the local newspapers.

1908 *Kunstschau*, Vienna. This exhibition, organized by the Viennese Secessionists, includes work by Oskar Kokoschka (his first show) as well as students from the classes of Franz Cizek. In what Jo Alice Leeds describes as a complimentary rather than a condescending gesture, the "entire entrance room to the exhibition [is] devoted to Cizek's collection of children's art," and this work is treated by the Secessionists as "an aesthetic contribution to be considered as seriously as their own."[229]

1908 The London Congress on Art Teachers, held by the Art Teachers' Guild, includes an exhibition organized by art teacher Mathew Webb, of "work by children at differ-

Chronology

ent age levels" to "demonstrate the value and importance of drawing to education."[230] Richard Carline suggests that this exhibit, unlike later exhibits, places emphasis on "how near children [can] get to adult work" rather than on what children are able to achieve on their own merit.[231] Franz Cizek also exhibits the work of his students during the congress, "including some striking pictures of Mount Etna exploding,"[232] but he is "not really known or imitated" until after later exhibits are held.[233] The success of the congress prompts the London County Council "to convene a conference on the problems related to the teaching of drawing," in which Ebenezer Cooke participates.[234]

1909 Salon d'Automne, Paris. Included in the Salon is the "Exposition de la Société Nationale de l'Art et l'Ecole," which presents children's drawings as well as handicraft items.[235] In his preface to the Salon's catalogue, Octave Mirbeau talks about child art, giving the display particular prominence.[236]

1909 Leon Bakst (1866–1924), "Puti klassitsizma v iskusstve" ("Paths of Classicism in Art").[237] Bakst's article is an important early appreciation of child art in Russia by a member of the advanced symbolist art circle.

1909 *Salon des enfants*, Paris. Organized by Henri Matisse, the exhibition presents work by Matisse's own children and the children of his friends.

1909 *Salon Izdebsky, International Exhibition of Paintings, Sculpture, Engravings, and Drawings*, Odessa. Organized by sculptor Vladimir Izdebsky, the exhibition contains 776 items, including works by Maurice Denis, Pierre Girieud, Wassily Kandinsky, Mikhail Larionov, Henri Matisse, Gabriele Münter, and Georges Rouault. At the suggestion of Kandinsky, drawings by children are shown side by side with the works of these avant-garde artists.[238]

1910 *Manet and the Post-Impressionists*, Grafton Galleries, London. This is the first postimpressionist exhibition in London. Roger Fry (1866–1934), the exhibition organizer, includes works by Paul Cézanne, Paul Gauguin, Henri Matisse, and Pablo Picasso. Critics are hostile, generally dismissing the work as "childish, clumsy and lacking skill,"[239] thus connecting simplified expression in modern art with child art.

1910–20 A cult of childhood plays a small part in the Bohemian culture of Greenwich Village, New York, helping to encourage support for the establishment of more kindergartens and Montessori schools.[240]

1910 *Salon Izdebsky, International Exhibition of Art*, Odessa, December 1910–January 1911. Vladimir Izdebsky's second exhibition of international art (his first was in 1909), organized with the participation of Mikhail Larionov and Wassily Kandinsky, includes children's drawings from the collection of P. M. Vinogradov.[241]

1911 Corrado Ricci's *L'Arte dei bambini* is published for the first time in Russian, as *Deti khudozhniki*.

1911 In April, the couturier Paul Poiret (1879–1944), impressed with children's drawings from Eastern Europe that he had seen, founds the Ecole Martine, a design school for young girls named after his new daughter. Under the supervision of the wife of the Nabis painter Paul Sérusier, working-class thirteen-year-olds are encouraged to paint freely imaginative watercolor designs inspired by their outings in Paris to the zoo, the aquarium, hothouses, and the parks. Their designs are then turned into wallpaper and fabric designs sold at the Martine shop. The Fauve painter Raoul Dufy, who is working with Poiret, and several of Dufy's Fauve colleagues (Derain, Vlaminck, and Matisse among them) have been inspired by the growing number of children's drawings on view in Paris from the 1908 Salon d'Automne, at which the Société Nationale de l'Art à l'Ecole mounted a display of "Decorations Scolaires."[242]

1911 M. A. van Gennep (1873–1957), "Dessins d'enfant et dessins préhistoriques."[243] Here, van Gennep corroborates Hugo Münsterberg's proposition that "art is, at its origins, foremost realist" with his research that demonstrates that this statement is founded on "a psycho-physiological constant."[244] Modeling sketches for his five-year-old daughter to copy, van Gennep observes that she struggles to copy what cannot be found in nature: alphabetic symbols, geometric figures, or abstract ideas such as *a window* rather than *the window* in the room. She rotates the objects, exaggerates secondary traits, and has difficulty limiting her movement, as when she loses control of her zigzags or her "M."[245] Van Gennep compares the

difficulties she exhibits with his findings on the origins of drawing and the techniques of semicivilized and prehistoric drawings. While some theorists argue that the ideographic works found in the Pyrenees represent the work of an aesthetically developed school of art and others argue that they indicate a racial degeneration, van Gennep argues, along with Münsterberg, that the drawings predate stylized and linear art.[246] He finds that "geometric ornaments or alphabetic symbols are of unheard-of difficulty for debutants, whereas realist representation is easy."[247] Thus, he finds that realist drawings reflect psycho-physiological capacity. He suggests that the tendency to see realism as a late stage owes to pedagogy; contrary to our developmental process, we first learn the alphabet, the most abstract part of language, and only after combining letters into words and finally words into phrases do we get to the "only living reality of language."[248]

1911 Exhibition of children's drawings, Galerie Brakl, Munich, April.[249]

1911 *Mostra d'arte libera*, Milan, May. Organized by the Italian futurists Carlo Carrà and Umberto Boccioni, the exhibition presents "spontaneous paintings by the untrained," including work by children and laborers as well as artists, for the purpose of proving, according to George Hamilton, "that the artistic sense ordinarily regarded as an exceptional gift is innate in everyone's soul."[250]

1911 The Moscow Salon Group, of which Mikhail Larionov is a member, shows two rooms of child art in their group exhibition in Moscow.[251]

1911 Paul Klee (1879–1940), "Der Blaue Reiter."[252] In reviewing the *Blaue Reiter* exhibition held in Munich in December 1911, Klee makes a positive comparison between the work of these artists and that of children: "For there are still primordial origins of art, as you would rather find them in the ethnographic museum or at home in the nursery (don't laugh, reader), children can do it too, and that is by no means devastating for the most recent tendencies, but there is positive wisdom in this fact. The more helpless these children are, the more instructive art they offer; for already here there is corruption: if children start to

absorb developed works of art or even to emulate them. Parallel phenomena are the drawings of the insane, and thus madness is no appropriate invective either. In truth all this is to be taken much more seriously, *if* the art of today is to be reformed."[253]

1912 Philip B. Ballard (1865–1950), "What London Children Like to Draw."[254] After examining nearly twenty thousand drawings by London schoolchildren, Ballard defines the favorite subjects of boys and girls. In order of the frequency with which they appear in the drawings Ballard studies, boys' favored subjects are ships, miscellaneous objects, plant life, houses, humans, vehicles, animals, weapons, and landscapes, while girls' are plant life, houses, miscellaneous objects, humans, animals, ships, vehicles, weapons, and landscapes. Ballard also concludes that the age of nine is critical for children in many ways. For example, before this age frontal views are predominant in representations of the human figure and garments are usually decorative or symbolic; after this age, children often draw profiles and pay more attention to details and fashion. Ballard summarizes his view by stating that "some time about 9 or 10 years of age imaginative drawing tends to pass over to observational drawing."[255]

1912 Gustav Hartlaub (1884–1963), *Das Genius im Kinde* (*The Genius in Child*).[256] In recognizing the important differences between children and adults, Hartlaub proposes that because children have not developed visual memory, they might view their drawings as *having* rather than *reproducing* "reality."[257] He reserves the title of "artist" for the adult and not the child.[258] Hartlaub further distinguishes the "gifted" child from the ordinary child (especially in terms of what children's drawings reveal about children as a whole).[259] Nevertheless, according to Michael Langer, Hartlaub argues that "even if the child desires play not art, creates without conscious artistic intention, and has few aesthetic judging capabilities, there is no logical reason why the child's creations cannot be valued as consequently aesthetic."[260]

1912 Wassily Kandinsky (1866–1944) and Franz Marc (1880–1916), eds., *Der Blaue Reiter* (*The Blaue Reiter Almanac*). In his article for the almanac, "Masks," August Macke celebrates the art of nontraditional, nonacademic con-

Chronology

texts whose "forms speak in a sublime language right in the face of European aesthetics." Macke also insists that children are "more creative in drawing directly from the secret of their sensations than the imitator of Greek forms."[261] Kandinsky, in "On the Question of Form," argues that children have access to inner "sounds" of forms because they are not concerned with "practical meanings" and claims that, "without exception, in each child's drawing the inner sound of the subject is revealed automatically."[262] According to Kandinsky, "an enormous unconscious power in the child" manifests itself in the child's creative work, raising it "to the level of adults' work (sometimes even higher!)." Despite his faith in the unconscious creative power of all children, Kandinsky distinguishes between the "gifted," "talented," and "good children's drawing" and that which is none of these: in the former category are drawings that show evidence of the "unconscious application" of composition, rather than deliberate design choices. As soon as the gifted child enters a system of academic training, however, this power is destroyed, and the child loses "the ability to hear his inner sound. He produces a 'correct' drawing that is dead."[263] For Kandinsky, the artist is "in many ways" like the child:[264] he not only has access to "the inner sound of things more easily than anyone else," but is perhaps also "indifferent to practical meanings since he looks at everything with fresh eyes."[265]

1912 *Work by Untaught Children, Aged Two to Eleven*, Gallery 291, New York, April 11–May 10.[266] Organized by Abraham Walkowitz and Alfred Stieglitz, the exhibition features drawings by children living in a settlement house on the Lower East Side. According to William Homer, Walkowitz is the first in the United States to "consistently [draw] inspiration from children's art" and is the one who "encouraged Stieglitz to present the first exhibition of children's art, *as art*."[267]

1912 Salon d'Automne, Paris. Two rooms are devoted to the work of the "Martines" of Paul Poiret.

1912 Undeterred by the reaction to the first exhibition, in 1910, Roger Fry organizes the *Second Post-Impressionist Exhibition* at the Grafton Galleries, October 5–December 31,

this time including the work of Henri Rousseau. In the exhibition catalogue, contributor Clive Bell declares: "Happily, there is no need to be defensive. The battle is won. We all agree, now, that any form in which an artist can express himself is legitimate."[268]

1913 Philip B. Ballard, "What Children Like to Draw."[269] One year after examining drawings by London schoolchildren (reported in his "What London Children Like to Draw"), Ballard obtains about ten thousand drawings by Welsh children from the small town and rural schools of Glamorgan. Here, he stresses the crucial influence of the environment on children's preferred drawing subjects. According to Ballard, the drawings by the Welsh children contain more animals than human beings, whereas the reverse is the case for the drawings by the London schoolchildren. Ballard also notes that city children often draw vehicles, while countryside children rarely do, and that houses are drawn more frequently by country children than by city children. He explains that "London children see buildings at such short range and in such conglomeration that rarely do they see a house steadily and see it whole." In both city and country, however, ships are the most popular subject drawn by boys, and this preference "rises to enormous proportion at seaside places."[270]

1913 Georges Luquet (1876–1965), *Les Dessins d'un enfant* (*The Drawings of a Child*).[271] Having studied more than 1,500 drawings produced by his daughter (with no "adult interference" or "other children present"[272]), Luquet proposes four stages of development: "involuntary drawing, synthetic incapacity, logical realism, and visual realism."[273] He broadens the concept of realism to include anything "that is real at the time it is created to whosoever creates it." By this token, he regards the process of copying other people's drawings as detrimental to children's development, since an imitation, by definition, cannot be real. Luquet also notes a "duplicity" of styles in children's drawings, whereby they exhibit a far greater freedom of expression when away from the supervised or restricted space of the classroom, as when drawing on fences and sidewalks.[274] Both of these ideas will have an influence on Viktor Lowenfeld.

1913 *Target*, Moscow, March 24–April 7. Organized by Mikhail Larionov and Natalia Goncharova, the exhibition includes "Children's Drawings from the Collection of A. Shevchenko" and "Children's Drawings from the Collection of N. Vinogradov."[275]

1913 *Original Icon Paintings and "Lubok,"* Moscow, April 6–20. Organized by Mikhail Larionov and Natalia Goncharova, the exhibition includes collections of children's art.

1913 Yuliia Boldyrev, *Risunki rebenka: Kak material dlia ego izucheniia* (*Children's Drawings: Materials for the Study of the Child*). This is one of the first serious Russian studies of visual perception in children.

1913 Aleksandr Shevchenko (1883–1948), *Neo-primitivizm. Ego teoriya. Ego vozmozhnosti. Ego dostizheniya* (*Neoprimitivism: Its Theory, Its Potentials, Its Achievements*).[276] Shevchenko discusses the importance of child art for the neoprimitivists.

1913 Aleksandr Shevchenko, *Printsipy kubizma i drugikh sovremennyjh techenii v zhivopisi vsekh vremen i narodov* (*The Principles of Cubism and Other Contemporary Trends in Painting of All Ages and All Nations*). Shevchenko includes a reproduction of a child's drawing in this volume.

1913 Russian poet Velimir Khlebnikov insists that two poems by a thirteen-year-old girl be included in *Sadok sudei* (*A Hatchery for Judges 2*).

1913 Roger Fry opens the Omega Workshops in London, a fine art gallery and workshop in which he would later exhibit child art.

1913 Salon des Arts décoratifs, Paris. A bathroom decorated by the "Martines" of Paul Poiret is included.

1913 Georges Rouma (1881–?), *Le Langage graphique de l'enfant.*[277] Florence Goodenough acknowledges Rouma's research as "the most extensive and valuable single study that has ever been made on the subject of children's drawings."[278] Having collected drawings from various sources, including his own drawing class and systematic drawings made by the same children over certain periods of time, and having also made direct daily observations of the drawings of "normal" and "retarded" children, Rouma distinguishes the following stages in the development of drawings of the human figure: the preliminary stage (adaptation of the hand to the instrument, naming the incoherent lines, announcing in advance what is being represented, noticing a resemblance between the lines obtained by chance and certain objects), and the subsequent evolution from the "tadpole" stage to the "transitional" stage, to the complete representation of the human figure in full face, to a transitional stage between full-face and profile views, and finally to the human figure in profile).[279] Rouma also describes four developmental stages in representing motion: neutral (the child draws a stereotyped, static representation of an object and announces the motion verbally), relative (movement shown by some form of relationship, such as a line drawn from the object that is supposed to be moving), partial (movement is partially indicated, such as by drawing a raised leg to show running, while the rest of the figure is stationary), and complete (the entire drawing depicts motion).

According to Fred Ayer, Rouma has some profound remarks on the connection between early childhood drawing and language, describing the general tendencies of language-drawing as follows: the indicative tendency (visual representation is entirely lacking—the child makes a mark and verbally indicates what it means); the descriptive tendency (visual representation enters the drawing—the representation is semi-ideographic and shows what the child knows about the object); the narrative tendency (the child draws a number of diverse characters and representations and unites them into a story through verbal comment); and drawing-language at its height (the child pays more sustained attention to the composition of scenes, becomes animated, speaks in a high voice, and completes imperfections of his drawing verbally, by gesture, and by facial expression).[280]

1914 Max Verworn (1863–1921), *Ideoplastische Kunst* (*Ideoplastic Art*).[281] A German philosopher, psychologist, physician, and professor at the University of Jena (and "the first to reproduce and defend [Wassily] Kandinsky's work"[282]), Verworn includes a section on children's art in this work. Verworn proposes two kinds of art—ideoplastic, "based upon associations and thoughts," and physioplastic, "based upon sensory experiences, sense

impressions, and physiological perception"—and two modes for each—conscious and unconscious—before relating both types to children's art. Viktor Lowenfeld will later base his visual-haptic model on Verworn's physioplastic-ideoplastic model.[283]

1914 William Stern (1871–1938), *Psychologie der frühen Kindheit bis zum sechsten Lebensjahre* (*Psychology of Early Childhood Up to the Sixth Year of Age*).[284] In chapter 20, Stern discusses the psychology of children's free drawing. He considers early drawings as play rather than art, since both the imitative tendency and aesthetic attempts are missing. He views child drawing as an intellectual activity and claims that the lines drawn by the child are "just markings of thought."[285] His understanding of children's drawings is very similar to Georges Luquet's: the child draws what he thinks and knows, not what he sees. Scribbling and "schema," according to the author, are the two major pictorial stages in early childhood, and some children never go beyond the schema stage.[286] Stern also compares drawing and language development: in both, associations are made by jumping from one schema (idea) to another schema (idea).[287] Usually, he notes, the child begins with a theme he wants to draw (mother, butterfly, and so on), and "jumps" occur when the child switches from one characteristic of an object to another. Stern stresses that copying from the model is the late stage of drawing, and that small children always draw from memory. One more essential characteristic of children's drawings, according to Stern, is the lack of synthesis that causes proportion and size problems. Children may also misplace or rotate certain details in their drawings without noticing: "left and right, up and down" may be interchanged. The author distinguishes two major themes in the drawings of early childhood, human beings and animals, and argues that the human figure does not represent a real person but rather a concept, "man as such," with his essential characteristics.[288]

1914 The Russian futurist artist and theorist Mikhail Matiushin uses a drawing by the seven-year-old niece of fellow futurist Elena Guro for the cover of her book *Nebesnye verbliuzhata* (*The Little Camels of the Sky*).

1914 The Russian futurist poet Aleksei Kruchenykh coauthors *Porosiata* (*Piglets*) with an eleven-year-old girl.[289]

1914 Aleksei Kruchenykh (1886–1964), *Sobstvennye razskazy i risunki detei* (*Actual Stories and Drawings of Children*). This volume includes poems and stories by children between the ages of seven and eleven. A somewhat revised edition will appear in 1923.

1914 A second show of children's art is held at Alfred Stieglitz's Gallery 291, New York, from February 18 to March 11.

1915 A third show of children's art is held at Alfred Stieglitz's Gallery 291, New York, from March 27 to April 17.

1915 *War in Children's Art*, Stroganov Institute, Moscow (spring). An exhibition organized by V. Voronov.

C. 1915 Erberg Konst [Konstantin Syunnenberg], *Tsel' tvorchestva* (*The Purpose of Art*). The book includes a chapter entitled "Genius and Children."

1915–16 Important articles on child art appear in the Russian newspaper *Rech'*, and the paper's supplement contains a collection of short statements about children and children's drawings by Russia's leading figures, from Arkady Averchenko to Fedor Shalyapin.[290]

1916 Fred C. Ayer, *The Psychology of Drawing; With Special Reference to Laboratory Teaching*.[291] Ayer describes the different research methods used to study children's drawings and summarizes and describes the major trends in research, such as investigations into the relation of drawing to intellectual development, studies of the drawing product (what subjects children draw, stages in the development of drawing, drawing as a form of language), and considerations of the act of drawing.

1916 The fall group show at Alfred Stieglitz's Gallery 291 in New York, from November 22 to December 20, includes works by Marsden Hartley, Georgia O'Keeffe, Stanton Macdonald-Wright, John Marin, and Abraham Walkowitz, along with a survey of drawings by the ten-year-old Georgia S. Englehard made between the ages of four and ten.

1917 Walter Krötzsch, *Rhythmus und Form in der freien Kinderzeichnung* (*Rhythm and Form of Free Art Expression of the*

Child).[292] A teacher, Krötzsch stresses the importance of observing children "in the act of creating" in addition to analyzing the results of their creations. His belief in the primacy of rhythm and movement as well as in the close connection between the "evolution of drawing" and the "evolution of language"[293] lead Krötzsch to analyze the process of scribbling in children's development. He proposes three phases, which he distinguishes by their rhythmic qualities: unrefined, refined, and naming.[294] According to Helga Eng, Krötzsch connects the rhythmic nature of children's drawings with the phenomenon of automatism. He claims that form, writing, and ornament develop out of the child's first rhythmic and automatic scribbling. He also points out that form again gives way to motion when the child's interest in the drawing subject diminishes: the form is enlarged and coarsened, sharply marked corners are lazily rounded off, straight lines are drawn crooked, and so on.[295]

1917 Roger Fry, "Children's Drawings."[296] In this article, Fry refers to the Omega Workshops by focusing on the quality and value of children's artworks. He stresses that in some drawings "the ordinary teaching destroyed completely the children's peculiar gifts of representation and design, replacing them with feeble imitations of some contemporary convention." He assumes that the best works are produced by untaught children and acknowledges them as having a unique "artistic value." The main strength of children's art, according to Fry, is its "vitality." He states that children's "habit of attributing strong emotional values to all the objects surrounding them is what makes the visual life of children so much more vivid and intense than the visual life of almost all grown-up people."[297]

1917 Galerie Dada, Zurich, May 2–29. In his *Zurich Chronicle 1915–19*, Tristan Tzara makes note of the following exhibition: "Third exhibition at Galerie Dada: Arp, Baumann, G. de Chirico, Helbig, Janco, P. Klee, O. Luthy, A. Macke, I. Modigliani, E. Prampolini, van Rees, Mme. van Rees, von Rebay, H. Richter, A. Segal, Slodky, J. von Tscharner, etc., Children's Drawings—Negro Sculptures. Embroidery. Reliefs."[298]

1917 *Exhibition of Children's Drawings*, Omega Workshops, London, February–March. Roger Fry holds an exhibition in which drawings by children are displayed "as real works of art in their own right."[299] Reluctant to consider schoolwork, which he feels would have been produced under misguided educational circumstances, Fry asks artist friends to contribute their children's work. While the exhibition is going on, a high school art teacher from Dudley, England, named Marion Richardson (1892–1946) comes to London to be interviewed about a teaching post and brings with her the best examples of her students' work, which meet with the selection committee's disapproval. That afternoon, having planned on "seeing pictures," Richardson goes to the Omega Workshops with her students' work in hand and listens with "breathless interest . . . to the conversation between the only two people who were there" besides herself—a schools inspector, who finds "nothing but faults" in the works on exhibit, and Fry, who patiently explains their value and merit. After the inspector leaves, Fry approaches Richardson, sees the work of her students, is impressed with their "forthright simplicity and freshness of vision" (which, he notes, is "characteristic of younger children's art"), and asks her to leave the works behind so that he can include them in the show.[300] According to Richard Carline, Richardson's approach "appealed to Fry precisely because she refused to give direct instruction and allowed the aesthetic sensibilities and imagination of the pupils to guide them."[301] Fry's exhibit attracts much attention in the press—"over one hundred mentions in national and international newspapers," according to Bruce Holdsworth—and is considered "a milestone in art education, being the first time in Britain that children's art [is] exhibited in its own right and for its own qualities."[302]

1917 Dudley Girls' High School, Dudley, England, December. Marion Richardson organizes an exhibition of drawings by her students. To accompany the exhibition, she presents a written statement concerning her approach, which Bruce Holdsworth describes as the "basic philosophy" of all her subsequent writings and therefore an indication that by this time "she [has] arrived at a co-

Chronology

herent and original theory of art education based on sound practice."[303] According to this approach, students "receive no help but the encouragement to draw," classes have "no fixed syllabus," "no emphasis [is] laid upon mere skill," and "no direct training of technical methods" is provided—instead, students decide for themselves as "far as possible" what they draw.[304] If Richardson teaches, it is to develop her students' visual power, to explain "that drawing is a language, which exists to speak about things that cannot be expressed in words," and to insist that the students "never begin to draw until they feel they have grasped the idea, until they know what they want to do and feel impelled to do it." Convinced that the ideas her students express—"emotional ideas about the beauty of the world . . . and not literal and photographic representation of appearances"—are in the same category as those "the artist seeks to express," Richardson believes that children's "drawing[s] must be considered as tiny works of art."[305] That the drawings in the exhibit were not done as adults "would have done them," she supposes, is "their greatest virtue": "Remembering that all art must reveal to us something of which we are not aware, we must not reject them for what seems to us queerness—queerness, which we mostly accept in primitive or foreign art—but look at them and try to receive the message they seek to convey, often simply an idea of space, colour, volume, contrast, etc."[306]

1917–18 Paris. A review appears in *Literary Digest*, August 17, 1918, of an exhibition of "Child Artists of Paris."

1919 Karl Bühler (1879–1963), *Die Geistige Entwicklung des Kindes* (*The Mental Development of the Child*).[307] Bühler, the head of the psychology department at the University of Vienna (and one of Viktor Lowenfeld's instructors), here presents his model of children's artistic development. This model draws upon his understanding of children's language development, especially the idea that learning begins with the whole before progressing to parts—for example, "water" (a general whole) may stand in for "Bring me a glass of water" or "See my boat on the water" (specific parts) for a young child.[308] In art, Bühler theorizes, the child discovers abstract shapes before she or he discovers meanings, and the beginnings of realism

depend upon the child's shifting attitude toward an object—on the object itself becoming "more important than the feelings associated with it" (an idea Lowenfeld will later develop).[309]

Bühler defines three major stages in children's drawings: preliminary drawing (scribbling, transition to representational drawings, and scribble-ornamentation), the schema, and the realistic picture. He states that schemata emerge from the child's knowledge and memories of objects and portray just "their constant and essential attributes."[310] According to Bühler, all mistakes in the schematic drawing lie in the "errors of translating from knowledge—formulated in language—to the spatial order of pictorial representation." However, he states, when the child adds part after part to the drawing, "it draws synthetically."[311] The development of schematic drawing can lead not just to the realistic picture, but to the development of writing, ornamental design, and geographical maps. The child often gives up spontaneous drawing, however, when she "outgrows fairy tales."[312] For most children, graphics ability transforms into writing: "Language has first spoilt drawing, and then swallowed it up completely," Bühler argues.[313] "It is in the main language which is responsible for the formation of concepts and therefore for the reorganization of mental life and the dominance of conceptual knowledge over concrete images."[314]

1919 Pavel Florenskii (1882–1937), "Obratnaja perspectiva" ("Inverted perspective").[315] A religious philosopher and the author of many works on art and Russian iconography, Florenskii writes here about the unique method of representation in Russian icons whereby objects are presented to the viewer from different sides and angles simultaneously. The approach, he notes, creates multiple distortions, but the image is nonetheless perceived by the viewer's eye as correct and enjoyable. According to Florenskii, the same principle exists in medieval art and in art by children. He stresses that children's art presents an original synthesis of the world, an independent representational method that springs from their "special type of thinking."[316]

1919 Pablo Picasso sees an exhibit of the work "of the

child Pamela Bianca" and is inspired to remark that "he no longer [feels] the desire to paint."[317]

1919 *Exhibition of Sketches by M. Larionov and Drawings by the Girls of the Dudley High School*, Omega Workshops, London, February.

1919 Roger Fry, "Teaching Art."[318] In this article, Fry expresses some critical thoughts on art teaching. The natural sources of art making, he claims, spring from one's ability to be oneself, as well as from one's personal reaction to and immediate contacts with the world. He argues that from this point of view, "Art . . . cannot be taught at all." Fry states that "it is not difficult for savages and children to be artists, but it is difficult for the grown-up civilized person to be one," since the civilized individual "tends to lose sight of his own immediate contacts." In the contemporary world, he notes, where "the average civilized man has replaced most of his sensations by opinions," the art teacher should not teach "anything at all," but rather "educate the native powers of perception and visualization of his pupils . . . by exciting and fixing their attention."[319] In order to help the child pass "from being child-artist to being civilized artist," the teacher should "preserve and develop the individual reaction to vision during the time when the child is also receiving the accumulated experience of mankind."[320]

1919 *Bulletin D Exhibition*, Cologne. A dadaist exhibition that includes the work of Hans Arp, Johannes Theodor Baargeld, Max Ernst, and Paul Klee, as well as that by children, Africans, and the insane.[321]

1920 An exhibition of work by Franz Cizek's students, organized by Marion Richardson, is presented in Cambridge, England. This and other exhibits held during the upcoming decade will ensure that Cizek's work as an art teacher will become widely known.[322]

1920 Grafton Gallery, London. Work by Marion Richardson's students is presented in an exhibition. During the course of the exhibition, Richardson meets R. R. Tomlinson, who is "profoundly moved" by the work on view and will later recommend Richardson's appointment to the London County Council in the position of District Inspector of Art.[323]

1920 Roger Fry, *Vision and Design*.[324] According to Sondra

Battist, Fry makes mention of children's drawings in this work, stating that though they deal little with "actual appearances," they nonetheless manage to "directly symbolize the most significant concepts of the thing represented" and can be seen, therefore, as "a kind of hieroglyphic script."[325]

1920 Aby Warburg (1866–1929). Writes about turn-of-the-century children's drawings by Native American children in an article around this time.

1921 Exhibitions of paintings and woodcuts by Franz Cizek's pupils are held in London, Edinburgh, and other cities. Both Wilhelm Viola and Stuart MacDonald propose that Austrians do not appreciate Cizek as much as people from other countries do, especially Britons and Americans.[326] Whether or not this is so, Austria is beset by financial trouble after World War I and cuts its funding for many programs, including Cizek's classes. Two "distinguished war relief workers," one of them Francesca Wilson, step in to help raise money, forming the Children's Art Exhibition Fund—Professor Cizek's Class. For the next fifteen years, Wilson will help publish catalogues and organize exhibitions in Britain, France, and the United States "with great success, and at regular intervals," and is instrumental in building Cizek's reputation.[327]

1921 Cyril Burt (1883–1971), *Mental and Scholastic Tests*.[328] According to Dale Harris, Burt's classification of the stages of children's drawings is "the most important single contribution of the early period of research."[329] Burt emphasizes the developmental character of drawing: "Progress in drawing shows successive changes in kind as well as in degree. It resembles, not so much the uniform accretions of the inanimate crystal, as the spasmodic growth of some lowly organism, one whose life-story is a fantastic cycle of unexpected metamorphosis. Each advance follows a different line from the last."[330] According to the author, there are seven distinctive stages that children's drawings undergo: scribble, between the ages of two and three (purposeless penciling that is essentially "muscular movement," purposive penciling in which "the results themselves become a center of attention," penciling that imitates an adult's general movements, and

Chronology

localized scribbling when the child seeks "to reproduce specific parts of the subject"); line, at age four (single movements replace "rhythmically repeated oscillations"); descriptive symbolism, at ages five to six ("a crude symbolic scheme" becomes apparent in drawings of people, and there is a little attention to shape and proportion); descriptive realism, from seven to nine or ten (drawing is still "a form of silent language," is "descriptive rather than depictive" and "logical rather than visual," and there is "a gathering interest in decorative detail"); visual realism, at ages ten to eleven (the child tends "to trace or copy the drawing made by others, and even spontaneously draw from nature," first using two-dimensional drawing, chiefly in outline, and then three-dimensional drawing that attempts to show a three-quarter view, overlapping, and perspective); repression, between the ages of eleven and fourteen (the human figure is rarely drawn and there is an interest in geometrical and ornamental art, though in general the interest in expression through drawing is transferred to expression through language); and artistic revival, during early adolescence (drawings are now made to tell a story, though most children never reach this stage, which is the time to determine artistic talent).[331] Burt also stresses that the correlation between drawing and intelligence is not "altogether linear": he argues that, among children, "intellectual ability usually connotes graphical ability; but graphical ability does not necessarily connote intellectual ability."[332]

1922 Art Club, Boston. According to a review in *Literary Digest*, the Art Club presents a touring exhibit from England that includes six hundred "imaginative drawings that a child makes for his own pleasure," put together in order to determine "if we have any imagination as a people."[333] The exhibit is praised in a review in the *Boston Transcript*; the reviewer especially likes the works' "ability to suggest motion" as well as their color and narrative content.[334]

1922 Hans Prinzhorn (1886–1933), *Bildnerei der Geisteskranken* (*Artistry of the Mentally Ill: A Contribution to the Psychology and Psychopathology of Configuration*).[335] In this study, Prinzhorn is interested in discovering the "pre-logical" and "pre-verbal" unconscious as a major source for making art, in the belief that an "aimless, rationally incomprehensive, playful attitude extends in to the most complicated artistic creations."[336] Prinzhorn's interest in children's art is directed mainly toward the scribbling stage, when drawing is the result of a free, unconscious "active urge." This explains Prinzhorn's interest in Walter Krötzsch's work.[337] Prinzhorn argues that the state of "diminished unconscious" described by Krötzsch is characteristic of both children and adults who regress "into the early stage of childhood." The "repression of form" always shows a predominance of rhythmic movement, he notes. Prinzhorn also draws attention to the spatial aspects of children's drawings, pointing out that they tend to lack depth and to obey the horizontal-vertical principle of up, down, right, and left. He stresses that "the separation of shape from spatial position is characteristic of children."[338]

1923 Independent Gallery, London. An exhibition of work by Marion Richardson's students from Dudley Girls' High School is presented.[339]

1924 Jean Piaget (1896–1980), *Le Langage et la pensée chez l'enfant* (*The Language and Thought of the Child*).[340] In his ongoing investigation into the child's inner life, Piaget assumes a "child-centered" approach that treats the child's world as self-valued and having its own laws of development. In *The Language and Thought of the Child*, he investigates speech and thinking in children between the ages of three and seven. Some of the monologues and conversations he records here take place during the process of drawing, but because he focuses on the child's speech, he does not pay attention to the content of the drawings. In a chapter on children's questions, however, Piaget does make some interesting comments about children's drawings, describing children's pictorial representation as "intellectual realism":[341] "The child, as we all know, begins by drawing only what he sees around him—men, houses, etc. In this sense, he is a realist. But instead of drawing them as he sees them, he reduces them to a fixed schematic type; in a word, he draws them as he knows them to be. In this sense, his realism is not visual, but intellectual."[342] Piaget

also stresses that the child's intellectual realism "extends beyond the sphere of drawing": "the child thinks and observes as he draws." Though the child clings to reality, his drawing's realism is "the outcome of his own mental constructions rather than the fruit of pure observation."[343]

1924 Stella Agnes McCarty (1872–1936), *Children's Drawings*.[344] Having obtained 31,239 spontaneous drawings by American kindergartners and schoolchildren between the ages of four and eight, McCarty studies them to define children's natural interests as they are expressed in drawing, focusing on "the ability to express meaning through line and mass."[345] According to McCarty, the younger children in her study show a preference for human and animal forms, while the older children tend toward drawing houses, flowers, natural objects, and simple scenes. McCarty points out that the main influences that foreordain children's choices come from school and the "wider social environment," and she notes that gender differences also influence the choice of subject.[346] Analyzing composition in the drawings, McCarty notes that the younger children tend to depict single objects or a number of unrelated objects, while the older children try to express ideas in relation to each other.[347]

1925 Nikolai Dmitrievich Bartram, "SSSR Na Parizhskoi Vystavke."[348] The author reviews the Soviet exhibits at the Exposition des Arts Décoratifs Modernes in Paris, including one titled "The World of the Child," which presents children's art as an example of the Soviet Union's native, inherent traditions, uninfluenced by the West, and thus attesting to the high development of Russian culture.

1926 An exhibition of Mexican art, presented in Paris, includes art from the Escuelas de Pintura al Aire Libre, part of the public education system in Mexico that encourages small children to explore their "native talent." The show is reviewed in all the major art journals and is the critical success of 1926.

1926 Gustaf Britsch (1879–1923), *Theorie der Bildenden Kunst* (*Theory of Plastic Art*), edited by Egon Kornmann.[349] Egon Kornmann spent a number of years working with Britsch, listening to his lectures, taking notes, and discussing re-

search problems with him. According to Kornmann, Britsch argued against looking at the work of art as an object; rather, he viewed it as a "mental accomplishment" or a "special kind of intellectual achievement." He was interested in children's drawings as documents of early mental achievement.[350] Scribble, he believed, is already distinguished by the child from a chaos of visual experiences and can also be seen as "a realization of a visual type of thought." Britsch argued that visual thought should be distinguished from conceptual or verbal thinking, which develops later in life. Further differentiation of visual thought occurs when the child starts using "direction judgment": scribble has no meaning or direction only when it is accidental, but when the child starts scribbling intentionally in particular directions (vertically or horizontally), it can be considered the next step in the development of visual thinking.[351]

According to Britsch, early symbols in children's drawings do not stand for real objects, but rather represent the child's knowledge about visual experiences; the object is formed "as a result of judgment possibility." In early representational drawings, directions are limited to vertical-horizontal relationships, but later they become more flexible. Britsch defined the next step in the development of visual thought as "changeability of directions";[352] at this stage, the child is able to judge movement. Subsequent development moves toward the "more unified achievement," or the intellectual ability of "holding a total context," which is accomplished at the true-to-appearance stage.[353] At the early stages of development, the child tends to think within individual contexts—for instance, trees are thought of as separate from the street and, therefore, are drawn perpendicular to it—because the child is able to think only about one object at a time and cannot hold the whole picture in mind. The lack of scale relationships in young children's drawings likewise derives from the child thinking in terms of individual contexts.[354] Britsch's revolutionary ideas will have a strong influence on research conducted by Henry Schaefer-Simmern and Rudolf Arnheim.

1926 Florence L. Goodenough (1886–1959), *Measurement of*

Intelligence by Drawings.[355] The first chapter of this book is dedicated to an extensive historical survey of the most important research on children's drawings. Goodenough summarizes them into twelve conclusions, the most important among them being as follows: in young children, a close relationship exists "between concept development" in drawing and "general intelligence"; drawing for the child is primarily "a language, a form of expression, rather than a means of creating beauty"; in the beginning, the child "draws what he knows, rather than what he sees"; the "ideoplastic basis" of children's drawings is seen in the relative proportions given to the separate parts (exaggeration of important parts and minimization or even omission of unimportant items); the order of drawing development is "remarkably constant" among children of all social antecedents and nationalities; and in drawing objects placed before them, young children "pay little or no attention to the model" and tend to draw from memory.[356]

In the rest of the book, Goodenough presents her own study of children's drawings as a measure of intelligence—a test method founded on the conventional belief that a direct connection exists between the representational stage of drawing and a specific level of mental development. Nearly four thousand drawings of the human figure were obtained from children in kindergarten through fourth grade in Perth Amboy, New Jersey. Children were discouraged from storytelling or adding "unnecessary details" such as a pipe or a hat to their figure since it could "distract" them from the original concept and make them forget the essential parts of the drawing. Goodenough then analyzed their drawings and gave each drawing a score based on whether the appropriate parts of the body were shown, whether the parts of the body were connected properly, whether proportion was present, and so on. The highest score was given to realistic drawings of figures seen in profile.[357]

1926 Lewis Mumford (1895–1990), "The Child as Artist."[358] In this article, Mumford describes the progressive art-education movement being supported by a number of experimental schools in the United States. For Mumford, the essence of this movement is the belief that art is a

"natural and normal human activity" rather than something that requires "mechanical skill." He explains that the methods of art education being used at these experimental schools attempt to escape "the dull motions of a utilitarian routine" and recover art "as a central creative activity." He stresses that each child is viewed as a potential artist. Their art "opens up a channel from the child's inner life, expressing symbolically some wordless desire," fixes the child's meaningful experiences into a "living pattern," or expresses imaginative ideas. Most of the paintings produced by students at these experimental schools, he notes, are direct, strong, vigorous in design, and frequently have "a power of formal expression." While the child's artistic activity is natural, Mumford asserts, it also requires "a certain amount of encouragement, instruction, and discipline."[359]

1927 Georges Luquet, *Le Dessin enfantin* (*Children's Drawings*).[360] This book expands on Luquet's *Les Dessins d'un enfant*, published in 1913. Here, he retains his classification of the developmental stages in children's drawings (fortuitous realism, failed realism or synthetic incapacity, intellectual realism, and visual realism), but provides further observations and conclusions. He describes the child's fundamental intention to draw as realistic, stating that "children are realists first of all in their motifs, in the subjects they draw."[361] In opposition to most researchers, who claim that the child draws from memory rather than from observation, Luquet asserts that children always look for an object to draw.[362] He stresses that, unlike adults who commit to visual realism, children draw not from the external model but rather from the "internal model" that is created when the child depicts an object for the first time.[363] At first, this internal model includes only those elements the child considers essential, but it is successively enriched "through synthesis."[364] Besides being influenced by models, the child may also be influenced by the "association of ideas" and by "graphic automatism."[365] Luquet notes that the interpretation children give to their drawings during their making or after they are completed is often different from their original intention.[366]

Luquet disagrees with researchers who define chil-

dren's graphic representations as "schemata," conceding only that drawing at the stage of synthetic incapacity has a schematic character.[367] Instead, to reflect the realistic nature of children's drawings, he asserts that they represent "types." He notes further that the types of children's drawings show both conversation and modification tendencies.[368] The strong conversation tendency in children's drawings excludes them from direct adult influences.

Discussing the stages of development in drawing, Luquet asserts that the synthetic incapacity that occurs in the second stage is due to the fact that "when children are thinking about depicting any particular detail, they think solely about how they are going to add it to their drawing," so they miss the whole picture.[369] Intellectual realism, the third stage of children's graphic development, presents "all of the actual details of the object, even if they are not visible either from the location from which they are observed or from any other viewpoint." In contrast, visual realism (the fourth stage) depicts "only those details which can be seen from where the object is viewed."[370] The characteristic features of drawings of this stage are the separation of details, "which in the actual object are not easy to distinguish"; showing what is invisible (transparency); and changes in viewpoint (plan, elevation, folding over). Luquet stresses that the stage of intellectual realism is unique and definitely realistic, "since the aim of all the techniques . . . is to provide the most faithful and complete representation of the objects."[371] The shift from intellectual to visual realism usually occurs between eight and nine years of age; however, "intellectual realism not only reappears in later drawings, but the same drawing may include aspects of visual realism and intellectual realism."[372] Children's narrative drawings, according to Luquet, also show a significant difference from the cinematographic principle of visual realism: "for the graphic representation of dynamic events, intellectual realism shows change as we experience it in our minds. . . . In contrast, visual realism . . . fragments the continuity into a succession of discontinuous instants."[373] Luquet's final statement in the book reflects his revolutionary view of children's drawings: "Visual re-

alism is no less a convention than intellectual realism. Intellectual realism allows children's drawings to be, in their representation of space, a kind of flat sculpture . . . and, in their representation of time, a miniature theatre. It could thus be said to be a universal art, which at least merits serious examination before being dismissed."[374]

1927 Katherine Anne Porter (1890–1980), "Children and Art."[375] Porter discusses an exhibition of work by Mexican and American schoolchildren that includes drawings, paintings, and clay sculptures. She stresses that only a few differences between the works of the two nationalities are evident; these include differences in costume and subject matter, a "stronger feeling for design" and accuracy in the Mexican pictures, and a "certain lack of detail and an ampler sweep of line" in the American works.[376] According to Porter, there are no other significant dissimilarities between the children's pictures. All of the children tend to draw similar figures, which "resemble gingerbread men a trifle warped in the baking"—but this satisfies them only "until someone tells them it is wrong, or they grow up," she notes. The author compares the children's pictures to the art of "primitives." According to Porter, "a primitive is one not fully equipped who does his best; he does not throw away a developed technique in order to be simple once more." Porter also admires a unique gift of color that both the American and the Mexican children possess. However, she writes, these children should not be viewed as artists yet, until they retain and show their talent in the future.[377]

1927 Oskar Wulff (1864–1946), *Die Kunst des Kindes* (*The Art of the Child*).[378] This is the first systematic study of children's drawings undertaken by a recognized art historian of the time. Wulff's research began shortly after the death of his own son, who was a prolific drawer, at the age of sixteen. In the first part of the book, he discusses general issues concerning child art, while in the second part he presents a thorough analysis of his son's drawings. He expresses regret that he did not ask his son about his drawings while he was alive because he was waiting for him to reach a mature age.

Wulff defines his perspective as "comparative developmental and historical," since he focuses on both the

history and the developmental stages of child art. In order to gain a broader foundation for his work, he conducted detailed research into recent writings on child art, being especially influenced by Georg Kerschensteiner's *Die Entwicklung der Zeichnerischen Begabung* (1905) and Karl Lamprecht's "Les Dessins d'enfants comme source historique" (1906). He also drew on the large collections of children's drawings presented in these two sources, as well as in Siegfried Levinstein's *Kinderzeichnungen bis zum 14. Lebensjahr* (1905). In the first part of the book, Wulff attempts to define some general tools for comparing the major issues of child art with the child's individual artistic development. He also wants to "connect art theory with child art" by presenting children's drawing, painting, and sculpture as an object for art theory research.

According to Wulff, children's graphic development can be divided into four major stages: from scribbling to the earliest appearances of the schema (or main view); the development of three basic views; forming things as they appear; and the subsequent perfection of views that goes "beyond the free unfolding of child art." However, he proposes to further reduce these stages to two major segments: ideographic (the first two stages) and physiographic (the second two).

Wulff believes that the same "forming forces" that exist in high art are present in art by children. In both adult art and child art, he states, there are two major "forming drives": rhythmic and reproductive (representational). Drawing and sculpture by both children and adults also exhibit two different expressions of artistic imagination, namely linear (two-dimensional) and plastic (three-dimensional). Spatial representation, according to Wulff, may be purely visual or may mirror constantly changing visual space.

1928 Whitworth Art Gallery, Manchester, England, spring. Work by Marion Richardson's students as well as students of R. J. Puttick, one of Richardson's followers, is presented in an exhibition. In her catalogue statement, Richardson once again describes a method of encouraging students "to concentrate upon and give expression to mental images formed upon their own observations." She also mentions that studying reproductions "of the works of great artists" helps students understand "the essentials of formal design"—but, she insists, "the value of an honest attempt at expression" is always more important than "the production of an accomplished rendering." Richardson notes that "a common tradition and style" has developed among her students because of their working together, in a way that was "unforeseen" by her.[379] Twenty-three block designs exhibited at the show are subsequently bought by manufacturers—"representatives of the cotton trade"—to be put into production as fabric patterns.[380]

1929 "Kinderzeichnungen," *Bauhaus*.[381] The summer issue contains several articles on children's art, evidently occasioned by an exhibition of child art organized at the Bauhaus in Dessau, Germany, by one of Klee's former students, Lene Schmidt-Nonne, who credits Klee with profoundly influencing her view of the subject.

1931 Helga Eng (1875–1966), *The Psychology of Children's Art: From the First Stroke to the Colored Drawings*.[382] In this extensive individual study, Eng follows the pictorial development of her niece from the age of ten months to eight years. The book is well illustrated and gives a thorough description of the drawings that were made by the girl during each year of her life. Eng distinguishes three major stages of the child's graphic development: scribbling, the transition from scribbling to formalized drawing, and formalized drawing. Scribbling evolves gradually from wavy scribbling to circular scribbling and then proceeds to variegated scribbling, "to which belongs the scribbling of zig-zag lines, straight lines, angles, crosses, ovals, spirals, loops, rectangles, wavy lines, imitation of handwriting, etc." Eng also discriminates between stages of scribbling according to placement pattern: mass scribbles, scattered scribbles, and isolated scribbles (single lines and shapes drawn and repeated separately).[383] At the transitional stage from scribbling to formalized drawing, the child names her scribbles, providing them with a definite meaning and connecting them to a real person or object. The child also consciously repeats certain lines and shapes.[384] According to Eng, the first formalized draw-

ing is usually a human figure. The first "human formula" is grasped "with great uncertainty by the child," then is often forgotten and abandoned, so that the human figure is later drawn differently.[385]

Eng expresses some interesting thoughts on the various characteristics of children's drawings. For instance, she points out that children draw from memory rather than from the model, as long as their drawing "is definitely ideomotive both in its origin and in its early development."[386] She agrees with Karl Bühler's definition of "orthoscopic forms" as the primary fundamental models of objects that children keep in their memory. For example, the child draws a tabletop as a rectangle, its primary "orthoscopic form," being unable to perceive it in perspective as a trapezium or rhombus. Eng stresses that, psychologically, the object is "best grasped in this manner."[387] She also notes that both the turning over and the elevation of objects in children's drawings are due to "false synthesis" (as does Georges Luquet, in *Le Dessin enfantin*). Formalized drawing, however, evolves in accordance with the child's mental development: it "begins automatically, formalized, unordered; advances, and finally becomes determined by reality, logical, synthetic."[388]

Noting the displacement in children's drawings—such as objects being drawn upside down—Eng asserts that this reflects essential characteristics of children's perception: "a paper lying on the table has neither a top nor a bottom so that it is quite comprehensible that the children put the legs on their figures in every possible direction."[389] She also notes that it is difficult for children to "retain a grasp of the whole" when they are occupied with drawing details, which might cause various exaggerations in size and proportion.[390] The child's attempt to add ornament to his or her drawing, according to Eng, reflects the conscious aesthetic aspiration "to make it pretty."[391] In conclusion, Eng emphasizes that the major aspects of children's drawings reflect their mental development: drawing develops together with speech (scribbling corresponds to gurgling, the simple outline of a formalized human figure corresponds to the single word "mother" substituted for a whole sentence); drawing illustrates the

child's first concepts; and the spontaneous process of drawing is an example of the "natural process of learning," which illustrates "how a child . . . learns something by itself."[392]

1931 Alfred G. Pelikan (1893–1987), *The Art of the Child*.[393] This book contains many beautiful plates of artworks by children from grades one through eight, including imaginative and spontaneous drawings and paintings as well as guided projects with some degree of imitation. The author supplies detailed commentary on the artworks, analyzing their content, aesthetic qualities, and expressive characteristics. Drawing, Pelikan believes, is an "instinctive" form of expression for the child and possesses distinctive artistic qualities.[394]

1932 G. W. Paget, "Some Drawings of Men and Women Made by Children of Certain Non-European Races."[395] Presenting a revolutionary approach to the study of child art, Paget analyzes the cultural influences in young children's drawings. For this study, Paget collected more than sixty thousand drawings of human figures by children from the remote parts of Africa, India, China, and other non-European countries. According to the author, the drawings were made by request; many of the children had no prior experience in pencil drawing, while others had some experience of "drawing with their fingers or with sticks in sand, or with charcoal or vegetable juices on mud walls or stones." When presented with a pencil, Paget reports, the majority of children seemed to arrive almost immediately "at the idea of drawing in outline."[396] Highly distinctive local conventions arose, in some cases among groups of children widely separated from one another. Paget describes four such schemata: a bi-triangular form used by different groups of children from southwest Africa; a "stick figure" form employed by twenty-two children of British Somaliland; distinctive conventions in drawings of faces within a group of children in Tanganyika; and a conventional nose form occurring in various places. The author writes that the bi-triangular body form found in the drawings by many African children exhibited the clear influence of contemporary drawings and carvings by adults, but that many of the other

Chronology

symbols drawn by youngsters were disconnected from the local adult traditions and were spontaneously invented by certain children and then copied by their peers.[397] Paget's findings will be used extensively by researchers, such as Maureen Cox and Claire Golomb, in the 1990s and early 2000s.

1933 Clara P. Reynolds, "Child Art in the Franz Cizek School in Vienna."[398] In this article, Reynolds describes a lecture by Franz Cizek she attended in Vienna in November 1930. Cizek's key statement, she reports, is that "the child has his own language and logic" and that "he has his own art." He showed slides of his students' artworks, beginning with drawings by two-year-olds and continuing through to the work of eight-year-olds, explaining the child's logic and artistic discoveries at each stage. Afterward, Reynolds notes, he provided listeners with art supplies and asked them to paint as six-year-olds, ending with a critique that illustrated his primary concerns: the strength of temperament involved in the work (confidence, joy, fearlessness in self-expression), as well as the feeling of its lines and composition.

1934 Lev Vygotsky (1896–1934), *Myshlenie i rech'* (*Thought and Language*).[399] The most influential book by this great Russian psychologist is published immediately after his death and soon after suppressed by Soviet authorities. His work was widely disseminated in the West by his student Alexander Luria. The major theme of Vygotsky's theoretical framework is that social interaction plays a fundamental role in the development of cognition. The essays that will later appear in his highly influential book *Mind in Society: The Development of Higher Psychological Processes* (1978) were written in the early 1930s.[400] Vygotsky argues that it is not enough to indicate the child's current level of mental maturity as it is a "completed developmental circle"; rather, the child's "zone of proximal development," showing his or her potential developmental level, should be considered as well. According to Vygotsky, "The state of a child's mental development can be determined only by clarifying its two levels: the actual developmental level and the zone of proximal development." The teacher plays the role of facilitator by creating a push

for the child's further maturing. "The only 'good learning,'" Vygotsky claims, "is that which is in advance of development."[401]

In the essay "The Prehistory of Written Language," Vygotsky discusses the connection between drawing in early childhood and the development of writing. For Vygotsky, the child always tells stories while drawing, and drawing can therefore be considered a "graphic speech that arises on the basis of verbal speech." He writes: "The schemes that distinguish children's first drawings are reminiscent . . . of verbal concepts that communicate only the essential features of objects. That gives us grounds for regarding children's drawing as a preliminary stage in the development of written language."[402] But in order to understand the nature of writing, the child should make a basic discovery "that one can draw not only things but also speech." In conclusion, Vygotsky states that the natural development of written language would be a sequential shift "from drawing of things to the drawing of words."[403]

1934 Reginald Robert Tomlinson (1885–?), *Picture Making by Children*.[404] In this short but thoughtful work, the author emphasizes that children's ability to draw is an "inborn talent."[405] He celebrates the pure aesthetics of children's drawings and argues that they are "not reflections of something imposed, but of something experienced." He also notes that drawings by children reject any irrelevancy, expressing only essential forms.[406] Imitation and copying, he states, are harmful for the child's creative abilities; the child "must not be placed in an environment where the inducement to imitate is overwhelming."[407] The child's natural ability to draw flourishes not through copying someone else's work, he argues, but through the direct observation and experience of the world: "The natural ability . . . requires no assistance whatever but experience, and if drawings were left alone and the children were denied access to illustrations, there would no doubt be a steady development towards drawings very similar to those of the Spanish caves. With free development based on the adventures and direct observation of the child himself, the outcome would be great art."[408]

1934 *International Exhibition of Children's Paintings*, New York, November 13–December 1, sponsored by the Little Red Schoolhouse, a progressive elementary school in Greenwich Village.[409]

1934 *International Exhibition of Children's Art*, Moscow.

1935 Osip Beskin (1892–1969), ed., *Iskusstvo detei* (*The Art of Children*).[410] This book of essays on children's art and teaching methods compares Soviet children with children of other nationalities, pointing out the differences in their representations of people, objects, and so on. The author argues for the ideological superiority of the Soviet children's work—a late Soviet theme, exemplifying the belief in the positive effects of a Soviet education and of growing up in a communist society.

1935 Ruth Griffiths (1895–1973), *A Study of Imagination in Early Childhood and Its Function in Mental Development*.[411] Here, Griffiths defines the major stages of graphic development in early childhood and their relation to the child's mental development, finding a high correlation between "mental age" and the stage of drawing that has been reached.[412] Griffiths identifies eleven drawing stages: undifferentiated scribble; the appearance of rough geometrical shapes (with names often being given to them); combinations of lines and squares, and combinations of circles (squares and circles are not yet combined together); the juxtaposition of many unrecognizable objects; the tendency to concentrate on one object at a time; the further juxtaposition of recognizable objects; partial synthesis (some objects are shown in definite relation to each other); the pure picture (a tendency to draw one picture only); the multiplication of pictures (a pure joy of representation); and the development of a theme by means of a series of pictures.[413] In order to measure the child's intellectual level, Griffiths suggests studying not just one drawing, but a series of drawings produced within a short period of time (for instance, twenty days), as there is considerable fluctuation from drawing to drawing in terms of the mental age with which they correlate.[414]

1936 Anne Anastasi (1908–2001) and John P. Foley, Jr. (1910–1994), "An Analysis of Spontaneous Drawings by Children in Different Cultures."[415] This study is based on 602 drawings included in the *International Exhibition of Children's Paintings* held in New York in 1934. According to the authors, these drawings, made by children between the ages of six and twelve from forty-one different countries, all share some features in common, while also presenting other features specific to the child's cultural environment. Among the latter are "geographical, climatic, and locational characteristics," as well as other elements typical of the child's environment: vegetation, people, occupations and activities, animals, and multiple accessory objects (dwellings, churches, factories, conveyances, weapons, agricultural and technological objects, clothing, and so on). Anastasi and Foley also point out that most drawings do not show any "imaginative character" and tend to portray objects of everyday life.[416]

1936 Wilhelm Viola, *Child Art and Franz Cizek*.[417] Writing after prolonged observation of Franz Cizek's Juvenile Art Class in Vienna, Viola writes of Cizek's approach: "To let children grow, flourish and mature according to their innate laws of development, not haphazardly, is a quintessence of Cizek's view and 'method'; if one may use the word 'method' in connection with Cizek."[418] Viola describes a case where a mother brings her nine-year-old daughter, who persistently refuses to draw at school, to Cizek's class. Cizek gives the child a piece of paper and a pencil and says: "Now draw something that you will enjoy!" The result, Viola reports, is a wonderful drawing.[419]

This way of teaching art is the opposite of that practiced in school settings, where small children are given "books with dotted pages" and are asked to connect the dots with straight lines, while older children copy designs from the blackboard.[420] Children in Cizek's class choose among different media, including linocut, woodcut, wood carving, modeling, embroidery, crochet, etching, distemper, chalk, and pencil. According to Viola, Cizek noticed that small children like to start their painting with colors without having made any previous drawing and gives them free rein to do so in his class, in contrast to established methods: "To paint creatively without having done any drawing before was regarded by the old school as almost immoral."[421] Cizek does not teach any

Chronology

techniques to his pupils and encourages them to find their own way of making art; he genuinely believes, Viola notes, in the "special laws of the mental working and logic of the child." Asserting that "primitives" continue to make art through puberty and beyond, Cizek believes that European children stop drawing at a certain age because they become "spoiled by schools."[422] Viola stresses that Cizek places the same value on children's art as that accorded to the great art of the ancients, stating: "We have no art that is so direct as that of children. Even the old Egyptians are not stronger."[423]

1936 Carl Gustav Jung (1875–1961), "The Concept of the Collective Unconscious."[424] Jung first articulates his concept of the collective unconscious in this article. His theory will profoundly influence those researchers looking for the universal and cross-cultural characteristics of child art as well as its connection with the art of "primitives." According to Jung, "the content of the collective unconscious is made up essentially of *archetypes*" that indicate "the existence of definite forms in the psyche which seem to be present always and everywhere."[425] Jung argues that archetypes are inherited and are "identical in all individuals," first appearing in children's fantasies or dreams between the ages of three and five.[426] Among the major archetypes, he notes, are the mother archetype, the child archetype, and the archetype of rebirth.

1936-48 As part of the Works Progress Administration's Federal Art Project, periodic exhibitions of artwork made by children in community art classes are presented throughout the United States.

1938 *They Still Draw Pictures! A Collection of Sixty Drawings Made by Spanish Children During the War*. The drawings reproduced in this book, made by children between the ages of five and fifteen, were collected from refugee camps in France and Spain and from Spanish schools by the American journalist Herbert Rutledge Southworth, the Spanish Board of Education, and the Carnegie Institute of Spain. The Spanish Child Welfare Association of America and the American Friends Service Committee publish the book, which includes an introduction by Aldous Huxley, to raise funds for children in the war-torn country.

1938 Robert Goldwater, *Primitivism in Modern Art.*[427] With this work, Goldwater provides an important preliminary account of the influence of child art on modern artists. Among those drawn to children's art, according to Goldwater, are Raoul Dufy, Marc Chagall, Lyonel Feininger, Johannes Itten, André Masson, Pablo Picasso, and especially Wassily Kandinsky, Paul Klee, Joan Miró, and Jean Dubuffet. The German Expressionist group Die Brücke, Goldwater also notes, "prized their own childhood drawings."[428] Goldwater devotes a chapter each to the work of Klee, Miró, and Dubuffet, all of whose work, he asserts, is deliberately "reminiscent" of the work of children.[429]

1938 *Drawings by London Children*, County Hall, London, July. Organized by Marion Richardson, this exhibition of six hundred works by children between the ages of three and eighteen reveals "beyond dispute," according to Richard Carline, that "old methods of art teaching [are] rapidly giving way in face of the new understanding of children's need to express their own ideas in their own way."[430] Bruce Holdsworth agrees that this exhibition "is widely regarded as the point at which [Richardson's] work . . . finally [convinces] even the most sceptical of the value of art in education."[431] In order to give "a sense of growth from the earliest to the final stages of schooling," the exhibit is hung according to age group; it is also arranged by school type, distinguishing between "schools for handicapped children, private schools, public schools, and finally . . . children who were educated at home."[432] The exhibition receives 26,000 visitors over the course of eight weeks. Richardson's efforts in organizing exhibitions will later influence the practices of the British Council.

1939 Roger Fry, *Last Lectures*. In a lecture on Egyptian art, Fry draws parallels between the art of ancient Egypt and children's drawings. Like Egyptian art, he says, child art shows "a highly conceptualized vision" in which "all images tend to represent objects rather than appearances, and objects therefore are seen in their widest lateral extension."[433]

1939 Viktor Lowenfeld (1903–1960), *The Nature of Creative Activity: Experimental and Comparative Studies of Visual and Non-*

Visual Sources of Drawing, Painting, and Sculpture by Means of the Artistic Products of Weak Sighted and Blind Subjects and of the Art of Different Epochs and Cultures.[434] Having observed that weak-sighted and blind students can produce excellent art-works that are sometimes hard to distinguish from those by normal-sighted students, Lowenfeld here compares drawings, paintings, and sculptures by normal-sighted, weak-sighted, and blind children. Looking for sources of drawing capacity other than the visual, he notices that at the scribbling stage all children, despite their sense of sight, draw the same way, and concludes that scribbling is fundamentally kinesthetic in nature. He points out that visual experience starts to play a role "from the time when the relation between rhythmical movement and line is perceived."[435] At this stage, children begin to name their scribbles, and as they search for a method of representation, they use a variety of symbols for the same object. Gradually, however, the child "creates its own expressive symbols for every form."[436] Lowenfeld defines these multiply repeated symbols as "schemata." While studying the human schema in different drawings, he is especially interested in cases where it is modified, finding that omissions, exaggerations of parts, and overemphasis are characteristic of the drawings of both normal and weak-sighted children. According to Lowenfeld, all these deviations from the "inflexible schema" are "called out by an experience," depend on "subjective attitudes," and have their own "order of values."[437] He states that "neither the development nor the formal aspects of the human schema have anything to do with the experience of the sense of sight." He comes to the same conclusion regarding the concept of space.[438] The infantile drawing, he states, is determined by "somatic experience" that includes "bodily sensations, muscular innervations, deep sensibilities, and their various emotional effects."[439] For normal-sighted children, visual impressions start to play a significant role only after the age of nine, and by the age of thirteen bodily experience is often replaced by the visual. For weak-sighted children, however, somatic experience remains the "generating principle" of their drawings.[440] Finally, Lowenfeld defines two creative types

based on two types of perception, visual and haptic: "When we investigate the artistic products of these two types," he writes, "we find that the visual type starts from his environment, that his concepts are developed into a perceptual whole through the fusion of partial visual experiences. The haptic type, on the other hand, is primarily concerned with his own body sensations and with the tactile space around him."[441]

1940–45 The British Council and its Fine Arts Committee, with the help of the most well-known English art critic of the period, Sir Herbert Read (1893–1968), select examples of British children's drawings for a series of international wartime exhibitions. Read and Pablo Picasso go to see one of the exhibitions in Paris, and Picasso reportedly remarks to Read, "When I was the age of these children I could paint like Raphael. It took me many years to learn how to paint like these children."[442]

1942 [?] Joseph Cornell arranges an exhibition of work by children and himself at the Wakefield Gallery, New York.

1942 Wilhelm Viola, *Child Art*. Viola analyzes the nature, psychogenesis, and aims of child art and gives a thorough description of lessons taught by Franz Cizek in his Juvenile Art Class in Vienna. He draws parallels between child art and the art of "primitives," noting similarities such as the absence of perspective, their imaginary quality, and biogenetic law (the ontogeny of the child repeats the phylogenetic history of mankind).[443] For both children and "primitives," he asserts, language is "too abstract," and therefore they express themselves in a "picture language." To explain the absence of a third dimension in "primitive" and child art, Viola refers to Oswald Spengler, who claims in his *Decline of the West*: "The symbolic experience of depth is what is lacking in the child, who grasps at the moon and knows as yet no meaning in the outer world, but, like the soul of primitive man, dawns in a dreamlike continuum of sensations. Of course, the child is not without experience of the extended, of a very similar kind, but there is no world-perception; distance is felt, but it does not yet speak to the soul."[444] Viola also interprets the absence of proportion in the art of "primitives" and children as stemming from the intention "to create

Chronology

or represent what is most important to them." He notes that both groups draw not what they see, but rather what they know about things; for instance, in both drawings by young children and ancient Egyptian art, two eyes are often included in depictions of the human figure in profile.[445]

In chapter 3, Viola describes the psychogenesis of child art based on the seven developmental stages described by Cizek: scribbling and smearing; rhythm of spirit and hand; abstract symbolism; the introduction of types; the introduction of characteristics (enrichment by perception and experience); the differentiation of color, form, and space; and the pure unity of *Gestalten* (forming and shaping). The formation of types, Viola notes, starts when the child leaves the early infantile stage; however, "the child's types have nothing in common with the adult's scheme" and only "those children who imitate adults are schematic." In other words, the child invents shapes, unlike adults, who often copy what they see. Viola criticizes the conventional view that the realistic stage is better than the earlier symbolic stage. He stresses that Cizek often preferred the work of an eight-year-old over that of a fourteen-year-old, finding it to be more creative. "We must give up the superstition," Viola argues, "that something is better because it is more modern; that merely means it is nearer to us. Yes, the fourteen-year-old's work is easier to understand, but that does not mean that it is stronger, more genuine, or better." One of the reasons for this commonly held bias among teachers, Viola writes, is "not knowing that a young child produces what he knows, not what he sees."[446] There is also an imaginative origin to everything the young child depicts, Viola notes. For example, if a child goes to the circus for the first time and sees an exotic animal, he or she might later draw it in light blue, red, or even pink; one girl who painted a purple elephant in Cizek's studio, Viola relates, insisted that "grey is not sufficiently exotic for an exotic animal like an elephant."[447]

Viola also discusses different approaches to the "crisis" of puberty. He notes that Karl Bühler claimed that graphic language "swallows up" drawing at this age, and that Hildegard Hetzer argued that "the child stops spontaneous drawing when he loses his joy in fairy-tales." Viola explains this phenomenon as the result of the "awakening intellect." He quotes Cizek, who said at one of his lectures: "People make a great mistake in thinking of Child Art merely as a step to adult art. It is a thing in itself, quite shut off and isolated, following its own laws and not the laws of the grown-up people. . . . The crisis in a child's life usually comes [at] about fourteen—this is the time of the awakening intellect. A child then often becomes so critical of his own work that he is completely paralyzed and unable to continue creative work."[448] Like Cizek, Viola believes that the principal aim of child art is not to produce artists, but to encourage the growth of creative power, which "develops and influences right through life."[449]

1942 Victor D'Amico (1904–1987), *Creative Teaching in Art*. A renowned art educator, D'Amico here defines the child as artist. He begins by arguing that the child may be considered an artist since he or she is aware of "design for its own sake" and is able "to subordinate subject matter and the story element to the elements of form, line, and color." He also points out that "the child, like an artist, integrates the elements and responds to them emotionally." However, he notes, these reactions are usually unconscious in the child. According to the author, the child is "attuned to visual rhythm and he is aware that colors and lines and shapes have their own meaning."[450] The child artist, however, differs from the professional artist in his lack of maturity, deep experience, skills, and techniques.

D'Amico recognizes the creative efforts of children as a call for action: "The art achievements of children should no longer be viewed with either wonder or indifference. We should by now realize that the creative experience is a necessity for the healthy growth of all children." He views the artistic experience itself, not the product, as an aim of art education.[451] To enhance children's art experience, D'Amico goes on to say, we should develop their ability to see with their "inner eyes." He refers to Franz Cizek, who taught children "how to see

pictures in every-day experience." According to D'Amico, "Seeing with the inner eye requires discrimination, putting down only those qualities that the artist feels are significant to the expression of a subject, mood, or idea."[452] It is also important to make the child conscious about the aesthetic values, including the nuances of line, form, and color, D'Amico argues; "sensitiveness to design," he adds, "cannot be acquired by memorizing and rationalizing a few laws, but must come by a continuous process of active participation and realization of creative experience." The young child, D'Amico notes, "uses line, form, and color intuitively and emotionally."[453]

D'Amico also describes the stages of children's artistic growth, beginning with abstract expression, when the child "works mainly with lines and masses," followed by the representation of objects and people using "self-devised symbols," and later by the expression of ideas for the purpose of communication. At this third stage, the subject of children's art "changes from broad, direct concepts to those requiring attention to detail."[454] Finally, children acquire the sense of realism and draughtsmanship and become interested in learning techniques.

1942–44 In the Nazi concentration camp in Terezín, Czechoslovakia, children's art lessons take place at the school established by the Jewish self-government. The Viennese painter and Bauhaus graduate Friedl Dicker-Brandeis leads the lessons, encouraging self-expression and the therapeutic use of art to cope with the trauma of life in the camp. (Approximately 4,500 drawings made at Terezín today form the Terezín Collection at the Jewish Museum in Prague.)

1943 Herbert Read, *Education Through Art*. In chapter 5, Read discusses the major philosophical, psychological, and aesthetic issues of children's art. He argues that spontaneous expression constitutes the nature of children's art activity and should be distinguished from inspiration: "Free or spontaneous expression is the unconstrained exteriorization of the mental activities of thinking, feeling sensation and intuition. Where, however, for some reason these mental activities cannot achieve immediate expression, and a state of tension is produced, the tension may

be suddenly and perhaps accidentally released, and then the expression takes on an inspirational character."[455]

Read provides a definition of the "schema" as a type of pictorial form that is widely and universally used by children of all nationalities and in all eras. First, the child elaborates a linear or one-dimensional schema, which is later transformed into an outline or two-dimensional schema.[456] According to Read, the schema is symbolic in nature, with a complex of emotions, images, and ideas all reduced to one sign.[457] The author challenges the conventional belief that children's drawings are always imitative. In his opinion, the imitative instinct plays a role solely "in the development of a child's drawing in the direction of realism." Yet even when the child draws under influence or instruction, "he does also draw for his own obscure purposes."[458] Read emphasizes the subjective nature of children's art: "What . . . we must realize is that the child's graphic activity is a specialized medium of communication with its own characteristics and laws. It is not determined by cannons of objective visual realism, but by the pressure of inner subjective feeling or sensation."[459]

Read also discusses the developmental stages of children's drawings. He describes the scribbling stage as a period of "kinesthetic imagination" when the line gradually becomes "controlled, repetitious and consciously rhythmical"—step by step, the child develops zigzag lines, wavy lines, loops, and finally spirals and circles. According to Read, kinesthetic activity does not stop at the representational stage, as most researchers of the time believed it did. "Long before the child evolves the schema," Read argues, "he will give a name to his scribble."[460] Read also creates an "empirical classification" of children's drawings by looking at the "stylistic grounds" of several thousands of drawings. Primarily, he distinguishes twelve categories, later reducing them to eight: organic, empathetic, rhythmical pattern, structural form, enumerative, haptic, decorative, and imaginative.[461]

1946 L. W. Rochowanski (1885–1961), *Die Wiener Jugendkunst: Franz Cizek und seine Pflegestätte* (*Vienna Youth Art: Franz Cizek and His Nurturing*).[462] As well as describing Franz Cizek's

teaching philosophy and studio environment, Rochowanski explains Cizek's views on children and their nature. For Cizek, Rochowanski states, the child is "a very special phenomenon and personality."[463] Rochowanski shares this belief with Cizek and offers his own understanding of the child's personality and development. According to the author, the most important development in the child occurs before the age of two, by which time "the sensitive, receptive sense organs have already received everything important" and all information has been absorbed in a "faithful, authentic, uninfluenced and completely personal manner." The following years bring the "ordering and sorting of impressions."[464] Rochowanski stresses that the child is naturally inclined toward art making; children's art, he states, springs from "drive-like, unbroken energies" and is directed toward a "secret purposelessness."[465] He argues that children "have no system, just themselves and the whole world."[466] According to Rochowanski, the primary task for children in Cizek's classroom is ordering their feelings. The experience they already have—both visual and mental experience—provides the "starting point of all creating," which "generates and gives birth to the work of art."[467] Rochowanski also stresses the importance of the teacher's personality: Cizek, he notes, is a unique "teacher without pedagogy," an "invisible director and protector."[468] The book includes numerous plates illustrating artworks by Cizek's students, made between the ages of five and fourteen.

1947 An exhibition of children's drawings is held at the Musée du Luxembourg, Paris.

1947 Rose H. Alschuler (1887–1979) and La Berta W. Hattwick (1909–?), *A Study of Painting and Personality of Young Children.* The goal of the extensive psychological study reported here, the authors explain, was to explore the possibility that "each child's painting tended to be both individual and directly expressive" as well as to determine to what extent "a systematic study of the paintings of individual children would reveal the effect of each child's specific … experiences on his particular nature and development."[469] The study, involving children between the ages of two and five, is well received; Rhoda Kellogg, an art teacher and author on child art, nevertheless criticizes the authors' position as "the most extreme example of adults' projecting their own emotions and ideas" on child art.

Alschuler and Hattwick stress that small children never think of their paintings as representations of objects; rather, the paintings express feelings that the child is not able to express verbally. The authors view the earliest representation of the human figure as the child's own self-portrait; small children, they note, paint themselves "as they feel themselves from within." The developmental order in which children add details to their portrayals "also reflects the fact that children tend to draw and paint what they are feeling and experiencing rather than what they see." It is characteristic, the authors state, that as children grow older their drawings and paintings become "less self-expressive." By the age of nine or ten, children's natural modes of self-expression are usually blocked off by the need for reproducing what is seen, and it becomes more difficult for children to express themselves spontaneously. By contrast, drawings and paintings by small children always express "their impulses, their natural drives, and their obvious frustrations." Consequently, the authors argue, "abstract or pre-representative paintings and drawings … often are more expressive of inner feeling than are representative products."[470]

Alschuler and Hattwick focus on the use of color, line, form, and space in young children's paintings. Color, in their opinion, gives definite clues "to the nature and the degree of intensity of the child's emotional life."[471] For instance, those children who consistently favor warm colors tend "to manifest the free emotional behavior, the warm affectionate relations, and the self-centered orientation"; whereas those children who prefer cold colors tend as a group "to stand out for their highly controlled, overadaptive behavior." The authors argue that the color spontaneously used by young children "seems to be a language of the feelings for which there tends to be … a quite general, if not universal, code."[472] Line and form, they state, are likely to indicate the balance "between the

236

child's impulsive drives ... and his overt, controlled behavior."[473] For instance, children using "single straight-line strokes" tend "to stand out as a group for their relatively assertive, outgoing behavior"; by contrast, children using curved, continuous strokes usually exhibit "more dependent, more compliant, more emotionally toned reactions." Different forms, the authors claim, also indicate emotional differences: "Children who emphasized circles tended ... to be more dependent, more withdrawn, more submissive, more subjectively oriented than children who predominantly painted vertical, square, or rectangular forms."[474] The use of space, according to their research, does not give a picture of the child's emotional life, but rather expresses the child's relation to his or her environment.[475]

1947 Viktor Lowenfeld, *Creative and Mental Growth: A Textbook on Art Education.*[476] Containing a discussion of the developmental stages of children's art, practical recommendations for studio topics and techniques, as well as exercises and laboratory work for art teachers, this book was perhaps the single most influential book for art educators in America in the second half of the twentieth century. According to Lowenfeld, art is, for the child, "a means of expression," and therefore adults should not impose their own images on the child, prefer one child's work over that of another, or let a child copy anything since he has "his own world of experiences." Lowenfeld warns against considering self-expression as merely the expression of thoughts and ideas, for they can also be expressed "imitatively." He stresses, "What matters then is the mode of expression, not the content; not the 'what' but the 'how.'"[477]

Lowenfeld argues that it is extremely important for art educators to know the developmental stages of children's art in order to teach children what they want to know at the stage they are in. He asserts that the main changes that take place at any age are those related to the child's "subjective relationship with man and environment": "A 'man' for a five-year-old child means mainly the self, the ego, which needs a head for thinking and eating and two legs for running (head-feet representation). For a ten-year-

old child, a 'man' still means mainly a projection of the self. However, consciously aware of the variety of man's actions, movements, and body parts, the ten-year-old presents 'man' accordingly. A sixteen-year-old youth, however, has already discovered that man is a part of the environment and he represents 'man' with conscious consideration of size and proportions in comparison to what surrounds him." Therefore, it is entirely wrong to teach realistic drawing to small children since they are not able to perceive and understand a man or a tree "in all its details as a part of environment." "What the child draws," Lowenfeld writes, "is his subjective experience of what is important to him during the act of drawing. Therefore, the child only draws what is actively in his mind."[478] The drawing represents some "active knowledge" about things that children have at a certain stage of their emotional and mental growth.

Lowenfeld describes six major stages of children's pictorial development: The scribbling stage (from ages two to four) includes disorderly scribbling, controlled longitudinal scribbling, controlled circular scribbling, naming of scribbling (i.e., the important shift from thinking kinesthetically to thinking imaginatively is made). The preschematic stage (from ages four to six) is characterized by constantly changing symbols. At this stage, the first connection between drawing and reality is established, but the interrelations of depicted objects in space "are not subject to any law."[479] During the schematic stage (from ages seven to nine), the child develops schemata for objects and can repeat them multiple times. According to Lowenfeld, "the schema of an object is the concept at which the child has finally arrived, which represents the child's active knowledge of the object."[480] Through deviations from the schema, the child expresses his or her particular experience (deviations include exaggerations of important parts, omissions of unimportant parts, and changes in emotionally significant parts). The origin of such deviations lies in "feelings of the bodily self," the "importance of value judgments," or "emotional significance."[481] To prevent the child from getting stuck with poorly defined schemata, "the child should be kept flex-

ible as long as possible until he has built up a rich source of active knowledge." At this stage also, the first "common experience of space" occurs, which means that the child "relates himself to others" and "sees himself as a part of the environment."[482] A base line is drawn to establish order, and sometimes subjective space representations occur (such as "folding over" or the mixture of plan and elevation). In "X-ray" pictures, the child "depicts the inside and outside simultaneously whenever the inside is emotionally . . . of more significance than the outside."[483] The stage of dawning realism (from ages nine to eleven) indicates the child's attempt "to represent reality as a visual concept."[484] As children become aware of the significance of their environment, the lines in their drawings lose their "mere symbolic significance," "the space between base lines becomes meaningful," and the plane is discovered.[485] The base line is now transformed into the "ground." The pseudorealistic stage, or the stage of reasoning (from eleven to thirteen), is a crucial period for determining the child's creative type (visual or haptic). Lowenfeld states that "only visually minded children who desire it will arrive at a realistic concept." While "the visually minded child concentrates more on the whole . . . , the nonvisually minded child will concentrate more on the details in which he is emotionally interested."[486] Whereas the visually minded child prefers environment and "feels like a spectator," the nonvisually minded child "concentrates more on the self and draws environment only when it has emotional significance for him."[487] At this stage, children establish spatial relationships since they have overcome "an egocentric attitude." The sixth stage of the child's graphic development, the period of decision (ages thirteen to seventeen), is connected with bodily and emotional changes. A postadolescent is likely to lose "the strong subjective relationship to the world of symbols"; now "conscious critical awareness" dominates his or her creative production.[488] For Lowenfeld, postadolescents can be clearly defined as either visual or haptic creative types.[489]

1947 Reginald Robert Tomlinson, *Children as Artists*.[490] In this book, Tomlinson criticizes the "soul destroying and sterile methods" of art teaching typical of the European education system of the time. The traditional art curriculum, he asserts, is based on copying and lacks in "imagination and understanding," aiming to develop children's technical skills with "adult standards in mind." Tomlinson opposes this prevailing approach with that of Franz Cizek, Marion Richardson, and other advanced art educators, who "refused to ignore the natural instincts, interests, and tendencies of the child."[491] He shares their belief that each child is "a law in himself and should be allowed to develop his own technique."

To explain the sequence of children's natural pictorial development, Tomlinson gives the example of how "primitive" people developed pictorial patterns: first, he writes, these patterns were derived from attempts "to make lifelike representations of nature, usually taking the form of animals and the human figure, which are afterwards simplified until they become decorative symbols"; they also were derived "from the use of tools and the characteristics of certain materials and processes."[492] Tomlinson warns not to teach the principles of perspective to children until they reach the stage at which they become "aware of the shortcoming in their attempts to express their ideas in a realistic way."[493] He also discusses the development of children's plastic expression, which he says is often overlooked by art teachers. He writes that children's "drawings and paintings come in the main from visual images. Muscular and touch images are, however, just as vividly felt by them."[494]

1948 Marion Richardson, *Art and the Child*.[495] Emphasizing the role of children's imagination in art education, Richardson asserts that children do their best not by copying or following conventional, adult ways of drawing, but rather by "painting from a mental image." She asks: "Why should any child wish to draw the watering-can or the coal-scuttle or bathroom tap, when he has within him the power to paint his own mental pictures: of trains and stations, stores and shops, barges, boats and big ships?"[496] Richardson does not reject teaching technique altogether, however, but believes that first the child should find a subject and create the picture he or she has

in mind. To develop this inner vision, she often plays imaginative games with her students by telling a story or describing a picture while students sit with their eyes closed and build a vision of the subject. When they feel their inner picture is complete, they start drawing. One of the core aims she had in developing her teaching philosophy, Richardson writes, was to help students develop a balance between inward and outward vision: "What I hoped for ... was to give the children complete confidence in their inner vision as the seeing eye, so that it would come to colour and control their whole habit of looking. They would then see pictures everywhere, in poor, plain places as well as lovely ones: in fried-fish and little shops, market stalls, chimney stacks, watchmen's huts, eating houses, slag-heaps, salt carts, cinderbanks, canal barges, pit mounds, and waste ground."[497] In reference to development, Richardson observes that the first stage of drawing is close to writing: "I saw that in scribble the same patterns occurred over and over again, and reduced themselves to six that were separate and essential; that in shape every letter of our alphabet was but a variation of these themes."[498]

1948 Jean Piaget and Barbel Inhelder (1913–1997), *La Répresentation de l'espace chez l'enfant* (*The Child's Conception of Space*).[499] This influential work by two prominent psychologists includes a discussion of how the child's spatial concepts affect his or her drawing ability. Piaget and Inhelder stress that the evolution of the child's perception of spatial relations proceeds at two different levels: the level of perception and the level of thought or imagination.[500]

In early childhood, the authors state, the perception of spatial relations is essentially sensorimotor; however, it goes "far beyond the limits of the purely perceptual" and usually presupposes "the translation of tactile perceptions and movements into visual images."[501] According to Piaget and Inhelder, there are three major stages in the development of spatial concepts: the sensorimotor period (from birth to the age of two), the stage of concrete operations (between the ages of two and eleven), and the period of formal operations (between the ages of eleven and fifteen). The sensorimotor stage, the authors write, is marked by "an absence of co-ordination between the various sensory spaces." Visual and tactile-kinesthetic space are not yet related to one another. An object is not perceived as being the same object if it is turned around, touched from different sides, or viewed from a distance. The child is able to perceive certain spatial characteristics, such as the proximity of objects (their "nearbyness"), their separation (dissociating objects), order (the succession of objects as they appear), enclosure (surrounding), and continuity (the uninterrupted nature of line and surface).[502] Piaget and Inhelder define this as a pre-Euclidean, topological type of spatial perception since "there is as yet neither constancy of size, nor any organization of the movements of objects," nor any "constancy of shape." Toward the end of the first year of life, the child's senses become coordinated and the child begins to perceive the elementary characteristics of Euclidean space, such as the constancies of shape and size. By the age of two, a purely perceptual sensorimotor space becomes "partly representational," the mental image develops, and, as a result, the first attempts at drawing appear. At this point, the child's ability "to perceive forms" is far in advance of his or her capacity "to reconstruct them at the level of mental images or representational thought." It is not until the child reaches seven or eight years of age that "measurement, conceptual co-ordination of perspective, understanding of proportions, etc., result in the construction of a conceptual space marking a real advance on perceptual space."[503] However, sensorimotor activity remains a foundation for representation: Piaget and Inhelder point out that the image is "an internalized imitation" derived from motor activity.[504] The authors view perceptual and representational activities as highly interwoven in early childhood. They stress that the small child's drawing expresses not so much "the model visually or tactilely perceived as the perceptual activity itself," which can be described as "the combination of movements, anticipations, reconstructions, comparisons, and so on, that accompany perception."[505]

Piaget and Inhelder also define three developmental

stages in children's drawing: synthetic incapacity (up to three years of age), characterized by developing topological spatial relationships; intellectual realism (from four to seven years of age), marked by universally applied topological space and emerging Euclidean and projective relationships; and visual realism (from eight or nine years of age on), which "shows . . . the real nature of projective and euclidean relationships," such as perspective and distance.[506] In conclusion, the authors affirm that the child's perception of topological relations, which precedes his or her perception of projective and Euclidean ones, is based on the child's intuition of space, his or her "basic awareness of space, at the level not yet formalized."[507] The authors also stress the importance of imagination, which expands sensorimotor activity beyond the field of direct perception and reinforces the appearance of representational symbolic function.[508]

1948 Henry Schaefer-Simmern (1896–1978), *The Unfolding of Artistic Activity*. In this book, Schaefer-Simmern reports on his extensive research into the importance of art making for people of different professions, personal inclinations, and mental abilities "as a necessary balance against the routine of daily occupations." Awakening a person's artistic abilities, he suggests, serves as "a weapon against the danger of the mechanization and disintegration of his life."[509] For Schaefer-Simmern, artistic experience can reconstruct the unity of intellectual, emotional, and physical forces that is broken by mechanical and manipulative work.

In looking at the roots of artistic activity, Schaefer-Simmern notes the unified and simple structure of children's art, which he defines as a "seed" of artistic form. He writes that "children's drawings not yet distorted by external methods of teaching or by imitation of nature possess a definite structural order, which in essence is similar to that of more developed works of art. . . . Simple structures of form have been found to precede more complicated ones, thus indicating the natural way in which artistic abilities unfold and develop." Even the earliest scribbles, he asserts, tend to form a circle—a definite form of an "intentional figure." The next stage in pictorial development is the extension of intentional figures

vertically, horizontally, or in both directions. All the parts of the newly formed shapes, Schaefer-Simmern writes, "are related to one another by the horizontal-vertical order." Further, the shapes and lines become more and more complicated and differentiated by following the same "organically developing principle of unity."[510]

Schaefer-Simmern argues against the view that children's drawings should be considered the representation of real objects or the pictorial realization of either abstract concepts or reproductive memory; for instance, children often draw additional legs on animals despite knowing how many legs they have. "What the child depicts is something completely new," the author writes. "For the variety and multiplicity of shapes in nature he creates a definite organization of form by which he comprehends the world visually. His drawings, therefore, must be evaluated as independent visual entities. Their existence can be explained only as a result of a definite mental activity of conceiving relationships of form in the realm of pure vision—an activity that may be called 'visual conceiving.'"[511] The ultimate purpose of art education, according to Schaefer-Simmern, is not teaching artistic elements or techniques, but rather the evolving of visual conceiving, "the natural cultivation of growing mental powers . . . within the process of artistic configuration."[512]

1949 An exhibition of children's drawings is presented at the Stedelijk Museum, Amsterdam.

1949 Children's drawings are published in the November issue of the journal *Cobra*.[513]

1951 Charles D. Gaitskell, *Children and Their Pictures*. In this small brochure for teachers, Gaitskell, a Canadian art educator, draws attention to the child's personal motivation for making pictures. Children's pictorial work, he argues, expresses their thoughts and feelings: "It is a communication from one human being to another. *It is a personal statement in pictorial form of a child's reactions to life.*" Gaitskell also emphasizes the value of picture making to the child's general education, since it helps the child clarify his or her thoughts and feelings and "gives them coherent form"— thus the child learns about life in general.[514]

1953 The San Francisco Museum of Art presents an exhi-

bition of preschoolers' finger paintings from the collection of Rhoda Kellogg. The aim of the exhibition, Kellogg notes, is to show "the structural sequence of children's work."[515]

1953 Child art is included in *Parallel of Art and Life*, an exhibition at the Institute of Contemporary Art in London, organized by the Independent Group (the emerging Pop art movement), from September 11 to October 18.

1954 Rudolf Arnheim (1904–), *Art and Visual Perception: A Psychology of the Creative Eye*.[516] In this book, Arnheim proposes a fundamentally different way of looking at children's drawings, countering the long-standing belief that children draw what they know with the claim that children draw what they see. Arnheim's approach, sometimes called "perceptual," stresses the creative nature of human perception. Some of his ideas are heavily influenced by the research of Gustaf Britsch and Henry Schaefer-Simmern.

According to Arnheim, "perception consists in the formation of perceptual concepts, in the grasping of integral features of structure. Thus, seeing the shape of a human head means seeing its roundness. . . . If the child makes a circle stand for a head, that circle is not given to him in the object. It is a genuine invention, an impressive achievement, at which the child arrives only after laborious experimentation." He argues that early human perception—found in children and "primitive" people alike—tends to reduce forms to basic shapes and patterns; both children and "primitives," he notes, "draw generalities and undistorted shapes precisely because they draw what they see."[517] Arnheim stresses that the young mind has a need for visual order "at a low level of complexity," which is clearly illustrated by the universal appearance of simple patterns (suns, hearts, and so on) in children's drawings.[518]

Arnheim describes the child's pictorial development as starting with simple shapes and growing to more complex forms. The child begins by making lines that gradually tend to form circular shapes. The circle is "the simplest visual pattern" and stands not for roundness, but rather "for the more general quality of 'thingness.'"[519] According to Arnheim, our perception spontaneously tends toward roundness.[520] The next step in children's pictorial development is the creation of a vertical-horizontal relationship, which is first mastered within "isolated units" and later applied "to the total picture space."[521] Oblique lines come only after the child has fully developed the vertical-horizontal stage. Finally, the child starts to fuse the parts of the drawing. Arnheim points out that at this stage the child "copes more convincingly with figures sitting on chairs, riding horseback, or climbing trees," than he or she was capable of doing earlier. He stresses that the absence of fusion and interaction prior to this is due to the child's "atomistic thinking," by which he or she conceives of everything as "separate entities added to, or subtracted from, the unchangeable unit of the body and mind."[522]

In Arnheim's view, size in children's drawings may vary according to "functional relations of spatial, emotional, or symbolic nature," and the absence of overlapping is explained by the child's need "for a simple and clear picture."[523] He argues that the child's mind spontaneously maintains the rules of the two-dimensional medium, and that all the characteristics of size and distance, as well as X-rayed objects, in children's drawings can be accounted for by the child's adaptation of the picture "to the conditions of the two-dimensional medium." Arnheim maintains that, in fact, our perceptual experience "does not contain the perspective changes of shape and size that are found in the retinal projection"; pictorial representation "is not a mechanical replica of the percept, but renders its characteristics through the properties of a particular medium."[524] Children, he notes, rarely discover the third dimension spontaneously. The problem they deal with is that only two of three dimensions can be represented directly in the picture plan, and in order to render their conception of space they often invent original devices such as "vertical space" (elevation views) or "horizontal space" (showing the directions of the compass in a ground plan).[525]

1955 Rhoda Kellogg (1898–1987), *What Children Scribble and Why*. This book is based on a formal analysis of more than 100,000 drawings and paintings by children from the ages of two to four in nursery schools in San Francisco.

Kellogg stresses that the purpose of the study is "to bring to the attention of parents, teachers, and artists certain sequential, developmental aspects to be found in the work of these children."[526] By showing "the structure and sequence in early scribbling," Kellogg writes, she hopes to emphasize objective characteristics of children's drawings, as distinct from the subjective, personal interpretation of meaning attributed to them. She also wants to show that the nature of scribbling is something more than just the joy of movement—for, she notes, children's scribbling patterns "look convincingly purposeful."[527]

Kellogg asserts that scribbles create the foundation for further drawings. She notes that they are "always present, both inherent to structure in the drawings and as pure embellishment."[528] Kellogg distinguishes twenty basic scribbles that create a starting point for the child's artistic development. According to the author, at about the age of three the child begins to make "definite forms out of certain Scribbles," which she defines as "Diagrams": Greek cross, square, circle, triangle, odd-shaped area, and diagonal cross.[529] When two Diagrams are put together, she asserts, they form "Combines," and when three or more Diagrams are used in one drawing, they create an "Aggregate." Kellogg considers these structures as authentic and universal for all children. The sequence of their development, she states, is clearly revealed in spontaneous child art, when the child is not influenced by adult suggestions.[530] The next logical step after creating "Aggregates," she asserts, is developing the human figure, which basically consists of the circle diagram and three scribbles: vertical lines, horizontal lines, and an imperfect circle.[531] In conclusion, Kellogg states that the basic structures in preschool drawings are "the natural and universal first unspoken, written language of the human race" and that this language has biological rather than psychological origins.[532]

1956 Thomas Munro (1897–1974), *Art Education: Its Philosophy and Psychology.*[533] An influential scholar of aesthetics and art education, Munro is also interested in discovering the child's potential in art. He describes an experiment carried out at the Cleveland Museum of Art, in-

volving children of different ages and drawing abilities. The children were asked to complete the "Seven Drawing Test," designed to define different types of drawing abilities: drawing from memory, from imagination, from another picture, from a moving or changing object, drawing a decorative design, drawing a favorite subject, and drawing a "man." Munro notes that museum staff had difficulty in summarizing the results of the test, leading to an interesting discussion on the criteria of drawing excellence. They realized that they had to take into account many other criteria, such as expressive strength, creativity, and inventive decorative ideas, in assessing the "best" drawings; that it wasn't just a developmental progression toward realism as they had expected going into the testing process. This finding proved to be an important assertion for the field at the time.

According to Munro, this traditional interpretation of drawing ability is closely connected to the concept of general maturation. However, he argues, the progressive art teacher "will not be satisfied with evaluating children's art entirely on the basis of increasing powers of realistic representation"; rather, "he will insist … that one six-year-old drawing can be better than another, even though both are definitely schematic in type and show no sign of advancement to the next stage." The major developments observed in the Cleveland Museum study, Munro notes, is that decorative characteristics, "especially in use of bright colors and rhythmic lines," tend "to die out as the child grows older," and realistic subject matter tends to start to dominate.[534] Munro cites another unusual finding of the study: that there is no radical difference between the "gifted" and the "average" child in art other than "a strong tendency" in the "gifted" child "to experience things visually" and an ability "to interpret the world in visual images." Thus, Munro states, "it is not mere precocity in visual realism that we must look for as a sign of artistic talent …, but rather such characteristics as perceptual, imaginative, emotional alertness, directed by preference into visual experience and manipulation of visible materials."[535] He also stresses that it would be a mistake to hasten the child's progress "toward visual re-

alism"; rather, it is better "to help each child achieve maximum fullness of experience . . . on each level as he comes to it rather than hurrying on to the next." Accordingly, Munro concludes, "we should not put a premium on mere maturational advancement in drawing." Rather, we should appreciate the "decorative charm of schematic art," which is basically a "conceptual drawing" that may develop "into mature scientific diagramming, mechanical drawing, and other types of expository art involving conceptual realism, without even yielding place entirely to visual realism."[536]

1957 Miriam Lindstrom, *Children's Art: A Study of Normal Development in Children's Modes of Visualization.*[537] Lindstrom views child art as an immediate symbolic expression of feeling (a concept established by the philosopher Susanne K. Langer in her 1953 book *Feeling and Form*[538]), stressing that although "meaning in the symbols of a child's art may be obscure to an adult it is clear and vivid for its maker."[539] Lindstrom defines six stages of children's artistic development: scribbling and chance forms, controlled marks, basic forms, and first schematic formulas (from ages two to five); use of repertory for developing formulas (from ages four to six); "whatever can be thought of can be pictured" (from ages five to eight); dissatisfaction with limitations of the schematic mode (from ages eight to twelve); a period when interest should be sustained by a series of exercises in observing and visualizing (from ages nine to eleven); and a stage of expression and appreciation (from ages twelve to fifteen).

1957 Herbert Read, *The Significance of Children's Art.* In this book, based on a lecture he presented at the University of British Columbia in 1956, Read discusses the symbolic nature of children's art. He claims that the main and most widely used symbol in children's drawings is the mandala, a "magic circle," which Read defines as a "primordial symbol for the psyche."[540] He refers to Rudolf Arnheim, who defines the circle as "the simplest visual pattern" that stands not for roundness, but rather for the more general quality of "thingness."[541] Read also mentions a diagram by Rhoda Kellogg in which the mandala form gradually transforms into a house, a ship, and an animal. Read concludes that many of the objects drawn spontaneously by children are "symbolic in nature,"[542] since only through spontaneous drawing can they express their inner being; however, "if a child is required to draw a set subject—a still-life, for example—there is not likely to be much symbolic content in the drawing."[543]

Read cautions that the symbol should be distinguished from the signal or token: "A signal is immediately translated into meaning, and that meaning can, but need not be expressed in language. A symbol on the other hand is pregnant with a meaning that cannot possibly be fully expressed in any other manner."[544] He criticizes the sexualized interpretation of symbols offered by Sigmund Freud and his followers, arguing that when the child, who is concerned "about the origins of its own self and of life," draws the image of an enclosed space, it is often decoded by Freudians as a womb, when a much broader interpretation is possible: "Anything deep—abyss, valley, ground, also the sea and the bottom of the sea, fountains, lakes and pools, the earth, the underworld, the cave, the house and the city—all are part of this archetype."[545]

1958 Charles D. Gaitskell, *Children and Their Art.*[546] Gaitskell's main focus here is on teaching methods for various art mediums, but he also offers an overview of the history of art-education theory and practice. Discussing the developmental stages of children's art, he stresses: "The fact that these stages appear in the work of most children in no way detracts from the unique qualities of each child's work." He then goes on to summarize the various stages: "First appears the stage in which the child manipulates materials, at first in an apparently exploratory and random fashion. Later in this stage the manipulation becomes increasingly organized until the child gives a title to the marks he makes. During the next stage the child develops a series of distinct marks or symbols which stand for objects in his experience. These symbols are eventually related to the environment. Finally comes a preadolescent stage at which the child begins to become critical of his work and expresses himself in a more self-conscious manner."[547] At the stage of manipulation, Gaitskell notes, the idea for the child's drawing often comes

from manipulative work, "because of kinesthetic or muscular associations."[548] He also points out that no one ever leaves the manipulative stage entirely, for it is crucial for gaining skills in the use of tools and materials. The author views the symbolic stage as unique in its pictorial form: "Even though the young child lacks a technical ability to express himself through visual forms, he is extraordinarily inventive in designing relatively complicated modes of composition in which to present his emotional and intellectual reactions to life." The composition at this developmental stage, he writes, reveals "a logic as well as an aesthetic quality."[549]

1961 June McFee, *Preparation for Art*. Unlike researchers who aim to find an "age based pattern of growth" in children's art, McFee assumes a "perception-delineation" approach, searching for the "individual variables" that affect children's artistic development. This approach, she explains, is based "on the understanding of the nature of children's perceptions, of the way they organize and use information, and the ways in which they communicate their ideas."[550] She defines "delineation" as "the act of producing symbols."

According to McFee, perception has three essential characteristics: it tends to classify "similar things as units" (leaves on a tree are perceived as a "green tree," for example), "the random by averages" (as when the visual details of a moving car are not actually seen but filled in by what we *have* seen or what we know), and "according to wholes or completions" (we perceive part of a circle as belonging to the whole circle, for instance).[551] In order to perceive an object within a broader context or to make visual discriminations, the child needs special preparation, McFee asserts. She writes that visual knowledge about the object can come from three different sources—cognitive learning, tactile perception, and visual discrimination—and stresses that "the child who has had all three types of training—cognitive, tactile, and visual has the greatest potential for responding."[552] According to this approach, prior learning plays a crucial role in children's artistic development.

McFee also stresses that growth does not happen in isolation, but rather "as an interaction with the environment."[553] She discusses the significance of cultural influences on children's artistic development; the values that children learn, she notes, direct them "to observe some things more closely than others." Cultural values also act as "directors" that accelerate children's ability to draw certain objects in favor of others. McFee views the tendency toward "photographic realism" in child art as a phenomenon of Western culture that is profoundly influenced by media imagery. Children from other cultures have different priorities, she notes; for instance, "the Hopi child has as a goal the drawing of a Kachina, and the north coast Indian child the symbol of the killer whale."[554]

McFee also summarizes the major theories of child art, distinguishing perception-delineation theory ("a framework in which the individual variables that affect art production are identified") from the theory of naïve realism (which claims that there is no difference between the physical object and its image as perceived by the mind, and that children cannot draw well because they lack motor skill); intellectualist theory (a child "draws what he knows" and "draws more detail as he learns more information"); perceptual theory (a child "draws what he sees" and "draws more details as he grows older and sees more"); haptic-visual theory (which divides children "according to assumed biogenic tendencies in space-orientation"); and the theory of developmental stages (which defines age-based patterns of pictorial development).

1963 Dale B. Harris, *Children's Drawings as Measures of Intellectual Maturity*.[555] In this book, Harris reevaluates Florence Goodenough's "draw-a-man" test of children's intelligence, proposing modifications to improve its validity. Harris's suggested changes include extending the test to older children, as well as adding a drawing of a woman and a self-portrait to the test. Harris notes that the notion of intelligence has changed significantly since 1926, when Goodenough's test was designed, with the concept of "general intelligence" established by Alfred Binet being replaced by the recognition of a number of distinct abilities. Harris suggests that Goodenough's test serves as

a measure not of intelligence *per se*, but of intellectual maturity—that is, the child's level of cognitive development. According to Harris, "it seems desirable to replace the notion of intelligence with the idea of *intellectual maturity*, and perhaps more specifically, *conceptual maturity*. This change gets away from the notion of unitary intelligence, and it permits consideration of children's concepts of the human figure as an index or sample of their concepts generally." By intellectual or conceptual maturity, Harris means "the ability to form concepts of increasingly abstract character," requiring the ability to discriminate likenesses and differences, the ability to classify, and the ability to generalize. Harris argues that Goodenough's test evaluates mainly "the ability to form concepts"; the drawing of such a frequently experienced object as a human being can be a key to the growing complexity of the child's concepts in general.[556]

The book contains a detailed manual for the revised Goodenough-Harris Drawing Test. It also includes a historical survey of the study of children's drawings, discusses nonintellectual and cultural influences on children's drawings, and provides an overview of the psychological theories of drawing and the theories of child art. In conclusion, Harris claims that there is "little confirmed basis" for interpreting children's drawings in terms of the child's "creativity," special interests, or deep psychological problems; rather, in his view, "the child's drawing reflects his concepts which grow with his mental level, experience, and knowledge."[557]

1967 Betty Lark-Horovitz, Hilda Lewis, and Mark Luca, *Understanding Children's Art for Better Teaching*. The authors' belief in the artistic nature of children's pictorial works is based on their notion of art as the "human ability to make things," or the "creativity of man as distinguished from the world of Nature."[558] Lark-Horovitz, Lewis, and Luca define "child art style" as having "certain distinctive and recognizable characteristics," which are produced as a result of children's visual expression and their "spontaneous picturing." This style, they assert, occurs universally in different cultures, with a "familiar sequence" from scribble to schema to "fully developed schema with its

characteristic details" and finally to an adolescent "plateau." The authors point out that, according to recent studies, the young children of "primitive populations, given the same drawing materials for drawing, produce approximately the same kinds of drawings as do the children of the more highly developed regions of the world."[559] Only the variety of subject matter reflects cultural and environmental differences.

The authors stress the similarities that exist between the child and the adult artist: both, they claim, "try to gain insight into the world and the self" and "use personifications to express themselves." Children's objective in making art, they assert, is to interpret, clarify, and order "the vast and puzzling world" as well as to find their own place in it.[560] The authors distinguish four major categories of children's drawings: "*spontaneous drawings*," made on children's "own initiative as a play activity or in pursuit of individual interests"; "*free* or *voluntary* drawings, made on request but with the children choosing their own subjects"; "*directed* pictures for which the topic is proposed"; and "*copied* or *to-be-completed drawings*."[561] The authors point to the fact that many children "who have reached the true-to-appearance stage" in representing a certain subject will not necessarily draw another subject "in an equally advanced way," attributing this to a lack of interest in the subject and, consequently, a lack of observation and practice.[562]

In their discussion of children's pictorial language, the authors emphasize the importance of developing a "graphic vocabulary."[563] They also describe children's sense of proportion as a nonrealistic and "empathetic device."[564] Regarding the representation of movement, they note that children "suggest" motion rather than showing it by using various rhythmic lines. They claim: "For children, objects are *the action* they induce. Thus a ladder is a 'climbing' thing, and an animal's snout is a 'snouter.'"[565] The authors also acknowledge the child's urge to tell stories through pictures. The child, they write, "creates a symbolic world in which he lives on paper, ordering and arranging the relationship of objects and people. A real experience for him, this serves an important purpose in

helping him to become objective, no longer tied to the early subject-object interpretation."566 According to the authors, the child also possesses a specific sense of orientation: at the early schematic stage, top and bottom, left and right, have no significance to the child, and the orientation of objects or parts of objects in the child's drawings "seldom follows any apparent logic or pattern."567 By the time children reach the developed schematic stage, they have made "an important step toward composition by using the standline." Sometimes, this line is omitted but objects "give the impression of being lined up on an invisible line." Multiple standlines denote "a space-distance relationship" showing "successive planes in the distance."568

Unlike Wassily Kandinsky, who admired what he saw as the "strong composition" and free spatial orientation of child art, Lark-Horovitz, Lewis, and Luca claim that children's drawings tend to be "loosely organized" and rigid in their composition. The spatial organization that children develop within the two-dimension medium, they state, has two distinct directions: "upward, earth to sky, and backward, foreground to horizon."569 Children also combine the "front- and side-view (elevation) and bird-eye view," they note, "to suggest space relationships."570 The authors also point out that automatism frequently occurs in children's drawings when "the child has fully developed his schemata and reached the peak of his individual achievement," at which time symbols are often drawn "with incredible rapidity" and, after a while, start to "degenerate," lose their "form, accuracy and character," and "become dull and uninteresting."571 Commenting on the child's concept of the beautiful, the authors state that it is closely related to the concept of goodness. They write: "The child's concept of the beautiful . . . is based more extensively on sense perceptions other than just the visual. . . . Familiarity, comfort, personal background, his entire complex of emotions, even fear, may affect the child's developing ideas of what is beautiful."572

1969 Rudolf Arnheim, *Visual Thinking*. In this work, Arnheim defines visual perception as a form of thinking: "to perceive an object," he writes, "means to find sufficiently simple, graspable form in it." He considers the same to be true of representational concepts in picture making. The child's mind, he notes, operates with elementary forms that are "easily distinguished from the complexity of the objects they depict."573

In the child's early drawings, Arnheim writes, geometrical forms such as the circle, straight line, oval, and rectangle are "presented explicitly"; they are combined by the child to form human figures, animals, or trees, but they "retain their own shapes." Later, however, "these independent units tend to fuse into more complex shapes." Arnheim asserts that "as the mind grows subtler, it becomes capable of incorporating the intricacies of perceptual appearance, thereby obtaining a richer image of reality, which suits the more differentiated thinking of the developed mind."574 This greater complexity, he states, is evident in the drawings of older children. Arnheim also notes that objects are not related to one another in the drawings of young children because things are viewed by the young child as "self-entities"; in the drawings of older children, however, the interaction of the parts becomes essential and leads to the internal modification of units.575 Arnheim stresses that children's drawings show vivid evidence of visual problem solving, noting that they possess "the inexhaustible originality of ever new solutions to the problem of how to draw a human figure or an animal, with a few simple lines."576

1969 Rhoda Kellogg, *Analyzing Children's Art*. Based on the author's analysis of half a million children's drawings, this book expands on Kellogg's *What Children Scribble and Why* (1955). While most scholars insist on the purely kinesthetic nature of scribbling, Kellogg argues that "the pleasure of scribbling comes from the combination of vision and movement."577 Profoundly influenced by Gestalt theory and Carl Jung's theory of archetypes, she often uses the word "Gestalt" in describing children's scribbling and pictorial patterns. She also believes that "the human eye and brain are predisposed to see over-all shapes."578 Scribbling, she asserts, has a natural order: "children as young as twenty-four months often guide their scribbling movements so that the marks fall into distinctive Patterns. These Patterns are made spontaneously,

without coaching or copying, and they are frequently made in response to the visual stimulus of the scribbling process."[579] In addition to the twenty basic "Scribbles," "Diagrams," and "Aggregates" she identified in her earlier book, Kellogg describes the Mandala, the Sun, and Radials as "favorite Gestalts" of the art of early childhood.

Kellogg asserts that interpreting the child's first depictions of the human figure as representations of real people—as "mama" or "daddy," for example—is no more than an adult stereotype. She states that "the child's early pictorials are not mainly based on observations of objects and persons in the child's environment," but are, rather, "esthetic compositions."[580] For instance, she notes, all children draw "the armless Human" after they make "the Human with arms." According to Kellogg, the child sees the human figure as "an esthetic unit" incorporated into the whole of the drawing.[581] Kellogg's understanding of child art is that it "has its own discipline, controlled in the child's mind by perceptions quite different from those that enable the child to recognize men, women, children, costumes, and various human characteristics."[582] The perceptions underlying the child's drawing, she asserts, are essentially aesthetic, and all children "work primarily in esthetic fashion." This statement provides the ground for her criticism of popular intelligence tests based on drawing that use the "adult approach" of looking at child art and place the child into an artificial situation. She recommends instead observing children during the spontaneous process of drawing and using "the Gestalts that children normally draw."[583]

Kellogg believes in the universal nature of child art, viewing it as "biological art," or as "art natural to the species." This explains why children draw symbols that are similar to those in ancient art, she explains: "the coordination of eye, hand, and brain which first produce them are as ancient as the human race."[584] Kellogg's suggestion for art education is to allow children to scribble without "oppressive guidance," since every child is a "born artist."[585]

1970-PRESENT Pentel of America sponsors the International Children's Art Exhibitions, annual traveling exhibitions of children's art that feature work by children between the ages of three to fifteen from around the world.

1972 Bohuslav Kovac, *Zazracny svet detskych kresieb* (*Marvelous World of Children's Drawings*).[586] Both poetic and scientific, this book looks at children's drawings from an aesthetic perspective and is widely read in the former socialist region of Western Europe. Kovac maintains that each child's drawing is essentially a deformation that shows the most significant features of an object. As such, he supports the idea of conceptual realism proposed by Georges Luquet in *Les Dessins d'un enfant* and *Le Dessin enfantin*: children draw what they know rather than what they see.

Kovac agrees with the traditional notion that children's drawing progresses toward realistic representation. The very first attempts of the child to draw, for Kovac, are driven by the intention to organize the chaotic flow of perception in accordance with the principle of formal unity. They are the product of an unconscious and innate feeling for form and order. According to Kovac, graphic development starts with the discovery of a circle and a spiral (the "symmetry principle"), continues with the detection of the rectangle and the triangle and their various combinations (the "commensurability principle"), and further progresses to the stage of fluent operation and repetition of the discovered forms (the "principle of rhythm"). Kovac states that when the child's drawing begins to obey all three principles—symmetry, commensurability, and rhythm—the world of multiple-valued and vague forms transforms into a specific graphic code of individualized forms. The first of these individualized forms is the "tadpole" figure. This stage is described by Kovac as a period of isolated concepts, during which the child creates his or her own depository of major artistic symbols. Later children's drawings, according to Kovac, are mainly the expression of different narratives. He defines them as "pictograms" or "graphic writing."

Kovac also outlines nine major characteristics of children's drawings: inverted and circular perspective (the child him- or herself is virtually present in the picture with the horizon line behind his or her back, and objects are depicted from various sides); the combination of

Chronology

different projection systems (showing an object from the front and from a bird's-eye view); the perpendicular principle; transparency; the reduction of details; the exaggeration in size of the most important objects and the diminution of less significant objects (to the point where they may even be omitted); ornamentation (repetition of elements in a certain sequence); the use of repetition to fill the space; and heterogeneous plots (the child derives his or her ideas for drawing from the whole bulk of his or her experiences).

1973 Howard Gardner, *The Arts and Human Development: A Psychological Study of the Artistic Process*. Focusing on children's artistic growth, Gardner proposes a fundamentally different developmental model to that put forth by Jean Piaget, who emphasized children's scientific reasoning. Gardner regards the child as an artist and argues that "the study of children would appear a natural source for insight about the arts."[587] Explaining the theoretical background for his research, the author recounts the major philosophical ideas of Ernst Cassirer and Susanne Langer (a follower of Cassirer), as well as some thoughts on development by Sigmund Freud and Piaget. Langer, he notes, emphasizes the "uniquely human capacity to employ symbolic forms" and contends that "the various art forms are 'virtual' forms of experience that capture within a symbolic medium intuitions about space, time, memory, and so forth."[588] Gardner points out that those following in Cassirer's tradition have "argued convincingly that man is a symbolic and abstracting creature, alone capable of the arts."[589] Freud, Gardner writes, had interesting thoughts on the artistic nature of child's play, while Piaget noted striking differences between the scientific and artistic development of the child, such as the continuous progression of the former and the retrogression of the latter.[590]

Rethinking Piaget's concept of development, Gardner argues that "the child fluent in symbol use may already be thought of as an artist, but he must pass through further discrete stages before he can be thought of as a scientist."[591] Further, he introduces his own ideas concerning the development that occurs within three basic systems:

making (acts or actions); perceiving (discriminations or distinctions); and feeling (affects). These systems, according to Gardner, are common to both humans and animals. He states: "Development can be seen as a process wherein the three initially discrete systems gradually begin to influence each other, with interaction eventually becoming so dominant that each system inevitably involves the other ones." Consequently, the moments of great psychological progress come when the separate systems "combine into a more integrated and flexible whole."[592]

It is symbol use, Gardner argues, that makes humans different from animals. Only higher animals can sporadically regard certain objects as symbols, whereas young children create symbols regularly (though they have trouble "reading" them).[593] From about the age of five, all children are able "to devise, use, and comprehend various kinds of symbols," which distinguishes them from animals and younger children.[594] The author defines a symbol as an element or material that denotes some other aspect of the world, such as a material object, a feeling, or a concept. As such, the symbol is fundamentally different from the signal, which dictates behavior or elicits a specific reaction. Symbol use, in Gardner's view, is the major developmental breakthrough in the early years of childhood, since it elevates the child's life from a purely material plane to the height of invention of new objects and events; it also opens up the opportunity to communicate with other people.[595]

Gardner also claims that the use of symbols brings the child and artist together. For instance, if a child relates to a broken cookie as a boat, she essentially transforms it into a new symbolic object, and her behavior can be considered similar to that of the painter or writer "who seizes upon an idea or percept in his environment and then embodies and transforms it in an available symbolic medium."[596] Gardner maintains that toward the age of seven or eight, most children are capable of expressing their ideas, feelings, and experiences through symbolic mediums and, therefore, have realized "the essential function of the artist."[597] A significant characteristic of artis-

tic activity in early childhood, he notes, is that art is highly interwoven with play.[598]

Gardner then traces his own model of children's graphic development, which later becomes known as the "U-shaped curve." According to Gardner, children's drawings from the ages of four to nine exhibit "increasing mastery in their technical aspects . . . while remaining visually interesting and formally satisfying." However, during the preadolescent and adolescent years there is a notable decline both in the amount of drawings and paintings the child produces and in the quality of his or her productions. In general, Gardner asserts, children's drawings become less self-expressive between the ages of eleven and fourteen and tend to adopt popular pictorial methods of realistic representation.[599] The author warns against premature imitation and copying, claiming that it limits the child's artistic creativity. For him, it is crucial for children's artistic development to start with the free exploration of a certain art medium and only after that to become influenced by different models. He stresses: "So long as the young artist does not conclude that the ways to capture a mode or achieve an effect are limited, he should benefit from . . . exposure to the works of others. But the peak of exposure to models should occur only after the child has had ample opportunities to explore the medium."[600]

1973–PRESENT The magazine *Stone Soup* publishes drawings, poems, and stories by children between the ages of eight and thirteen from around the world.

1974 Claire Golomb, *Young Children's Sculpture and Drawing*.[601] Influenced by the perceptual approach put forth by Rudolf Arnheim in his *Art and Visual Perception* (1954) and *Visual Thinking* (1969), Golomb investigates the young child's attempts at representing the human figure in two mediums: drawing and sculpture. Her study focuses on the work of preschool-age children.

Golomb describes three major stages in the young child's development: a purely motor, prerepresentational stage; a period during which the first representational forms appear; and a stage of developed representational means.[602] During the first stage, she asserts, the child is engaged in the action of scribbling or making simple shapes without any attempt at representation.[603] She notes that "romancing" (her term for the spontaneous talking that children do when drawing) and "imitative actions" (when children act out the action they are drawing) "serve as substitutes for representation proper and are pseudo-representational devices to meet the demands of the task." The child usually does not spontaneously name his or her scribbles, but will do so if pressed to interpret them by adults.[604]

During the second period of development, children form their first representational concepts—such as "circularity, facial features, and verticality"—in both drawing and sculpture. In drawing, a circle with facial features evolves, and later a "tadpole" figure; in sculpture, a snake, a pancake shape, a ball, and a standing column shape all evolve.[605] At this stage, some "primitive representational devices"—such as romancing and action-imitation—are still used by the child. In depictions of the human figure, the child often completes the drawing or sculpture by describing absent characteristics verbally.[606] According to Golomb, the extensive narratives that accompany both drawing and modeling reveal that the child is actually "not interested in a complete depiction of what he knows about a man"; rather, "much is left out because it is difficult to represent, superfluous to the basic structure of the human, and can be accomplished by verbal description."[607] Golomb points out that the only essential difference between the child's representational development in drawing and that in sculpture springs from the nature of the particular medium: while the two-dimensional medium "elicits more depiction of detail and embellishment," in sculpture there is less emphasis on detail.[608] The author stresses that in both mediums the child's spontaneous experimentation and exploration plays a crucial part in the development of forms and often causes dramatic improvement.[609] Very often, too, the child's development in sculpture is affected by his or her more rapid growth in drawing: the child may flatten out his or her sculptures by applying previously invented pictorial models.[610] However, if the child spends a great deal of time

modeling, spontaneous exploration leads to adaptation to the medium.[611]

In both mediums, the child gradually progresses from a "tadpole" figure to the "full-fledged" human figure with the appearance of a trunk. Golomb notes that at this stage the circular shape is still "the easiest and the most familiar one for the child." The human figure is often drawn as a "sunburst pattern," which seems to be a "universally preferred form at early stages of graphic development since it combines balance, symmetry, and pleasing appearance with relative ease of drawing."[612] Gradually, the circular shape gives way to other shapes, such as the square, rectangle, or triangle, which Golomb refers to as "spontaneous differentiations of shapes."[613] Golomb stresses that the emphasis on spontaneous exploration does not negate the importance of learning new ways of drawing from other children, parents, or even picture books: "The child learns from others, but within the limits of what makes sense at a given stage of development. . . . He learns that which is within easy reach and might be discovered all by himself shortly."[614]

The child's further differentiation of the human figure occurs with an increase in the number of depicted parts as "self-contained units" and, finally, by the adoption of a continuous outline that fuses several parts into a "highly unified whole."[615] In sculpture, the differentiation of the human figure leads to three major models: the upright standing figure, composed of several parts; the outline figure, which is essentially a graphic model; and the horizontal figure, constructed of solid rounded or flattened parts, which seems to be a compromise between the two mediums.[616] Golomb notes that while drawings at this stage display many details and embellishments, the child's sculptures are composed "with utmost simplicity."[617]

In conclusion, Golomb emphasizes the crucial role of invention in young children's drawing and sculpture. She argues, "In the past preoccupation with the notion of 'schemata' has tended to obscure the explorative nature of the child's activities and the wealth of representational symbols he invents and varies." Consequently, the child's

progress toward increasingly differentiated representations of the human figure should be viewed as the result of the child's experimentation, rather than as an "increase in the accuracy of the child's concept of a man."[618] Golomb juxtaposes the concept of children's drawing as symbolic play to the traditional idea of drawing as an imitation of the mental image, developed by Jean Piaget. She suggests, "Unlike imitation, which in Piaget's system is synonymous with the tendency to accommodate to the object, symbolic play tends to transform the object in line with the child's emotional needs." She denies the child's desire to copy reality; rather, she insists, the child plays with reality by creating symbolic attributes of objects and their functions. In this sense, Golomb asserts, the child shares the aims of the visual artist.[619]

1974 Brent Wilson, "The Superheroes of J. C. Holz: Plus an Outline of a Theory of Child Art."[620] In this pioneering inquiry into the narratives and themes of children's spontaneous drawings, Wilson analyzes drawings of superheroes and comic strips by a ten-year-old boy, also discussing the reasons for children's spontaneous drawing activity. Wilson opposes children's "spontaneous play art," which is produced during spare time at school or at home, to school art, which is influenced by adults' beliefs about how it should appear. He proposes the "homeostatic model of motivation" as a primary reason for children's spontaneous drawing activity. This model assumes that "there are optimal conditions for existence and survival, establishing an equilibrium between the overly boring and overly stimulating"; each individual, Wilson argues, is always looking for "new and more highly stimulating experiences" that will continue his or her amusement.[621]

J.C.'s drawings, for Wilson, are stimulated by a need for excitement, "a strong drive to avoid boredom." For J.C., art is a form of play, or an "arousal-seeking behavior." Wilson writes: "J.C.'s appetite for steadily escalating stimulation through his art play has led him to be keenly aware of the formal qualities of his work, the techniques and skills that will increase his satisfaction, and the characters, themes, and plots that will give him a kick."[622]

1977 Jacqueline Goodnow, *Children Drawing*. A developmental psychologist, Goodnow is primarily concerned with the way young children draw. The major focus of her research, which involves children's pictures of the human figure and their construction of maps, is viewing the young child's graphic work "as a set of parts or units combined into a whole or pattern."[623] Her findings can be correlated with the Wilsons' inquiry concerning graphic principles universally employed by young children.[624] Goodnow defines four major features of children's drawings: the repetition of a single graphic unit; conservatism in using a particular unit (children often discover that changes may lead to unexpected difficulties—"a problem solved is a problem created"); the correlation of parts according to specific principles (absence of overlapping, perpendicularity of parts); and the relation of parts to one another in a sequence. She stresses that these features are basically the principles of "visible thinking" and problem solving.[625]

1977 Brent Wilson and Marjorie Wilson, "An Iconoclastic View of the Imagery Sources in the Drawings of Young People."[626] Arguing against Franz Cizek's and Viktor Lowenfeld's approach to children's art education, in which copying and outside influences are removed from the child's art-making activity, the Wilsons maintain that children draw mainly "through imitation and influence." This point of view is based on the assumption that drawing is a sign rather than a representation of real objects.[627] For the Wilsons, our everyday perceptions of objects are too numerous, too complex, and too vague to provide mental images from which to draw. In the images that surround us in the world, the visual configurations have already been translated into two dimensions, where they are more simple and more abstract, frozen in time and space, and seen from a single vantage point. "These images," the authors claim, "provide the basis for the mental configurations from which an individual draws."[628]

The Wilsons also stress that "a refined and sophisticated program for drawing one object does not necessarily affect the ability to draw other objects."[629] Learning to draw configurational signs, they write, is similar to the process of learning to form and employ words.[630] However, whereas new verbal signs are seldom invented, graphic configurational signs exist in a great variety of flexible and nonstandard forms, offering an invitation "to alter them and to elaborate upon their forms."[631] The most talented and productive young people, they note, draw "primarily from images derived from the popular media and from illustrations."[632] The process of borrowing usually starts before the age of six.

1980s Rainbow Connection Art Gallery, New York. Founded and directed by Delorys Welch-Tyson, this gallery is devoted to the work of artists from eight to eighteen years of age. Works are priced from $100 to $5,000.[633]

1980 Howard Gardner, *Artful Scribbles: The Significance of Children's Drawings*. Gardner attributes the emerging interest in children's drawings to two major factors: the change of attitude toward childhood beginning with Jean-Jacques Rousseau, and the crucial shift in art values that took place at the end of the nineteenth century.[634] Gardner notes that the interpretation of the young child's graphic work as the "careless scribbles" of an immature individual has been replaced by almost the opposite approach. At the end of the preschool period, he writes, children's drawings are "characteristically colorful, balanced, rhythmic, and expressive, conveying something of the range and the vitality associated with artistic mastery." He argues, "drawings constitute an important and perhaps a primary vehicle of expression for the young child."[635] While possessing their own identity, children's artworks, in their sources, processes, and significance, possess some distinct parallels to the art of gifted adults.[636] Viewing children's drawings as artistic, Gardner claims, would be impossible using the old criteria for judging a work of art, such as its degree of realism.[637] However, the new artistic values established in the twentieth century have introduced different aesthetic standards to judge whether or not the work is artistic. Gardner suggests two major criteria for assessing a work's artistic worth: expressiveness and repleteness. The best of children's drawings, in his view, meet both criteria. He argues, "If a child uses the

materials of a medium in such a way as to make a drawing that is 'lovely,' 'sad,' 'angry,' or 'powerful,' he has provided one sign that he can fashion the work of art"; "if in his drawings the thickness, shape, shading, and uniformity of line contribute to the work's effect, the child is exhibiting a command over repleteness."[638] To some extent, these criteria are achieved by children of preschool age, Gardner asserts. However, he notes, young children are only in "partial control" of their gift; the child is often "aware of practices, canons, or standards, and options," but they do not dominate his or her thought and action: he or she can take or leave them.[639]

In addition, Gardner defines two distinct types among young children: *patterners* tend to analyze the world in terms of configurations, patterns, and the physical attributes of objects, such as color, shape, or size, while *dramatists* are more interested in the structure of events, actions, and conflicts in the real or imaginary worlds, and romancing becomes central in their drawing activity. Some children, however, exhibit both patterning and dramatizing approaches.[640]

Gardner also further develops the U-shaped model of children's artistic development he outlined in *The Arts and Human Development* (1973). According to this model, the "extent to which drawings incorporate individual features" reaches its apogee in the first grade and then steadily recedes.[641] The free exploration, sense of form, and readiness "to flout conventional practices" characteristic of work by young children disappear from the works of most children during the period of middle childhood (between the ages of eleven and fourteen). At this point, the child begins to develop his or her technical skills and becomes able to plan his or her work with "thoroughness and accuracy."[642] Further artistic development exhibits both individual expressiveness and technical mastery. Gardner considers the artistic decline a problem specific to Western culture. In all cultures, he maintains, children want to learn graphic rules during the period of middle school, but these are not offered to children in Western culture: "Our ambivalence about whether one should draw and, if so, in what manner,"

Gardner writes, "seems responsible in significant measure for the decline in graphic artistry." In contrast, he notes, graphic artistry often persists in cultures with more rigid constraints. Gardner insists that despite the diverse graphic models available in Western culture, children can still be taught "the rules."[643]

Gardner also discusses the issue of whether or not children should copy from graphic models. He advocates a balance between copying and personal expression. In his view, models should serve "as a means of helping the artist achieve what he himself wants to express, in a way that makes sense to him and to others, rather than a path toward sterile duplication of what someone else . . . may have produced."[644] He maintains that it is important for the young artist to have the capacity "to look very carefully at objects, to remember their appearance but also to go beyond what was seen before—in life or in books—and to combine these capacities in ways suited to one's own purposes."[645]

1980 David H. Feldman, *Beyond the Universals in Cognitive Development*. Feldman proposes a new approach to the understanding of cognitive development. "The developmental psychology of intelligence," he writes, "has preoccupied itself with the study of *universals* . . . and has ignored other equally interesting aspects of cognitive development."[646] He defines universal achievements as those "acquired under conditions so varied that they occur in all environments in all cultures."[647] In the study of developmental stages established by Jean Piaget, he states, the phases of cognitive achievement have been traditionally understood as universal levels attained by all children in a similar time frame and sequence. They have also been considered as existing "in the mind of a child" as "structured wholes." Feldman argues that these are, in fact, "idealized stages": "The stages are ideal because the behavior of any given child . . . is never as consistent, orderly or stage-appropriate as the hypothetical ideal would predict. 'Structures as a whole' therefore represents to us the ideal sequence of achievement in a domain of knowledge that never actually exists except as a model or template against which to gauge the actual behavior of actual children."

Feldman argues that developmental stages should be viewed not as universal and absolute, but rather "as levels of achievement within a specific field or domain."[648]

According to Feldman, theories of psychological development traditionally share four basic assumptions: universal achievement (common accomplishments are eventually attained by all individuals in all cultures); spontaneous acquisition (the achievement of universals occurs spontaneously, without any influence from the environment); invariant sequence (all individuals pass through sequences of cognitive development in a prescribed order); and transition rules (the earlier steps in a developmental sequence are incorporated into later ones, creating a hierarchical integration). These assumptions "reflect the fact that the developmental psychology has concentrated on understanding those changes in the child's behavior that occur without special environmental intervention."[649]

By contrast, Feldman's concept of stages as "nonuniversal developmental domains" implies that these domains are not necessarily mastered by all children in all cultures and they are not acquired spontaneously, "independent of the environmental conditions prevailing in a particular culture at a particular moment of time." Consequently, Feldman denies universality and spontaneousness as developmental criteria; however, he continues to accept "sequentiality and hierarchical integration as necessary characteristics of developmental domains." Feldman describes four nonuniversal developmental domains: cultural, discipline-based, idiosyncratic, and unique achievements.[650] In his view, some achievements may be common within a certain culture, while others are more specialized, reflecting mastery of a particular field of knowledge.

Feldman also draws attention to the transitions between developmental stages, which have never been an emphasis of developmental psychology before. He revisits the experiment on children's map drawing that Piaget and Barbel Inhelder used "to study universal aspects of spatial reasoning development," proposing that map drawing is not so much a reflection of universal achievement as "an example of a culture-linked, nonuniversal developmental domain" that requires "modern cartographic skills."[651] He then reevaluates Piaget and Inhelder's results: "Rather than classifying each map as belonging to a single developmental stage, we divided the domain of map drawing into the four spatial concepts and skills that Piaget and Inhelder identified in their own research: (a) spatial arrangement, (b) proportion, (c) perspective, and (d) symbolization. Building upon the general Piagetian stage description, we were able to construct four parallel sequences of developmental levels, one for each of the sets of concepts just mentioned."[652] The developmental transition, in this case, is understood as not just a change from one general stage to another, indicated by a sturdy novel behavior, but rather as "one . . . of many changes in a system which are suggestive of the organization of the child's cognitive functioning at that point of time."[653] From this point of view, "level mixture" is inevitable.

Feldman provides persuasive proof of this developmental approach in his study of early prodigious achievements. He points out that all prodigies seem to be at a normal-to-their-age general developmental level in regards to logic, spatial reasoning, and moral judgment.[654] However, they outstrip others at this stage in their specific fields. Feldman explains this by the fact that "achievement in a specific field, contrary to Piaget's expectation, is not dependent on achieving the most advanced stage of intellectual development but rather depends on advancing through levels of mastery of *a particular domain*."[655] This mastery does not occur spontaneously, he notes, but is a result of intense, systematic, and prolonged instruction.[656] The implication of his theory for education, Feldman proposes, is a "child as craftsman" model: he stresses that the main purpose of education must be providing conditions "under which each child pursue[s] and achieve[s] more advanced levels of mastery within a chosen field or fields of work."[657]

1980 Norman H. Freeman, *Strategies of Representation in Young Children: Analysis of Spatial Skills and Drawing Processes*. Freeman pioneers a new approach to the study of children's

drawings by shifting the focus from drawings as end products to "the ongoing activity of drawing."[658] From this perspective, the child is viewed as a problem solver who copes with a particular drawing task. Freeman argues that all so-called errors in children's graphic representation of space reflect performance factors rather than deficiencies in children's knowledge.[659] He criticizes both the "intellectualist" approach of Jean Piaget and the "Gestaltist" theory of Rudolf Arnheim, writing that Piaget "often underestimates what the child knows because he does not adequately consider the child's problems in organizing his performance to do himself justice," while Arnheim "overestimates what the child is representing in drawing because he sees them as successful solutions to pictorial problems, reading into them sophistication of performance which is too optimistic."[660]

Freeman stresses that the analysis of children's performance reveals "the set of decisions" that children make during the drawing process and the complex relationships that exist between children's initial intentions and the decisions they employ to realize them.[661] He asserts that there is no direct connection between the mental image of an object and its graphic representation, and that there is evidence to confirm that children know far more than their drawings would indicate.[662] Children appear to fail in performing certain drawing tasks, he states, not because they lack the necessary abilities, but because they do not know how to use the abilities they have in different situations.[663]

Freeman defines six basic concepts pertaining to children's graphic performance. First, he states that young children do not intend to make realistic drawings; rather, they draw in the genre of caricature, which is both "a way of avoiding the effects of anatomical ignorance and of permitting concentration on meaning."[664] Second, children tend to draw the canonical view of an object, which presents "an optimal method of conveying basic structural information."[665] Third, there is a strong perpendicular bias in children's graphic representation; that is, children tend to draw objects perpendicularly to the baseline in order to obey the vertical-horizontal axis.[666] They

are often "reasonably adept" at using these relations and also show "systematic rotations of their drawings to fall along one favored axis or another."[667] At the same time, Freeman notes, children are contextually sensitive; for example, they can draw the human figure with respect to three spatial cues: themselves, the face, and the page.[668] Freeman's fifth important concept is that children employ drawing systems, which he defines as "a set of rules for projecting a crucial aspect of the scene onto the picture plane."[669] He describes five major drawing systems: orthographic projection, which is based on the use of parallel lines and produces an impression of flatness; horizontal oblique projection, which exhibits a mixture of two views, front and side; vertical oblique projection, in which the front and top views are combined; oblique projection, which attempts to disambiguate verticality and depth; and linear perspective, which "pins down" the spectator's view to a fixed point.[670] Freeman argues that these systems gradually arise at different ages, from orthographic projection through to perspective, for they all have different degrees of complexity. The more complex the system, he writes, "the more it dictates to the viewer what view to take."[671] Freeman states that although many drawing systems might be available to children at an early age, it is a big challenge for them to learn how to "transform the geometry of the scene into the geometry of the picture."[672] Freeman's final concept is the drawing device, or "planning decision," which can "crop up within more than one drawing system." He identifies four such drawing devices: segregation, interposition, enclosure, and hidden-line elimination. There is also another class of devices dealing with constructing acute angles.[673]

Freeman emphasizes that the major focus in developmental studies of children's drawings should be placed not on children's conceptual maturity, but on their systematic efforts to make strategic choices and to change their repertoire of rules.[674] All the major experimental discoveries presented in this book will be further developed by Maureen Cox in her *Children's Drawings* (1992).

1981 Diana Korzenik, "Is Children's Work Art? Some Historical Views."[675] Korzenik examines the changing per-

ception of children's art. Before the end of the nineteenth century, she writes, the majority of artists, art educators, and scholars concluded that children's drawings and paintings were not art. However, cultural influences—both within the domain of art and in society in general—subsequently changed this point of view. Now, she writes, "we must acknowledge that we look at a child's painting with an eye not only influenced by the array of other flat painted surfaces made by adults and called 'art,' but by many other influences that generate controversies and vitality within the society as well."[676] Expressionistic tendencies of the 1960s caused viewers' perception of adult art and preschool pictorial work to fuse, she claims, but this vision obscured some essential characteristics unique to child art as well as the individuality of works by adult artists. In the 1980s, she recounts, interest shifted from early childhood art to pictorial works made by children between nine and twelve years of age. This tendency, according to the author, again reflects changes in art and society: "Now as the art world moves to enjoying and being self-conscious about the uses of convention, the convention-based work of children has risen in esteem. It is as if the developments in adult art have given the art educator license to be interested in what children will spontaneously do, and probably have done through the centuries." Thus, the author concludes, whether or not adults value children's paintings, drawings, and sculptures, "may be a function of what adult society [takes] to be art at any given time."[677]

1981 Brent Wilson and Marjorie Wilson, "As I See It: The Use and Uselessness of Developmental Stages."[678] Here, the Wilsons argue against the traditional concept of developmental stages in children's drawings for its imposition of expectations and standards that all children are "generally expected to meet."[679] They state, "the developmental stages assume that there is a natural, spontaneous innate unfolding, and that this unfettered and uninfluenced process is all there is," whereas their research shows that all children are "profoundly influenced both by each other and by graphic images from the culture." Another weakness of the developmental stages theory,

they assert, is that it classifies only formal graphic traits, such as "the way in which human figures are drawn, and changes in color and spatial concepts." Developmental stages, the Wilsons argue, "fail to deal with themes, with the variety of ways in which children compose pictures; and they do not account for gender-related differences." They are also "not generally concerned with aesthetic or emotional aspects nor with narrative content of children's drawings." Finally, the Wilsons claim, the stages represent "generalizations" that attempt to "subsume into a single classification a variety of phenomena." In reality, they note, very often one drawing contains objects that fall into different stage categories. The authors conclude that the traditional accounts of development "tend to obscure more than they reveal about children's drawings."[680]

1982 Hilda Lewis, "Tools and Tasks: The Place of Developmental Studies, An Open Letter to Brent and Marjorie Wilson."[681] In response to the Wilsons' article "As I See It: The Use and Uselessness of Developmental Stages" (1981), Lewis defends the concept of developmental stages as a useful tool in estimating the essentials of a child's artistic growth. Acknowledging that this approach fails to "explain themes, composition, sex differences, affect, aesthetics, and narrative content,"[682] the author argues that it nonetheless provides a convenient way of describing various orientations and organizations within the drawing process, from scribbling to elaborate representations. She states, "My belief is that the locus of a stage is in the task and not in the individual." Lewis admits that the boundaries of each stage are permeable and that a child might be at different representational levels in different drawing tasks. However, she asserts, this does not diminish the importance of developmental stages as a "tool" in the study of children's art.[683]

1982 Marjorie Wilson and Brent Wilson, "The Case of the Disappearing Two-Eye Profile: Or How Little Children Influence the Drawings of Little Children."[684] The appearance of the two-eye profile in children's drawings was reported by many researchers at the end of the nineteenth century and beginning of the twentieth century, such as Corrado Ricci (1887), Earl Barnes (1892), Lena Partridge

(1902), James Sully (1903), Siegfried Levinstein (1905), Georg Kerschensteiner (1905), Georges Rouma (1912), and Florence Goodenough (1923). However, the Wilsons point out, by the mid-twentieth century this phenomenon seems to have completely disappeared.[685] Since the early researchers considered the two-eye profile to be a natural stage in children's drawing development, the Wilsons propose, its disappearance presents a considerable challenge to the universalist point of view. The Wilsons argue that the phenomenon of the two-eye profile was the result of children's influence on one another rather than an intrinsic stage of graphic development. Since children in that era were little influenced by adult graphic models, such as picture books or mass media, the Wilsons assert, they acquired graphic forms from their siblings, friends, and classmates. The two-eye profile was easily modeled from one child to the next, they claim, because it was close to an innate developmental form.[686]

The Wilsons offer three major hypotheses to explain the existence and disappearance of the two-eye profile. First, they propose, when adult influence on children is slight, peer influence is greater. Second, when peer influence is strong, fewer graphic models are available, and the homogeneity of representations of the human figure is greatest. Third, when adult influence is high, more models are available to children, leading to greater variability in children's drawings and less spontaneously or "innately" derived images. In conclusion, the Wilsons stress the importance of cultural influences in children's drawing development: "we wish to place the influence factor at the very genesis of childhood graphic form— . . . to say that any theory of graphic development must surely account for the effects of influence from the beginning."[687]

1982 Brent Wilson and Marjorie Wilson, *Teaching Children to Draw: A Guide for Parents and Teachers*.[688] Here, the Wilsons present an extensive study of children's spontaneous art, which they distinguish from school art: while spontaneous art is produced "at home or in spare and stolen time at school, on the edges of notebooks or on any available paper," they write, school art is encouraged by a teacher, a parent, or any other adult. They point out that spontaneous drawings are often dismissed by adults as mere play or as less colorful and visually compelling than work done at school, but they stress the importance of spontaneous drawings as disclosing "a set of symbols through which the child might present and experiment with personal and developing ideas about himself and about his world—ideas that once recorded on paper leave a perceivable record."[689]

According to the Wilsons, children's spontaneous drawings represent four major realities: common, archeological, normative, and prophetic. "Common" reality involves familiar and everyday perceptions. The child's aspiration to draw familiar objects is explained by the desire to construct and reinvent them for better understanding. "Archeological" reality is "the reality of the self." The human mind, the authors argue, is composed of layers of "memories, feelings, thoughts, impressions, and desires,"[690] and art helps the child "to hold up images of himself—in order to reveal the essential self."[691] "Normative" reality involves the exploration of good and bad, right and wrong, just and unjust. The Wilsons stress, "Young children must reinvent for themselves the standards of right and wrong."[692] "Prophetic" reality symbolizes the future. Drawings offer "a vehicle for children to develop models for their own future selves, actions, and worlds."[693] According to the authors, "Drawings provide an early means . . . by which ideas and feelings may be made concrete and perceivable."[694] Drawing is also more flexible than language, since it does not require a precise placement of elements for conveying meaning.

The Wilsons describe seven graphic principles that are universally employed by small children: the simplicity principle (the child tends to depict an object in a simple and undifferentiated way—for instance, an irregular circle with two dots for eyes can stand for the whole human figure); the perpendicular principle (the child draws with the greatest possible degree of contrast between the drawing parts, as in the orientation of objects at a ninety-degree angle to the baseline or in the depiction of a chimney as being perpendicular to a house); the territorial imperative principle (the child avoids overlapping in order to reach the most clarity possible); the fill-the-format

Chronology

principle (the size and shape of the format determine the number and size of appendages—for instance, if the length of an animal's body accommodates more than four legs, as many legs as will fill the space may be drawn); the conservation and multiple application principle (the child may repeat the same configuration over and over—for instance, suns may be reemployed as hands and feet, the human head may serve as a head for different animals); the draw-everything principle (an object may be drawn from several points of view, or some invisible things may be included—a depiction of a house may include both the inside and the outside, tables may be seen simultaneously from the side and the top, and so on); the plastic principle (children tend to exaggerate those objects, persons, or actions that are most important to them—the arm throwing a ball may be longer than the other arm, for example, or a flower may be drawn the same size as a house).

Despite their great respect for children's spontaneous art, the Wilsons stress the importance of adult assistance, which they say is "necessary to the actuating of the child's spontaneity and creativity." They point out that "one of the most effective ways to facilitate drawing development is to interact and to present the child with drawings at slightly higher levels than her own."[695] The authors also emphasize the influences that affect children's drawings from an early age. These influences include illustrations—"drawings and photographs in picture books and in magazines or images on television"—as well as drawings by other children close to the child's own level.[696] The Wilsons offer various exercises and games for extending the number and variety of things to draw, facilitating story drawings, and encouraging imagination and fantasy in children's drawings.

1982 Ellen Winner, *Invented Worlds: The Psychology of the Arts.*[697] In a chapter on the developmental stages of children's drawings, Winner summarizes a Western model that frames development in terms of a growing tendency toward naturalistic representation. According to this model, she claims, children's drawings undergo five basic stages: scribbling, prerepresentational designs, first spontaneous representational drawings, more coherent representations, and optical realism.[698] Winner stresses that the stage of prerepresentational designs does not appear in all cultures and therefore should not be viewed as a necessary step "along the road to graphic representation." Furthermore, she notes, children in Western culture may continue to make abstract designs "even when they more typically produce only representational drawings."[699] Winner also criticizes the belief that drawing development reflects the child's concepts of the world, suggesting instead that drawings represent the child's visual logic within the two-dimensional medium. The "tadpole" figure, for instance, is not a direct reflection of the child's knowledge of a person's appearance, but an attempt to symbolize a human using a circular symmetrical form.[700] The representational forms of middle childhood also have their own distinctive visual logic, she notes: the perpendicular folding-over principle, non-overlapping units, and the X-ray principle.[701] At the end of middle childhood, according to Winner, all children strive toward optical realism, but this is purely a cultural phenomenon. She argues, "If children naturally invented perspective on their own, then perspective would have been invented long before the Renaissance. The opportunity to view perspective drawings produced by adults must be a factor in the discovery of perspective, even if perspective need not be formally taught in school."[702]

Winner also makes suggestions regarding the criteria used to evaluate children's art. She states that it is important to consider not only the repleteness and expressive qualities of the forms, but also—and primarily—the intention of the artist: "The issue is to determine," she writes, "whether these properties were intentionally or accidentally produced."[703] Winner cautions not to confuse the child artist with the adult artist, since they use different means of creation. However, she agrees with Howard Gardner about what makes children's drawings truly artistic: children's emotional involvement with the medium and their willingness to experiment and explore.[704]

1983 Alexander Alland, *Playing with Form: Children Draw in Six Cultures.*[705] Alland presents an extensive study of preschool children's drawings from six different countries:

Japan, Taiwan, Ponape (in Micronesia), Bali, France, and the United States. The study shows a pronounced diversity among the drawings. Alland points out that most of the children from Bali, Taiwan, and Ponape had had no art instruction and, in some cases, no drawing experience prior to the study.[706] The drawings from Bali were mostly abstract or a mixture of abstraction and representation, Alland notes, with very complex and coherent compositions and no narrative content.[707] Children tended to fill the whole page using simple marks or discrete units. Alland stresses that while Balinese children are exposed to various arts, such as music and dance, from birth, they do not "draw, paint, or carve," unlike Balinese adults.[708]

The drawings by the Ponapean children revealed a limited graphic vocabulary due to a lack of aesthetic stimulation, Alland asserts. While drawing, they tended "to play safe with a few formulae and to build their pictures out of these." At school, the children had been taught a few simple schemata, such as a flower and a schoolhouse, and these schemata seemed to influence their drawings.[709] Alland also observes that Ponapean children do not engage in kinesthetic scribbling, do not use the circle as a design element, and, like Balinese children, do not intend to tell a story through their pictures.[710]

While Taiwanese culture is visually rich, Alland notes —with visual stimulation in the form of museum exhibitions, popular culture, and mass media—art is not emphasized in the school curriculum. All children, nevertheless, have considerable experience in writing simple Chinese characters. Alland observes that the children from Taiwan tended to draw "rather stereotypical compositions that were organized according to one or another realistic schemata," and their compositions were very coherent.[711] He concludes that the Taiwanese children's picture making seemed to be influenced "by relationships between pictorial representation and writing." This would also explain the tendency to draw units and elements not touching one another.[712]

According to Alland, the urban Japanese children's drawings reflected both the influence of a highly visual culture and experience with various art materials, such as painting, drawing, and origami.[713] Most of the children produced simple pictures with coherent themes and some formulaic elements. The drawings were well-balanced, harmoniously structured, and skillful, Alland asserts.[714] While most of the Japanese children relied on stereotypic elements based on simple formulas, they also were able "to combine these into aesthetically interesting compositions that reflect both their culture and their individuality."[715]

Alland's analysis of the pictures by the American children revealed a strong drive to scribble as well as a considerable degree of aggression. Alland states that the kinetic scribbles from the American sample seem to have been caused "by an affective element, namely aggression and the need for physical activity." He asserts that the American children, though having experience in art, produced less organized pictures than the Balinese and Ponapean children.[716] He also notes that scribbling "persists longer among American children than among children in the other five cultures in the study."[717]

The drawings made by the rural French children exhibited a pronounced abstract nonkinetic tendency, Alland writes, and their designs were dense and complex.[718] Unlike the American children, the French children were able to control their energy and produce well-organized, though mainly abstract, pictures.[719] In this regard, Alland notes, their drawings were like those from Bali and Taiwan.

In conclusion, Alland comments on the use of the human figure in the six cultures. He points out that, in general, it seemed to be closely related to the amount of art training the children had received. For instance, the Japanese children produced the most sophisticated drawings of people, while the children from Bali and Ponape very rarely drew the human figure.[720] Alland also emphasizes the stylistic differences among the drawings, claiming that "cultural influences appear early and have a strong effect on the overall style of children's drawings." This observation calls into question the concept of universal developmental stages and suggests that develop-

ment from scribbling toward representation is not "an automatic result of maturation" but the outcome of cultural influence. Each culture, according to Alland, has its original "generative rules" for graphic organization.[721] He argues, however, that while all children below a certain age are likely to produce scribbles, after the scribbling stage ends "one cannot predict what the picture-making pattern will be in any specific culture that does not include some form of Western-style art education."[722]

1985 Henri Michaux (1899–1984), "Essais d'enfants; dessins d'enfants."[723] The continually repeated circles in children's drawings, Michaux asserts, satisfy a desire for departure and return; the "first unconscious abstraction," they are "midway between inside and outside, thinkable and imaginable." The child continually goes back to the circle, driven by the intoxication of repetition, which Michaux refers to as "the first drug."[724] Although the adult misunderstands the child's circle, Michaux writes, it is a gesture toward Man: the child makes curved lines that alight upon man, and then makes them again and again to find Man, whom he has "found for good" and who has become "retraceable at will."[725] This is not to say that the child's drawing is a copy; rather, it is a resemblance, an allusion, a parallel.[726]

Once children are introduced to color, Michaux notes, their drawings are no longer ideas or schemata; they are amplified and at once "snowed under by colors." Colors, to a child, "detonate"; heedless of the adult compulsion for cleanliness, the child applies them savagely, with natural imprudence. Welcoming the extraordinary into their drawings and making it more extraordinary, children passionately paint the shocking. Children's drawings, though daring, are inoffensive as they lack the means to be truly perverse or naughty, Michaux asserts.[727]

Even if it is unhealthy or psychotic, Michaux writes, helplessness sticks to children, who receive blows they cannot combat. Through drawings, children tell stories in which only "the mute figures remain."[728] "Open as he will never be after," the child is driven to believe and accept the unbelievable and extraordinary. Powerless, the child nevertheless finds in drawing what adults have lost: si-

multaneity, or that which unites and combines the seen and the imagined. Children translate space and show the "*coexistence of the seen and believed*"; the drawings of the child, then, and not the adult, are faithful to reality.[729] For a child, to live is to be open: all is consumed, taken in, imitated. Once they have sketched and used colors, but before adolescence, children create "charged paintings."[730] Something about them captivates—the faces they depict beam with shameless pleasure and bliss. Their drawings are no longer skimpy and laughable to adults, but enlarge, open. Gradually, the child will be less open and will eventually close[731]—then the child becomes a great refusal, refusing to eat or to walk, resisting the desire to repeat and to go unrestrained, disgusted and embarrassed with the deficiency of the body. This is more internal, more abstract, according to Michaux, than a revolt.[732]

1985 Sven B. Andersson, "Local Conventions in Children's Drawings: A Comparative Study in Three Cultures."[733] After studying 232 drawings of houses by three different groups of fifth graders—one from Tanzania, another from a refugee settlement of the African National Congress, and the third from Sweden—Andersson found a fundamental difference in the ways African and Swedish children depict buildings. While the Swedish children depicted houses using the symbolization typical of all Western cultures—placing windows in the middle— most of the African children demonstrated a "nonrepresentational" graphic model, locating windows in the corners of their houses. According to the author, the graphic model employed by the African children did not have anything in common with the houses in which they lived.[734] Andersson offers two possible explanations for this. First, he argues, children "might have employed the cornered window location because they primarily wanted to provide more space for X-ray display of important events inside the house." However, since some of the African children did not include any X-ray elements in their drawings, the author admits, this cannot be considered the major reason. Second, Andersson suggests, it is possible that the African children "drew on traditional patterns in the culture in which they live."[735] Andersson

argues that "local conventions" such as this "challenge representational models that embody a universalist approach to the development of child art."[736] He stresses that the African children's drawings "deviate from 'realism' in ways that cannot be reconciled with traditional representational models of children's drawing." He suggests that more substantial research is needed to study both the extent to which children employ distinctive local conventions and "the relationship between the phenomenon of local conventions in children's drawings and existing graphic models in a specific cultural context."[737]

MID-1980S–PRESENT With the aim of promoting world peace through creative art exercises, the International Child Art Foundation (ICAF) organizes international exhibitions of art by children between the ages of eight and twelve in cities around the world.

1987 Brent Wilson, Al Hurwitz, and Marjorie Wilson, *Teaching Drawing from Art*.[738] In this book, the authors elaborate on the Wilsons' discussion of the graphic principles universally used by children in their *Teaching Children to Draw* (1982). Here, they call these principles "intrinsic graphic biases." According to the authors, these biases need to be overcome if one is to avoid "a lifetime of involuntary childlike behavior."[739] The authors stress, however, that these graphic principles are defined as biases specifically with regard to the realistic tendencies of American culture.[740]

Wilson, Hurwitz, and Wilson describe nine "graphic biases," all of them tending toward simplicity and non-differentiation: the avoidance of overlapping (previously defined as the "territorial imperative principle"); the presentation of objects from their most characteristic point of view (people are seen from the front, horses and cars from the side, and so on—this expands on the "simplicity principle" of the earlier text); the placement of objects at right angles to one another (earlier defined as the "perpendicular principle"); the nondifferentiation of parts (size is exaggerated, arms and legs are depicted "without angles or bends"—this expands on the Wilsons' "plastic principle"); conservation (previously defined as the "conservation and multiple application principle"); format conformation (formerly defined as the "fill-the-format principle"); intuitive balance (with no instruction in composition or design, children tend "to produce drawings in which one shape or group of shapes balance another or others"—this is a new principle); embellishment (some youngsters have "an intrinsic propensity to embellish and to fill space in a decorative manner"—another new principle); and intellectual realism (previously defined as the "draw-everything principle").[741]

The authors also emphasize the cultural influences on children's drawings, asserting that a culturally specific "vocabulary" of shapes and configurations composes a certain "graphic language"; that "personal perceptions of objects" often have "less effect on how objects are drawn than the standard cultural symbol"; that if there are few graphic configurations available to young people, they "borrow them from other children"; and that "the fewer the graphic influences, the more graphically impoverished and predictable a style will be."[742]

1988 Dennie Wolf and Martha Devis Perry, "From Endpoints to Repertoires: Some New Conclusions about Drawing Development."[743] Wolf and Perry argue for the reconceptualization of children's drawing development, conventionally understood as having a single endpoint —namely, optical realism. They claim that "in Western cultures, where pictorial realism dominates, many developmental studies of drawing focus chiefly on the acquisition of those drawing skills that make illusionist picturing possible." According to the authors, there are two major pitfalls to this conviction. First, by focusing solely on the endpoint of "illusionistic picturing," it is impossible to see that drawing "takes on definition in the context of other forms of graphic representation, such as mapping and diagramming." Second, other drawing systems that young children discover are seen "as simply preparatory rather than alternative and continuously useful ways of picturing."[744]

The authors offer another way of looking at drawing development: rather than conceiving it as a path heading toward a single type of drawing, they view it as a process

Chronology

that establishes "a repertoire of visual languages." These languages may include various drawing systems and genres, as well as the capacity to make any number of variations. For Wolf and Perry, a range of distinguishable drawing systems appears as early as twelve to fifteen months.[745] Among these early systems are object-based representations that signify objects and gestural representations that symbolize motions and actions. Later in the second year, children begin to use another drawing system—one that includes "relative shape and size."[746] During the third year, one more drawing system emerges: children start making "lookalike pictures," which mark the onset of representational drawing. Between five and seven, children begin to construct yet another drawing system, "one that requires the representation of objects as they are situated in a larger space."[747] Children who continue drawing through adolescence acquire a number of other "renditions," which become highly individualized and reflect a search for style.[748] The authors stress that each of these drawing systems should not be viewed as a stage on the way to realism, but rather "as a system with distinct motives and powers" that gradually develops independently of others.[749] Wolf and Perry also insist on adding diagrams, maps, and graphs to the list of drawing systems, arguing that "each of these genres provides a distinct cultural language for conceptualizing and recording the nature of visual experience."[750] Thereby, the authors conclude, drawing development can be viewed from a completely different perspective—as a repertoire, meaning that children have the capacity to generate and use an entire range of visual languages.[751]

1990 Glyn V. Thomas and Angele M. J. Silk, *An Introduction to the Psychology of Children's Drawings.*[752] This book presents a summary of various approaches to studying children's drawings. According to Thomas and Silk, there are four major theoretical movements: developmental approaches, which assume that a child's drawing is "a copy of the image in the child's mind" and that children's drawings are realistic in intention (major figures include Jean Piaget, Georges Luquet, Florence Goodenough, and Dale Harris);[753] clinical-projective approaches, which suppose that

children "project their emotions and motives into their drawings" and, like developmental approaches, consider only "the surface structure of the finished drawing" (the major figure here is Hermann Rorschach);[754] artistic approaches, which consider children's creative self-expression to be the nature of drawing and to account for the perceptual principles of picture organization (major figures include Franz Cizek, Viktor Lowenfeld, Rhoda Kellogg, Rudolf Arnheim, and Jacqueline Goodnow);[755] and process approaches, which focus on how the process of picture making determines the final product, viewing children's drawings not as replicas of mental contents, but as "constructions whose final form depends crucially on the procedures used to produce them" (the major figure here is Norman Freeman).[756] Thomas and Silk go on to discuss the problems and challenges of each of these theoretical views. For instance, the major problem with any classification into stages, according to the authors, is its tendency to "obscure the continuities in development." They also note that the concept of developmental stages relates primarily to children in Western cultures and does not account for non-Western specifics of development.[757]

Thomas and Silk also provide classifications of various views regarding the nature of drawing, why children draw, the drawing process and its effects, what information is presented in a drawing, and children's drawings as art. They outline several theories on the nature of drawing: the drawing-as-symbol theory, which views drawings as graphic symbols that do not suggest any physical similarity with the object (the major proponent of this view is Goodman);[758] perspective-projection theories of picture perception, which consider the picture to be a replica of the image on the retina and view children's drawings as imperfect attempts to produce a "realistic copy" of the object and as "deviations from an ideal, visually correct, perspective projection" (major proponents include James J. Gibson, Ralph Norman Haber, Florence Goodenough, D. B. Harris, K. Machover, and E. M. Koppitz);[759] the invariant theory of picture perception, which assumes that input from the moving eye is constantly changing and is

somewhat abstracted from the actual scene (the major proponent is Gibson);[760] constructivist theories of perception, which assume that the image on the retina is ambiguous and has several possible perceptual interpretations, depending on the perceiver's knowledge and experience in visual perception, among other things (major proponents include Hermann von Helmholtz, Julian Hochberg, C. C. L. Gregory, and Sir Ernst Gombrich);[761] and the Gestalt theory of picture perception, which proposes that visual input is organized into configurations "by fundamental laws of perceptual organization" that are innate, and simple forms may stand for a variety of different objects (major proponents include Wolfgang Köhler and Rudolf Arnheim).[762]

The question of why children draw, the authors note, has been raised within several different approaches. In the developmental approaches, drawing is seen as a form of play that provides the opportunity "to practice and perfect activities and skills" that are necessary for the adult life; according to Piaget, drawings are the child's attempts to represent the real world and are based on the child's concepts about the world.[763] In clinical-projective approaches, drawings are seen as a form of catharsis; Freud, for example, views the child's artwork as a projection of his or her unconscious wishes and fears.[764] In artistic approaches, drawing is seen as an expression of children's interests and experiences; Kellogg proposes that picture making provides visual pleasure, Freeman suggests that it has a representational purpose, and Gardner views picture making as an expression of feelings.[765]

Theories concerned with the process of drawing, Thomas and Silk state, propose that the construction of a drawing is "much more complex than a simple translation of a mental image onto paper."[766] Such theories suggest that it is first necessary to acquire a "graphic description" of an object. Gombrich, for instance, states that without graphic descriptions (schemata) and a knowledge of pictorial devices "no picture making would be possible," and Brent and Marjorie Wilson stress that children are likely to learn graphic conventions from each other, parents, and picture books.[767] Thomas and Silk then go on to discuss Goodman's criteria for the evalua-

tion of children's drawings as art, which include repleteness, expression, and composition.[768] The authors argue that the fact that adults "find children's drawings aesthetically pleasing" does not mean that children themselves have artistic intentions.[769] In conclusion, they outline the major gaps in the existing research on children's drawings, suggesting areas of inquiry that might be undertaken in the future: "First, almost without exception, children's drawings have been studied from an adult point of view. We know very little of what children themselves think about their own drawings and those of others." Second, they note, there is a lack of research on the drawings of children younger than four years.[770] Third, they suggest, an investigation of children's problem solving as it occurs might be undertaken in order to determine "whether or not encouraging children to sketch out possible solutions results in more diverse and creative thinking."[771]

1992 Robert Coles, *Their Eyes Meeting the World: The Drawings and Paintings of Children*.[772] Written by a psychiatrist, this book emphasizes children's drawings as reflections of the child's life experiences. Trained to see children's drawings from a therapeutic perspective, which focuses on their symbolic nature, Coles nevertheless attempts to move closer to the child's intimate world with this study. By imposing his own understanding of the particular graphic symbols in children's drawings, he arrives at a rather different interpretation of child art than those who normally study child art. He observes children as they draw and records the statements they make about their pictures and life experiences. The book includes illustrations of more than forty drawings by children of various nationalities and ages, accompanied by the children's own comments about them as well as the author's interpretations. In one case, a boy who is the son of a landowner draws a large sun, covering half the page, and a field with many people harvesting crops. The boy explains that he never draws a smiling face on the sun, but rather puts teeth around it: the sun is not nice because "it's burning the back of one of our pickers."[773]

In Coles's view, each child's drawing can be understood from various perspectives: as a personal statement; as a

demonstration of artistic skill, aesthetic capacity, and imaginative resourcefulness; as an example of intellectual savvy; and as a communicative effort. Coles stresses that it is not difficult to see in children's drawings "the influences of personal experience, or the influences of race and class and region and the historical moment on a boy's, a girl's, sense of what matters in life—the shaping forces upon the particular world a child calls his or her own."[774] For the author, a child struggles to comprehend the world, to seek out its "beauties and mysteries," and to give them "the substance of shape and form, of color, of suggestive or symbolic significance."[775] Children use drawings in a number of ways: to tell a story, to convey information, to indicate something that is happening, to connect events in their lives to ideas, attitudes, concerns, or worries that press for expression.[776]

1992 Maureen V. Cox, *Children's Drawings*. Adopting the psychological approach to studying children's drawings pioneered by Norman Freeman in his *Strategies of Representation in Young Children* (1980), Cox here emphasizes the importance of children's planning and problem solving during the drawing process. According to recent early childhood and cross-cultural studies, she states, no special knowledge or experience with pictures is necessary to recognize real objects depicted in line drawings;[777] thus, she argues, the connection between drawings and objects in the real world is innate. She notes that even very small children engaged in scribbling shortly start naming their scribbles and then attempt to draw recognizable forms. Cox also cites evidence from Alexander Alland's study in *Playing with Form* (1983), suggesting that children do not need to go through the long scribbling period and can quickly move toward representational forms. Further, she notes, scribbling "does not necessarily lead to representation"—for instance, in the case of chimpanzees' scribbling.[778] Consequently, she concludes, it is the ability of humans to name things using symbols that may have encouraged the development of drawing toward representation. Children's early representational attempts, though they may look disorganized, already present "a good deal of knowledge" about picture making, she notes. For instance, young children know that each object or its part

can have "its own mark or shape." They also have a "grasp of how the shapes should be arranged on the page."[779] Cox goes on to say that children do not necessarily give up scribbling while making representational pictures: scribbling continues to provide practice at using lines and the enjoyment of a well-mastered activity.[780]

Having observed small children making their first drawings of the human figure, Cox comments on the "tadpole" figures that often result. When asked to add a tummy to their tadpole figures, most children locate the tummy in the "head" if it is drawn longer than legs or between the "legs" if they are drawn longer than the "head." Thus, the child's pictorial concept of a "body" varies depending on how the figure is drawn. Cox also argues that the graphic model of a tadpole with longer legs might be a "transitional form" between the tadpole and conventional human forms.[781] During one of her studies, children were presented with three models (tadpole, transitional figure, and conventional human figure) and were asked to show which one they preferred. All tadpole drawers chose the tadpole figure, while transitional and conventional drawers preferred the conventional drawing.[782] When tadpole drawers were asked to add body parts to their drawings, most of them added a body, suggesting that they knew the conventions of the human body, but were reluctant to change their way of drawing it.[783] Cox also found that the tadpole, transitional figure, and conventional human forms can "co-exist in the same child, who is clearly capable of drawing a more mature form but often does not." She explains that this choice frequently depends on whether the human figure is a main topic of the picture or only "incidental to the scene."[784]

As a rule, Cox notes, further development of the human figure exhibits exaggerations of size. The author argues that this is mainly a planning problem for the child. For instance, children may draw a big head since it includes facial features and hair and make the trunk much smaller because they do not want to add any features to it or because there is not much space left for it on the page. Therefore, young drawers can be considered to be "making a planning decision indicating that they are

Chronology

thinking ahead."[785] The transparency effect is also often a result of a planning problem, Cox suggests—children may not intend the body structure to be seen through the clothing, but this can happen if they draw the body first and then add the cloth. By contrast, older children and adults usually begin with the clothing and then attach visible body parts.[786]

Cox agrees with Georges Luquet that children strive toward recognizable forms (i.e., realism), asserting that they attempt to depict "what the object is" (intellectual realism) rather than "how it happens to look" (visual realism). However, she stresses that even though young children "may opt for the canonical view—or *intellectual realism* . . . —they are not totally unaware of the actual appearance of the object." Cox recounts asking her six-year-old daughter to draw a cup whose handle was out of her view; her daughter first drew it without the handle, but then looked at the drawing carefully and added the handle, saying, "It makes it look better." Cox identifies several reasons why this would happen. She claims that children "usually draw a canonical view if there is no reason to do otherwise." They also may draw this view if they think that "a realistic view might lead to some doubt about the objects' identity."[787] Furthermore, she notes, it is possible that when researchers name an object for a young child, it suggests to them a canonical view of the object, for when the object is not named, children seem to be "less likely to draw the canonical view and more likely to draw a more realistic picture."[788] Consequently, Cox writes, there is no "abrupt stage-like progression" from "intellectual realism" to "visual realism"; rather, there is "a shift in emphasis from one kind of depiction to another depending on what children consider is important."[789] Cox goes on to say that occlusion presents a considerable problem to the child, who often uses transparency to solve it. In most cases, transparency is used when the hidden object and its occluder "are structurally related" (the hidden object is inside, through, or under another object). However, when the object is totally occluded and there is no particular need to include it, most children as young as five will omit the object from the

drawing. The author then states that the overall scenes in young children's drawings involve considerable problem solving, even if they do not give the impression of being planned.[790] According to Cox, children who draw conventional figures "take account of both the internal cues of the figure *and* the external cues of the page," while even tadpole drawings show some organization within the figures themselves.[791]

Discussing the "perpendicular bias" that often informs children's drawings (according to which objects are drawn perpendicular to the baseline, and so on), Cox suggests a possible reason for its appearance: The perpendicular principle, she notes, seems to relate not to children's knowledge (whether a chimney is typically perpendicular to a roof, for instance), but is more likely related "to the drawing process itself": "children simply lose sight of the overall horizontal and vertical dimensions of the page." There is also some evidence, she notes, that the perpendicular bias does not operate in children's attempts "to represent spatial relationships either in abstract copying tasks or in pictures of real scenes."[792] Cox goes on to discuss the appearance of optical realism in children's drawings. In Western societies, she asserts, children between the ages of eight and nine tend to pursue linear perspective, which "confines the artist to a single, fixed viewpoint," because it is a culturally accepted form.[793] Cox stresses that most children do not naturally adopt linear perspective; for both children and adults, she notes, it is a great challenge and requires formal training.[794] Cox also argues that children should be encouraged to copy from models and pictures. She disagrees with the belief that copying inhibits creativity. By disapproving of children's copying activities, she asserts, "we may be closing the door on a very useful way of maintaining their interest in drawing and in widening their knowledge of the many ways in which things can be drawn," as many children copy the work of other children and adult artists "to widen their drawing repertoire and to draw more realistic pictures."[795]

1992 Janet L. Olson, *Envisioning Writing: Toward an Integration of Drawing and Writing*. Concerned with the fate of "visual

learners" in conventional schooling, Olson proposes a new program for elementary schools that integrates the visual into classroom instruction and facilitates the improvement of writing skills through an emphasis on visual thinking. The idea for this program, she notes, owes its origin to her work with Brent and Marjorie Wilson at Backer Elementary School in Massachusetts in 1977–78. She identifies "visual learners" as those who "process information through images instead of through words" and asserts that these children face great difficulties in the school environment since the conventional curriculum is essentially verbal-oriented: they do not progress well academically, perform poorly on tests, and often suffer from poor self-esteem.[796]

The visual-narrative program Olson proposes is aimed to meet the needs of "reluctant writers" by developing their narrative skills through drawing. She argues that Rudolf Arnheim's concept of "visual thinking"—put forth in his book *Visual Thinking* (1969)—supports the development of an art curriculum based on the "drawing of visual stories."[797] The program she outlines takes advantage of children's natural inclination to draw stories. She notes that stories "are frequently more complex and detailed in children's drawings than is evident in their writings."[798] The program provides for the gradual enrichment of children's drawing vocabulary and results in a dramatic improvement in visual language, according to Olson. Children start by drawing different characters, such as "firemen," "policemen," "grandpa," or "ballerinas," then develop character exaggerations ("too skinny," "too fat," "too pretty," "too ugly"). After that, they explore how to make characters move, how to show various emotions by making changes to eyebrows, eyes, mouth, and forehead, and how to create various environments. The next step that Olson proposes is the development of various plots, or sequential drawings.

Olson asserts that based on her work with the Wilsons, the implementation of this drawing program not only improved children's visual vocabulary, but also caused a noticeable improvement in their writing skills. In conclusion, she stresses that drawing stories should not be perceived as a "preliterate tendency"; rather, she notes, visual and verbal modes of expression have an "interactive continuity," and their integration can be very beneficial for "visual children/reluctant writers."[799]

1995 *Mit dem Auge des Kindes: Kinderzeichnung und Moderne Kunst*, Städtische Galerie im Lenbachhaus, Munich, and Kunstmuseum Bern. The first major scholarly effort to investigate the connection between child art and modern art, this exhibition includes works by Mikhail Larionov, Wassily Kandinsky, Paul Klee, Joan Miró, Pablo Picasso, Jean Dubuffet, and artists of the CoBrA group, among others, together with a selection of children's drawings collected by these artists and sometimes used as source material in their work. Curated by Jonathan Fineberg, Josef Helfenstein, and Helmut Friedel, the exhibition is accompanied by a catalogue of the same title by Jonathan Fineberg and a volume of essays entitled *Kinderzeichnung und die Kunst des 20. Jahrhunderts*.[800]

1997 Anna M. Kindler and Bernard Darras, "Map of Artistic Development." Kindler and Darras propose an alternative to the widely accepted stage-based theories of children's artistic development formulated by Viktor Lowenfeld in 1947 and subsequently developed by many others. Their model of development, they note, is the result of their reflections on recent cross-cultural research and the work of other scholars, including Dennie Wolf and Martha Devis Perry's concept of graphic development as an unfolding repertoire of visual languages, put forth in their article "From Endpoints to Repertoires" (1988).[801] Kindler and Darras's major objections to stage-based theories of artistic development are as follows: First, the authors argue, these theories do not account for the diversity of work produced within the boundaries of each stage. Second, they concentrate on progress toward optical realism, which is not "a cross-culturally preferred representational convention," nor "a consistent goal" even within the Western tradition.[802] Third, the stage theories lack generalizability "when addressing artistic development of adolescents and adults" and do not account for diagrams, sketches, home videos, photographs, and other pictorial productions. Finally, they are founded "on

Chronology

a culture-free assumption and either neglect the implications of the cultural and social context, or view any extraneous influences as detrimental to the natural, biologically defined process of development."[803]

According to Kindler and Darras, the model they propose does not rely on a particular definition of art, embraces "a diversity of pictorial manifestations," and "allows for consideration of sociocultural variables." Further, it is based on the assumption that children's art has a communicative potential, whether it is the communication of "thoughts, ideas, emotions, values, states, understandings, or realities."[804] From a philosophical perspective, the authors view artistic development as a continuing struggle between two opposing forces: "the generic tendency, which favours rule, regularity, predictability, and order, and the individuate tendency, which leads towards exception, uniqueness, and unpredictability."[805]

Kindler and Darras's "map" of artistic development in the early childhood years has five "iconicity levels," which indicate "points of bifurcation" or qualitative changes in the nature of semiotic activity. They stress that each of these levels "delineates a range of behaviors and possibilities, rather than describing a precisely defined form."[806] Iconicity 1 signifies "the recognition of ability to produce icons of actions" and reflects the influence of the individuate tendency. (In traditional stage theories, this level is defined as uncontrolled scribbling.) Iconicity 2 delineates the phase when "a child's attention shifts from causing an effect to the effect itself." Here, a child begins to explore the relationships between marks and traces, and the social environment stimulates the emergence of a generic tendency toward organization, order, and predictability.[807] Iconicity 3 indicates the further development of the child's interest in dynamic events: "the kinetic self-imitation extends to the understanding that imaginary actions can be pictorially recorded." This iconicity level is marked by an increase in social interaction and, consequently, a generic tendency in children's drawings as children begin to mimic one another's iconic gestures and sounds. Iconicity 4 reflects the child's recog-

nition of graphic forms as standing for objects rather than dynamic events. This level is marked by two strategies of graphic substitution: producing familiar objects and inventing new symbols to convey certain meanings.[808] While graphic development at this point becomes increasingly generic and about communicating socially shared meaning, individualization occurs "through the verbal channel." Iconicity 5 is marked "by a competent use of semiotic process and extensive exploration in the realm of visual imagery." Children's drawings begin to carry meaning that can be "shared socially" and "appear to be independent of verbal narrative or supporting gestural cues." At this point, the interplay between generic and individuated tendencies is pronounced.[809]

Kindler and Darras stress that while in Western cultures art making is often considered a solitary experience, children do not exhibit a need for autonomy. They are concerned neither with the notion of individuality and uniqueness, nor with the creative merit of their pictures. Instead, they seem to focus "on the efficiency with which their pictorial representations function as carriers of intended meaning." According to the authors, the five iconicity levels they present should not be viewed as definite stages through which a child gradually moves, but rather as a repertoire of strategies of pictorial representation that are applied according to the child's needs, the function of the drawing, and the particular context in which the drawing is produced.[810]

1997 Jonathan Fineberg, *The Innocent Eye: Children's Art and the Modern Artist*.[811] An expanded version of the catalogue accompanying the 1995 exhibition *Mit dem Auge des Kindes*, this book examines in scholarly detail the frequently noted, but until this time discounted, visual connection between modern art and the art of children. The project has its roots in the author's discovery that some of the major figures in the history of modern art collected child art in depth and used it as source material for their own art. Fineberg notes that these collections looked completely different from one another, but that each artist's collection related directly to the central artistic innovations of that artist. For some—including Wassily Kan-

dinsky, Paul Klee, Joan Miró, and Pablo Picasso—concepts they observed in children's art informed the structure of their major stylistic breakthroughs; for others, including Gabriele Münter and Henri Matisse, child art provoked a more general impetus toward simplification.

1998 Jonathan Fineberg, ed., *Discovering Child Art: Essays on Childhood, Primitivism, and Modernism.*[812] The role of child art in the work of modern artists is the central theme of this collection of essays by art critics, curators, and historians (including Troels Anderson, Rudolf Arnheim, Marcel Franciscono, Ernst Gombrich, Christopher Green, Josef Helfenstein, G. G. Pospelov, Yuri Molok, Richard Shiff, Dora Vallier, and Barbara Wörwag, among others). The authors discuss the formal and ideological functions of child art in the work of Keith Haring, Wassily Kandinsky, Paul Klee, Mikhail Larionov, Joan Miró, Gabriele Münter, and the artists of the CoBrA group.

The use of child art by artists is a twentieth-century phenomenon, the book proposes, stemming from a cultural and ideological reorientation that drove modern artists to consider the art produced during childhood to be a truly authentic means of representation. In his essay, Werner Hofmann considers the use of child art to be a function of political consciousness: the relation of child art to innocence and to direct creative expression, he asserts, led artists to take up child art as an instrument of revolutionary thinking. Other essays address the specific role of child art in determining the formal qualities of modern painting. Pospelov identifies several formal qualities in paintings by Larionov—the dominance of frontal perspective, the compartmentalization of the pictorial plane, and the subordination of objects to space, for example—that he suggests may have their roots in child art. The simplicity of form in child art provided modern artists with a way to combine inner content and outer form in a move toward truer and more immediate expression.

1999 Paul Duncum, "A Multiple Pathways/Multiple Endpoints Model of Graphic Development."[813] Here, Duncum offers a new "descriptive, sociological model of graphic development" with "both diverse pathways and multiple endpoints," in place of three previously established models: "the hierarchic and linear stage approach" of Viktor Lowenfeld and W. Lambert Brittain, the U-shaped curve proposed by Howard Gardner, and Duncum's earlier equal-value model. Duncum maintains, "Each of these models describes development in terms of stages. . . . They offer idealizations of development, whereas the proposed model attempts to describe typical, current patterns of development under current social circumstances and educational opportunities." His new model also "attempts to capture something of the conceptual complexity of development."[814]

According to Duncum, each of the existing developmental models has certain pitfalls. Lowenfeld's approach —long the dominant model of graphic development— describes development "as a series of progressive stages from infancy to late adolescence." Here, development is viewed "as based substantially upon the genetic fuel common to all children and is thereby thought to be universal." In this case, Duncum stresses, "The false assumption of universality leads to the mistaken view that development is not subject to cultural constraints or opportunities. If development is inevitable, intervention is unnecessary."[815] Gardner's U-shaped model acknowledges both cultural influences and natural growth. It defines three major steps in development—the playful and spontaneous art of early childhood, with its rich aesthetic qualities; the developmental decline of the middle-childhood years, when art loses its aesthetic qualities; and the aesthetic and skillful art of adolescence—but asserts that the transitions between these stages are not always clear. According to Duncum, Gardner's model has two major pitfalls: first, it "conflates graphic development with aesthetic development," and second, Gardner shows a clear preference for the modernist aesthetics of fauvism and expressionism, according to which spontaneous play is an important form of artistic self-expression. Consequently, Duncum argues, "he privileges personal expression and aesthetic flavorsomeness over skill development." Duncum's earlier equal-value model agrees with most of Gardner's observations, rejecting only his proposal that

skill development experiences decline in middle childhood. Duncum writes that the equal-value model dissociates children's graphic development from any particular aesthetics, but it "fails to address the contextual complexity of development."[816]

The multiple pathways/multiple endpoints model Duncum proposes here attempts to capture "the complexities of individual children's interests, abilities, and circumstances."[817] He argues, "Instead of a singular, linear development, development is pluralist, multifaceted, shifting, and very much more complicated than previously envisaged."[818] Based on this understanding, his new model is pictured "as a series of lines which start together but shortly thereafter branch out.... Some branches continue through to late adolescence while others stop along the way." The starting point, he states, is scribbling, which becomes qualitatively dissimilar in children, in terms of motivation, at around eighteen months. From this point, various branches of individual development appear. Some children draw only until "written language acquisition," some draw a lot until middle childhood and then "only occasionally," some start late "due to illness or lack of materials," some draw until high school, some draw "while in trauma or ill," and others continue drawing through adolescence but in fundamentally different styles, either expressionist or realistic. This model portrays development as "driven by self-initiated practice, educational intervention, and educational neglect."[819] Its major contribution, according to Duncum, "lies in incorporating both long-standing and recent observations of development that emphasize difference." It is also an open-ended approach, he asserts, and allows "research questions about what other developmental patterns might exist which have hitherto been overlooked."[820]

2001 Phil Pearson, "Towards a Theory of Children's Drawings as Social Practice."[821] This article proposes approaching children's drawings individually, as "an entity in its own right," independent of any particular theory of children's art. "We should understand children's graphic practices as a form of social practice," Pearson claims, "and should attend to the way this form of practice is related to other, non-graphic, practices." He emphasizes the reasons children engage in the practice of drawing, which he notes are not identical "with what can be found out from the residues of their practices."[822] The core problem with the existing literature on children's drawings, Pearson asserts, is that it attempts to construct knowledge about drawing that fits the professional beliefs, interests, and needs of the authors: "The literature does not contain a form of discourse that enables the practice of drawing to be thought about independently of our interests in drawing." He argues that each of the existing theories develops its own perspective on children's drawings, and often these perspectives are conflicting (cognitive development versus artistic development, for example).[823] Pearson writes that none of these theories "can stand up to critical scrutiny" because all of them "begin with an interest in something that is not children drawing"; they merely use drawings to support their own ideologies.[824]

For Pearson, drawing activity can be observed without any theoretical framework; it can be perceived as an activity taking place among the many other activities in which children are daily engaged. Using this approach, the absence of drawing activity, and not just its presence, becomes an integral part of understanding the domain of drawing. According to Pearson, the most important question to ask is "Does drawing happen?" A negative answer can be viewed as signifying that drawing "offers nothing necessary to children's lives."[825] At present, he notes, there is no theory of drawing that can explain a child's decision "not to draw but to play sports instead." He asserts that drawing should be understood as having a specific function within a particular context, as children use it in different ways: as a play activity, a narrative activity, a strategy for social approval, a strategy for coping with boredom or isolation, a retreat from violent social relations, or the means for pursuing a passionate interest in a subject such as horses or trains. The author suggests, "Grasping the relativity of the engagement children have with drawing is a matter of grasping the levels of agency with which children conduct their lives." He also insists

that knowledge about the interest of children in graphic activity is "critical to any subsequent knowledge of graphic skill."[826]

2002 Claire Golomb, *Child Art in Context: A Cultural and Comparative Perspective*. Starting from the premise that the "child should be studied within an ecologically meaningful context," Golomb pays special attention "to the process of creation and to the child's ongoing commentary and interpretation" as well as "themes that interest the young artist." The author argues against the prevailing notion that young children's drawings reflect their conceptual immaturity. Golomb stresses that this position stems from the "uniquely Western perspective that progress in drawing consists of a unilinear path toward optical realism in art" and ignores the nature of the medium of representation. According to Golomb, graphic representation is a "constructive mental activity" and not a "literal imitation or copy of the object"; it is "a major biological, psychological, and cultural achievement."[827]

While discussing major trends in drawing development, Golomb analyzes the child's use of form, space, composition, and color as well as some aspects of artistic giftedness. (A more detailed discussion of these topics is presented in Golomb's 1992 book *The Child's Creation of a Pictorial World*.[828]) She states that the beginning of representation "as a pictorial symbolic activity" happens when "the drawn shape points beyond itself to an entity that it merely 'stands' for."[829] First representations are the child's inventions and are a hallmark "of a symbolizing intelligence," she notes; they are essentially "globals," with the underlying principle of "simplicity and economy of form."[830] According to Golomb, there is no direct connection between unitary mental images and graphic models. In the beginning, children are concerned with a "basic likeness" and do not intend to represent objects realistically. Aesthetics emerge in young children's drawings as a tendency toward balance.[831]

Golomb notes further that representation of three-dimensional space on a two-dimensional surface presents a substantial challenge to the child. The earliest attempts to organize pictorial space begin with the application of a "principle of proximity" along the vertical and horizontal axes. Later, during their middle- and late-childhood years, children attempt to create "the illusion of volume and depth on the flat surface" by diminishing the size of objects to imply distance or by partial overlapping. However, few children arrive at linear perspective without training.[832] The use of color in children's drawings serves multiple functions, she writes, such as embellishment and the expression of a particular state of mind. Realistic application of colors usually becomes important for the child around the age of six. For Golomb, composition "refers to an arrangement of the elements of line, form, space, and color that indicates to the viewer what the work is about." She describes two basic compositional tendencies in young children's drawings: "a gridlike arrangement of figures along horizontal and vertical axes and centering strategies that organize items around a pictorial center."[833] Later, she states, the use of symmetry appears. Golomb emphasizes that the formal, spatial, and compositional trends she discusses are elements of a "so-called child art style," with its characteristic "flat, two-dimensional renderings of objects and scenes in the preferred frontal orientation," and that this style often reaches its expressive and aesthetic high point around the age of nine.[834] Golomb also stresses the significance of the child's sociocultural environment to his or her drawings, including his or her exposure to culture-specific tools, graphic models, and teaching strategies. However, she writes, these influences do not change "the basic structural similarities of child art, which are easily detected despite changes in time and space."[835]

Golomb also studies children's development in modeling, drawing comparisons between the representational growth in three-dimensional and two-dimensional mediums. She claims that "modeling in clay appears not to follow the hypothesized linear progression from one- to two-dimensional and finally three-dimensional representation." Instead, it begins with an "incipiently three-dimensional conception that is gradually refined and differentiated."[836] For instance, young children's drawings of the human figure often omit the trunk, which is present

from the very beginning in clay modeling. According to Golomb, these striking representational differences between the two mediums reflect children's sensitivity "to the possibilities and demands of each medium" and their "spontaneous awareness that a representation is not a literal imitation of an object."[837]

Golomb notes that a number of cross-cultural studies in child art (by Gustav Jahoda, Malka Haas, W. Dennis, and Jane Bela) reveal "very similar graphic configurations" among children from different cultures as well as untrained adults. However, she states, these studies also record differences in graphic patterns or configurations, which are influenced by sociocultural factors and by individual differences among drawers.[838] Further, she writes, these studies also make clear that child art does not have "a universal and uniform endpoint in optical realism or in any other particular art form";[839] rather, its style, theme, and medium are determined by the sociocultural environment. Sometime between the ages of five and seven, she says, children increasingly begin to draw in the culturally dictated manner.[840] Thus, the child artist can be seen from various perspectives: as a "creator-inventor" of a basic graphic vocabulary, as a "participant in a peer culture," and as a "member of a community that promulgates certain views of art."[841]

Golomb argues against the cognitive perspective that refers to the child's "innocent eye," a state of "pure vision" attached to a mind "dominated by its perceptual experiences." She claims that there is "little evidence for the assumption of the innocent eye that translates retinal images into naturalistic depiction." The concept of the "innocent eye," she says, reflects a romantic tradition of viewing that goes back to the nineteenth century and sees the child as close to nature, "uncorrupted by cultural practices," and more authentic than adults.[842] The use of child art as a source of inspiration by modern artists, she states, reflects this romantic "cult of childhood."

2003 John Matthews, *Drawing and Painting: Children and Visual Representation*.[843] Matthews argues against the traditional belief that young children begin their graphic development with scribbling as a pure kinesthetic activity. He claims that children actually rarely scribble, and their

drawing "has organization and meaning all the way from the beginning."[844] Matthews insists that the existing concept of representation should be revised to include the early forms of representation and expression. He writes that even after more than a hundred years of research, contemporary theorists and practitioners lack an understanding of children's intentions in making art, and these intentions "are not captured by *any* adult definition of art." Art forms spontaneously generated by children are still largely dismissed, he states, even though they are developmentally significant activities "vital to the intellectual and emotional growth of young children." Children are guided toward specific endpoints by their art teachers, with little respect to the nature of their unsolicited artistic activity.[845]

Matthews's research includes a longitudinal study of his own son, Ben; a two-year study of forty nursery school children in London; and a ten-year study of young children in Singapore. Based on this research, Matthews concludes that the first form of representation emerges much earlier than has traditionally been thought. He challenges the concept of representation as a symbolization of a prior experience (associated with "picturing"), arguing that, "although representation does often try to make sense of previous experience, it is not a copy of that experience. Representation is an essentially dynamic, constructive act which shapes the experience itself." According to Matthews, first representations are "dynamic actions"; he notes that some writers, such as Eliot, define these actions as "attractors," which are not stored as representations in the brain (as Jean Piaget thought), but emerge in specific contexts.[846]

Matthews stresses that children purposely randomize explorative and investigative actions "in such a way as to generate a fertile ground of representational possibilities."[847] He identifies three basic action representations used by infants: horizontal arc, vertical arc, and push-pull. These drawing actions are discovered from earlier body movements, he writes: "the earliest drawing actions are based upon early gesticulation of the body already articulated into emotional and expressive phrases and passages."[848] Therefore, it is meaningless "to seek the precise

moment when 'real' drawing begins" for it is embedded into the development of children's intelligence.[849] According to Matthews, action representations are neither merely the imitation of someone's movements, nor completely free from outside influences; rather, they are a form of interaction with the immediate environment and with caregivers.[850] Further representational development in early childhood, Matthews states, leads to the discovery of "inside and outside relationships, as well as basic directions of movement, across, round and round, and up and down." At this point, graphic activity is hard to separate from language acquisition, and together they create a kind of "dynamic language."[851]

Matthews also argues against the stage-based approach to children's drawing development, which posits a gradual progression from intellectual to visual realism. He asserts that graphic development is "a continuum which undergoes transformations woven together in dynamic, co-operating, perceptual-motor systems."[852] At a very early age, he notes, children are able to draw from observation; however, they do not intend to draw an object just from a single viewpoint, but want to preserve its main characteristics.[853] For Matthews, intellectual and visual realism are equally important drawing systems, and both are present in children's works from the beginning to the very end of their graphic development; which system the child decides to use depends on the particular task and context and the child's intentions. He gives the example of his son, who at the age of four was able to combine various drawing devices, including some elements of perspective, and to blend different genres, so as to create his "hypothetical universes."[854]

Matthews also calls for revising Western culture's concept of "realism," arguing that there is no "true reality existing independently of the modes of representation we use to describe it." Representation is not a copy of some absolute reality, he writes, but "a human construction."[855]

2003 Michael Parsons, "Endpoint, Repertoires, and Toolboxes: Development in Art as the Acquisition of Tools."[856] Parsons summarizes the crucial shifts in theories of artistic development, from the linear model of development (proposed by Jean Piaget and Viktor Lowenfeld, among others), to the U-shaped model (Howard Gardner), and, most recently, to the tree-shaped model (Dennie Wolf and Martha Devis Perry, and Anna M. Kindler and Bernard Darras). He notes that while the linear and U-shaped models of artistic development consider only one endpoint (visual realism and art that has distinctive modernist aesthetic qualities, respectively), the tree-shaped model offers multiple endpoints, which are defined as a repertoire of visual languages. Parsons argues that the last model responds to "our increasing postmodern sense of the diversity of art itself and of the diversity of goals for art education."[857] However, he proposes to shift the metaphor "from that of a repertoire of performances to that of a box of tools, to emphasize both the diversity and the cultural character of development in arts." These tools, the author explains, are culturally specific pictorial models, social creations that "are afforded by a society for children to use." From this point of view, development is understood as a child's increasing ability to use these tools.[858] For Parsons, this concept is reflected in Arthur Efland's image of development as an irregular lattice, which suggests that there are a number of different beginning and end points and that "development may be proceeding simultaneously on several different paths at the same time."[859] Parsons argues that it is culture, not nature, that is responsible for the choice of developmental ends. The author also emphasizes that in the course of this "multi-faceted" development, "the trajectories of the different abilities interact with each other and make possible understandings of greater sophistication."[860]

CURRENT *When They Were Children*. This on-line exhibition of childhood drawings and paintings by contemporary artists posts hundreds of works by an international assortment of artists. See http://www.papaink.org/gallery/home/artist/list_adult.html.

Chronology

NOTES

1. Valentin Yanin, "The Drawings of Onfim," *School Arts* (Worcester, Mass.) 84 (March 1985): 6.

2. Giovanni Boccaccio, *Decameron* (1348–53), trans. Mark Musa and Peter Bondanella (New York: New American Library, 1982), 395.

3. Translated into English in 1561.

4. Vasari, quoted in Laurie Rubin, "First Draft Artistry: Children's Drawings in the Sixteenth and Seventeenth Centuries," in J. M. Muller, ed., *Children of Mercury: The Education of Artists in the Sixteenth and Seventeenth Centuries* (Providence, R.I.: Brown University, Department of Art, 1984), 10.

5. Published as Jean Héroard, *Journal de Jean Héroard: Médecin de Louis XIII*, 2 vols., ed. Madeleine Foisil (Paris: Fayard, 1989).

6. M. V. C. Jeffreys, *John Locke: Prophet of Common Sense* (London: Methuen, 1967), 101.

7. Franklin, quoted in Foster Wygant, *Art in American Schools in the Nineteenth Century* (Cincinnati, Ohio: Interwood Press, 1983), 8.

8. Jeffreys, *John Locke*, 57.

9. Jean-Jacques Rousseau, *Emile* (1762), trans. Allan Bloom (New York: Basic Books, 1979), 130.

10. Allan Bloom, Introduction, in ibid., 13.

11. Rousseau, *Emile*, 132.

12. Ibid., 143.

13. Ibid., 144.

14. Ibid.

15. Ibid., 199.

16. Ibid.

17. Part of this diary was published in 1828.

18. Pestalozzi, quoted in J. A. Green, *Life and Work of Pestalozzi* (London: W. B. Clive, 1913), 35; see Clive Ashwin, *Drawing and Education in German-Speaking Europe, 1800–1900* (Ann Arbor, Mich.: UMI Research Press, 1981), 7.

19. Pestalozzi, quoted in Green, *Life and Work of Pestalozzi*, 43; see Ashwin, *Drawing and Education in German-Speaking Europe*, 7.

20. Johann Heinrich Pestalozzi, *Wie Gertrud ihre Kinder lehrt* (1801), translated into English by L. E. Holland and F. C. Turner as *How Gertrude Teaches Her Children* (London: Swan Sonnenschein, 1900). Ebenezer Cooke produced an earlier translation into English, in 1894, according to Stuart MacDonald, *The History of Philosophy of Art Education* (New York: American Elsevier, 1970), 225.

21. Kate Silber, *Pestalozzi: The Man and His Work* (London: Routledge and Kegan Paul, 1960), 133.

22. Ashwin, *Drawing and Education in German-Speaking Europe*, 11.

23. Ibid., 11.

24. Ibid.

25. Johann Heinrich Pestalozzi, *ABC der Anschauung* (Zurich: J. G. Cotta, 1803).

26. Ashwin, *Drawing and Education in German-Speaking Europe*, 15.

27. Pestalozzi, quoted in Ashwin, *Drawing and Education in German-Speaking Europe*, 15.

28. Ibid., 17.

29. Ibid., 28.

30. Schmid, quoted in ibid., 33.

31. Ibid.

32. Ibid., 36.

33. Ibid., 36–37.

34. Friedrich Froebel, *The Education of Man* (1826), trans. W. N. Hailman (New York: D. Appleton, 1895).

35. John A. Michael and Jerry W. Morris, "European Influences on the Theory and Philosophy of Viktor Lowenfeld," *Studies in Art Education* (Reston, Va.) 26 (1984): 103.

36. Carol Sienkiewicz, "The Froebelian Kindergarten as an Art Academy," in *The History of Art Education: Proceedings from the Penn State Conference* (Reston, Va.: Pennsylvania State University, 1985).

37. Patricia Tarr, "Pestalozzian and Froebelian Influences on Contemporary Elementary Art," *Studies in Art Education* (Reston, Va.) 30 (Winter 1989): 116.

38. Stuart MacDonald, *The History and Philosophy of Art Education*, 344.

39. Tarr, "Pestalozzian and Froebelian Influences on Contemporary Elementary School Art," 117.

40. Michael and Morris, "European Influences on the Theory and Philosophy of Viktor Lowenfeld," 104.

41. Peter Schmid, *Das Naturzeichnen für den Schul- und Selbstunterricht*, 4 vols. (Berlin: Nicolai'sche Buchhandlung, 1828–32). Peter Schmid should not be confused with Joseph Schmid, who appears above.

42. Ashwin, *Drawing and Education in German-Speaking Europe*, 79–80.

43. Ibid., 89.

44. Ibid., 93.

45. Ibid., 111.

46. See Wygant, *Art in American Schools in the Nineteenth Century*, 34–36.

47. Rodolphe Töpfer, *Réflexions et menus-propos d'un peintre génevois* (Paris: J.-J. Dubochet, Lechevalier, 1848).

48. Töpfer, quoted in Meyer Schapiro, *Modern Art: Nineteenth and Twentieth Centuries* (New York: G. Braziller, 1978), 61.

49. Ibid., 62.

50. Töpfer, quoted in Jo Alice Leeds, "The History of Attitudes Toward Children's Art," *Studies in Art Education* (Reston, Va.) 30 (Winter 1989): 98.

51. Schapiro, *Modern Art*, 61.

52. Töpfer, quoted in Leeds, "The History of Attitudes Toward Children's Art," 98.

53. See Hannah Swart, *M. M. Schurz: A Biography* (Watertown, Wis.: Watertown Historical Society, 1967).

54. John Ruskin, *The Elements of Drawing* (1857; New York: Dover Publications, 1971), 9.

55. Ibid.

56. Ibid., 9–10.

57. Tarr, "Pestalozzian and Froebelian Influences on Contemporary Elementary School Art," 117.

58. Ibid., 117–18.

59. Ibid., 118. Peabody may have been involved in organizing an exhibit for the Philadelphia Centennial Exposition in 1876. In 1890, her "Plea for Froebel's Kindergarten

as the First Grade of Primary Art Education" was published in the *American Journal of Education*; see Wygant, *Art in American Schools in the Nineteenth Century*, 34–36.

60. Herbert Spencer, *Education* (1861; London: Williams and Northgate, 1878).

61. MacDonald, *The History and Philosophy of Art Education*, 321.

62. T. L. Jarman, *Landmarks in the History of Education* (1951; London: John Murray, 1963), 159.

63. Spencer, quoted in Wilhelm Viola, *Child Art* (Peoria, Ill.: Chas. A. Bennet Co., 1945), 8.

64. Ibid., 7.

65. Spencer, quoted in MacDonald, *The History and Philosophy of Art Education*, 323.

66. Ibid., 321–22.

67. Ibid., 323.

68. Wygant, *Art in American Schools in the Nineteenth Century*, 50.

69. Charles Darwin, "Biographical Sketch of an Infant," *Mind* (London) 2, no. 7 (1877): 285–94.

70. See Arlene E. Richards, "The History of Developmental Stages of Child Art: 1857–1921," *Ball State University Lecture Series* (Muncie, Ind.: Ball State University, October 1974).

71. See G. Stanley Hall's chapter on the work of Wundt in his *Founders of Modern Psychology* (London: D. Appleton, 1912).

72. Wilhelm Preyer, *Die Seele des Kindes* (1881), translated into English by H. W. Brown as *The Mind of the Child, Part 1: The Senses and the Will* (New York: D. Appleton, 1888).

73. Ibid., 65.

74. Ibid., 66.

75. Ibid.

76. See Michel Thévoz, *Art Brut* (New York: Rizzoli, 1976), 23.

77. Ebenezer Cooke, "Our Art Teaching and Child Nature," *Journal of Education* (December 1885 and January 1886): 462–65 and 12–16; excerpts in Herbert Read, *Education Through Art* (1943; London: Faber and Faber, 1958), 169–70.

78. Ashwin, *Drawing and Education in German-Speaking Europe*, 148.

79. Ibid.

80. Lichtwark, quoted in ibid., 148.

81. Peter Smith, "Germanic Foundations: A Look at What We Are Standing On," *Studies in Art Education* (Reston, Va.) 23, no. 3 (1982): 27.

82. Corrado Ricci, *L'Arte dei bambini* (Bologna: Nicola Zanichelli, 1887); abridged version translated into English by Louise Maitland as "The Art of Little Children," *The Pedagogical Seminary* (Worcester, Mass.) 3 (October 1895): 302–7; translated into German as *Die Kinderkunst* (Leipzig: Voigtlaender, 1906).

83. Ricci, "The Art of Little Children," 303.

84. Leeds, "The History of Attitudes Toward Children's Art," 97.

85. Ricci, "The Art of Little Children," 304–5.

86. Ibid., 303–4.

87. Leeds, "The History of Attitudes Toward Children's Art," 98.

88. Lichtwark, quoted in MacDonald, *The History and Philosophy of Art Education*, 330.

89. Georg Hirth, *Ideen über Zeichenunterricht* (Munich: G. Hirth, 1887).

90. Ashwin, *Drawing and Education in German-Speaking Europe*, 149.

91. Hirth, quoted in ibid., 149.

92. Ibid., 149–50.

93. Bernard Perez, *L'Art et la poésie chez l'enfant* (Paris: Félix Alcan, 1888); translated into English by A. M. Christie as *The First Three Years of Childhood* (London: Sonnenschein, 1888).

94. Leeds, "The History of Attitudes Toward Children's Art," 97.

95. MacDonald, *The History and Philosophy of Art Education*, 325.

96. Leeds, "The History of Attitudes Toward Children's Art," 96.

97. Perez, quoted in ibid., 96.

98. MacDonald, *The History and Philosophy of Art Education*, 325.

99. Francis Paulhan, "L'Art chez l'enfant," *Revue philosophique de la France et de l'étranger* 28 (July–December 1889).

100. Ibid., 327.

101. Richard Carline, *Draw They Must: A History of the Teaching and Examining of Art* (London: Edward Arnold, 1968), 135; see also MacDonald, *The History and Philosophy of Art Education*, 327.

102. Alfred Binet, "Perceptions d'enfants: Interprétation des dessins," *Revue philosophique de la France et de l'étranger* (December 1890): 582–611.

103. Ibid., 582.

104. Ibid., 583.

105. Ibid., 589.

106. Ibid., 591; translations by Jonathan Fineberg.

107. Ibid., 592.

108. Ibid., 592–94.

109. Ibid., 595–96.

110. Ibid., 606–8.

111. Ibid., 610.

112. G. Stanley Hall, "The Contents of Children's Minds," *The Pedagogical Seminary* (Worcester, Mass.) 1 (1891): 139–73.

113. Richards, "The History of Developmental Stages of Child Art: 1857–1921," 6.

114. Ibid., 7.

115. Ibid., 10.

116. Jacques Passy, "Note sur les dessins d'enfants," *Revue philosophique de la France et de l'étranger* 32 (July–December 1891): 614–21.

117. Earl Barnes, "A Study of Children's Drawings," *The Pedagogical Seminary* (Worcester, Mass.) 2 (1892): 455–63.

118. Ibid., 460–61.

119. The children participating in Barnes's study are primarily from the California school system; see Richards, "The History of Developmental Stages of Child Art: 1857–1921," 12.

120. Barnes, "A Study of Children's Drawings," 455.

121. Ibid., 457.

122. Ibid., 458–59.

123. Ibid., 462.

124. Richards, "The History of Developmental Stages of Child Art: 1857–1921," 12.

125. Barnes, "A Study of Children's Drawings," 455.

126. Tadd, quoted in Wygant, *Art in American Schools in the Nineteenth Century*, 112.

127. Konrad Lange, *Die künstlerische Erziehung der deutschen Jugend* (Darmstadt: Bergstrasser, 1893).

128. Ashwin, *Drawing and Education in German-Speaking Europe*, 155.

129. Ibid.

130. Ibid., 143.

131. Ibid., 71.

132. Ibid., 72.

133. Ibid., 76.

134. Ibid., 72.

135. Ibid., 158.

136. Ibid., 155–56.

137. Louise Maitland, "What Children Draw to Please Themselves," *The Inland Educator* (Terre Haute, Ind.) 1 (September 1, 1895): 77–81.

138. Ibid., 77.

139. Ibid., 80.

140. Ibid., 81.

141. James Mark Baldwin, *Mental Development in the Child and the Race: Methods and Processes* (New York: Macmillan, 1895).

142. Ibid., 83.

143. Ibid., 87.

144. Ibid., 88.

145. Ibid., 91.

146. Herman T. Lukens, "A Study of Children's Drawings in the Early Years," *The Pedagogical Seminary* (Worcester, Mass.) 4 (1896): 79–110.

147. Ibid., 87–88.

148. Ibid., 98.

149. Ibid., 87.

150. Ibid., 89.

151. Richards, "The History of Developmental Stages of Child Art: 1857–1921," 17.

152. James Sully, *Studies of Childhood* (New York: D. Appleton, 1896); in Daniel N. Robinson, ed., *Significant Contributions to the History of Psychology, 1750–1920* (Washington, D.C.: University Publications of America, 1977).

153. Read, *Education Through Art*, 117.

154. Michael and Morris, "European Influences on the Theory and Philosophy of Viktor Lowenfeld," 104–5.

155. Leeds, "The History of Attitudes Toward Children's Art," 96–97.

156. Cizek, quoted in Wilhelm Viola, *Child Art*, 34.

157. Cizek, quoted in Leeds, "The History of Attitudes Toward Children's Art," 99.

158. Cizek, quoted in Viola, *Child Art*, 33.

159. Cizek, quoted in MacDonald, *The History and Philosophy of Art Education*, 323.

160. MacDonald, *The History and Philosophy of Art Education*, 341.

161. See Viola's *Child Art* (1942) as well as Francesca M. Wilson, *The Child as Artist: Some Conversations with Franz Cizek* (London: Children's Art Exhibition Fund, 1921).

162. MacDonald, *The History and Philosophy of Art Education*, 345.

163. Ibid., 347.

164. Carline, *Draw They Must*, 161.

165. Cizek, quoted in ibid., 160.

166. Ibid., 161.

167. Elmer E. Brown, ed., "Notes on Children's Drawings," *University of California Studies in Education* (1897, vol. 2): 1–75.

168. Ibid., 67.

169. Ibid., 64.

170. Ibid., 73.

171. Ebenezer Cooke, "The ABC of Drawing," in *Special Reports on Educational Subjects, 1896–7* (London: Eyre and Spottiswoode, 1897), 121.

172. Ibid., 139–41.

173. Ibid., 118–20.

174. Carl Götze, "Was offenbart das Kind durch eine Zeichnung?," *Pädagogische Reform* 21 (March 10, 1897).

175. Ashwin, *Drawing and Education in German-Speaking Europe*, 156.

176. Götze, quoted in ibid., 156.

177. Ibid.

178. Carl Götze, *Zur Reform des Zeichenunterrichts* (Hamburg: Commissionsverlag von Boysen und Maasch, 1897).

179. Ashwin, *Drawing and Education in German-Speaking Europe*, 156–57.

180. James Sully, *Children's Ways* (1897; New York: D. Appleton, 1914).

181. Ibid., 187.

182. Ibid., 190–91.

183. Carl Götze, *Das Kind als Künstler: Ausstellung von freien Kinderzeichnungen in der Künsthalle zu Hamburg* (Hamburg: Lehrervereinigung für die Pflege der künstlerischen Bildung in Hamburg, 1898).

184. Ashwin, *Drawing and Education in German-Speaking Europe*, 157.

185. Götze, quoted in ibid.

186. Smith, "Germanic Foundations: A Look at What We Are Standing On," 28.

187. Götze, *Das Kind als Künstler*, 31–34.

188. Ibid., 28.

189. Ashwin, *Drawing and Education in German-Speaking Europe*, 157–58.

190. John Dewey, *The Child and the Curriculum / The School and Society* (1902 and 1899; Chicago: University of Chicago Press, 1956).

191. Ibid., 11.

192. Ibid., 12.

193. Ibid., 23.

194. Ibid., 40.

195. Ibid., 47.

196. Ibid., 61.

197. Earl Barnes, "Studies on Children's Drawings, VII: The Beginning of Synthesis," *Studies in Education* (Philadelphia, Pa.) 2 (October 1902): 314–16. See also Earl Barnes, "Children's Pictures and Stories," *Studies in Education*, I, Stanford University, 1896–97; and Earl Barnes, "Children's Pictures and Stories," *Studies in Education*, II, Philadelphia, 1902.

198. Barnes, "Studies on Children's Drawings, VII," 315–16.

199. Earl Barnes, "The Present and Future of Child Study in America," *Studies in Education* (Philadelphia, Pa.) 2 (December 1902): 363–72.

200. Ibid., 363.

201. Ibid., 368.

202. Lena Partridge, "Children's Drawings of Men and Women," *Studies in Education* (Philadelphia, Pa.) 2 (July 1902): 163–79.

203. Ibid., 176.

204. Ibid., 178.

205. Ibid., 179.

206. Mme. Albert Besnard, "Dessins d'enfants," *Bulletin de la Société libre pour l'étude psychologique de l'enfant* 7 (April 1902): 162–69.

207. Ibid., 163.

208. Ibid., 169; translation by Jonathan Fineberg.

209. Ibid., 164.

210. Georg Kerschensteiner, *Die Entwicklung der Zeichnerischen Begabung* (Munich: Carl Gerber, 1905).

211. O. K. Werckmeister, "The Issue of Childhood in the Art of Paul Klee," *Arts Magazine* 52 (September 1977): 142.

212. Kerschensteiner, quoted in ibid.

213. Peter Smith, "Germanic Foundations: A Look at What We Are Standing On," 27.

214. Diane Simons, *Georg Kerschensteiner: His Thought and Its Relevance Today* (London: Methuen, 1966), 78.

215. Brunhilde A. Kraus, "History of German Art Education and Contemporary Trends" (Ph.D. diss., Pennsylvania State University, 1968), 45.

216. Simons, *Georg Kerschensteiner*, 79.

217. Kraus, "History of German Art Education and Contemporary Trends," 45; see also Simons, *Georg Kerschensteiner*.

218. Siegfried Levinstein, *Kinderzeichnungen bis zum 14. Lebensjahr* (Leipzig: R. Voigtländer, 1905).

219. Viktor Lowenfeld, *The Nature of Creative Activity* (London: Routledge and Kegan Paul, 1939).

220. Michael and Morris, "European Influences on the Theory and Philosophy of Viktor Lowenfeld," 106.

221. Karl Lamprecht, "Les Dessins d'enfants comme source historique," *Bulletin de l'Académie Royale de Belgique* 9–10 (1906): 457–69.

222. See Florence L. Goodenough, *Measurement of Intelligence by Drawings* (Yonkers-on-Hudson, N.Y.: World Book Co., 1926), 2.

223. E[douard] Claparède, "Plan d'expériences collectives sur le dessin des enfants," *Archives de Psychologie* 6 (1906): 276–78.

224. See Lamprecht, "Les Dessins d'enfants comme source historique."

225. Goodenough, *Measurement of Intelligence by Drawings*, 2.

226. Marcel Réja (pseudonym of Paul Meunier), *L'Art chez les fous: le dessin, la prose, la poésie* (Paris: Société du Mercure de France, 1907).

227. *Les Tendances Nouvelles* 3rd year, no. 30 (1907 or 1908): 577.

228. E.-T. Hamy, "La Figure humaine chez les sauvages et chez l'enfant," *L'Anthropologie* (Paris) 19 (1908).

229. Leeds, "The History of Attitudes Toward Children's Art," 99.

230. Carline, *Draw They Must*, 140.

231. Ibid., 167.

232. MacDonald, *The History and Philosophy of Art Education*, 342.

233. Bruce Holdsworth, "Marion Richardson (1892–1946)," *Journal of Art and Design Education* 7, no. 2 (1988): 141.

234. Ibid., 150, n. 2.

235. See the catalogue of the Salon d'Automne, 214.

236. Ibid., 50–51.

237. Leon Bakst, "Puti klassitsizma v iskusstve," *Apollon* 2 (November 1909), 63–78.

238. Valentine Marcadé, *Le Renouveau de l'art pictural russe 1863–1914* (Lausanne: Editions l'age d'homme, 1971), 297–305, 773–76. The exhibition was in Odessa December 17, 1909–February 6, 1910, and then went to Kiev February 25–March 27, according to Donald E. Gordon, *Modern Art Exhibitions, 1900–1916*, vol. 2 (Munich: Prestel, 1974), 356ff. Marcadé has it in Odessa and then St. Petersburg, December 4, 1909–July 7, 1910. But it appears that they are both referring to the same exhibition.

239. Carline, *Draw They Must*, 165.

240. Steven Watson, *Strange Bedfellows: The First American Avant-Garde* (New York: Abbeville Press, 1991), 152–54.

241. Marcadé, *Le Renouveau de l'art pictural russe*, 329–31.

242. Sarah Wilson, "Raoul Dufy: Tradition, Innovation, Decoration 1900–1925," in *Raoul Dufy 1877–1953* (London: Arts Council of Great Britain, Hayward Gallery, 1983), 74.

243. M. A. van Gennep, "Dessins d'enfant et dessins préhistoriques," *Archives de Psychologie* 10 (1911): 327–37.

244. Ibid., 335 and 336.

245. Ibid., 328, 332, 329–31, and 336–37.

246. Ibid., 334–36.

247. Ibid., 336; translation Jonathan Fineberg.

248. Ibid., 337.

249. See *Münchner Nachrichten*, April 21, 1911; cited in Beeke Sell Tower, *Klee and Kandinsky in Munich and at the Bauhaus* (Ann Arbor, Mich.: UMI Research Press, 1981), 41, 281.

250. George Heard Hamilton, *Painting and Sculpture in Europe: 1880–1940* (Harmondsworth, Eng.: Penguin Books, 1967), 282, n. 48.

251. Anthony Parton, *Mikhail Larionov and the Russian Avant-Garde* (Princeton, N.J.: Princeton University Press, 1993), 94.

252. Paul Klee, "Der Blaue Reiter," *Die Alpen* (December 1911); in Paul Klee,

Tagebücher 1898–1918, ed. Wolfgang Kersten, textkritische Neuedition (Stuttgart, Germany: Gert Hatje and Teufen, Switzerland: Arthur Niggli, 1988) entry 905, 320–22.

253. Klee, quoted in Werckmeister, "The Issue of Childhood in the Art of Paul Klee," 138.

254. Philip B. Ballard, "What London Children Like to Draw," *Journal of Experimental Pedagogy* 1, no. 3 (1912): 185–97.

255. Ibid., 187.

256. Gustav Hartlaub, *Der Genius im Kinde* (1912; Breslau: Ferdinand Hirt, 1922).

257. Kraus, "History of German Art Education and Contemporary Trends," 48.

258. Michael Langer, *Kunst am Nullpunkt* (Worms, Germany: Werner, 1984), 100.

259. Helga Eng, *The Psychology of Children's Art: From the First Stroke to the Colored Drawings* (London: Kegan Paul, Trench, Trubner, 1931), 201.

260. Hartlaub, quoted in Langer, *Kunst am Nullpunkt*, 100.

261. August Macke, "Masks," in Wassily Kandinsky and Franz Marc, eds., *The Blaue Reiter Almanac* (1912; New York: Viking Press, 1974), 89.

262. Wassily Kandinsky, "On the Question of Form," in Kandinsky and Marc, *The Blaue Reiter Almanac*, 174.

263. Ibid., 175–76.

264. Ibid., 178.

265. Ibid., 174; see also Werckmeister, "The Issue of Childhood in the Art of Paul Klee," 139, and Leeds, "The History of Attitudes Toward Children's Art," 99–100.

266. See the review of the exhibition by Sadakichi Hartmann in *Camera Work* (New York) 39 (Spring 1912): 45.

267. William Innes Homer, *Alfred Stieglitz and the American Avant-Garde* (Boston: New York Graphic Society, 1977), 144 and 146.

268. Carline, *Draw They Must*, 166.

269. Philip B. Ballard, "What Children Like to Draw," *Journal of Experimental Pedagogy* 2, no. 2 (1913): 127–29.

270. Ibid., 129.

271. Georges Luquet, *Les Dessins d'un enfant* (Paris: Alcan, 1913).

272. Richards, "The History of Developmental Stages of Child Art: 1857–1921," 28.

273. Michael and Morris, "European Influences on the Theory and Philosophy of Viktor Lowenfeld," 109.

274. Ibid., 108.

275. This is widely reported in the literature, most recently in Parton, *Mikhail Larionov and the Russian Avant-Garde*, 94. See also Marcadé *Le Renouveau de l'art pictural russe*, 329–31.

276. Aleksandr Shevchenko, *Neo-primitivizm. Ego teoriya. Ego vozmozhnosti. Ego dostizheniya* (1913), translated into English by John Bowlt as *Neoprimitivism: Its Theory, Its Potentials, Its Achievements*, in John Bowlt, ed., *Russian Art of the Avant-Garde Theory and Criticism 1902–1934* (New York: Viking Press, 1976), 41–54.

277. Georges Rouma, *Le Langage graphique de l'enfant* (Paris: Misch et Tron, 1913).

278. Goodenough, *Measurement of Intelligence by Drawings*, 5.

279. Ibid., 6–7.

280. Fred C. Ayer, *The Psychology of Drawing; With Special Reference to Laboratory Teaching* (Baltimore: Warwick and York, 1916), 83–84.

281. Max Verworn, *Ideoplastische Kunst* (Jena, Germany: Gustaf Fischer, 1914).

282. Michael and Morris, "European Influences on the Theory and Philosophy of Viktor Lowenfeld," 106.

283. Ibid., 106–7.

284. William Stern, *Psychologie der frühen Kindheit bis zum sechsten Lebensjahre* (Leipzig: Quelle und Meyer, 1914); translated into English by Anna Barwell as *Psychology of Early Childhood Up to the Sixth Year of Age* (New York: H. Holt, 1924).

285. Stern, *Psychologie der frühen Kindheit*, 237; translations here and below by Jonathan Fineberg.

286. Ibid., 238.

287. Ibid., 198.

288. Ibid., 239–41.

289. See John E. Bowlt, "Esoteric Culture and Russian Society," in Maurice Tuchman, ed., *The Spiritual in Art: Abstract Painting 1890–1985* (Los Angeles: County Museum of Art; New York: Abbeville Press, 1986), 178.

290. See D. Filosofov, "Zhorzhik i garrik," *Rech'*, February 13, 1915, 2; and A. Benois, "O detskom tvorchestve," *Rech'*, May 27, 1916, 62.

291. Ayer, *The Psychology of Drawing* (see n. 280 above).

292. Walter Krötzsch, *Rhythmus und Form in der freien Kinderzeichnung* (Leipzig: Haase, 1917).

293. Kraus, "History of German Art Education and Contemporary Trends," 47.

294. Michael and Morris, "European Influences on the Theory and Philosophy of Viktor Lowenfeld," 107.

295. Eng, *The Psychology of Children's Art*, 141, 142.

296. Roger Fry, "Children's Drawings," *Burlington Magazine* 30 (June 1917): 225–31.

297. Ibid., 225, 226.

298. Reprinted in Hans Richter, *Dada, Art and Anti-art* (New York: McGraw-Hill, 1965), 225.

299. Carline, *Draw They Must*, 167.

300. Marion Richardson, *Art and the Child* (London: University of London Press, 1948), 30–31, 32.

301. Carline, *Draw They Must*, 170.

302. Holdsworth, "Marion Richardson," 143.

303. Ibid., 145.

304. Richardson, quoted in ibid., 143.

305. Ibid.

306. Ibid., 145.

307. Karl Bühler, *Die Geistige Entwicklung des Kindes*, 3rd ed. (1919; Jena, Germany: G. Fischer, 1922); a concise version of the text, translated into English by O. A. Oeser, was published as *The Mental Development of the Child* (London: Routledge and Kegan Paul, 1930).

308. Michael and Morris, "European Influences on the Theory and Philosophy of Viktor Lowenfeld," 108–9.

309. Ibid., 109.

310. Bühler, *The Mental Development of the Child*, 114–15.

311. Ibid., 116.

312. Ibid., 119.

313. Ibid., 120.

314. Ibid., 124.

315. Pavel Florenskii, "Obratnaja Perspectiva" (1919), in *Ikonostas: izbrannye trudy po iskusstvu* (St. Petersburg: Mifril, Russkaja Kniga, 1993).

316. Ibid., 208; translation by Olga Ivashkevich.

317. George Biddle, "Creative Art in Children," *The American Magazine of Art* 27 (October 1934): 532.

318. Roger Fry, "Teaching Art," *The Athenaeum* 2 (September 1919): 887–88.

319. Ibid., 887.

320. Ibid., 888.

321. John MacGregor, *The Discovery of the Art of the Insane* (Princeton, N.J.: Princeton University Press, 1989), 279; and Ann Temkin, "Klee and the Avant Garde 1912–1940," in Carolyn Lanchner, ed., *Paul Klee* (New York: Museum of Modern Art, 1987), 19.

322. Holdsworth, "Marion Richardson," 141.

323. Carline, *Draw They Must*, 172; see also R. R. Tomlinson, *Children as Artists* (London: King Penguin Books, 1947), 21.

324. Roger Fry, *Vision and Design* (London: Chatto and Windus, 1920).

325. Sondra Battist, "Child Art and Visual Perception," *Art Education* 20, no. 1 (1967): 26.

326. MacDonald, *The History and Philosophy of Art Education*, 342.

327. Ibid.

328. Cyril Burt, *Mental and Scholastic Tests* (London: P. S. King and Son, 1933).

329. Dale B. Harris, *Children's Drawings as Measures of Intellectual Maturity* (New York: Harcourt, Brace and World, 1963), 17.

330. Burt, *Mental and Scholastic Tests*, 318.

331. Ibid., 319–325.

332. Ibid., 326.

333. "The Bewildering Art of Children," *Literary Digest*, July 1, 1922, 34–35.

334. Margaret F. Browne, quoted in ibid.

335. Hans Prinzhorn, *Bildnerei der Geisteskranken* (Berlin: Julius Springer, 1922); translated into English from the second German edition by Eric von Brockdorff as *Artistry of the Mentally Ill: A Contribution to the Psychology and Psychopathology of Configuration* (New York: Springer-Verlag, 1972).

336. Ibid., 16.

337. See Krötzsch, *Rhythmus und Form in der freien Kinderzeichnung.*

338. Prinzhorn, *Artistry of the Mentally Ill*, 246.

339. Carline, *Draw They Must*, 170.

340. Jean Piaget, *Le Langage et la pensée chez l'enfant* (Neuchâtel: Delachaux et Niestlé, 1923); translated into English by Marjorie Warden as *The Language and Thought of the Child* (New York: Harcourt, Brace, 1926).

341. See Luquet, *Les Dessins d'un enfant*; and Georges Luquet, *Le Dessin enfantin* (Paris: Delachaux et Niestlé, 1927), translated into English by Alan Costall as *Children's Drawings* (London: Free Association Books, 2001).

342. Piaget, *The Language and Thought of the Child*, 182.

343. Ibid.

344. Stella Agnes McCarty, *Children's Drawings* (Baltimore: Williams and Wilkins, 1924).

345. Ibid., 7.

346. Ibid., 23–25.

347. Ibid., 26, 28.

348. Nikolai Dmitrievich Bartram, "SSSR Na Parizhskoi Vystavke," *Sovetskoe iskusstvo* 1 (April 1925), 95–96.

349. Gustaf Britsch, *Theorie der Bildenden Kunst*, edited by Egon Kornmann (Munich: F. Bruckmann, 1926).

350. Ibid., 17; translations here and below are by Klaus Witz.

351. Ibid., 18, 19, 20–21.

352. Ibid., 23, 24.

353. Ibid., 28.

354. Ibid., 43–44.

355. Goodenough, *Measurement of Intelligence by Drawings* (see n. 222 above).

356. Ibid., 12–13.

357. Ibid., 86.

358. Lewis Mumford, "The Child as Artist," *The New Republic*, June 30, 1926, 165–67.

359. Ibid., 165–66.

360. Luquet, *Children's Drawings* (see n. 341 above).

361. Luquet, *Children's Drawings*, 77.

362. Ibid., 11.

363. Ibid., 47, 51.

364. Ibid., 55.

365. Ibid., 13–17.

366. Ibid., 23.

367. Ibid., 83.

368. Ibid., 31.

369. Ibid., 95.

370. Ibid., 102.

371. Ibid., 122.

372. Ibid., 125.

373. Ibid., 138.

374. Ibid., 156–157.

375. Katherine Anne Porter, "Children and Art," *The Nation*, March 2, 1927, 233–34.

376. Ibid., 233.

377. Ibid., 234.

378. Oskar Wulff, *Die Kunst des Kindes* (Stuttgart: Ferdinand Enke, 1927).

379. Richardson, quoted in Holdsworth, "Marion Richardson," 147.

380. Richardson, *Art and the Child*, 35.

381. Lene Schmidt-Nonne, "Kinderzeichnungen," *Bauhaus* 3 (July–September 1929), 13–16.

382. Eng, *The Psychology of Children's Art* (see n. 259 above).

383. Ibid., 101–2.

384. Ibid., 106.

385. Ibid., 109–10.

386. Ibid., 125.

387. Ibid., 129, 130.

388. Ibid., 138.

389. Ibid., 150.

390. Ibid., 162–63.

391. Ibid., 177.

392. Ibid., 181–83.

393. Alfred G. Pelikan, *The Art of the Child* (New York: Bruce Publishing Company, 1931).

394. Ibid., 9.

395. G. W. Paget, "Some Drawings of Men and Women Made by Children of Certain Non-European Races," *The Journal of the Royal Anthropological Institute of Great Britain and Ireland* 62, no. 35 (1932): 127–44.

396. Ibid., 128.

397. Ibid., 134–37.

398. Clara P. Reynolds, "Child Art in the Franz Cizek School in Vienna," *Childhood Education* 10, no. 3 (December 1933): 121–26, 152.

399. Lev Vygotsky, *Myshlenie i rech'*, translated into English by Eugenia Hanfmann and Gertrude Vakor as *Thought and Language*, revised edition by Alex Kozulin (1934; Boston: MIT Press, 1986).

400. Lev S. Vygotsky, *Mind in Society: The Development of Higher Psychological Processes* (Cambridge, Mass.: Harvard University Press, 1978).

401. Ibid., 87, 89.

402. Ibid., 112–13.

403. Ibid., 115.

404. Reginald Robert Tomlinson, *Picture Making by Children* (London: The Studio, 1934).

405. Ibid., 10.

406. Ibid., 18.

407. Ibid., 23.

408. Ibid., 19.

409. See Anne Anastasi and John P. Foley, Jr., "An Analysis of Spontaneous Drawings by Children in Different Cultures," *Journal of Applied Psychology* no. 20 (1936): 689–726, esp. 700.

410. Osip Beskin, ed., *Iskusstvo detei* (Leningrad: Oblastnoi soiuz, 1935).

411. Ruth Griffiths, *A Study of Imagination in Early Childhood and Its Function in Mental Development* (London: Routledge and Kegan Paul, 1935).

412. Ibid., 210.

413. Ibid., 190–210.

414. Ibid., 218.

415. Anastasi and Foley, "An Analysis of Spontaneous Drawings by Children in Different Cultures," 689–726 (see n. 409 above).

416. Ibid., 721.

417. Wilhelm Viola, *Child Art and Franz Cizek* (Vienna: Austrian Junior Red Cross, 1936).

418. Ibid., 13.

419. Ibid., 30.

420. Ibid., 14.

421. Ibid., 17, 18.

422. Ibid., 24, 25.

423. Cizek, quoted in ibid., 35–36.

424. Carl Gustav Jung, "The Concept of the Collective Unconscious," *Journal of St. Bartholomew's Hospital* no. 44 (1936–37): 46–49, 64–66; reprinted in Jung, *The Archetypes and the Collective Unconscious*, trans. R. F. C. Hull (Princeton, N.J.: Princeton University Press, 1953).

425. Ibid., 42.

426. Ibid., 50.

427. Robert Goldwater, *Primitivism in Modern Art* (New York: Harper and Brothers, 1938).

428. Ibid., 192–93.

429. Ibid., 214.

430. Carline, *Draw They Must*, 173.

431. Holdsworth, "Marion Richardson," 150.

432. Richardson, *Art and the Child*, 79.

433. Roger Fry, *Last Lectures* (Cambridge: Cambridge University Press, 1939), 51–52.

434. Viktor Lowenfeld, *The Nature of Creative Activity: Experimental and Comparative Studies of Visual and Non-Visual Sources of Drawing, Painting, and Sculpture by Means of the Artistic Products of Weak Sighted and Blind Subjects and of the Art of Different Epochs and Cultures* (New York: Harcourt, Brace, 1939).

435. Ibid., 17–18.

436. Ibid., 21.

437. Ibid., 38–39.

438. Ibid., 63.

439. Ibid., 68, 82.

440. Ibid., 69.

441. Ibid., 87.

442. Read goes on to say, "The story has often been repeated, generally in a distorted form, but this is the authentic version." See Herbert Read, "Whatever Happened to the Great Simplicities?," *Saturday Review*, February 18, 1967, 23.

443. Wilhelm Viola, *Child Art* (1942; Peoria, Ill.: Chas. A. Bennet, 1949), 16–18.

444. Ibid., 20, and Spengler, quoted in ibid., 21.

445. Ibid., 22.

446. Ibid., 25–29 passim.

447. Ibid., 30–31.

448. Ibid., 62, 63.

449. Ibid., 60.

450. Victor D'Amico, *Creative Teaching in Art* (Scranton, Pa.: International Textbook Company, 1953), 1.

451. Ibid., 2–3.

452. Ibid., 9.

453. Ibid., 15, 16.

454. Ibid., 23.

455. Herbert Read, *Education Through Art* (New York: Pantheon Books, 1943), 112.

456. Ibid., 121.

457. Ibid., 128.

458. Ibid., 123–25.

459. Ibid., 134.

460. Ibid., 125–26.

461. Ibid., 138–43.

462. L. W. Rochowanski, *Die Wiener Jugendkunst: Franz Cizek und seine Pflegestätte* (Vienna: Wilhelm Frick, 1946). Mark Rothko will make extensive notes on this book in his personal notebooks; see Jonathan Fineberg, *The Innocent Eye: Children's Art and the Modern Artist* (Princeton, N.J.: Princeton University Press, 1997), 226, n. 3.

463. Rochowanski, *Die Wiener Jugendkunst*, 21; translations by Klaus Witz.

464. Ibid., 23.

465. Ibid., 28.

466. Ibid., 24.

467. Ibid., 32.

468. Ibid., 29, 36.

469. Rose H. Alschuler and La Berta W. Hattwick, *A Study of Painting and Personality of Young Children*, 2 vols. (Chicago: University of Chicago Press, 1947), 3.

470. Ibid., 6, 7, 8, 9, 11, 13.

471. Ibid., 14–15.

472. Ibid., 17–18.

473. Ibid., 14.

474. Ibid., 55.

475. Ibid., 14.

476. Viktor Lowenfeld, *Creative and Mental Growth: A Textbook on Art Education* (New York: Macmillan, 1947).

477. Ibid., 1–4.

478. Ibid., 9, 10.

479. Ibid., 29.

480. Ibid., 38.

481. Ibid., 40.

482. Ibid., 43–44.

483. Ibid., 57.

484. Ibid., 74.

485. Ibid., 79.

486. Ibid., 99–100.

487. Ibid., 104.

488. Ibid., 129–30.

489. See also Lowenfeld's *The Nature of Creative Activity* (see n. 434 above).

490. Reginald Robert Tomlinson, *Children as Artists* (London: Penguin Books, 1947).

491. Ibid., 10, 14, 15.

492. Ibid., 22.

493. Ibid., 25.

494. Ibid., 30.

495. Richardson, *Art and the Child* (see n. 300 above).

496. Ibid., 14.

497. Ibid., 15.

498. Ibid., 55.

499. Jean Piaget and Barbel Inhelder, *La Répresentation de l'espace chez l'enfant* (Paris: Presses Universitaires de France, 1948); also published in English in the same year as *The Child's Conception of Space* (London: Routledge and Kegan Paul, 1948).

500. Piaget and Inhelder, *The Child's Conception of Space*, 3.

501. Ibid., 4.

502. Ibid., 6–8.

503. Ibid., 9, 10–11, 12, 13.

504. Ibid., 17.

505. Ibid., 33.

506. Ibid., 46–52. On the developmental stages, see also Piaget, *The Language and Thought of the Child*.

507. Piaget and Inhelder, *The Child's Conception of Space*, 448.

508. Ibid., 452.

509. Henry Schaefer-Simmern, *The Unfolding of Artistic Activity* (Berkeley: University of California Press, 1948), 4–5.

510. Ibid., 9, 10–11, 14.

511. Ibid., 12–13.

512. Ibid., 27.

513. Children's drawings are reproduced in *Cobra* no. 4 (1949), on pages 18 and 25 and on unnumbered pages facing pages 10, 11, 18, and 19.

514. Charles D. Gaitskell, *Children and Their Pictures* (Toronto: Ryerson Press, 1951), 2.

515. Rhoda Kellogg, *What Children Scribble and Why* (Palo Alto, Calif.: National Press Books, 1959).

516. Rudolf Arnheim, *Art and Visual Perception: A Psychology of the Creative Eye* (Berkeley: University of California Press, 1954).

517. Ibid., 131.

518. Ibid., 167.

519. Ibid., 140.

520. Ibid., 136.

521. Ibid., 149.

522. Ibid., 154.

523. Ibid., 156–57.

524. Ibid., 159.

525. Ibid., 161.

526. Kellogg, *What Children Scribble and Why* (see n. 515 above), 1.

527. Ibid., 32.

528. Ibid., 36.

529. Ibid., 16–18.

530. Ibid., 20.

531. Ibid., 28.

532. Ibid., 127–28.

533. Thomas Munro, *Art Education: Its Philosophy and Psychology* (New York: Liberal Arts Press, 1956).

534. Ibid., 223, 224, 226.

535. Ibid., 231, 233.

536. Ibid., 234–35.

537. Miriam Lindstrom, *Children's Art: A Study of Normal Development in Children's Modes of Visualization* (Berkeley: University of California Press, 1957).

538. Susanne K. Langer, *Feeling and Form* (New York: Scribner's, 1953).

539. Lindstrom, *Children's Art*, 11.

540. Herbert Read, *The Significance of Children's Art* (Vancouver: University of British Columbia, 1957), 2.

541. Arnheim, quoted in ibid., 3. See Arnheim's *Art and Visual Perception*.

542. Ibid., 4.

543. Ibid., 27.

544. Ibid., 5.

545. Ibid., 27.

546. Charles D. Gaitskell, *Children and Their Art* (New York: Harcourt, Brace, 1958).

547. Ibid., 127.

548. Ibid., 129.

549. Ibid., 138, 139.

550. June McFee, *Preparation for Art* (San Francisco: Wadsworth, 1961), 38.

551. Ibid., 39–40.

552. Ibid., 46–47.

553. Ibid., 72.

554. Ibid., 86, 87, 89.

555. Harris, *Children's Drawings as Measures of Intellectual Maturity* (see n. 329 above).

556. Ibid., 5, 7.

557. Ibid., 247.

558. Betty Lark-Horovitz, Hilda Lewis, and Mark Luca, *Understanding Children's Art for Better Teaching* (1967; Columbus, Ohio: Charles E. Merrill, 1973), 3.

559. Ibid., 21, 22.

560. Ibid., 27.

561. Ibid., 35.

562. Ibid., 59.

563. Ibid., 72.

564. Ibid., 75.

565. Ibid., 81.

566. Ibid., 85.

567. Ibid., 88.

568. Ibid., 90, 91.

569. Ibid., 100.

570. Ibid., 98, 101.

571. Ibid., 115.

572. Ibid., 212, 213.

573. Rudolf Arnheim, *Visual Thinking* (Berkeley: University of California Press, 1969), 257, 255.

574. Ibid., 267.

575. Ibid., 264–65.

576. Ibid., 257.

577. Rhoda Kellogg, *Analyzing Children's Art* (Palo Alto, Calif.: Mayfield, 1969), 255, 257.

578. Ibid., 248.

579. Ibid., 31.

580. Ibid., 96.

581. Ibid., 101, 103.

582. Ibid., 100.

583. Ibid., 188, 189.

584. Ibid., 224, 225.

585. Ibid., 266.

586. Bohuslav Kovac, *Zazracny svet detskych kresieb* (Bratislava, Slovakia: Pallas, 1972). The summary of this book is based on an unpublished Russian version, translated from the Slovak by I. Zaliotnaya in 1990.

587. Howard Gardner, *The Arts and Human Development: A Psychological Study of the Artistic Process* (New York: John Wiley and Sons, 1973), 20.

588. Ibid., 14–15.

589. Ibid., 15–16.

590. Ibid., 18–19.

591. Ibid., 23.

592. Ibid., 37, 39, 40.

593. Ibid., 83–84.

594. Ibid., 88.

595. Ibid., 128–29.

596. Ibid., 126.

597. Ibid., 168.

598. Ibid., 166.

599. Ibid., 220.

600. Ibid., 286.

601. Claire Golomb, *Young Children's Sculpture and Drawing* (Cambridge, Mass.: Harvard University Press, 1974).

602. Ibid., 177–78.

603. Ibid., 3.

604. Ibid., 8.

605. Ibid., 18.

606. Ibid., 22.

607. Ibid., 60.

608. Ibid., 30.

609. Ibid., 44, 52, 97.

610. Ibid., 83.

611. Ibid., 85.

612. Ibid., 102.

613. Ibid., 106.

614. Ibid., 110.

615. Ibid., 119.

616. Ibid., 122, 125.

617. Ibid., 149, 151.

618. Ibid., 179.

619. Ibid., 185–87.

620. Brent Wilson, "The Superheroes of J. C. Holz: Plus an Outline of a Theory of Child Art," *Art Education* 27, no. 8 (1974): 2–7.

621. Ibid., 3.

622. Ibid., 3, 5.

623. Jacqueline Goodnow, *Children Drawing* (Cambridge, Mass.: Harvard University Press, 1977), 141.

624. Marjorie Wilson and Brent Wilson, "The Case of the Disappearing Two-Eye Profile: Or How Little Children Influence the Drawings of Little Children," *Review of Research in Visual Arts Education* 15 (Winter 1982): 19–32.

625. Goodnow, *Children Drawing*, 141–44, 145.

626. Brent Wilson and Marjorie Wilson, "An Iconoclastic View of the Imagery Sources in the Drawings of Young People," *Art Education* 30, no. 1 (January 1977): 5–11.

627. Ibid., 5, 6.

628. Ibid., 8–9.

629. Ibid., 10.

630. Ibid., 6, 11.

631. Ibid., 6.

632. Ibid., 5.

633. See Jane Bell, "Rainbow Connection," *Art News* 83, no. 7 (September 1984): 9–10.

634. Howard Gardner, *Artful Scribbles: The Significance of Children's Drawings* (New York: Basic Books, 1980), 3–10.

635. Ibid., 11.

636. Ibid., 16.

637. Ibid., 129.

638. Ibid., 133.

639. Ibid., 142.

640. Ibid., 47, 49.

641. Ibid., 148.

642. Ibid., 261.

643. Ibid., 160–62.

644. Ibid., 174.

645. Ibid., 189.

646. David H. Feldman, *Beyond the Universals in Cognitive Development* (Norwood, N.J.: Ablex, 1980), xiii.

647. Ibid., 1.

648. Ibid., 4–5.

649. Ibid., 6–7.

650. Ibid., 8–9.

651. Ibid., 47.

652. Ibid., 59.

653. Ibid., 76.

654. Ibid., 141.

655. Ibid., 143–44.

656. Ibid., 125.

657. Ibid., 166.

658. Norman H. Freeman, *Strategies of Representation in Young Children: Analysis of Spatial Skills and Drawing Processes* (London: Academic Press, 1980), 4.

659. Ibid., 9.

660. Ibid., 11.

661. Ibid., 40.

662. Ibid., 44, 52.

663. Ibid., 68.

664. Ibid., 343.

665. Ibid., 346.

666. Ibid., 348, 204.

667. Ibid., 206.

668. Ibid., 348, 192.

669. Ibid., 346.

670. Ibid., 212–13.

671. Ibid., 221.

672. Ibid., 261, 346.

673. Ibid., 347.

674. Ibid., 231.

675. Diana Korzenik, "Is Children's Work Art? Some Historical Views," *Art Education* 34, no. 5 (September 1981): 20–24.

676. Ibid., 20.

677. Ibid., 20–21.

678. Brent Wilson and Marjorie Wilson, "As I See It: The Use and Uselessness of Developmental Stages," *Art Education* 34, no. 5 (September 1981): 4–5.

679. Ibid., 4.

680. Ibid., 5.

681. Hilda Lewis, "Tools and Tasks: The Place of Developmental Studies, An Open Letter to Brent and Marjorie Wilson," *Art Education* 35, no. 3 (May 1982): 8–9.

682. Ibid., 8.

683. Ibid., 9.

684. Wilson and Wilson, "The Case of the Disappearing Two-Eye Profile" (see n. 624 above).

685. Ibid., 24–25.

686. Ibid., 27–28.

687. Ibid., 30–31.

688. Brent Wilson and Marjorie Wilson, *Teaching Children to Draw: A Guide for Parents and Teachers* (Englewood Cliffs, N.J.: Prentice Hall, 1982).

689. Ibid., xv.

690. Ibid., 24.

691. Ibid., 28.

692. Ibid., 29, 31.

693. Ibid., 35.

694. Ibid., 36.

695. Ibid., 48.

696. Ibid., 64, 66.

697. Ellen Winner, *Invented Worlds: The Psychology of the Arts* (Cambridge, Mass.: Harvard University Press, 1982).

698. Ibid., 147.

699. Ibid., 150, 151.

700. Ibid., 152, 155.

701. Ibid., 156–59.

702. Ibid., 163.

703. Ibid., 171.

704. Ibid., 175.

705. Alexander Alland, *Playing with Form: Children Draw in Six Cultures* (New York: Columbia University Press, 1983).

706. Ibid., 23.

707. Ibid., 33.

708. Ibid., 61.

709. Ibid., 96, 95.

710. Ibid., 69, 95.

711. Ibid., 99–103.

712. Ibid., 129.

713. Ibid., 131–32.

714. Ibid., 134, 153–54.

715. Ibid., 154.

716. Ibid., 158–59.

717. Ibid., 170.

718. Ibid., 173, 172, 183.

719. Ibid., 184.

720. Ibid., 203, 205.

721. Ibid., 211, 212.

722. Ibid., 215.

723. Henri Michaux, "Essais d'enfants; dessins d'enfants," in Michaux, *Déplacements Dégagements* (Paris: Gallimard, 1985): 55–80.

724. Ibid., 57; translations here and below by Jonathan Fineberg.

725. Ibid., 58, 62.

726. Ibid., 64, 62.

727. Ibid., 65–69.

728. Ibid., 70, 71.

729. Ibid., 72, 73.

730. Ibid., 75.

731. Ibid., 76.

732. Ibid., 78.

733. Sven B. Andersson, "Local Conventions in Children's Drawings: A Comparative Study in Three Cultures," *Journal of Multicultural and Cross-cultural Research in Art Education* 13 (Fall 1995): 101–12.

734. Ibid., 102.

735. Ibid., 109, 110.

736. Ibid., 101, 110.

737. Ibid., 110–11.

738. Brent Wilson, Al Hurwitz, and Mar-jorie Wilson, *Teaching Drawing from Art* (Worcester, Mass.: Davis, 1987).

739. Ibid., 18.

740. Ibid., 21.

741. Ibid., 18–21.

742. Ibid., 25.

743. Dennie Wolf and Martha Devis Perry, "From Endpoints to Repertoires: Some New Conclusions about Drawing Development," *Journal of Aesthetic Education* 22, no. 1 (Spring 1988): 17–34.

744. Ibid., 18.

745. Ibid., 18, 19.

746. Ibid., 20.

747. Ibid., 21.

748. Ibid., 28, 30.

749. Ibid., 21.

750. Ibid., 24.

751. Ibid., 33.

752. Glyn V. Thomas and Angele M. J. Silk, *An Introduction to the Psychology of Children's Drawings* (New York: New York University Press, 1990).

753. Ibid., 27–28.

754. Ibid., 29–30.

755. Ibid., 30–31.

756. Ibid., 32.

757. Ibid., 40, 39.

758. Ibid., 43–44.

759. Ibid., 45–47.

760. Ibid., 49–50.

761. Ibid., 51–53.

762. Ibid., 54–56.

763. Ibid., 59–63.

764. Ibid., 64–65.

765. Ibid., 67–68.

766. Ibid., 71.

767. Ibid., 72, 75.

768. Ibid., 140–41.

769. Ibid., 144.

770. Ibid., 154, 155.

771. Ibid., 158–59.

772. Robert Coles, *Their Eyes Meeting the World: The Drawings and Paintings of Children* (Boston: Houghton Mifflin, 1992).

773. Ibid., 26.

774. Ibid., 6–7, 8.

775. Ibid., 16, 20.

776. Ibid., 49.

777. Maureen V. Cox, *Children's Drawings* (New York: Penguin Press, 1992), 12.

778. Ibid., 16.

779. Ibid., 18, 19.

780. Ibid., 22.

781. Ibid., 33, 35.

782. Ibid., 43.

783. Ibid., 39, 44.

784. Ibid., 45.

785. Ibid., 52–53.

786. Ibid., 55–56.

787. Ibid., 92, 93, 94–95.

788. Ibid., 97.

789. Ibid., 107.

790. Ibid., 124–26.

791. Ibid., 128.

792. Ibid., 132–33, 134.

793. Ibid., 147.

794. Ibid., 159.

795. Ibid., 160, 179.

796. Janet L. Olson, *Envisioning Writing: Toward an Integration of Drawing and Writing* (Portsmouth, N.H.: Heinemann Educational Books, 1992), 1.

797. Ibid., 4, 11.

798. Ibid., 12.

799. Ibid., 156.

800. Jonathan Fineberg, *Mit dem Auge des Kindes: Kinderzeichnung und Moderne Kunst* (Munich: Städtische Galerie im Lenbachhaus; Bern: Kunstmuseum; Stuttgart: Hatje, 1995); Jonathan Fineberg, ed., *Kinderzeichnung und die Kunst des 20. Jahrhunderts, Essays zur Ausstellung* (Stuttgart: Hatje, 1995).

801. Anna M. Kindler and Bernard Darras, "Map of Artistic Development," in Kindler, ed., *Child Development in Art* (Reston, Va.: National Art Education Association, 1997), 17.

802. Ibid., 18.

803. Ibid., 19.

804. Ibid.

805. Ibid., 22.

806. Ibid., 23.

807. Ibid., 25, 26.

808. Ibid., 28–29.

809. Ibid., 30–31, 34.

810. Ibid., 31, 34.

811. Jonathan Fineberg, *The Innocent Eye: Children's Art and the Modern Artist* (Princeton, N.J.: Princeton University Press, 1997).

812. Jonathan Fineberg, ed., *Discovering Child Art: Essays on Childhood, Primitivism, and Modernism* (Princeton, N.J.: Princeton University Press, 1998). This is an expanded English version of *Kinderzeichnung und die Kunst des 20. Jahrhunderts* (see n. 800 above).

813. Paul Duncum, "A Multiple Pathways/Multiple Endpoints Model of Graphic Development," *Visual Arts Research* 25, no. 2 (Fall 1999), 38–47.

814. Ibid., 38.

815. Ibid., 40.

816. Ibid., 41–42.

817. Ibid., 42.

818. Ibid., 44.

819. Ibid., 43–44.

820. Ibid., 45–46.

821. Phil Pearson, "Towards a Theory of Children's Drawings as Social Practice," *Studies in Art Education* 42, no. 4 (Spring 2001), 348–65.

822. Ibid., 348.

823. Ibid., 349, 350–51.

824. Ibid., 352.

825. Ibid., 357–58.

826. Ibid., 358–61.

827. Claire Golomb, *Child Art in Context: A Cultural and Comparative Perspective* (Washington, D.C.: American Psychological Association, 2002), 4–5.

828. Claire Golomb, *The Child's Creation of a Pictorial World* (Berkeley: University of California Press, 1992).

829. Golomb, *Child Art in Context*, 19.

830. Ibid.

831. Ibid., 20–21.

832. Ibid., 22–23, 24, 26.

833. Ibid., 27–28, 29.

834. Ibid., 30, 31.

835. Ibid., 42, 43.

836. Ibid., 76.

837. Ibid., 84.

838. Ibid., 90.

839. Ibid., 116.

840. Ibid., 91.

841. Ibid., 138.

842. Ibid., 111, 115.

843. John Matthews, *Drawing and Painting: Children and Visual Representation*, 2nd ed. (London: Paul Chapman, 2003); first edition published as: *Helping Children to Draw and Paint in Early Childhood: Children and Visual Representation* (London: Hodder & Stoughton, 1994).

844. Ibid., 13.

845. Ibid., 3–4.

846. Ibid., 24, 23.

847. Ibid., 22.

848. Ibid., 42.

849. Ibid., 50.

850. Ibid., 20–21, 38.

851. Ibid., 89.

852. Ibid., 109.

853. Ibid., 97.

854. Ibid., 167.

855. Ibid., 209.

856. Michael Parsons, "Endpoint, Repertoires, and Toolboxes: Development in Art as the Acquisition of Tools," *The International Journal of Arts Education* 1, no. 1 (May 2003), 67–82.

857. Ibid., 68–69, 70.

858. Ibid., 71.

859. Ibid., 73. See Arthur Efland, "The Spiral and the Lattice: Changes in Cognitive Learning Theory with Implications for Art Education," *Studies in Art Education* 36, no. 3 (Spring 1995), 134–53.

860. Parsons, "Endpoint, Repertoires, and Toolboxes," 81.

INDEX

Index

Index

Index

Index

WHEN WE WERE YOUNG NEW PERSPECTIVES ON THE ART OF THE CHILD

WAS PRODUCED BY THE UNIVERSITY OF CALIFORNIA PRESS

SPONSORING EDITOR: DEBORAH KIRSHMAN

ASSISTANT ACQUISITIONS EDITOR: SIGI NACSON

PROJECT EDITOR: SUE HEINEMANN

PRODUCTION COORDINATOR: JOHN CRONIN

PUBLISHING SERVICES BY WILSTED AND TAYLOR

PROJECT MANAGEMENT: CHRISTINE TAYLOR

PRODUCTION MANAGEMENT: JENNIFER UHLICH, WITH THE ASSISTANCE OF DREW PATTY AND MARY LAMPRECH

COPY EDITING: JENNIFER KNOX WHITE, WITH THE ASSISTANCE OF NANCY EVANS

PROOFREADING: MELODY LACINA

DESIGN: JEFF CLARK

COMPOSITION: JEFF CLARK, TAG SAVAGE, AND YVONNE TSANG

TYPEFACES: CENTAUR AND AKZIDENZ GROTESK

PRINTER'S DEVILS: LILLIAN MARIE WILSTED AND JUNA HUME CLARK

PRINTING BY FRIESENS